Content and Context of Visual Arts
in the Islamic World

Richard Ettinghausen (photo by Stephen E. Ettinghausen)

Edited by
PRISCILLA P. SOUCEK

Content and Context of Visual Arts in the Islamic World

Papers from
A Colloquium in Memory of Richard Ettinghausen
Institute of Fine Arts, New York University, 2–4 April 1980
Planned and Organized by Carol Manson Bier

Published for
THE COLLEGE ART ASSOCIATION OF AMERICA
by
THE PENNSYLVANIA STATE UNIVERSITY PRESS
UNIVERSITY PARK AND LONDON

1988

Monographs on the Fine Arts
sponsored by
THE COLLEGE ART ASSOCIATION OF AMERICA
XLIV

Editors, Lucy Freeman Sandler and Isabelle Hyman

Library of Congress Cataloging-in-Publication Data

Content and context of visual arts in the Islamic world.

(Monographs on the fine arts; 44)
Papers presented at a memorial colloquium in tribute
to Richard Ettinghausen, held at New York University's
Institute of Fine Arts, Apr. 2–4, 1980.
Includes index.
1. Art, Islamic—Congresses. 2. Ettinghausen,
Richard. I. Soucek, Priscilla Parsons.
II. Ettinghausen, Richard. III. Series.
N6260.C6 1988 709'.17'671 85–43605
ISBN 0-271-00614-5

Contents

List of Illustrations

Foreword

RICHARD ETTINGHAUSEN returned to the Institute of Fine Arts in 1961, where he had taught shortly after coming to the United States, to develop a program that would meet the urgent need for trained scholars in the history of Islamic art. First as a commuter from Washington, then as a permanent member of the faculty, he established, through his preeminence as a scholar and his extraordinarily successful teaching, Islamic art as a cornerstone of the Institute's work. His death on 2 April 1979 deprived us of a remarkable colleague and friend, to whom the Institute owed an enormous debt.

To recognize that debt and to honor the memory of a great human being, the faculty chose a symposium that would both illustrate the extent of Richard Ettinghausen's own range and influence in the field of Islamic art and build upon his work. The symposium was planned by Carol Manson Bier, a doctoral candidate of Professor Ettinghausen, in consultation with others of his students, with Donald P. Hansen, representing the faculty, and with Elizabeth Ettinghausen. Its realization was owed both to Carol Bier's tireless work and to the generous support offered by the Hagop Kevorkian Fund.

The burdensome task of editing the papers delivered at the symposium for this volume and assembling the illustrative material for them fell to Priscilla P. Soucek, Richard Ettinghausen's successor as Hagop Kevorkian Professor of Islamic Art at the Institute; in this work she has been assisted by Linda Komaroff, Laura Tennan, and Hannah Davis; additional drawings were prepared by Thomas Amorosi and Lenora Paglia.

On behalf of the Institute, I should like to express profound gratitude to all of these people, especially to Carol Bier and Priscilla Soucek, for the time and effort devoted to this tribute.

James R. McCredie
Director of the Institute of Fine Arts
New York University

Note on Transliteration

THE system used for the transliteration of Arabic and Persian is that of the Library of Congress as outlined in the *Cataloging Service Bulletin* 118, Summer 1976 (Arabic), and 119, Fall 1976 (Persian) with the following modifications: *s* will appear as *th; z* will appear as *dh;* ẓ will appear as ḍ; and *v* will appear as *w* in certain Persian names and titles of Arabic derivation. Some, though not all, place names are here rendered in their most commonly accepted form. Titles are also rendered in their most commonly accepted form, except when given as part of a name, while dynastic titles are given in their anglicized form.

List of Abbreviations

BSOAS Bulletin of the School of Oriental and African Studies

Creswell, *EMA* *K. A. C. Creswell, Early Muslim Architecture,* part 1, Oxford, 1932; part 2, Oxford, 1942; 2d ed. in 2 vols., Oxford, 1969

EI *Encyclopaedia of Islam,* 1st ed., 4 vols., Leiden and London, 1913–34; 2d ed., vols. 1–v, Leiden and London, 1960–84

MAE K. A. C. Creswell, *The Muslim Architecture of Egypt,* 2 vols., Oxford, 1952–59

Pope, *SPA* A. U. Pope and P. Ackerman, eds., *A Survey of Persian Art,* 6 vols., London and New York, 1938; reprint ed., London and Tokyo, 1964

RCEA E. Combe, J. Sauvaget, and G. Wiet, *Répertoire chronologique d'épigraphie arabe,* 16 vols., Cairo, 1931–64

Van Berchem, *CIA* M. van Berchem, *Matériaux pour un Corpus Inscriptionum Arabicarum, Egypte,* 1, Paris, 1904; *Syrie du Sud,* 1. *Jérusalem "Ville,"* Cairo, 1922

ZDMG *Zeitschrift der Deutschen Morganländischen Gesellschaft*

Introduction

THE edited papers presented in this memorial volume offer tribute to Richard Ettinghausen, scholar, teacher, curator and friend, a great man who affected within his own lifetime the study of Islamic art throughout the Western world. Through the high caliber of his scholarship and his discerning connoisseurship, he had a profound effect on the intellectual development of those whom he touched through his manifold activities, whether in publications, formal lectures, or an informal sharing of his knowledge. In recognition of his many achievements he received in 1976 "Pour le Merite," the highest civil decoration awarded by the Federal Republic of Germany.

As a teacher of Islamic art at New York University's Institute of Fine Arts from 1961, where he held the Hagop Kevorkian Professorship of Islamic Art from its establishment until his death in April 1979, his training of graduate students was enhanced by his active participation in the museum world. He was active both as a curator at the Freer Gallery of Art of the Smithsonian Institution in Washington, D.C., and as a consultant to the Walters Art Gallery in Baltimore, the Virginia Museum of Fine Arts in Richmond, and the L. A. Mayer Memorial Institute of Islamic Art in Jerusalem. In his final museum post, as Consultative Chairman of the Department of Islamic Art at The Metropolitan Museum of Art from 1967 to 1979, he supervised not only the building and publication of that collection but also directed its permanent installation, thereby furthering knowledge of both the scholarly community and the general public. He also served on the Board of Trustees for The Hagop Kevorkian Fund, The Phillips Gallery, and The Textile Museum.

Richard Ettinghausen was generous with his time, offering advice or criticism to colleagues, students, and friends, and was also active as a public lecturer in both the United States and Europe. He was distinguished by the wide range of his interests. Very much aware of the larger cultural context of great works of art he was also concerned with the significance of objects in daily use and their connection with the life of people in the Islamic world. He encouraged his students to enhance public appreciation of Islamic art by working with museum and gallery exhibitions and by contributing to publications and educational programs.

With the passing of Richard Ettinghausen on 2 April 1979, the study of Islamic art could no longer be encompassed within the domain of one individual. In recognition of his great contribution, a memorial colloquium entitled "Iconography: Content and Context of Visual Arts in the Islamic World," was held from 2–4 April 1980 at the Institute of Fine Arts in New York. In contrast to more institutionalized conferences or to annual meetings of societies and professional

organizations, the scholarly colloquium carried with it an air of intimacy. In its ambience and warmth, and in the exchange of ideas, one might liken it to experiences shared by so many of us on previous occasions—as visitors at the home of Richard and Elizabeth Ettinghausen in Princeton, where they graciously entertained guests from abroad as well as curators, professors, collectors, and graduate students, who were all made to feel welcome as friends.

Both this volume and the memorial colloquium at which these papers were first presented preserve in part the legacy of what has now passed. For they attest to the humanity of Richard Ettinghausen, his wisdom, alert wit, and discerning eye. Each of the contributing authors shares with the reader perspectives and perceptions shaped to an important extent by the inspiration of his work.

Among the larger concerns of the art historian, it was the question of meaning in the visual arts that particularly fascinated Richard Ettinghausen. He sought to understand the fundamental assumptions that have shaped the character of Islamic art by delving into religious, philosophical, historical, and literary texts. He followed the formal transformations of themes, objects, or motifs and sought explanations in the context of Islamic civilization. He explored the factors that have shaped aesthetic perceptions of Islamic artists and patrons. Through these various studies he demonstrated that meaning can be revealed in many different ways.

The papers collected here mirror the diversity of Richard Ettinghausen's concerns and interests. They deal with a wide array of visual sources—ceramics, metalwork, stone carving, textiles, manuscript illustration, and architectural forms and their decoration—and range in date from the seventh to seventeenth centuries. In their investigation of meaning the authors utilize a variety of primary sources, from historical chronicles and literary texts to monumental inscriptions and numismatics. This volume advances our understanding of both the content and context of visual arts in the Islamic world.

Carol Manson Bier
The Textile Museum
Washington, D.C.

Priscilla P. Soucek
Institute of Fine Arts
New York University

The Nishapur Metalwork: Cultural Interaction in Early Islamic Iran

James W. Allan

SINCE it was Richard Ettinghausen who invited me to write a monograph on the Nishapur metalwork (subsequently published by the Metropolitan Museum of Art), it seems especially appropriate to focus this essay on that group of objects.[1] It is an added bonus that Ettinghausen himself had written an important article on a facet of Persian metalwork highly relevant to the second part of this essay. Nishapur metalwork is diverse in quality, in function, and in date, and large numbers of objects must remain outside the scope of this essay, although they have received detailed treatment in the monograph. The discussion that follows is limited to two groups of objects that exhibit important cultural characteristics and that add significantly to our knowledge of cultural movements and patterns in medieval Islam.

COSMETIC OBJECTS

It is generally held in the study of Islamic metalwork that most influences move in an east-west direction. For example, we know that the Umayyad caliphs used Sasanian or post-Sasanian Persian wine bowls at court,[2] and that large quantities of silver and gold objects were imported as taxes into the Umayyad heartlands from northern Iran and Khurasan.[3] So, too, it is often claimed

that Khurasan was the source of the northern Mesopotamian and Syrian inlaid bronze or brass fashion in the early thirteenth century.[4] Such westward movements were evidently not confined to metal. For example, there is no evidence that ʿIraqī or Persian governors under the Umayyads wore classical garb, but we know that Hishām[5] and Walīd II[6] wore Persian attire, and the stucco of Khirbat al-Mafjar likewise shows Eastern influence.

It is therefore highly significant that the Nishapur metalwork seems to offer evidence of a rather different cultural movement. In 1920 Kühnel[7]—and in 1945 Aǧa-Oǧlu[8]—suggested a relationship between certain domed incense burners from Iraq and Iran and a closely comparable Coptic incense-burner type. Both scholars were guarded in their conclusions, as Coptic metalwork is notoriously difficult to date accurately, but Aǧa-Oǧlu quoted literary evidence for the settling of Copts in the vicinity of Baghdad in the year A.D. 829 and suggested that such enforced settlement would account for the introduction into Iraq of this new form of object, of Egyptian origin, and its subsequent spread eastward to Iran.

Further evidence of cultural movement from west to east was provided by Boris Marshak; in an article of 1972,[9] he traced the development of ewer forms in Iraq and Iran prior to the Mongol invasions. Marshak convincingly illustrated the use of particular shapes of ewers over a period of three or four centuries and a gradually changing decorative scheme pointing to a movement of those shapes eastward.

While studying the Nishapur material, it became clear to me that certain objects may shed new light on this process and add significant new evidence of this eastward cultural movement in early Islamic times. The evidence lies in a number of cosmetic objects found at Nishapur and in related objects now housed in various museums and collections in the Western world.

First to be considered here is one of the commonest metal objects of medieval times—the kohl-stick, used for eye makeup. Among the Nishapur finds are two halves of two different kohl-sticks (fig. 1). They are of a type common in Iran, and examples have been found at Rayy, Istakhr, and Siraf, though none of these has yet been published. This type of kohl-stick is also found elsewhere in the Islamic world in medieval times, for example, at Fustat, Hama,[10] and Samarra.[11] Of particular interest is the fact that, in the Egyptian context, Flinders Petrie ascribed almost identical kohl-sticks to the Roman period.[12]

Another type of cosmetic object found both in Iran and further west is the adjustable tweezers. The Nishapur piece (fig. 2) has a cut in either arm up and down which slides a piece of bronze, enabling the tweezers to be held closed or opened for use. This same mechanism is found on a virtually identical pair from Siraf (unpublished), datable from its excavation context to the early ninth century, and on one example found at Fustat in the ARCE excavations in 1972.[13] There appears to be no precedent for this form in pre-Islamic Iran, but such tweezers were known to the classical world, though they were usually closed by a sliding piece of metal fitting around both arms, rather than by a piece fitting within them.[14]

A third kind of cosmetic object excavated at Nishapur, the toilet flask, tells us little, since comparative material is at present extremely difficult to find (fig. 3). However, another type of Persian toilet flask should be noted here: an approximately double-cube form, of which there is an example in the Victoria and Albert Museum, brought back from Iran by Major-General Murdoch-Smith in the 1870s (fig. 4).[15] The Nishapur flask derives from a classic type of Islamic glass flask of which numerous examples have survived.[16] The center of this particular glass industry was Egypt, from which most of the pieces come, and the usual dating for them is the ninth/tenth century. An eleventh-century Persian metal example is therefore likely to have been based on an Egyptian glass prototype.

Cosmetic mortars are among the commonest cosmetic objects found in Iran; the Nishapur

excavations brought four to light, two of which are in the Metropolitan Museum of Art (fig. 5). Others have been found at Tal-i Zuhak,[17] Siraf,[18] Susa,[19] Rayy,[20] Qalᶜah-i Yazdigird, and Istakhr.[21] Again, these are to be found throughout the Islamic Near East, especially in Egypt. A lidded example (probably eleventh/twelfth century) was found at Fustat;[22] other Egyptian examples are in Berlin[23] and in the Coptic museum in Cairo;[24] one from Medina Habu, near Luxor, is in the British Museum.[25]

The exact origin of such objects is uncertain, but cooking vessels offer a useful analogy. Charles Wilkinson, in his article on heating and cooking at Nishapur,[26] illustrated three cauldronlike objects—one of ceramic, one of metal, and one of stone—the first and last having been found at the site. It is readily apparent that the medium for which the design with flanged handles is most appropriate is stone; stone can be carved to leave such handles protruding. In metal, however, handles of this shape must be cast, using cumbersome multipiece molds. Producing flanged handles in ceramic is even more difficult as they must be luted on, with the inevitable result that they can be easily damaged. Hence a stone prototype is likely not only for such cauldrons but also for cosmetic mortars of the type found at Nishapur. It is noteworthy that classical Egypt also produced stone cosmetic dishes with flanged handles and a short stubby spout.[27] The imitation stone vessels in metal seen at Nishapur are also paralleled in the ancient world. A Hellenistic silver vessel closely follows the shape of the stone cosmetic dishes used in classical Egypt.[28]

A review of kohl-sticks, tweezers, and cosmetic mortars suggests the possibility, but not more, of an Egyptian connection for the objects found in Iran. The evidence is admittedly scanty, and any conclusion must be extremely tentative at this point. The next section of this essay, however, concerns a type of Persian object not found at Nishapur—a type of small toilet dish, its concave body in the form of a bird, with flat lip and projecting flat head, wing, and tail (fig. 6).[29] The Keir Collection piece was purchased in Iran, and another almost-identical example was found at Ghubayra in 1971.[30] In Islamic Iran animal or bird forms are normally used in the round—bird incense burners and incense holders,[31] lion incense burners,[32] bird kohl-bottles,[33] and so on. This concept of form was also typical of pre-Islamic Iran, in which rhytons, animal handles, and figurines all point to a tradition of animals in the round. Moreover, toilet dishes in pre-Islamic Indo-Persian culture were traditionally decorated with figures in relief.[34] Hence, the Islamic toilet dishes under discussion are strikingly at variance with the Persian norm, and the question of their origin immediately arises.

Here one may turn with confidence to Egypt. During the eighteenth dynasty, toilet dishes in the form of gazelles lying on their sides with their bodies hollowed out were common,[35] and although classical forms were introduced in the Roman period, this use of hollowed-out animal forms continued. Examples are two fish at University College, London, one of which bears an Arabic inscription (fig. 7).[36] It is of course possible that the latter was added and that the object is pre-Islamic, but the inscription certainly indicates the use of the object in early Islamic times. Another example from an early Islamic context is an ivory dish in the form of a bird holding a worm, excavated in the pre-Tulunid levels at Fustat.[37]

Thus there seems little doubt that the Persian toilet-dish form in question is of Egyptian origin, and this has a bearing on an unusual Persian cosmetic mortar in the Victoria and Albert Museum (fig. 8).[38] For, unlike all other known examples, it has side flanges in the form of wings, a handle in the form of a human or bird head, and a pouring spout in the form of a tail. This is as untypical of Persian forms as the toilet dishes just discussed; like them, it must be based on an Egyptian style. This object therefore provides additional evidence that Persian Islamic cosmetic mortars are probably derived from Egyptian prototypes.

It may be objected that such cosmetic traditions could have arrived in Iran prior to the Islamic conquest through Sasanian contact with the Romans. While this cannot be ruled out, it seems to me highly significant that traditional forms of toilet dish were still in use in the eighth and ninth centuries in Egypt, and that the double-cube flasks do not appear to be earlier than the ninth century. It therefore seems more likely that Persian taste was influenced by Egyptian customs in early Islamic times, and that what we have here is, in terms of Islamic metalwork, an unusual phenomenon: cultural movement from west to east.

EQUESTRIAN ACCOUTREMENTS

The second cultural phenomenon I want to explore is the role of the Turks in bringing new customs and art forms into Iran. From recent publications it is difficult to surmise the precise nature of their influence, since individual authors tend either to show a bias that would put any and every strain of Iranian Islamic culture into a Turkish setting, or an indifference to the question and a casual avoidance of it. This is not of course true of every scholar, and during his lifetime Ettinghausen stood out among the exceptions in his concern for precise evidence and for conclusions that were strictly in keeping with that evidence. In his paper on Turkish elements on silver objects of the Saljuq period of Iran,[39] published in the *Proceedings of the First International Congress of Turkish Arts,* Ettinghausen isolated decorative styles and particular techniques that can be associated with the Turkish tribes of Central Asia: the beveled style, the widespread use of niello, the linear arabesque of even width, and animal or bird designs in silhouettelike relief. His conclusion was cautious and appropriate:

> In the decorative arts of Saljuq Iran certain features were isolated which had had a long Inner-Asian history and could often be connected with Turkish people. It is therefore assumed that a further study of other material belonging to Turkish officials in Iran, living in the eleventh and twelfth century, or from Turkestan will further enrich or enlarge this picture.[40]

The material from Nishapur that forms the subject of the rest of this essay is not proved to have belonged to Turkish officials in Iran. Nevertheless, it provides valuable additional evidence on the Turkish connection.

Among the Nishapur belt fittings, I found three of the characteristics Ettinghausen isolated: the beveled style (fig. 9), though a rather rounded, debased form of it; the linear arabesque of even width (fig. 10), though again not a perfect example; and the animal or bird designs in silhouettelike relief (fig. 11). Some additional points should be noted, however. First of all, many Nishapur belt pieces reflect the Avar belt style deriving from Central Asia and common in Europe in Migration Period finds. A typical example is the Bocsa double belt from Hungary,[41] fitted with numerous ornamental short straps with metal terminals, and other straps with ring terminals for carrying additional items of equipment. The Nishapur finds contain examples of both types of terminal (figs. 10 and 12). Migration Period finds in Europe also offer close parallels to particular shapes of belt plates from Nishapur—the cordiform style (fig. 13) can be compared to examples from Russia and Scandinavia,[42] the rectangular plates with floral designs (fig. 14) are similar to a belt plate found in Russia,[43] and the tall, narrow belt-plate form (fig. 15) is similar to Hungarian examples on the Kiskörös-Városalatt belt.[44] From the Nishapur belt-plate finds it is

therefore clear that the belts worn by men of rank in early Islamic Iran were closely related to those of Central Asia and Migration Period Europe, and it is noteworthy that Islamic influence is remarkably small, consisting of three belt plates inscribed simply *al-mulk lillāh* ("sovereignty belongs to God") (fig. 16).

Another set of objects from Nishapur relevant to this discussion is a group I propose to call horse harness ornaments. These differ in form, method of manufacture, and design from the belt plates just discussed; their size, designs, and in certain cases their relative crudity suggest that they are more likely to be decoration from horse harnesses than anything else. Hungarian finds show that the horse harness in the Migration Period was decorated with metal plaques,[45] and this has been the Islamic tradition ever since.[46] One of the most striking objects in this group is a silvered bronze in the form of a pair of horns (fig. 17). The design is of Altaic origin and occurs on bridle ornaments and saddle pendants from Pazyryk,[47] whereas the style and conception of the objects can be paralleled in numerous woodcarvings, especially wooden bridle ornaments, from the same site;[48] one notices, for example, the flat back and rounded front, the solidity, and the conception of a shape surrounded by space. Other Nishapur harness ornaments display the same characteristics (fig. 18). They are obviously based on felt work, in which pieces of material of one color are sewn onto a ground of another color—the spaces may either symbolize the appliqués or the felt ground, but in both cases the felt source is perfectly clear.[49] Thus the Nishapur horse ornaments, like the belt fittings, suggest a close link with Central Asia, though here the link is with a very ancient horse-centered culture, rather than with contemporary objects spread over wide areas of Asia and Eastern Europe.

Perhaps the most important object among the Nishapur finds is the so-called Nishapur sword. This sword (fig. 19) consists of a long straight single-edged blade with cross-guard attached, the remains of a scabbard with twin bronze mounts, the top of the hilt, and a swivel ring. The grain of the wood of the hilt top shows that the hilt was curved, and that the sword was therefore a slashing weapon, not a thrusting one. The twin mounts and the cross-guard relate the sword to a group of swords found in Asia and Europe. An extremely close parallel is a sword found at Srostki in the Altai Mountains, now in the Museum at Biisk, which—at least as it has been reconstructed—has a straight hilt.[50] Mounts similar to those on the Nishapur sword have come to light further west in Russia and the Caucasus, as, for example, a sword now in Vienna with a curved hilt.[51] Migration Period swords of this type average 70–79 cm in their blade length and 3.0–3.3 cm in blade width, comparing well with the Nishapur sword's blade length of 71.5 cm and width of 3.5 cm.

The Russian and Central Asian swords mentioned can be approximately dated from the find spot of one sword of this type from the area of Kharkov that is now in the Moscow Anthropological Museum.[52] This sword was part of a find from a group of graves containing Islamic coins of the years A.D. 740 and 799, pointing to a late eighth- or early ninth-century date for the sword itself. This dating is supported by two simple sword-mount brackets of similar form found in excavations at Puszta-Toti;[53] from their excavation context they are unlikely to be earlier than the eighth century. Moreover, Wilkinson tells me that the Nishapur sword was found at "low level" in the Y2 area of Tepe Madraseh, while at "intermediate level" a tenth-century monochrome luster dish was found, thus suggesting a ninth-century date for the Nishapur sword. The Nishapur sword thus provides further evidence of the intrusion of Central Asian or Turkish culture into early Islamic Iran.

On the basis of the material discussed in the second half of this essay, two observations are in order. The first concerns the impact of Turkish customs on Iranian society. As seen in the Nishapur metal finds, the Turkish impact is certainly striking and yet it is also limited: the

Nishapur sword, the belt fittings, and the horse harness ornaments are all characterized by the Turkish source of their style and designs, but these are the only metal objects from Nishapur that reflect Turkish culture at all. In other words, on the basis of these finds, one would have to conclude that the Turkish impact was military—and only military—and that it did not affect urban life and culture in other ways.

The more important point arises from the dating of the pieces discussed. Ettinghausen, in the article cited, pointed to the influence of Turkish decorative styles in Saljuq times. In this essay, however, I am dealing with an apparently pre-Saljuq situation. The belt pieces often correspond to Migration Period finds in Asia and Europe; the horse ornaments, though obviously Islamic to judge from their find-spots, are undatable themselves, but they reflect centuries-old tradition; the Nishapur sword is a weapon of the late eighth or early ninth century. On the basis of these objects it seems that the novelty of Turkish or Central Asian culture in the Saljuq period in Iran may have been overemphasized in the past.

CONCLUSION

The Nishapur metalwork provides important information about cultural interaction in medieval Iran. First of all, it draws attention to a previously unnoticed eastward cultural movement in early Islam. Then it adds new dimensions to our understanding of the nature of Turkish cultural influence, suggesting that its impact was limited to the military sphere, and that it had that impact well before the Saljuq invasions. Indeed, we might conjecture that the *galāchūrī*, the long slashing Turkish calvary sword, of which the Nishapur sword is a fine example, may well have been standard equipment of the Turkish caliphal guard in Baghdad and Samarra in the ninth century. If so, this would add an important dimension to the understanding of the role and the impact of the Turks under the Abbasids.

NOTES

1. I am grateful to the late Richard Ettinghausen, whose writings on Islamic art I greatly admire. He allowed me freely to study and photograph the Nishapur material when I was at the Metropolitan Museum in 1972, and his invitation led in 1982 to the publication of *Nishapur: Metalwork of the Early Islamic Period*. In addition, I would like to thank Dr. Marilyn Jenkins of the Islamic Department, Manuel Keene, formerly of the Islamic Department, and Drs. Helmut Nickel and David Alexander of the Arms and Armor Department at the Metropolitan Museum for their cooperation and assistance.

2. I. Krachkovski, "Sasanidskaya chasha v'stikhakh' Abū Nuvāsa," *Seminarium Kondakovianum*, II, 1928, 113–25; R. Ghirshman, *Iran: Parthians and Sassanians*, London, 1962, 204, 209, 214.

3. R. B. Serjeant, "Material for the History of Islamic Textiles up to the Mongol Conquests," *Ars Islamica*, IX, 1942, 63; XI–XII, 1946, 98.

4. E.g., A. S. Melikian-Chirvani in *Arts de L'Islam des origines à 1700*, Paris, 1971, 102, no. 149.

5. D. Schlumberger, "Les fouilles de Qasr el-Heir el-Gharbi," *Syria*, XX, 1939, pl. XLV (3).

6. R. W. Hamilton, "Who Built Khirbat al-Mafjar?" *Levant*, I, 1969, 61–67.

7. E. Kühnel, "Islamische Rauchergerät," *Berliner Museen. Berichte aus den preuszischen Kunstsammlungen*, XLI, 1920, 241–50.

8. M. Aǧa-Oǧlu, "About a Type of Islamic Incense-Burner," *The Art Bulletin*, XXVII, 1945, 28–45, especially 29–32.

9. B. I. Marshak, "Bronzoviy kuvshin iz Samarkanda," *Srednyaya Aziya i Iran*, Hermitage, Leningrad, 1972, 61–90.

10. P. J. Riis, ed., *Hama. Fouilles et recherches 1931–*

1938, IV, 3. *Les petits objets médiévaux sauf des verreries et poteries*, Copenhagen, 1969, fig. 24.

11. *Excavations at Samarra 1936–39*, Baghdad, Department of Antiquities, 1940, II, pl. 142.

12. F. Petrie, *Objects of Daily Use*, London, 1927, 28, nos. 45–50, and pl. 23 (hereafter, Petrie).

13. Unpublished; information supplied by Dr. George Scanlon.

14. E. Babelon and J.-A. Blanchet, *Catalogue des bronzes antiques de la Bibliothèque Nationale*, Paris, 1895, no. 1627.

15. London, Victoria and Albert Museum, 528–'76, h: 7.4 cm, w: 2.0 cm. The top of each side of the body is decorated with the word al-daw[lah] in Kufic script. A. S. Melikian-Chirvani, *Islamic Metalwork from the Iranian World*, Victoria and Albert Museum, London, 1982, 43–44, no. 4 (hereafter, Melikian-Chirvani, 1982).

16. C. J. Lamm, *Mittelalterliche Gläser und Steinschnittarbeiten aus dem nahen Osten*, Berlin, 1929, I, 163–64; II, pl. 59, 61–62.

17. A. Stein, "An Archaeological Tour in the Ancient Persis," *Iraq*, III, 1936, pl. 29, nos. 47 and 57. Objects of this form have provoked considerable disagreement with regard to their original use and purpose; this problem is discussed in the Nishapur metalwork catalogue, p. 37. Members of the audience at the Ettinghausen Memorial Symposium suggested that the long spout implied drop-by-drop pouring of whatever liquid the object contained—indicating its ability to conserve a precious liquid or to dispense it in small quantities with considerable accuracy. Another observation was that the flanges enabled the contents to be heated.

18. Nos. S.69/70, 3197, and 5195.

19. Paris, Louvre, S. 417.

20. Philadelphia, University Museum, RCH 1711.

21. No. QY 78.11. See "Survey of Excavations," *Iran*, XVII, 1979, pl. VIIIa; and Philadelphia, University Museum, I₂–274.

22. G. Scanlon, "Fusṭāṭ Expedition: Preliminary Report, 1965, Part I," *Journal of the American Research Center in Egypt*, V, 1966, 97, fig. 11 (hereafter, Scanlon).

23. O. Wulff, *Altchristliche und mittelalterliche byzantinische und italienische Bildwerke*, I, 1909, pl. 53, nos. 1057–58 and 1060–61.

24. J. Strzygowski, *Catalogue générale des antiquités égyptiennes du Musée du Caire, Koptische Kunst*, Vienna, 1904, nos. 9150–52.

25. O. M. Dalton, *Catalogue of Early Christian Antiquities*, London, 1901, 104, no. 527, pl. 27.

26. C. K. Wilkinson, "Heating and Cooking at Nishapur," *Bulletin of the Metropolitan Museum of Art*, n.s. 2, 1943–44, 288.

27. F. W. von Bissing, *Catalogue générale des antiquités égyptiennes du Musée du Caire, Steingefässe*, Vienna, 1904, no. 18754.

28. T. Schreiber, *Die Alexandrinische Toreutik*, Leipzig, 1894, 333, fig. 69–70.

29. G. Fehérvári, *Islamic Metalwork of the Eighth to the Fifteenth Century in the Keir Collection*, London, 1976, no. 107, pl. 36a.

30. Ibid., 87.

31. Ibid., nos. 109–10, pl. 37a–b.

32. Pope, *SPA*, pls. 1297 and 1304.

33. Ibid., pl. 1312B.

34. Sir John Marshall, *Taxila*, Cambridge, 1951, III, pls. 144–46.

35. Petrie, pl. 34, nos. 18 and 20.

36. Ibid., pl. 34, nos. 33–34.

37. Scanlon, 104, fig. 14. Dr. Scanlon informs me that there is a wooden example of this type in the Islamic Museum, Cairo, and that he saw a schist example in the collection of M. David-Weill.

38. No. 1533–3903 (I: 10.8 cm, w: 8.0 cm, h: 2.5 cm). Melikian-Chirvani, 1982, 51–52, no. 15.

39. R. Ettinghausen, "Turkish Elements on Silver Objects of the Seljuq Period of Iran," *Communications Presented to the First International Congress of Turkish Arts*, Ankara, 1961, 128–33.

40. Ibid., 133.

41. G. László, *Études archéologiques sur l'histoire de la société des Avars*, 1955, *Archaeologia Hungarica*, XXXIV, 223, fig. 60 (hereafter, László).

42. T. J. Arne, *La Suède et l'Orient*, Upsala, 1914, figs. 194–204.

43. Ibid., fig. 127.

44. László, 163, fig. 47.

45. Ibid., 281, fig. 85.

46. E.g., a seventeenth-century Turkish horse harness in Karlsruhe, *Die Türkenbeute*, Badishes Landesmuseum, Karlsruhe, 1970, pls. 18–19.

47. S. I. Rudenko, *Kul'tura naseleniya tsentral'nogo altaya v skifskoe vremya*, Moscow and Leningrad, 1960, fig. 133.

48. Ibid., *Frozen Tombs of Siberia*, London, 1970, pl. 82A.

49. Ibid., *Kul'tura naseleniya gornovo altaya v skifskoe vremya*, Moscow and Leningrad, 1953, pl. CIII.

50. N. Fettich, "Die Metallkunst der landnehmanden Ungarn," *Archaeologia Hungarica*, XXI, 1937, pl. XXXI.

51. W. W. Arendt, "Türkische Säbel aus dem VIII–IX. Jahrhundert," *Archaeologia Hungarica*, XVI, 1935, pl. VI(12).

52. Ibid., 50.

53. J. Hampel, *Alterthümer des Frühen Mittelalters in Ungarn*, Braunschweig, 1905, I, 24; III, pl. 268, nos. 12–13.

FIG. 1. Two half kohl-sticks (Nishapur cat. nos. 83–84★). Tehran, Iran Bastan Museum

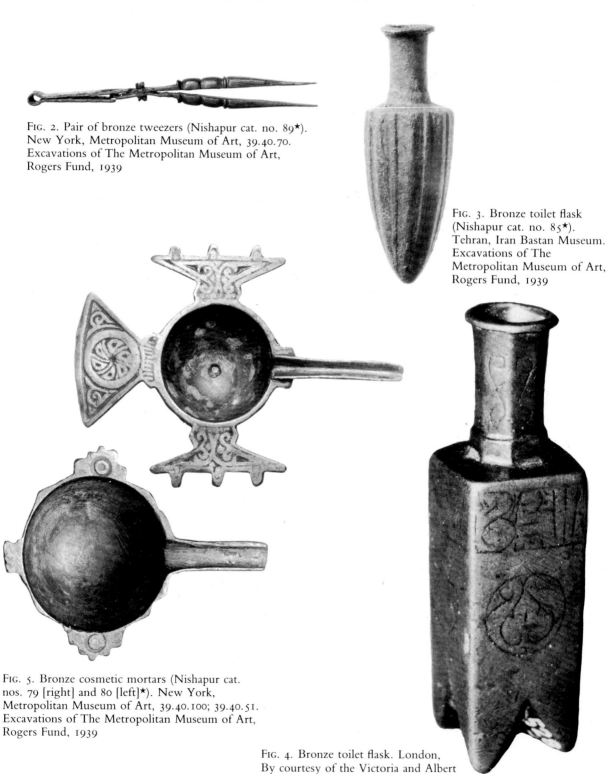

FIG. 2. Pair of bronze tweezers (Nishapur cat. no. 89★).
New York, Metropolitan Museum of Art, 39.40.70.
Excavations of The Metropolitan Museum of Art,
Rogers Fund, 1939

FIG. 3. Bronze toilet flask
(Nishapur cat. no. 85★).
Tehran, Iran Bastan Museum.
Excavations of The
Metropolitan Museum of Art,
Rogers Fund, 1939

FIG. 5. Bronze cosmetic mortars (Nishapur cat.
nos. 79 [right] and 80 [left]★). New York,
Metropolitan Museum of Art, 39.40.100; 39.40.51.
Excavations of The Metropolitan Museum of Art,
Rogers Fund, 1939

FIG. 4. Bronze toilet flask. London,
By courtesy of the Victoria and Albert
Museum, Crown Copyright (no. 528–'76)

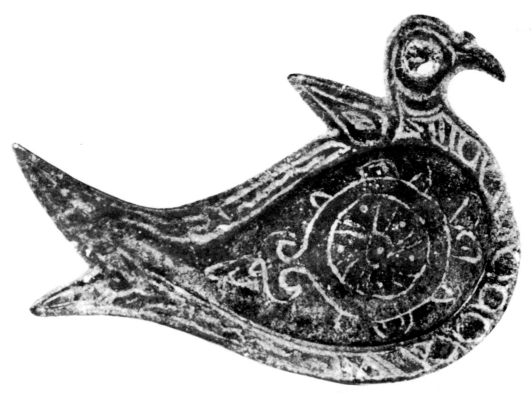

FIG. 6. Bronze toilet dish. Keir Collection no. 107

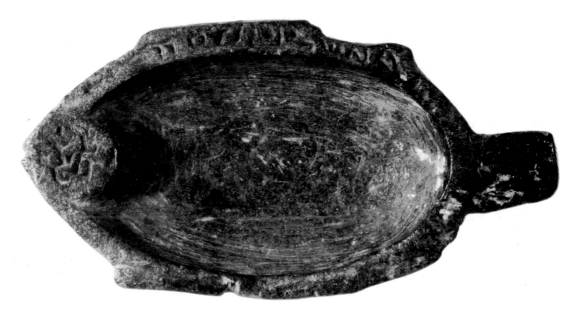

FIG. 7. Stone toilet dish in the form of a fish. London, University College

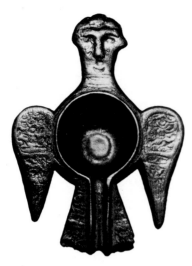

FIG. 8. Bronze cosmetic mortar. London, By courtesy of the Victoria and Albert Museum, Crown Copyright (no. 1533–1903)

FIG. 9. Bronze belt fittings (Nishapur cat. nos. 17, 18★). New York, Metropolitan Museum of Art, 40.170.208; Tehran, Iran Bastan Museum

FIG. 10. Silver belt fitting with niello inlay (Nishapur cat. no. 35★). Tehran, Iran Bastan Museum. Excavations of The Metropolitan Museum of Art, Rogers Fund, 1939

FIG. 11. Gilt-bronze belt fitting (Nishapur cat. no. 32★). New York, Metropolitan Museum of Art, 40.170.254. Excavations of The Metropolitan Museum of Art, Rogers Fund, 1940

FIG. 12. Bronze belt fitting (Nishapur cat. no. 12★). New York, Metropolitan Museum of Art, 40.170.277. Excavations of The Metropolitan Museum of Art, Rogers Fund, 1939

FIG. 13. Bronze belt fitting (Nishapur cat. nos. 25–27★). Tehran, Iran Bastan Museum. Excavations of The Metropolitan Museum of Art, Rogers fund, 1939

FIG. 14. Gilt-bronze belt fitting (Nishapur cat. no. 15★). New York, Metropolitan Museum of Art, 40.170.210. Excavations of The Metropolitan Museum of Art, Rogers Fund, 1940

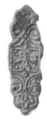

FIG. 15. Bronze belt fitting (Nishapur cat. no. 33★). Tehran, Iran Bastan Museum. Excavations of The Metropolitan Museum of Art, Rogers Fund, 1939

FIG. 16. Bronze belt fittings (Nishapur cat. nos. 9, 10★). New York, Metropolitan Museum of Art, 40.170.215; Tehran, Iran Bastan Museum

Fig. 17. Silvered bronze horse ornament (Nishapur cat. no. 132★). New York, Metropolitan Museum of Art, 40.170.212

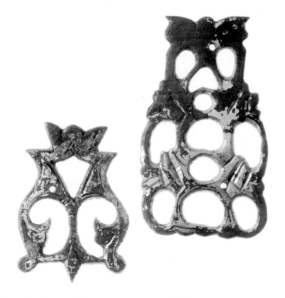

Fig. 18. Bronze horse ornaments (Nishapur cat. nos. 135 [left] and 137 [right]★). New York, Metropolitan Museum of Art, 39.40.136; Tehran, Iran Bastan Museum

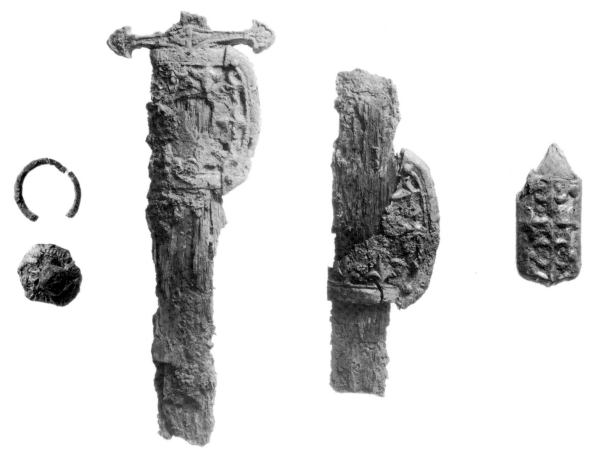

Fig. 19. The Nishapur sword (Nishapur cat. no. 208★). New York, Metropolitan Museum of Art, 40.170.168

★For more complete descriptions, see the author's *Nishapur: Metalwork of the Early Islamic Period,* New York, 1982.

Observations on the Iconography of the Mosaics in the Great Mosque at Damascus

Klaus Brisch

God has struck a similitude for the believers—the wife of Pharoah, when she said, My Lord, build for me a house in Paradise, in Thy presence.

Koran 66:1

THE history of the Great Mosque at Damascus[1] we owe to the late Archibald Creswell;[2] the technical, historical, and iconographical aspects of its mosaics have been thoroughly recorded by Marguerite Gautier-van Berchem in the same volume.[3] From their work we know that only a small portion of the original mosaics has survived; the walls and arches of both the *ḥaram* and the *ṣahn* (the Prayer Hall and the courtyard) were once covered with mosaics, but most of these perished in the many earthquakes and fires that ravaged the venerable House of Prayer in the course of centuries.

The sequence of the first Islamic mosaics is also well known: The Dome of the Rock at Jerusalem (dated by an inscription to 72/691 and commissioned by ʿAbd al-Malik);[4] those in the Damascus mosque (dated in the years 88–96/707–715) and those in the Prophet's Mosque at Medina (from 88–89/707–709)[5]—both commissioned by al-Walīd b. ʿAbd al-Malik, who was caliph from 86–96/705–15. In the second edition of his *Early Muslim Architecture*, Creswell added

a drawing of the southern part of the western wall of the Damascus courtyard. It was executed by Farīd Shāfiʿī and to my mind is one of the most brilliant archaeological drawings of the last decades (fig. 1). The drawing shows a socle of marble panels, 4.88 m high, and above it a second band 1.77 m high, consisting of marble panels divided by pillars into four compartments, in each of which there is a marble window grill. A study of this wall would constitute a fascinating subchapter in the as-yet-unwritten grammar of Umayyad ornament.

Above these marble panels there is a band of mosaic that originally measured 7 m in height and reached the ceiling; a section of it, 34 m long, is still preserved. The mosaic's lower frame consists of an uninterrupted band of acanthus scrolls, accompanied by a wider band of scalelike forms and a very small band of rosettes. This frame continues right to the southern edge of the western wall. The vertical frame is formed on the left by a repetition of the band with scalelike ornaments; on the right there is a band of larger acanthus scrolls flanked by rows of small rosettes. It seems noteworthy that the vertical frame not only differs from the horizontal one in pattern, but that the horizontal frame continues straight to the edge of the wall. This frame clearly provides a visual parallel to the river that stretches along the bottom of the mosaic, whereas the vertical frame serves as an announcement of the huge trees above the river, which articulate the entire mosaic and serve as frames for different landscapes with buildings. Five such groups of buildings can be seen in Professor Shāfiʿī's drawing.

It is the group farthest to the right in this drawing (fig. 2) that will be considered here.[6] The drawing shows a building that might be best described as an exedra or portico with a semicircular ground plan; its roof is supported by six fluted pillars, with a golden balustrade between them. In each compartment a door is visible, with a blue frame and golden jambs, and a lintel from which a large pearl is suspended. The shorter sides of the building, near the river, are covered by small square towers with conical roofs that are joined to houses with flat roofs. Only the towers and houses on the right side of the portico have windows. No entrance is visible. In front of the exedra, in the center of what appears to be a plaza, there is another group of buildings covered by roofs of various types. These structures have entrances, but windows appear only in their highest floors. It is their scale, however, that invites astonishment. If one assumes that the balustrades of the main building have a height of 0.80 m, then the houses in the plaza would be inhabitable only by very small people, such as Lilliputians. There is no reason to doubt that this change of scale is intentional.

In the next architectural group (fig. 3),[7] to the right of the architectural scene just described, some seven buildings rise in front of and on top of a hill. Several of the lower structures and all of the high ones are towers. Some of the houses have gable roofs, others flat ones. Most of the houses have entrances and all have windows in the highest stories. The Roman architectural term *villa rustica* is often used to describe these buildings.

The trees are drawn in a series of superimposed silhouettes: the outer ones dark blue, the inner ones first dark and then light green. The golden ground used throughout the mosaics sometimes intrudes into the trees as well.

A classical building also appears on the spandrel of the second arch from the south in the western arcade of the Damascus mosque (fig. 4).[8] At the center of this spandrel is a two-storied building with nonclassical proportions. In its lower story, two lateral pillars support an arch, behind which is an apse with a semidome set above a double arch. Scrolls growing from acanthuslike bases similar to those in the mosaics of the Dome of the Rock fill the arches. White plant forms are placed on their spandrels. Above a base of acanthus ornament, the niche head is scalloped and adorned with pearls. The blue spandrels on either side of the arch are filled with simple vegetal designs in gold on a blue ground.

The upper story of the same building is either a pavilion or the narrow end of a hall. In front of it are a pair of arches supported by two columns and a central fluted pillar. The shape of the roof is clearly not derived from a real structure but looks rather like a basket of leaves turned upside down. The leaves at each end curl toward the center. Behind and between these arches a second pair of arches is visible. It is clear that the inner spandrel of each arch is supported on a pillar, but that the outer one lacks a proper support and appears to merely abut the outer side wall. Behind and between the second set of arches four doors are visible; they are surmounted by mullioned windows, and large pearls suspended by chains hang from their lintels. The lower portion of each door is covered with a latticed balustrade with three pearls in each opening of the lattice.

Curiously, the supports of both sets of arches and the balustrade all appear to be in alignment— which is architecturally impossible since the inner arches must be behind the outer ones. Such an obvious misrepresentation of architectural features cannot be easily explained even if one assumes that the diaper pattern represents a floor rather than a balustrade. If this distortion was indeed deliberate, then it is possible that this building is not a normal structure and very likely belongs to a world outside our normal experience.

The building situated to the right of the pavilion is also of interest. It is roofless, consisting of four arches supporting an architrave. Upon closer examination it appears that the right rear support is missing. Again, it is possible that this omission of a principal supporting member was intentional. Its absence may demonstrate that the building defies the laws of gravity.

The structure on the left side of the spandrel is also two-storied, with an upper story considerably smaller than the one below. This discrepancy in size is accentuated by the alignment of the left sides of the two floors and by the placement of a balustrade adorned with a four-petaled flower over the right side of the lower story. As if to draw the spectator's attention to this irregularity, a tree rises diagonally from the juncture of the balustrade and the right wall of the upper story.

In addition to these three structures of classical appearance, this spandrel also contains miniature versions of the *villa rustica* similar to those in the panel discussed above. One is placed on each side of the central two-storied pavilion, three are underneath the open-roofed structure on the right, and two are near the building on the left. As usual, windows appear only in the upper stories.

I believe that the portion of the mosaics described here is sufficient to enable conclusions to be drawn. Basically the structures represented in the spandrel mosaics can be divided into two categories: one consists of buildings similar to the castles and *tholoi* depicted in the middle section of the "Barada" mosaic; the other has simple rustic structures often in the form of a tower with a door but with windows only in the uppermost floor.[9] This second type of structure appears in two sizes, the smaller so tiny that one cannot conceive that it would be inhabited by the people who live in the large villas and classical buildings. Both types of buildings appear together in a symbiosis difficult to imagine in an ordinary setting, and thus contribute to the dreamlike quality of these compositions.

No living creatures are represented in any of the extant mosaics, not even animals or birds, and even the river seems devoid of fish. A world of arrested motion is suggested by these mosaics. Their golden ground contributes to the impression of an airless world—a vacuum uninhabitable by the spectator who views them. This impression is caused primarily by the fact that the golden ground of the mosaics often extends into the trees and other landscape features. Since the buildings too—in particular, the classical ones—are often richly decorated with gold, it is difficult to distinguish between the setting and its buildings. The river serves as a dividing line between the world of the viewer and the world beyond his experience.

I believe that the overall impression of these mosaics is more significant than detailed observations of the buildings. Anyone who attempted to construct scale models of these buildings would discover that they were surrealistic—as if part of a dream or vision. For this reason it seems appropriate to search for a new iconographical interpretation. My theory is that the mosaics at Damascus present a vision of Paradise. Two of my colleagues have already made suggestions along these lines. One, Egyptologist E. Börsch-Supan,[10] connected the large trees with the vegetation of the Koranic Paradise; the other, B. Finster, without focusing on the otherworldly, imaginary features of the buildings in the mosaics, saw a general similarity to Paradise.[11] In addition, she was the first to collect Arabic texts describing the Damascus mosque in which the authors refer to the Koranic passages once inscribed in the mosques's mosaics, i.e., Sūrahs 79, 80, and 81 in addition to the *Fātiḥah*.[12] These three sūrahs, "The Pluckers," "He Frowned," and "The Darkening," all revealed at Mecca, are devoted to the Day of Judgment and the world beyond; or as al-Walīd's court poet, Nābighah Banī Shaybān, described them, they are revelations that deal with "the promises of our Lord and his threats."[13]

Since the lost inscriptions from the Damascus mosaics were not only Koranic but dealt with the Last Judgment, Paradise, and Hell, it seems appropriate to examine other Koranic passages that might shed light on the interpretation of these mosaics. One of the Koranic terms for Paradise is *jannah* (garden). It is frequently used and on eighteen occasions is associated with a flowing river. The Koran speaks of "a garden underneath which rivers flow," of "Gardens of Eden underneath which rivers flow," or "Beneath them rivers flowing in the Gardens of Bliss." The Koran also states "Surely the godfearing shall dwell amid gardens and a river [*nahr*] in a sure abode."[14] Also significant are portions of the Koran where the buildings associated with Paradise are described. These will be cited here *in extenso*.[15]

In Koran 29, *al-ʿAnkabūt* (The Spider), after the famous verse 58, "Every soul shall taste of death; then into Us you shall be returned," the text continues:

> And those who believe, and do righteous deeds, We shall surely lodge them in lofty chambers of Paradise, underneath which rivers flow, therein dwelling forever . . .

"Lofty chambers" is a translation of the Arabic term *ghuraf,* a plural of *ghurfah*. A different plural, *ghurufāt,* occurs in Koran 34, *Sabā* (Sheba), verse 37, at the end of one of the promises of Paradise to the believers:

> There awaits them the double recompense for that they did, and they shall be in lofty chambers in security.

In Koran 39, *al-Zumar* (The Companies), verse 20, the term *ghuraf* (chambers) appears in the phrase *ghuraf min fawqihā ghuraf:*

> But those who fear their Lord—for them await lofty chambers, above which are built lofty chambers, underneath which rivers flow—God's promise.

The text of Koran 25, *al-Furqān* (Salvation), verse 75, also contains the term *ghurfah*. Arberry translated that word as "highest heaven," but I have amended the text to "lofty chambers" because of the way this term is used in other Koranic passages. The amended text reads:

Those shall be recompensed with lofty chambers, for that they endured patiently. . . . Therein they shall dwell forever; fair it is as a lodging place and an abode.

An earlier verse in that same sūrah (Koran 25:10) is also of interest here. The term *quṣūr* (palaces), a plural of *qaṣr,* describes buildings in Paradise.

Blessed be He who, if He will, shall assign to thee better than that—gardens underneath which rivers flow, and He shall assign to thee palaces.

Some explanations are in order. The phrase "gardens underneath which rivers flow," a translation of *min taḥtihā al-anhur,* is sometimes understood to refer to subterranean rivers. Despite this implication, most translators (including the late Rudi Paret) follow Arberry's interpretation[16] and exclude the possibility that the rivers mentioned were understood to be running under the gardens.[17]

Thus it appears that many of the themes depicted in the Damascus mosaics have parallels in the Koranic text. The term *ghurfah* (room), found in several of the passages cited, is still used in contemporary Arabic to designate a room in a hotel. Originally it appears to have designated "a chamber in an upper or uppermost story." In addition, in pre-Islamic Arabic it seems to have had the connotation of "Seventh Heaven" or "the highest section of Paradise" or even of Paradise itself.[18] Here it can be suggested that the term *ghurfah* might be applied to the upper stories of the depicted buildings—those with windows. As for the larger buildings, or palaces, they can be equated with the term *quṣūr,* a plural of *qaṣr,* which is a cognate of the Latin *castellum.*

If it can be established that the paradisaic structures described in the Koran may be divided into two categories—*ghurufāt* and *quṣūr*—then the "villas" portrayed in the mosaics may be understood as *ghurufāt,* and those of classical form as the *quṣūr,* or castles mentioned in Koranic passages. Both types of buildings are understood to be located in the paradisaic gardens described in the Koran. Thus in this interpretation the mosaics of the Damascus mosque would present a vision of both the gardens and the buildings of Paradise as described in the Koran. If so, it may be possible to connect the phrase in Koran 39:20, *ghuraf min fawqihā ghuraf* (lofty chambers above which are built lofty chambers), with the portion of the "Barada" panel where there are two groups of houses, one below, the other above, divided by a hill.

The Islamic conception of Paradise needs further elaboration. From the time of the Prophet to the present day, many Muslims have believed that Paradise already exists. It is thought to be inhabited by Muḥammad and certain other of the elect, such as the martyrs who have fallen in the *jihād,* or Holy War.[19] The existence of Paradise is affirmed not only by the Prophet's miraculous ascent to heaven in the *Miʿrāj* but also by portions of the Koran itself. Aside from the Prophet and certain of the elect, the Koran stresses that both Paradise and Hell will be entered only after the Day of Resurrection and the Last Judgment. Thus in Koran 39, *al-Zumar* (The Companies), verse 78 reads:

Then those that feared their Lord shall be driven in companies into Paradise, till, when they have come thither, and its gates are opened, and its keepers will say to them, "Peace be upon you!"

It is my hypothesis that the landscape and buildings of the Damascus mosaic present an arrested world, lifeless and as empty as a vacuum, and that this scheme represents an attempt by artists to interpret certain passages of the Koran. These artists apparently wished to portray a world that exists, but one that can only be inhabited by believers after the Resurrection. By means of the

techniques described in this essay, that world beyond—a Paradise uninhabitable by those of this world—is made attractive through the great richness of the mosaics.

An Arabic source, familiar to the readers of J. Sauvaget's book on the mosque at Medina, contains information that supports this interpretation.[20] The mosque was rebuilt during the years 88–89/707–709 by the same caliph, al-Walīd, who ordered the construction of the one in Damascus. The interior of the Medina mosque once had marble dados like those at Damascus, as well as mosaics on the upper section of the walls, but no trace of these elements survives. The earliest-known history of Medina, that of Ibn Zabala, completed in Ṣafar 199/September–October 814, relates a curious discussion involving the artisans who had actually executed the mosaics. In a defensive fashion some of them said: "There [in the mosaics] we reproduced of what we have found of images of the trees and castles of Paradise." He also reports: "When an artisan had skillfully created a large tree in mosaic, ʿUmar gave him a bonus of thirty dirhams."[21]

The implications of this narrative are obvious. The mosaics in the rebuilt mosque at Medina depicted Paradise. Apparently the artists had some difficulty in creating an image of Paradise; this is another reason to admire the successful designers of the Damascus mosaics, where similar trees and castles are represented.

The ʿUmar mentioned in the account of Ibn Zabala is ʿUmar b. ʿAbd al-ʿAzīz[22] to whom ʿAbd al-Malik, his uncle, had given in marriage his own daughter, Fāṭimah. ʿUmar, who was born in Medina, served as governor of the Ḥijāz for al-Walīd from 706 to 711. According to the sources, he was in charge of the rebuilding of the Prophet's mosque in Medina that stood on the site earlier occupied by the Prophet's own residence. ʿUmar was also a theologian, whose authority was not challenged even by the Abbasids, and the leader of a religious movement that could be compared to Christian Pietism. This would explain how he might have been responsible not only for the decorative program in the Medina mosque but also for the program at Damascus. As caliph from 99/717 to 101/720, he was known for his tolerance toward Christian and Jewish minorities in Islamic lands. He believed in winning converts by missionary activity rather than by the force of conquest.

The mosaics of Damascus can be understood not only as a vision of Paradise deriving from Koranic descriptions appropriate at a moment when only certain segments of the Muslim community were fully familiar with the Koranic text but also as a missionary act of *propaganda fidei,* an invitation to the Jewish and Christian subjects of the Islamic ruler, to convert. Just as the inscriptions inside the Dome of the Rock at Jerusalem appeal in particular to the Christians under Islam,[23] defining clearly what they may retain of their former religion and what they must abandon, so the mosaics at Damascus could have provided them with a vision of Paradise similar to the one with which they were familiar, yet which had the particular appeal of its glorious artistic language.

Accepting this theory that the iconography of the Great Mosque of Damascus is a vision of Paradise based on Koranic descriptions would mean that the archaeology of Early Islam could for the first time situate the origin of Islamic art to between the years 706 and, at the latest, 715.

NOTES

1. Some aspects of the subject have been excluded from this essay in order to emphasize the iconography of the mosaics proper. These are:

a. The importance of Damascus as the new capital of the Umayyad Empire and its connections with the second civil war; cf. R.

Sellheim, *Der Zweite Bürgerkrieg (680–692). Das Ende der mekkanisch-medinenischen Vorherrschaft,* Wiesbaden, 1970; G. Rotter, *Die Umayyaden und der zweite Bürgerkrieg (680–692),* Wiesbaden, 1982, with a discussion of the reasons for the construction of the Dome of the Rock at Jerusalem and the time of its actual building, 228–230.

b. The strong possibility of a coordinated religious-political building program during the reigns of ʿAbd al-Malik and al-Walīd I (685–715); see B. Finster, "Die Mosaiken der Umayyadenmoschee von Damascus," *Kunst des Orients,* VII, fasc. 2, 1972, 127–36 (hereafter, Finster).

c. The history of the Great Mosque at Damascus; see Creswell, *EMA²* I:1, 151ff.

d. The place of origin of craftsmen; see M. van Berchem in Creswell, *EMA²* I:1, 228–45; O. Grabar, "Islamic Art and Byzantium," *Dumbarton Oaks Papers,* XVIII, 1964, 69–88, on the definition of the *fanān al-rūmī* not as craftsmen from Byzantine territory but as local artists trained in the tradition of Byzantine art in the *bilād al-Shām.*

e. The technical descriptions of the mosaics following the methods of Byzantine workmanship; see M. van Berchem in Creswell, *EMA²* I:1, 364–66.

f. The historical explanation for the style of the mosaics, basically continuing directly from Roman, Hellenistic, and Byzantine art of the Near East. Certain similarities of the architecture represented at Damascus and the second style of wall paintings at Pompeii are noticeable; see M. van Berchem in Creswell, *EMA²* I:1, 367–72; K. Fittschen, "Zur Herkunft und Entstehung des 2. Stils," in P. Zanker, ed., *Hellenismus in Mittelitalien, Kolloquium in Göttingen vom 5.–9. Juni 1974,* Abhandlungen der Akademie der Wissenschaften in Göttingen, Philosophisch-Historische Klasse, III. Folge, Göttingen, 1976, 539–63.

g. The relationship between the mosaics in the Dome of the Rock at Jerusalem and those of Damascus. It is probable that the iconography at Jerusalem is closely related to that at Damascus.

h. The restoration of the mosaics; see M. van Berchem in Creswell, *EMA²,* I:1, 348.

i. The interpretation of the iconography in the mosaics at Damascus found in works by classical Arab authors and modern scholars; see M. van Berchem, in Creswell, *EMA²,* I:1, 231–42, and R. Ettinghausen, *Arab Painting,* Geneva, 1962, 22–28 (hereafter, Ettinghausen).

j. A discussion of all the mosaics extant in the Great Mosque of Damascus and their possible date; those described here—ex-amples from long bands of mosaics known as the "Barada" mosaic and one mosaic panel from the spandrels of the inner side of the west-*riwāq*—are taken as belonging to the original mosque of al-Walīd.

2. Creswell, *EMA²,* I:1, 151–210. O. Grabar, "La Grande Mosquée de Damas et les origines architecturales de la mosquée," *Synthronon, Art et Archéologie de la fin de l'Antiquité et du Moyen Age,* Paris, 1968, 107–14. It might be useful here to add an unpublished observation of Professor H. Luschey, former director of the German Archaeological Institute, Tehran, that he communicated to me many years ago. In spite of the fact that the arcades of the courtyard of the Damascus mosque are two-storied, no floor has been built between the lower and the upper story of the galleries. This is a break with the tradition of Late Antiquity and can be explained only be presuming the architect's wish to offer the viewer an unobstructed contemplation of the mosaics on the walls behind the arcades. This in itself is an indication that the mosaics were planned before the design of the *riwāq*s was undertaken.

3. Creswell, *EMA²,* I:1, 323–72.

4. Ibid., 65–131.

5. Ibid., 142–49.

6. Best reproduction in Ettinghausen, 24.

7. Best reproduction in Ettinghausen, 25.

8. Best reproduction in Ettinghausen, 27; a drawing by L. Cavro is reproduced in Creswell, *EMA²,* I:1, as fig. 389, which shows the missing parts of the building to the right.

9. During my formulation of the theory presented here, I was most encouraged by the division into three groups that Ettinghausen proposed (24–25). After realizing that the Koran mentions two types of buildings in Paradise, I now believe that his third group can be seen as part of his first one.

10. E. Börsch-Supan, *Garten-, Landschafts- und Paradiesmotive im Innenraum,* Berlin, 1967, 118–20.

11. Finster, 118–21.

12. Ibid., 119.

13. Ibid., 118.

14. "Gardens underneath which rivers flow" is found in 2:25; 9:72; 14:23; 22:23; 48:5; 58:22; 61:12; 64:9; 65:11; and 66:8; "Beneath them rivers flowing in the gardens of Bliss," 10:9; "Gardens of Eden underneath which rivers flow," 18:31 and 20:76; "Amid gardens and a river in a sure abode," 54:54–55.

15. Following the translation of Arthur J. Arberry (*The Koran Interpreted,* London and New York, 1971).

16. Ḥamza Boubakeur, *Le Coran,* 2 vols., Paris, 1979.

17. R. Paret, *Der Koran, Kommentar und Konkordanz,* Stuttgart, 1971, 14 under 2,15.

18. E. W. Lane, *An Arabic-English Lexicon,* Part 6, London, 1877, 2249, right column, top.

19. *"Shahīd," EI,*[1] s.v.; *"Djanna," EI,*[2] s.v. Ṣoubḥī El-Ṣaleḥ, *La Vie future selon Le Coran,* Paris, 1971, 15–16, on the entrance into Paradise with the Prophet.

20. J. Sauvaget, *La Mosquée Omeyyade de Médine,* Paris, 1947, 26 (on Ibn Zabala's *Ta'rīkh Madīnah* as a source "d'une importance capitale" and its survival in the scriptures of later historians) and 81 (with remarks by the artists). Finster quotes the passage without mentioning Sauvaget. I cite C. Brockelmann, *Geschichte der arabischen Literatur* I, Weimar and Berlin, 1898, 137, because the author is not mentioned in its index.

21. Sauvaget, 26; 81.

22. *EI*[1], "ᶜOmar," s.v.

23. Van Berchem, *CIA,* II:2, 222–25, H. Busse, "Die arabischen Inschriften im und am Felsendom," *Deutscher Verein vom Heiligen Land, Das Heilige Land,* CVIII, fasc. 1/2, 1977, 8–24.

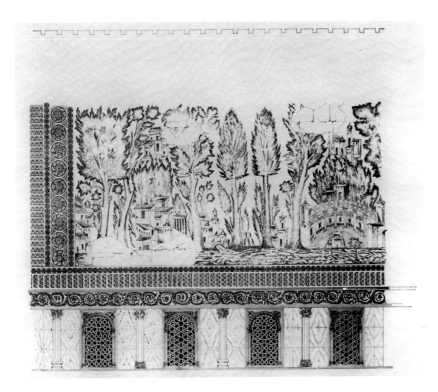

Fig. 1. Damascus, Great Mosque, the southern parts of the western wall of the west *riwāq* (drawing: Farīd Shāfiʿī, after K. A. C. Creswell, *Early Muslim Architecture,* 1, Oxford [Oxford University Press], 1969, fig. 92)

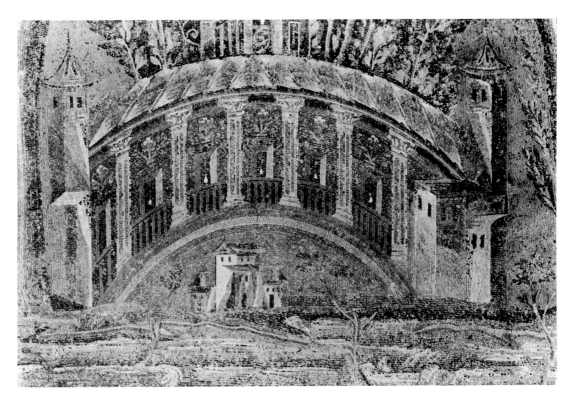

Fig. 2. Damascus, Great Mosque, scene from the western wall of the west *riwāq* (after R. Ettinghausen, *Arab Painting,* Geneva [Skira], 1962, 24)

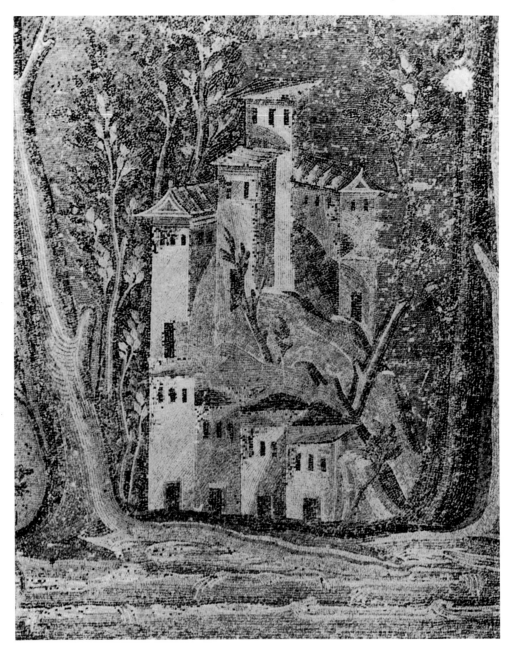

Fɪɢ. 3. Damascus, Great Mosque, scene from the western wall of the west *riwāq* (after R. Ettinghausen, *Arab Painting,* Geneva [Skira], 1962, 25)

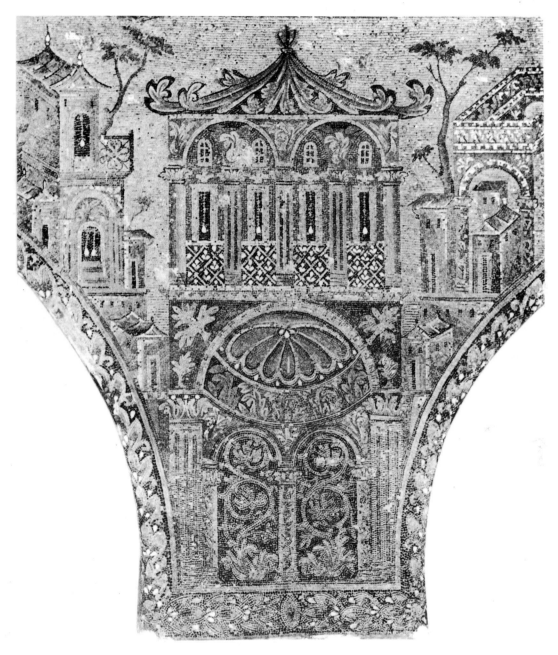

FIG. 4. Damascus, Great Mosque, mosaic above the second pier of the west *riwāq,* inner face (K. A. C. Creswell, *Early Muslim Architecture,* I, Oxford [Oxford University Press], 1969, fig. 398, after a drawing by L. Cavro)

The Draped Universe of Islam

Lisa Golombek

LTHOUGH many of Richard Ettinghausen's articles dealt with specific groups of objects and have become classics in art-historical literature, his last work showed a return to those broader but elusive questions that were first raised by such individuals as Strzygowski and Riegl at the turn of the century.[1] In his article "Taming of the Horror Vacui," which seeks an explanation for the alleged "fear of empty spaces" so characteristic of much of Islamic art, Ettinghausen resurrected the concept of Weltanschauung.[2] In recent years few scholars have attempted to publish their ideas about the nature of Islamic art; there has been a tacit moratorium on such questions. As a reaction against the racist doctrines that surfaced during World War II, the topic of "national style" became virtually taboo. Rather, in the postwar information explosion the emphasis has been on documentation. But this new body of information has of itself brought about greater sophistication and sensitivity. The time may be ripe to return to these questions and follow Ettinghausen's lead.

What is presented here is the working hypothesis that textiles in Islamic society fulfilled far more than the functions normally expected of them in other societies.[3] This obsession with textiles, if one may call it so, can account for some of the major characteristics of Islamic art in general. Many of the details in this hypothesis will take time and new information to work out, and what follows is an attempt to sketch it only in broad strokes.

It is difficult to understand how such monumental sites as the excavated palace at Khirbat al-Mafjar could have represented the ultimate in luxury living in the early eighth century, with its bare, cold stone walls and its nondescript quarters affording little privacy beyond the open doors. Even when buildings have remained intact and are elaborately decorated, such as the Alhambra, something seems to be missing.

When we study Islamic architecture, we tend to forget that doorways were hung with curtains;

that hangings made the open colonnade a private place; that the bare floors, sometimes unpaved, were laid with carpets and mats; and that through these halls marched a continual procession of richly clothed personages (fig. 1). Outside in the gardens, royal spaces were created by spreading a cloth or rug and erecting over it a tent of brocade, or a baldachin (fig. 2). We are struck by the fact that textiles played not only a large role in the life of Islam but perhaps even an exaggerated one.

Data for evaluating the role of textiles in Islamic society can be gleaned from various sources: numerous medieval texts, representations in illustrated manuscripts and on objects, the surviving archaeological textiles, and certain ethnographic information. The bibliography on each of these sources is extensive and will not be discussed here in detail. It is essential, however, to assess the value of each type of source for the specific purposes of this study and to touch on some of the precautions that must be taken in using them. Already in 1845, when Dozy published his dictionary of Arab costume, the problem of correlating these different sources in order to form an idea of the history of costume was apparent.[4] Under each heading Dozy had no choice but to reproduce several differing and sometimes contradictory meanings. Yedida Stillman's recent catalogue of Palestinian costume makes it clear that fashions change faster than the terminology on which they are hung.[5]

The medieval texts have been gathered by Serjeant according to geographical region.[6] His material is presented in a raw state with little attempt to analyze the data or to reconcile contradictions. Since his publication, new sources have come to light, such as the *Book of Gifts and Treasures* by Ibn al-Zubayr,[7] a source used by Maqrīzī. For the most part the medieval sources speak of the use of textiles by the court and the production of certain textiles in specific locales. The account is balanced, however, by the documents of the Cairo *Geniza,* which are a rich fund of information about the life of the bourgeoisie.[8] Despite the quantity of detail that comes from all these textual sources, they are not very helpful for the study of costume and textiles per se, for there is little description of the individual garment.

More elusive than costume is the vast terminology used to distinguish types of cloth. A few attempts have been made to match the terms with surviving textiles, by Dorothy Shepherd and others,[9] but there is little likelihood that much further progress can be made in this direction. Certain terms that describe the technique of manufacture can with some certainty be identified with actual textiles. For example, the *ikat*-dyed cottons of Yemen, achieved through the process of tie-dying the warps, are described as ʿaṣb, or "bound (thread)" cloths.[10] Further complications are introduced by the use of geographical terms to describe textiles coming from particular regions. This information is of no help in matching the text with the textile, though it is, of course, of interest for other purposes.

First, the terminology tells a great deal about the movement of textiles as objects of trade, and second, the sheer quantity of the terminology is significant. Following the axiom that a society will invent an extensive vocabulary to distinguish variations in areas that are most important to it, one may conclude that textiles were of primary importance to the average resident of the medieval Islamic world. The Islamic use of textile terminology may be compared with the Eskimo's differentiation of some forty types of snow, or the Bedouin's insistence on multiple terms for the camel.

It is the quantity of terms rather than the specific terms themselves that is of central interest here. What motivated this society to distinguish so finely between one type of scarf and another, between one type of cushion and another? What were the considerations necessitating such a wide variety of textile objects?

The representational arts of Islam comprise wall paintings, for the pre-Islamic, Umayyad, and Abbasid periods (with a few later examples); objects with figural imagery, from the twelfth and

thirteenth centuries; and the arts of the book, from the thirteenth century on.[11] Not all of these sources are of equal value for this study. Some representations, such as the striped garment worn by men on a minai bowl (fig. 3), are too generic to be useful, whereas the costume on the man in the Dioscorides frontispiece is so accurately depicted that the gusset under his arm is shown (fig. 4). The fact that his *ṭirāz*[12] arm bands do not fully encircle the upper arm is most interesting; few representations bother to show this detail when depicting such bands. *Ṭirāz* bands on the turban ends have been tucked in. It would be fair to conclude that this is an accurate description of a type of garment actually worn by a scholar living in Syria or Iraq in the early thirteenth century. Later Persian paintings are a rich source for costume and textile study and are particularly important because they illustrate the manner in which contemporary furnishings were used.

Archaeological textiles themselves pose many problems.[13] Because of their fragmentary nature, it is difficult, if not impossible, to determine to what kind of garment most of the fragments once belonged. The bulk of the fragments come from Egyptian burial grounds, where their use as shrouds may not have been anticipated when they were first produced. Because the find-spots of these textiles were never recorded in detail, we do not even know who finally used them as shrouds. Was it the aristocracy or the bourgeoisie? The textiles themselves do give some information. As a group they convey a picture of a highly developed and complex industry, producing for a diversified range of tastes and functions. Many contain inscription bands like those in the Dioscorides painting, which identify them as products of the *Dār al-Ṭirāz,* the royal textile workshops, under the control of the caliph. Some inscriptions record a place and date of manufacture.

Notwithstanding the limitations of the ethnographic data mentioned above, it can be most enlightening to look at some of the more traditional cultures of the Muslim world today. Westernization has introduced new habits, but traditional attitudes toward dress and codes of behavior are still evident in such areas. Anyone visiting more traditional Islamic societies, such as those of North Africa or Uzbekistan, will be struck by the quantity of clothing an individual wears. Women appear to be bandaged in scarves, cloaks, and headdresses. Each of these items is of a different fabric, weave, and color, appearing haphazardly chosen. The fact that historically many garments were worn simultaneously may have stimulated the development of many terms for clothing. The use of many layers of clothing appears to have been most popular in regions where garments were not tailored. Many were worn just as they had come off the loom, with little or no sewing. They were draped over the body and held in place by pins. Insulation was achieved by adding more layers beneath loosely fitting outergarments.

Following the assessment of the sources that can be employed to study the uses of textiles in Islamic society, these functions can be enumerated. Some are utilitarian, whereas others were the result of the values attached to textiles by the people who used them. I shall deal first with garments and then with furnishings.

The preference for loosely draped clothing was evident in the Mediterranean region before the advent of Islam, although the turban appears to be an Islamic innovation. The preference for draped garments appears then to have gradually spread to more eastern areas during the Islamic period, a diffusion that has yet to be investigated. In pre-Islamic Iran, textiles were woven on a loom of smaller format than that used in the Mediterranean area, and tailored garments were favored. With fitted garments multiple layers were not needed, especially when the outermost layer, a coat, was padded, as was frequently the case. In the Islamic era fashions changed. Clerics and scholars adopted the flowing gowns popular in Arabia, and women acquired the face veil and body envelope. Later, during the twelfth and thirteenth centuries, fitted garments had a renewed popularity through the influence of peoples from the east, another phenomenon that deserves further documentation.

According to the evidence from the *Geniza* documents and other texts, the clothing in wide use during the medieval period was much the same as that still used in North Africa today.[14] It consisted of four elements: headgear, undergarments, gowns, and a wide variety of mantles, wraps, and veils. For women, some of these outer garments were for insulation, others for modesty. Because the garments did not conform to the body's shape, they were to some extent interchangeable. One gets the impression from the *Geniza* letters of traders that the larger garments were sold as a form of bulk goods that could be modified by the purchaser.[15]

Certainly one of the functional considerations behind the elaboration of the garments was the change of seasons. The archaeological evidence suggests that the wide range of weights and variation in fineness of weaves distinguished fabrics used for winter and summer apparel. Numerous texts confirm an almost ritualized change of clothing from winter to summer. For example, in May the Mamluk sultan discarded his woolen clothing and put on white, including a white silk ʿabāʾ (a one-piece mantle that enveloped the body and was closed at the shoulders). He returned to his woolen garments in November.[16] A semiannual change was also the practice in Spain, until the musician Zaryāb came from Baghdad in 821–822. He introduced a spring costume, a *mulḥam* or colored silk *jubbah,* and marked the arrival of autumn with a *minsha* (cloak) from Marv.[17] These refinements no doubt had as much a psychological significance as they had functional value, much as pastel colors are still favored in summer.

Another category of costume tied to specific functions consisted of garments that were to be worn only out-of-doors, such as the modesty veils of women.[18] Certain activities demanded garments designed especially for them, particularly those requiring freedom of movement, such as the *jūkānīyah,* presumably a polo costume.[19]

Apart from these functional considerations were the many facets of social behavior in which textiles played an important role. Textiles could reflect social values and codes of behavior, but they might also be actual tools of the social system.

Wealth was measured in terms of one's textile possessions, and certainly the largest wardrobes were to be found at court. An inventory of the Caliph al-Amīn for the year 809 lists 8,000 *jubbahs* (coats), half of which were silk lined with sable, fox, or goat hair, and the other half figured cloth (*washshī*); 10,000 shirts and tunics; 1,000 pairs of pants; 10,000 caftans, 4,000 turbans; and 1,000 cloaks.[20] It is difficult to surmise how many people this wardrobe would have served. If one assumes the allotment of two pairs of pants per person, it would clothe 500. The caliphal wardrobe was obviously larger, so perhaps the figure of 100 wearers is more likely. That would still provide each with some 40 outer coats for winter and another 40 for summer, with 100 caftans to rotate through the year. These figures should not be taken as definitive, but a study of such lists together with the trousseaux lists could give some idea of the quantity of each type of garment needed by the various classes of society. A wealthy Jewish middle-class bride had in her trousseau a mere 18 dresses, while a more modest trousseau included only eight.[21]

"Clothes made the man," and uniforms identifying rank in the court and bureaucracy certainly focused attention on costume (fig. 5). The conspicuous consumer invested heavily in headgear; as Goitein has remarked, "Luxury in turbans was the passion of the medieval Oriental."[22] Not all wearers of luxurious turbans achieved the status they had sought, as this poem indicates:

> O, you who covers your empty head with a beautiful
> white turban of Marv fabric, everything which is beneath
> is hideous: It (meaning the turban) is as a light
> shining in the darkness.[23]

Many of the luxury fabrics were intended for special occasions. The wedding costume was perhaps the most elaborate of these. The *Geniza* letters often convey the personal concern of the client or merchant with regard to such orders. The urgency of the merchant of Fez writing to Spain on behalf of a certain Abraham whose wedding was imminent demonstrates the importance of having the proper garment for the occasion.[24] In this case the merchant was ordered to buy a custom-made garment if none was available on the market. Time was an important factor.

Funerals also called for specific dress—not garments made for the occasion but rather a different mode of wearing one's ordinary garments. Ibn Baṭṭūṭah observed that people had put their own clothing on inside-out and covered it with coarse cotton robes.[25] In Samarqand the population put on *jāmah*s of black and blue for the mourning of Tīmūr's son Jahāngīr.[26]

Religious holidays for all faiths required special garments. A *Geniza* document records an order for such a costume for the Day of Atonement. White was worn during Ramaḍān.[27] It should also be borne in mind that the preparation for the spiritual change that was to come with the pilgrimage to Mecca was effected through a change in costume. The discriminatory sumptuary laws, dictating the types and colors of garments to be worn by minority groups, were yet another example of how textiles were used as instruments of the social system.[28]

The use of textiles to confer as well as identify status is also well known. Robes of honor, often inscribed with the name of the caliph, were bestowed on officials of the court, prominent visitors (including ambassadors), and private individuals whom the caliph wished to honor. Although referred to as "robes," these gifts often included full sets of clothing as well as numerous other items.

In the art-historical literature there has been a tendency to view the large body of very fragmentary archaeological textiles that bear the *ṭirāz* of a caliph as "robes of honor."[29] A review of the relevant texts, however, has suggested that these textiles, with some exceptions, do not fit the descriptions. The texts that speak of "robes of honor" generally mention fine materials—silks, brocades, and furs—although the very fine linens, *sharb* and *dabīqī*, or *qaṣab*, woven with metallic threads, were also suitable as gifts. The archaeological examples are primarily linen or cotton, some quite coarse, with wool, silk, or linen wefts, embroidered or tapesty-woven. Some of the cottons are painted or stamped.

One is therefore led to conclude that this large body of material, found in museums all over the world, should not be identified as the so-called robes of honor mentioned in texts. The surviving textiles appear to belong to the standard wardrobe of the court, such as the one described above, and represent the numerous undergarments, and perhaps some of the lighter summer mantles. That they were widely used as shrouds may possibly be accounted for by a distribution of court garments to the general populace from the looting of the Fatimid treasury in the years following 1060.[30]

It is most curious that among the large number of such textiles now in Toronto there are numerous fragments of ornaments cut in the shape of rectangular panels and sewn as insets into coarsely woven linens, often with the inscription reversed (fig. 6). The stitching is also sometimes crude. Some occur below distinguishable necklines and appear to be chest panels like those depicted on a *Coronation of the Virgin* by Paolo Veneziano (fig. 7). These panels may be the forerunners of the *qabbah* on nineteenth-century Palestinian wedding dresses.[31] The reuse of precious stuffs is also attested to in texts and in the *Geniza* documents, where "old" garments are considered the "best."[32] This appreciation of textile antiques was applied to furnishings (discussed below) as well as garments.

To sum up: in addition to their functional value, garments were the means by which an individual identified his changing status. Clothing reflected not only his public state (that is, his religion, his occupation, and his rank within society) but also his private state (that is, his passage through the life cycle). Clothing provided the opportunity for an individual to emphasize any chosen aspect of his inner or outer state at any given moment.

The utilitarian and social aspects of furnishings in the Islamic world have recently been treated in great detail by J. Sadan.[33] According to his study, the Islamic world developed a set of behavior patterns concerning sitting and reclining that precluded the creation of a wide variety of movable, rigid furnishings: chairs, tables, and beds. Although these existed, they were always supplemented by cushions, pillows, spreads, and carpets. More often, these ad hoc furnishings sufficed alone. Most activities took place on or close to the floor. Cushions served as seats and propped up the back, the head, and even the elbow. Carpets and cloths spread on the floor served as tables. Trays set on tripods or on the floor bore vessels containing food and drink.

It could be argued that the climate in the Mediterranean required warm floor coverings in the winter to insulate against the cold of stone floors. Many Roman mosaics, as well as their Umayyad successors, have tassels depicted around their edges.[34] These tassels have generally been taken as evidence that the beautiful mosaics were replicas of floor coverings that have not survived. The level of textile technology at the time does not make this possibility very likely, but the tassels may well be an allusion to winter mats of less ambitious design that would have covered the mosaics until spring.

One can also argue that the origin of textile furnishings should be sought in the nomadic life. Although floor coverings and wall hangings are associated with both indoor and outdoor space, one could say that the indoor use of carpets is a tautology. A house already has a floor and walls. Outside these must be created. It is therefore in the use of textiles out-of-doors that one must seek the origins of rugs and drapes for the interior.

Various forms of nomadism have persisted within and around the Islamic world since its beginnings.[35] When one reads the history of the Mongol or Timurid princes, it is never clear whether the change of quarters has a military or an ecological objective.[36] The sultan moves between city and country, often taking his whole household with him. The setting of the "encampment" has been a celebrated theme of many painters.[37] In these encampments textiles are used not only for furniture and decoration but even for the domicile itself, the tent. The carpet is the floor. The curtain is the door. An ambiguity of intention on the part of the Persian painter can be seen in a sixteenth-century painting (fig. 8). Is he depicting a seasonal dwelling or a summer holiday? Descriptions of the great tents of Tīmūr, both in texts and in paintings, indicate that tents eventually came full cycle. In every detail—crenellations, porticoes, silver cords imitating metal grilles—they simulated real architecture.[38]

Sadan has also suggested that the ascetic strain in Islam may have reinforced the existing Oriental tradition of close-to-the-ground living, just as it had rejected vessels of precious metal.[39] Whatever the cause, it is clear that textile furnishings were a very important concern for both indoor and outdoor life.

The well-to-do sitting room, according to al-Azdī, writing in the early eleventh century, had four different kinds of floor coverings, three types of cushions, and at least two expensive textile draperies, such as *sūsanjīrd* or *būqalimūn*.[40] The royal precincts were, of course, totally draped and spread with textiles.

Paintings illustrate well the ways in which textile furnishings were used. Curtains could be hung, knotted, or drawn aside. They served primarily as temporary room dividers, providing privacy where needed. In Abraham's tent, depicted in the Rashīd al-Dīn manuscript of 1314, a

curtain blocks the visitors' view of his wife, as would be expected in the normal Muslim domicile.[41] In later Persian paintings one cannot fail to appreciate the importance of textile elements in the interior setting: the drapery, the cushions, and the floor coverings (fig. 1).

Like costume, furnishings were appreciated for various reasons. As purely functional objects, they provided insulation and comfort. They were also a means of transforming the character of a space without altering its structure. But they could do far more. They could create an ambience through the quality of the material, and this ambience could be changed at will. Changes might entail a mere seasonal rotation of fabrics. The Fatimid Caliph had brocade curtains for his *majlis* in the winter and fine linen ones in the summer.[42] Floor coverings were likewise suited to the season.

The need for a change in scenery might arise in anticipation of a special occasion; furnishings were chosen to impress and delight the individual guest. Visits of ambassadors to the court provided an opportunity to display the choice objects of the royal textile collection, which was itself symbolic of the empire's wealth. When the Byzantine ambassadors made their famous visit to Baghdad in 305/917, some 38,000 curtains were hung in the palace.[43] On the occasion of the reception of the Emperor Basil, the Fatimid Caliph al-Ḥakim ordered his keepers of the treasury to find something remarkable for covering the entire *īwān*. They discovered twenty-one textiles of brocade stippled with gold, brought by al-Muᶜizz from Qairowan. With these they covered the whole floor of the *īwān* and draped all of its walls.[44] When the sovereign of Ferghana paid a call on his vassal in Bukhara, the entire city was repainted and draped with rich stuffs, banners, and silk tents to impress him.[45]

Guests were impressed not only by the normal luxury fabrics but also by curiosities. As al-Ḥakim's preparations indicate, antique furnishings were particularly cherished. Among the 38,000 curtains displayed in the palace at Baghdad were 12,500 bearing the names of five earlier caliphs dating back a hundred years. Another curiosity were the textiles with recognizable images. The Baghdad palace was also hung with curtains of brocade bearing "representations of goblets, elephants, horses and camels, lions, and birds."[46] This category of furnishing is most interesting because it relates to a series of other unique textiles, both carpets and curtains, on which were depicted themes belonging to royal iconography, including historical or quasi-historical narratives.

The tradition of iconographic textiles which begins with the first century of Islam had roots in the Byzantine and Sasanian past. According to Ibn Rustah, the tent of the Prophet was made of a woolen textile decorated with fabulous beasts, eagles, confronted lions, human figures, and Christian crosses.[47] The tent commissioned by the Fatimid vizier, al-Yazūrī, portrayed all the animals in the world.[48] Another tent, made for the Hamdanid prince Sayf al-Dawlah and celebrated in an ode by Mutannabī in 947, had all this and more. It was erected to receive Sayf al-Dawlah after his capture of the Byzantine fortress of Barqūyah. Inside was a scene depicting the Byzantine emperor paying homage to Sayf al-Dawlah, surrounded by a pearl-lined border containing images of wild and tame beasts and vegetation. The poet refers to the border as a garden, which is animated by the fluttering of the tent walls.[49]

Tents with images of animals and vegetation can be related to two traditions, Sasanian and Early Christian. These images can be found in the Sasanian Paradise theme as it occurs as part of the royal hunt, for example, at Tāq-i Būstān. The hunt also appears contemporaneously in the imperial imagery of Byzantium and in the Early Christian iconography expressing the Triumph of Good over Evil. The Western version, studied by Veronika Gervers in the series of Coptic linen curtains with tapestry-woven images of huntsmen and wild beasts,[50] suggests a close parallel for the Prophet's tent, which may itself have come from the furnishings of a church.

The second theme occurring in the Hamdanid tent—human figures identified as historical personalities—relates these textiles to images found in wall paintings, such as the painting of the six kings at Quṣayr ʿAmrah.[51] A similar example would be the famous *sūsanjīrd* carpet on which the Abbasid caliph Mutawakkil was murdered; this had a border of compartments enclosing portraits of the Sasanian and Umayyad rulers, all identified by Persian inscriptions.[52] This was probably an heirloom from the Umayyad dynasty. An equally extraordinary silk curtain was found in the Fatimid treasury on which were depicted all of the nations of the world, their rulers, years of reign, and remarks on their state of affairs.[53]

Textile furnishings could therefore be used in two ways by a person wishing to impress his visitors. The costliness of the fabric or its rarity testified to the sheer wealth of the host, whereas the textile itself might be the bearer of a more specific message through its imagery. Iconographic textiles have the obvious advantage of versatility over wall paintings since textile display could be varied according to the intended message.

The selection of draperies and floor coverings, just as seating arrangements for guests, reflected a host's assessment of his visitors. Protocol as reflected in seating arrangements is a matter of grave importance in all societies, but in the Islamic world, because the seating was on the floor, the focus was again on textiles. Sadan has demonstrated that the social rank of a guest was indicated by the placement of his mat within a room, especially in relation to other persons present, and by the size and quality of the cushions assigned to him.[54] The variations possible with a range of cushions is far greater than can be imagined for a dining hall with table and chairs. (In the European tradition guests could be honored or offended only by their placement; the furnishings remained uniform.) Using a mat or carpet for definition of personal space was a tradition so ingrained in the life of the Middle East that it could not fail to be of continuing symbolic importance under Islam. Pre-Islamic Central Asian paintings show a group of nobles, seated on small mats arranged to reflect the social hierarchy, just like the courtiers of later Persian miniatures. Even the monster-deities in a Manichaean illustration are seated on a carpet according to protocol.[55] Given the strength of this symbolic aspect of carpets, it is not surprising that the earliest ritual object in Islam was the prayer rug.

Curtains also had symbolic as well as practical functions. As in the Byzantine world, the ruler was to be kept aloof from his subjects, and this ideal was expressed tangibly through the presence of a curtain placed between them. Such curtains concealed the thrones of the Umayyad, Abbasid, and Fatimid caliphs and were placed around the *miḥrāb* in the mosque.[56] On certain occasions the curtain was used as a means of attaining dramatic surprise. The caliph, dressed in his regalia, made a sudden appearance as the curtain was drawn. The visitor was devastated by this splendor.

A unique use of curtains to both honor and protect a structure is the *kiswah*, the veil draped over the Kaʿbah at Mecca.[57] Although one tends to think of the *kiswah* as a drab black veil with gold inscriptions, it was not always so. When Ibn Jubayr visited in the late twelfth century, he saw the Kaʿbah clothed in varicolored silk.[58] The four sides were draped in a set of thirty-four curtains of green silk that had cotton warps. It was inscribed in its upper part with the Koranic verse 3:90, invocations to the Abbasid caliph al-Nāṣir, and the image of a colonnade of *miḥrābs*. It was customary for the old *kiswah* to be cut up and sold as relics to pilgrims.

The last item to be mentioned here, the *mandīl*, or napkin, was used both as a garment and a furnishing. According to F. Rosenthal's fascinating study, the *mandīl* was used for drying the hands and face, wiping tears, blowing the nose, for massage, for covering things, wrapping things, and was worn as various garments, such as loincloth, apron, belt, turban, and kerchief.[59]

The *mandīl* was remarkable for being an instrument of communication, so closely was it

associated with the sensual organs—the mouth, the eyes, the nose, the ears, and the hands. Messages were inscribed on *mandīl*s, such as,

> I am the *mandīl* of a lover who never stopped
> Drying with me his eyes of their tears.
> Then he gave me as a present to a girl he loves
> Who wipes with me the wine from his lips.[60]

A number of such verses are recorded by al-Washshā' in the early tenth century, but to my knowledge no actual fragment of such a textile has survived. To these inscribed textiles may be added the *mandīl* or *dastār* with the lover's portrait. Most famous is the portrait of Khusraw sent to Shirīn in the *Khamsah* of Niẓāmī.[61] The motif recurs in many Persian stories.

As a background, one may consider the pre-Islamic traditions of Central Asia. Manichaean paintings on silk have survived, and the wall paintings at Kutscha show such a textile depicting the life of the Buddha, being held by a woman.[62] The notion that images and even inscriptions on textiles could have magical power—that is, the ability to make happen what is portrayed or foretold—is reflected in the story of the silk inscribed by the Sasanian king Anūshīrvān with the prophecy of the execution of Hormizd.[63] These iconic and magical uses of textiles prefigure the mystique that was later attached to the writing of invocations in the *ṭirāz* of Islamic textiles.

In this essay I have attempted to evoke a world submerged in textiles, where textiles played a role in every facet of life, for everyone, rich or poor. They served far more than a purely functional role and were incorporated into codes of social and religious behavior at every level of society and in every phase of human existence. The important role textiles played in the economic life of the Middle Ages is revealed in the *Geniza* documents. S. D. Goitein has demonstrated that textiles were the primary object of trade, the cash-in-hand, negotiable anywhere in the world. The economic and political role of textiles in the Islamic world has long been studied. The government often controlled textile production, which constituted a large sector of the economy. The inclusion of the ruler's name in textile inscriptions was an acknowledgment of suzerainty tantamount to the inclusion of his name on coinage, and in the Friday *khuṭbah* (sermon).[64]

Not only was the social, economic, and political life of the Islamic world caught up with textiles, the individual himself was fully cognizant of the technical aspects of textile production even though he was not a weaver. The medieval client was far more conscious of the technology involved in manufacturing goods than the consumer today. Textiles were so vital that the average man could not afford to be without some knowledge of their manufacture. A merchant could expect his client to provide detailed instructions regarding the choice of threads.[65] In one documented case, the client had sent a merchant linen and cotton threads to make a set of clothes. But the merchant discovered, after the garments were partially completed, that not enough of the finer threads remained to make the other garments. The leftover linen threads were too coarse to weave with the cotton. He wrote to his client asking whether to buy more threads to go with the linen or finer linen to go with the cotton. This inquiry reveals that a surprising degree of expertise was expected of the client. Expertise in textiles comes from another unexpected quarter, the eleventh-century historian of Isfahan, al-Māfarrukhī. He expresses amazement that some 1,000 inhabitants of a *bidonville* on their way to the *muṣalla* to celebrate the ʿīd were "wearing fine turbans of gold-embroidered linen, *Tūzī, Bamī* and *Baqyār* cloths, Egyptian wool and garments of *Siqlātūn* and ʿ*Aṭabī* . . ." —that is, all of the normal luxury textiles.[66] This historian's ability to identify and differentiate between the various luxury fabrics as they paraded by is characteristic of the middle-class concern and familiarity with textiles.

Color-consciousness is yet another aspect of this obsession with textiles that has been documented. No doubt the size of the textile vocabulary is in part due to a heightened sensitivity to colors and patterns. The *Geniza* speaks of pistachio green, iridescent peacock, chick-pea, wax-, tin-, pearl-, and sand-colored. There is a pomegranate red, a flame-colored, a lead-gray, and many varieties of stripes and ornaments, such as *muṭayyar* (ornamented with birds).[67] Color preferences seem quite pronounced in the personalized orders recorded in the *Geniza*. The archaeological textiles also exhibit a wide range of colors and motifs, although it must be remembered that the most elaborate overgarments are, for the most part, missing.

It was on the strength of Nāṣir-i Khusraw's comparison of luster pottery to *būqālimūn* textiles that Grabar concluded: ". . . much of the contemporary world acquired its aesthetic judgement through textiles."[68] I would like to carry this idea further by suggesting that a "textile mentality" was responsible for the development of certain characteristic idioms in Islamic art. In other words, if textiles penetrated so deeply into all aspects of life, can they not be expected to have had some impact on the formation of aesthetics as well? My conclusions are presented here as a series of six cases.

The first case concerns the transfer of the term *ṭirāz* from garment ornamentation to the ornamentation of other things. Maqrīzī often refers to the inscription band on the façade of a building as a *ṭirāz*.[69] The term came to be used metaphorically. Learning and culture "embroidered" a person's character, as a *ṭirāz* band gave class to a fine piece of cloth.[70]

The next case demonstrates that the compulsion to drape everything is implicit in certain art objects. Animals had to be dressed, like the rooster aquamanile with its medallion copied from garment types (fig. 9), such as the so-called Veil of St. Anne ᶜabāʾ in Apt Cathedral, or like the goat from a Samarra painting (fig. 10). An incense burner in the form of a cheetah is robed in a textile pattern, bordered with *ṭirāz* bands, and even has the rectangular chest panel, or *qabbah*, discussed above (fig. 11). There was something in the nature of a "textile-reflex"—whatever could be draped should be draped.

The third case refers to architecture. If one studies the evolution of surface decoration, it becomes increasingly clear that the practice of hanging the walls with textiles led to the development of mosaic faience and polychrome painted panels. The walls were broken up into small rectangular panels, as if they were products of the loom (fig. 12). The pattern changes abruptly from one panel to the next, as if the eye were moving from fabric to fabric. Many of the large tile panels reproduce carpet designs, and their large expanse may be a reflection of the increasing size of carpets. A corner column in the Mosque of Yazd (fig. 13), revetted in mosaic faience in a chevron pattern, appears to be imitating the *ikat*-dyed cottons of Yemen, even with regard to the brown, blue, and white color scheme (fig. 14). The lacy quality of the deeply carved stucco ornament in Western Islamic monuments such as the Alhambra may not be fortuitous.

The final three cases show the imprint of the technique of weaving itself. One is the use of decorative brickwork in eastern Iran, first popular in the tenth century (fig. 15). Brick patterns had much in common with textiles, in that they conform to some kind of grid involving a vertical and horizontal axis (fig. 16). In weaving, these are the warp and weft. The warp, or vertical element, is static. The weft moves and makes the pattern by changes in color and variations in the number of warps covered. In brickwork, the horizontal axis dominates. The design is always worked in the vertical. One of the terms used to describe this kind of decoration is *hazār-bāf* (a thousand weaves). This woven decoration allowed the architect to virtually swathe his forms (fig. 17), and thereby bring out the volumetric quality of the architecture, as if it were, in fact, draped with textiles.

The fifth case concerns Samanid epigraphic pottery of the tenth century.[71] On one class of this pottery the only decoration is a band of Kufic writing (figs. 18, 19). The absence of any further decoration on the stark white background caused Ettinghausen some alarm because it seemed to be an exception to the rule of *horror vacui*. A plate from the Freer Gallery (fig. 18) poses still another problem. The majority of bowls and plates in this class have inscriptions encircling the rim—that is, respecting the circular character of the object. This one violates it outright. The calligrapher simply ignored the shape of the object. Or did he?

One is struck by the resemblance of this format to the archaeological textiles with their *ṭirāz* bands (fig. 20). The plate is like a pure-white linen cloth across which runs a thin *ṭirāz* band. This comparison may seem farfetched, but not if one considers the custom of covering serving objects with napkins (*mandīls*). Consider the following scenario. (Although this reconstruction is a fantasy, there are numerous texts describing the serving of beverages from covered vessels.)[72] A servant brings his master a goblet of water or other drink carried on an inscribed plate. The goblet is covered by a *ṭirāz*-ornamented linen *mandīl*. The servant removes the goblet and gives it to the master. The inscription on the plate is now visible. The napkin is then replaced, but directly over the plate. The inscriptions on the napkin and the plate spatially coincide.

The final case, which consists of two parts, illustrates ways in which the very grammar of ornament was affected by weaving technology. The dynamic in question is the interlace—the basic over-and-under process whereby loose threads become bound together. The early history of Islamic ornament shows an increasing interest in ever more complex geometric compositions. By the middle of the ninth century, the lines of the geometric grid took on a life of their own and became more important than the compartments they delineated.

At the same moment, in the Yemen, a strange form of calligraphy began to appear on the famous *ikat* cottons (fig. 14):[73] The Kufic letters of the inscription became knotted. The horizontal bars in the letter *dāl* of Muḥammad are twisted around each other like threads of a chain stitch (fig. 21). Vegetal ornaments erupt amid this chaos. The textile mentality has triumphed.

When I first began to study plaited Kufic Samanid pottery, I came to the conclusion that it had been invented by the potters and exported westward to the Yemenite weavers.[74] This conclusion was based on two observations: the earliest dated examples were to be found on the coins of Rayy and Khurasan (fig. 22), and the plaited Kufic alphabet appeared in monumental art in the East at least a century before it did in the West, where it never became as popular. However, in the light of the present evidence, the reverse now seems more plausible. Such an idea was more likely to have been the brainstorm of a weaver than a potter. Textiles are more portable than pottery, and no Samanid wares appear to have been exported to the Red Sea, to judge from excavated examples.[75] We know from texts, however, that the *ikat*, or ʿaṣb of Yemen, was exported to Iran, and that it was in fact imitated at Rayy,[76] where the earliest coin with plaited letters was minted in 324/936.

This love for interlace even penetrated architecture, for it is seen in the arched screens that cordon off the bays at the entrance to al-Ḥakam's additions to the Mosque of Cordova and in front of its *miḥrāb*s (fig. 23). Whether the metaphor can be carried further is debatable, but it might be suggested that the architects saw in these compositions a vertical, stable "warp" in the form of the arches. The surface produced is more like a woven textile than tracery, for, as Ewart's study has shown,[77] many of the spaces between the arches are blocked to provide a surface for a different pattern on the reverse. A most bizarre version of interlacing arches occurs in the Aljaferia Palace at Saragossa a century after Cordova.[78]

Interlace dominated the *Grammatik* of ornament of the tenth-eleventh centuries, if one may

borrow Riegl's expression. It provided a means of penetrating two-dimensional space and opened the way for the development of the multilevel arabesque, which Ettinghausen compared with "polyphonic music" in his article on the *horror vacui*.

It would seem that the origins of this love for the interlace may be found in the "textile mentality" that in certain ways possessed the society. The heightened importance of costume and the preference for soft furnishings made the development of textiles practically a cult in itself. The preeminence of textiles also helps to explain why it was possible, and perfectly acceptable, in Islamic art for different media to share the same decorative treatment—why it is that bookbindings, wood carving, architectural faience, and Koran pages all look like carpets.

NOTES

1. A. Riegl, *Stilfragen, Grundlegnungen zu einer Geschichte der Ornamentik*, Berlin, 1893; Riegl, *Historische Grammaktik der bildenden Künste*, post. ed. K. M. Swoboda and O. Pacht, Graz-Köln, 1966; J. Strzygowski, *Asiens bildende Kunst*, Augsburg, 1930 (hereafter, Strzygowski).

2. *Proceedings of the American Philosophical Society*, CXXIII, no. 1, 1979, 15–28.

3. I owe my introduction to textile studies to my dear friend Dr. Veronika Gervers, who was curator of the Royal Ontario Museum Textile Department from 1968 until her death in 1979. Her enthusiasm, generosity, and insight will always be remembered.

4. R. P. A. Dozy, *Dictionnaire détaillé des noms de vêtements chez les Arabes*, Amsterdam, 1845 (hereafter, Dozy).

5. Y. K. Stillman, *Palestinian Costume and Jewelry*, Albuquerque, 1979 (hereafter, Stillman, 1979).

6. R. B. Serjeant, *Islamic Textiles: Material for a History up to the Mongol Conquest*, Beirut, 1972 (hereafter, Serjeant): collection of articles originally published serially in *Ars Islamica*, IX–XIV, 1942–51 (hereafter, Serjeant, *Ars Islamica*).

7. Aḥmad b. al-Rashīd b. al-Zubayr, *Kitāb al-Dhakhā'ir wa-al-Tuḥaf*, ed. Muḥammad Ḥamīd Allāh, Kuwait, 1959 (hereafter, Ibn al-Zubayr).

8. " 'Cairo *Geniza* documents' refers to material dating from the 10th through the 13th centuries A.D., written mostly in Hebrew characters but in the Arabic language, and originally preserved in a synagogue, and partly also in a cemetery at Fustat." S. D. Goitein, "Cairo: An Islamic City in Light of the Geniza Documents," *Middle Eastern Cities: A Symposium*, Berkeley, 1969, 80. See also Goitein, *A Mediterranean Society*, Berkeley, 1967. Among the documents are official, business, and private correspondence, contracts, accounts, receipts, and inventories.

9. E.g., D. G. Shepherd and W. B. Henning, "Zandanījī Identified?" *Festschrift für Ernst Kühnel, Aus der Welt der Islamischen Kunst*, Berlin, 1959, 15–40.

10. C. Lamm, *Cotton in Mediaeval Textiles of the Near East*, Paris, 1937, Class 9, 144ff. (hereafter, Lamm); A. Bühler, *Ikat-Batik-Plangi: Reservmüsterungen auf Garn und Stoff aus Vorderasien, Zentralasien, Sudosteuropa und Nordafrika*, Basel, 1972; L. Golombek and V. Gervers, "Tiraz Fabrics in the Royal Ontario Museum," *Studies in Textile History in Memory of Harold P. Burnham*, ed. V. Gervers, Toronto, 1977, 82–125 (hereafter, Golombek and Gervers, "Tiraz Fabrics").

11. A. von Le Coq, *Chotscho, Königlich-Preussiche Turfan-Expedition*, Berlin, 1913; Le Coq, *Bilderatlas zur Kunst und Kulturgeschichte Mittel-Asiens*, Berlin, 1925 (hereafter, Von Le Coq, *Bilderatlas* . . .); E. Herzfeld, *Die Malereen von Samarra*, Berlin, 1927; M. Bussagli, *Painting of Central Asia*, Geneva, 1963 (hereafter, Bussagli); illustrations on objects in Pope, *SPA*; A. Lane, *Early Islamic Pottery*, London, 1965; E. Atıl, *Ceramics from the World of Islam*, Washington, D.C., 1973; numerous illustrations in *Islam and the Arab World*, ed. B. Lewis, New York, 1976.

12. "*Ṭirāz* bands" refer to the narrow strips of ornament (serving as arm bands or borders) that often bore inscriptions. The term *ṭirāz* is borrowed from the Persian word for embroidery but was used for other techniques of decoration as well. On the manufacture of such textiles for the court, see below.

13. For bibliography, see N. P. Britton, *A Study of Some Early Islamic Textiles in the Museum of Fine Arts, Boston*, Boston, 1938; E. Kühnel and L. Bellinger, *Catalogue of Dated Tiraz Fabrics: Umayyad, Abbasid, Fatimid, The Textile Museum, Washington, D.C.*, Washington, D.C., 1952; Golombek and Gervers, "Tiraz Fabrics."

14. Y. K. Stillman, "The Importance of the Cairo Geniza Manuscripts for the History of Medieval Female Attire," *International Journal of Middle East Studies*, VII,

1976, 579–89 (hereafter, Stillman, 1976); Stillman, "The Wardrobe of a Jewish Bride in Medieval Egypt," *Studies in Marriage Customs,* Folklore Research Center Studies, Hebrew University, IV, 1974, 297–304 (hereafter, Stillman, 1974).

15. S. D. Goitein, *Letters of Medieval Jewish Traders,* Princeton, 1973, nos. 11, 64 (hereafter, Goitein, 1973).

16. L. Mayer, *Mamluk Costume,* Geneva, 1952, 18, no. 2.

17. al-Maqqārī, cited by Lamm, 246.

18. Stillman, 1974, 304.

19. S. D. Goitein, "Two Arabic Textiles," *Journal of the Economic and Social History of the Orient,* XIX, part 2, 1976, 221–24,

20. Ibn al-Zubayr, no. 302.

21. S. D. Goitein, "Three Trousseaux of Jewish Brides from the Fatimid Period," *Association for Jewish Studies Review,* II, 1977, 77–110.

22. S. D. Goitein, "Sicily and Southern Italy in the Cairo Geniza Documents," *Archivio storico der la Sicilia orientale,* LXVII, 1971, 14.

23. *Kitāb Yatīmat al-Dahr,* cited by Lamm, 199.

24. Goitein, 1973, 265.

25. Lamm, 210.

26. Sharaf al-Dīn ʿAlī al-Yazdī, *Ẓafar-nāmah,* Tehran, 1336 s./1957–58, I, 199.

27. Goitein, 1973, 141.

28. Stillman, 1976, 582; Dozy, 28.

29. Numerous references in Serjeant, see *khilʿa.*

30. The importance of this event for the history of Fatimid art has been suggested by O. Grabar in "Imperial and Urban Art in Islam: The Subject Matter of Fatimid Art," *Colloque International sur l'Histoire de Caire,* Cairo, 1972, reprinted in *Studies in Medieval Islamic Art,* London, 1976, no. VII (hereafter, Grabar, VII).

31. Stillman, 1979, 32–33.

32. Goitein, 1973, no. 11.

33. J. Sadan, *Le Mobilier au proche orient mediéval,* Leiden, 1976 (hereafter, Sadan).

34. E.g., in the "Dīwān" of the Bath at Khirbat al-Mafjar, cf. R. Ettinghausen, *Arab Painting,* Geneva, 1962, 39 (hereafter, Ettinghausen, *Arab Painting*); mosaics as substitutes for textiles, Strzygowski, 441.

35. On nomadism in the Mediterranean, see F. Braudel, *The Mediterranean and the Mediterranean World in the Age of Phillip II,* London, 1972–73; on Iran, see the works of V. Barthold, C. Cahen, J. Aubin, and on a specific dynasty, J. E. Woods, *The Aqquyunlu: Clan, Confederation and Empire,* Chicago, 1976.

36. Seasonal movements of Timurid princes were recorded by the Spanish envoy, Ruy Gonzalez de Clavijo,

Embassy to Tamerlaine, trans. Le Strange, London, 1928 (hereafter, Clavijo).

37. E.g., found especially in illustrations of the *Maqāmāt* of al-Ḥarīrī, in Ettinghausen, *Arab Painting,* 112; and in scenes from Niẓāmī's *Laylā and Majnūn,* e.g., L. Binyon, *The Poems of Nizami,* London, 1928, pl. 12; and E. Grube, *The World of Islam,* New York, 1966, 127.

38. Cf. Clavijo, 238; D. Wilber, "The Timurid Court: Life in Gardens and Tents," *Iran,* XVII, 1979, 127–33.

39. Sadan, 7ff.

40. Lamm, 185.

41. B. Gray, *Persian Painting,* Geneva, 1961, 25.

42. M. Canard, "Le cérémonial Fatimite et le cérémonial Byzantin," *Byzantion,* XXI, 1951, 360 (hereafter, Canard, 1951).

43. J. Lassner, *The Topography of Baghdad in the Early Middle Ages,* Detroit, 1970, 88–99 (hereafter, Lassner); Ibn al-Zubayr, 134.

44. Ibn al-Zubayr, 150–51.

45. Ibid., 141–45; other "scenery changes" are described in A. Mez, *The Renaissance of Islam,* Oxford, 1937, 65.

46. Lassner, 88–89.

47. Lamm, 78.

48. T. Arnold, *Painting in Islam,* Oxford, 1928, rpt., New York, 1965, 21 (hereafter, Arnold); al-Maqrīzī, *al-Mawāʿiz wa-al-Iʿtibār fī Dhikr al-Khiṭaṭ wa-al-Āthār,* Būlāq, 1854, I, 419 (hereafter, al-Maqrīzī).

49. Arnold, 21.

50. V. Gervers, "An Early Christian Curtain in the Royal Ontario Museum," *Studies in Textile History,* 56–81 (see note 10 for the complete reference).

51. O. Grabar, "The Six Kings at Qusayr Amrah," *Ars Orientalis,* I, 1954, 185–87.

52. al-Masʿūdī, cited in Pope, *SPA,* 2276–77; Lamm, 57.

53. Ibn al-Zubayr, 254.

54. Sadan, 14–17.

55. Bussagli, ill. frontispiece.

56. On the ceremonial role of curtains, see D. Sourdel, "Questions de cérémonial Abbaside," *Revue des Études Islamiques,* 1960, and Canard, 1951. For curtains placed around the *miḥrāb,* see Canard, 1951, 376.

57. See "*Kiswa,*" *EI¹,* s.v. The custom of covering idols and shrines may be traced to ancient Semitic usage (cf. Bosworth, 42, al-Thaʿālibī, text discussing "first persons" to cover Kaʿbah, see note 76 below).

58. *Riḥlah,* Leiden, 1907, 83.

59. F. Rosenthal, *Four Essays on Art and Literature in*

Islam, IV: "A Note on the Mandīl," Leiden, 1971 (hereafter, Rosenthal).

60. Ibid., 93.

61. E.g., Niẓāmī, *Khamsah,* Brit. Mus. Add. 27261, ill. F. R. Martin, *The Miniature Painting and Painters of Persia, India and Turkey,* London, 1912, pl. 53; also Niẓāmī, *Haft Paikar,* trans. C. E. Wilson, London, 1924, 175, 198.

62. Von Le Coq, *Bilderatlas . . . ,* fig. 157 (Kutscha), fig. 63 (actual painting on silk).

63. al-Thaʿālibī, *Histoire des Rois des Perses,* ed. and trans. H. Zotenberg, Paris, 1900, 640.

64. Serjeant, *Ars Islamica,* IX, 71ff.

65. Goitein, 1973, 134.

66. al-Māfarrūkhī, Pers. trans. Ḥusayn b. Muḥammad b. Abī al-Riḍā' Āvī, *Maḥāsin Iṣfahān,* ed. A. Iqbal, Tehran, 1327, 75.

67. Stillman, 1974, 302.

68. Grabar, VII, 45.

69. E.g., al-Maqrīzī, II, 79.

70. Examples cited in "*Ṭirāz,*" *EI¹,* s.v.

71. L. Volov (Golombek), "Plaited Kufic on Samanid Epigraphic Pottery," *Ars Orientalis,* VI, 1966, 107–33.

72. Rosenthal, 81, 83–84, 86.

73. Lamm, 144ff.; Golombek and Gervers, "Tiraz Fabrics."

74. L. Volov (Golombek).

75. I have been informed by George Scanlon that no Samanid wares have been found in the excavations of Fustat.

76. al-Thaʿālibī, *The Book of Curious and Entertaining Information (Latā'if al-Maʿārif),* trans. C. E. Bosworth, Edinburgh, 1968, 129.

77. C. Ewart, *Spanisch-Islamische Systeme sich Kreuzender Bögen,* Berlin, 1968.

78. R. A. Jairazbhoy, *An Outline of Islamic Architecture,* London, 1972, pl. 31.

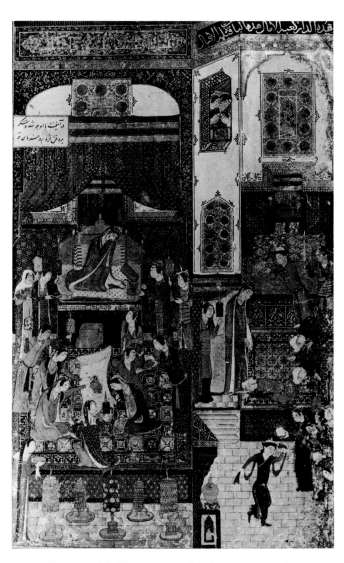

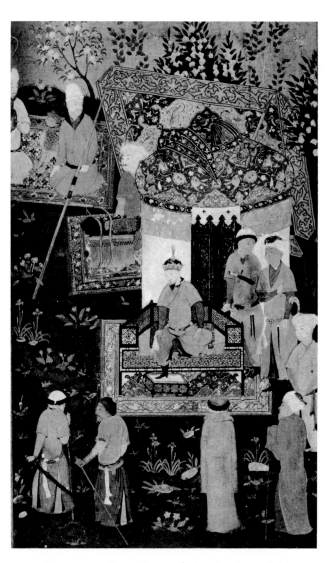

Fig. 1. The Nuptial Chamber, Baghdad, 1396, from the
Masnavī of Khvājū Kirmānī. London, Brit. Mus. Add. 18113,
fol. 45 b. Courtesy the Trustees of The British Museum.
Copyright the British Library

Fig. 2. Tīmūr granting audience on the occasion of his
succession, from the Ẓafar-nāmah of Sharaf al-Dīn Yazdī,
dated 1467, paintings c. 1490. Courtesy The John Work
Garrett Collection, Special Collection Division, The Milton
S. Eisenhower Library, The Johns Hopkins University, fol.
82v

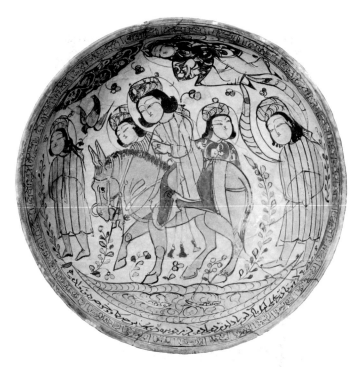

FIG. 3. Abū Zayd Kashānī, minai bowl, Iran, dated 1187. New York, Metropolitan Museum of Art, 64.178.2, Fletcher Fund, 1964. Courtesy The Metropolitan Museum of Art

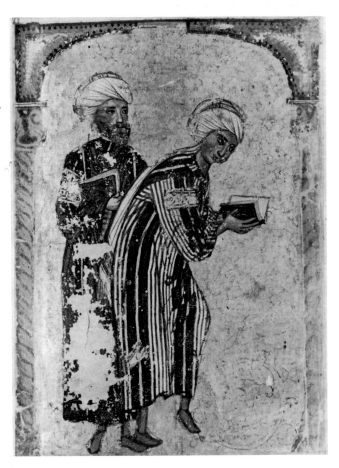

FIG. 4. Frontispiece, Dioscorides MS, Materia Medica, dated 1229. Istanbul, TKS, Ahmet III, 2127, fol. 2A

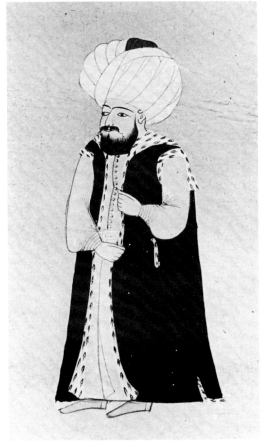

FIG. 5. The military judge of Anatolia, from a series of Ottoman costume drawings. Toronto, Royal Ontario Museum, 971.292. Courtesy Royal Ontario Museum

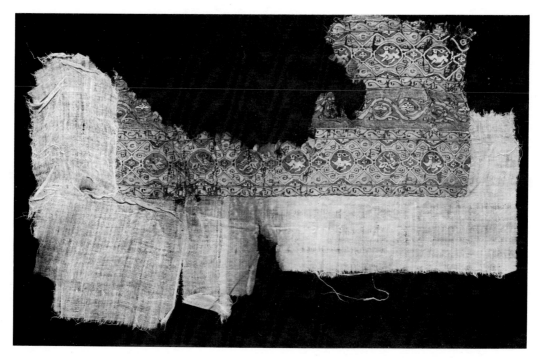

FIG. 6. Linen fabric with tapestry-woven *ṭirāz* inset, Egypt, eleventh century. Toronto, ROM, 963.95.2. Courtesy Royal Ontario Museum

FIG. 7. Paolo Veneziano, *Coronation of the Virgin,* late fourteenth century, detail of chest panel (photo: Soprintendenza al Beni Artistici e Storici di Venezia, cat. no. 21)

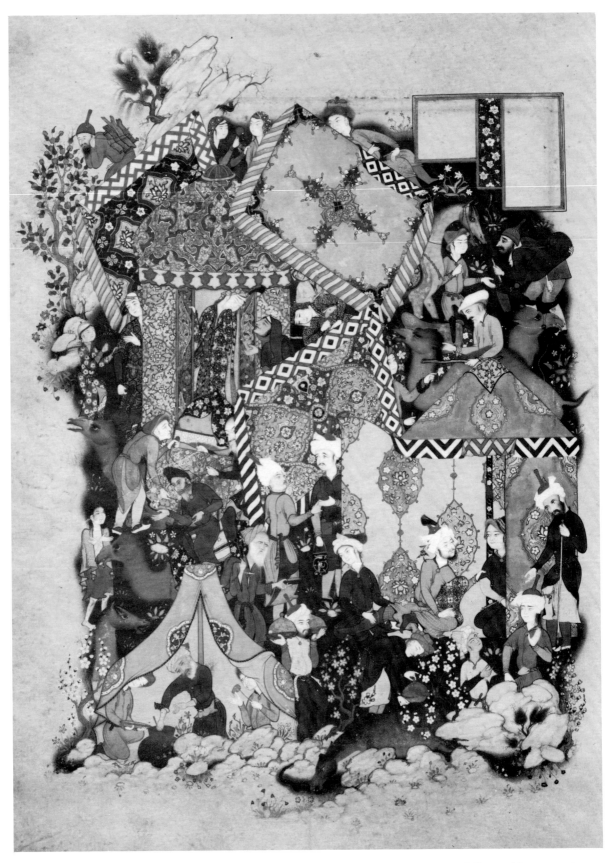

FIG. 8. Encampment from Jāmī, *Haft Awrang,* dated 1556–65. Washington, D.C., Freer Gallery of Art, no. 46.12. Courtesy Freer Gallery of Art, Smithsonian Institution

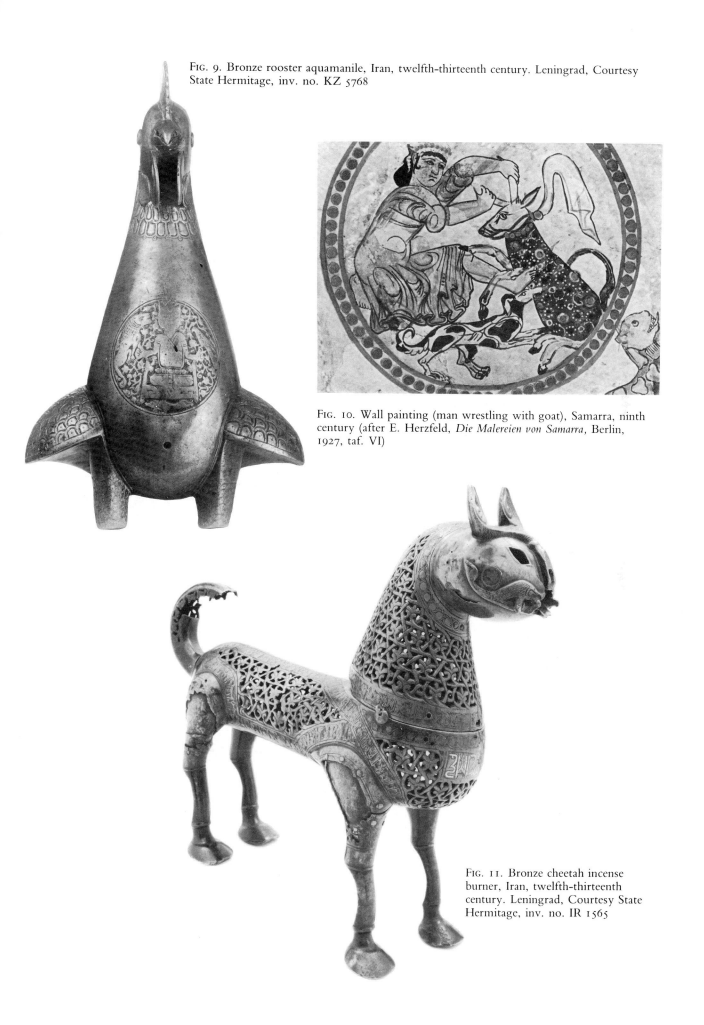

FIG. 9. Bronze rooster aquamanile, Iran, twelfth-thirteenth century. Leningrad, Courtesy State Hermitage, inv. no. KZ 5768

FIG. 10. Wall painting (man wrestling with goat), Samarra, ninth century (after E. Herzfeld, *Die Malereien von Samarra,* Berlin, 1927, taf. VI)

FIG. 11. Bronze cheetah incense burner, Iran, twelfth-thirteenth century. Leningrad, Courtesy State Hermitage, inv. no. IR 1565

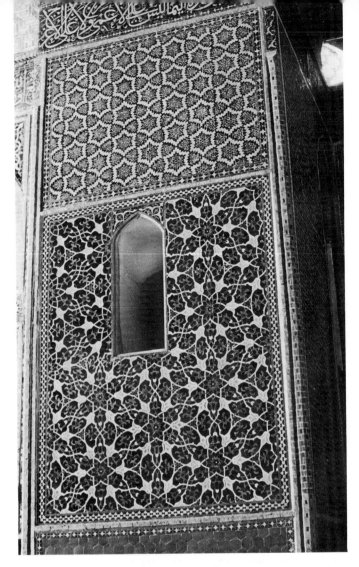

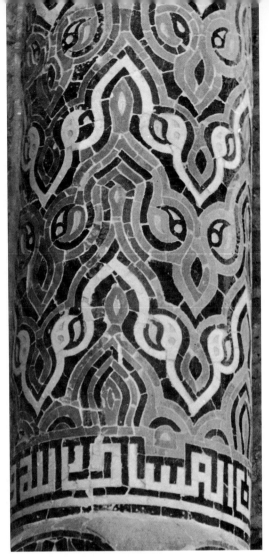

FIG. 12. Yazd, Masjid-i Jāmiᶜ, mosaic faience revetments, fourteenth–fifteenth century

FIG. 13. Yazd, Masjid-i Jāmiᶜ, mosaic faience reveted column

FIG. 14. *Ikat* cotton with painted inscription, Yemen, tenth century. Toronto, ROM, 963.95.9 or 970.364.20. Courtesy Royal Ontario Museum

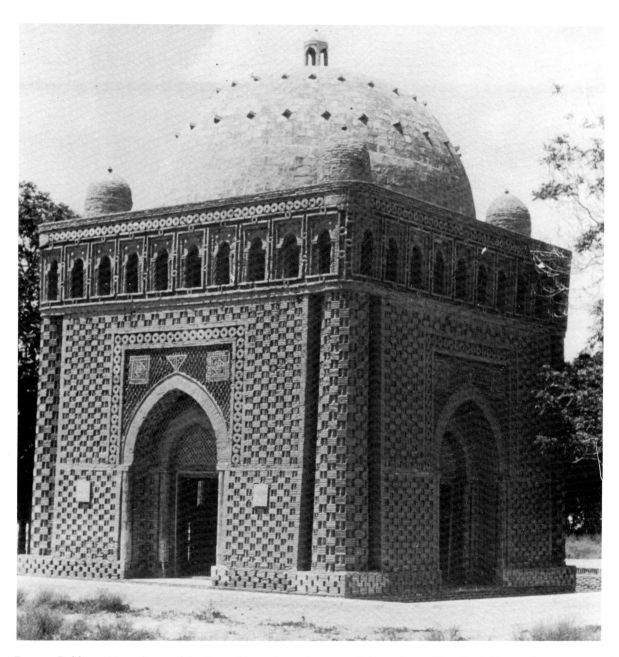

FIG. 15. Bukhara, Mausoleum of the Samanids, early tenth century (photo: James H. Acland, Toronto)

FIG. 16. *Hazār-bāf* tile work, Khargird Madrasah, 1444

FIG. 17. Samarqand, Masjid-i Jāmiᶜ, side of main sanctuary, 1404

FIG. 18. Slip-painted plate with inscription, Khurasan, tenth century. Washington, D.C., Freer Gallery of Art, 54.16. Courtesy Freer Gallery of Art, Smithsonian Institution

FIG. 19. Slip-painted bowl with inscription, Khurasan, tenth century. Toronto, ROM, 961.119.3. Courtesy Royal Ontario Museum

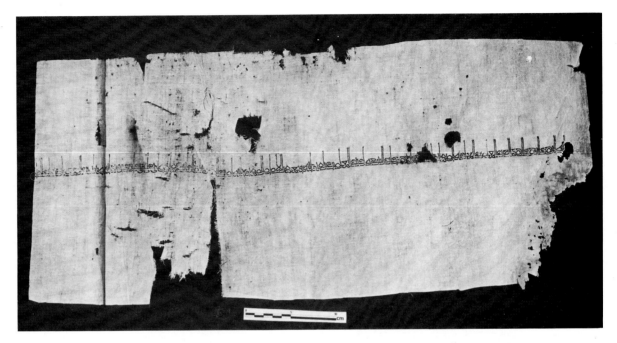

FIG. 20. Cotton fabric with embroidered *ṭirāz* band, Persia or Iraq. Toronto, ROM, 978.76.290, The Abemayor Collection, gift of Messrs. Albert and Federico Friedberg. Courtesy Royal Ontario Museum

FIG. 21. Drawing of word "Muḥammad" from an *ikat* cotton, Yemen, tenth century. Washington, D.C., Courtesy Textile Museum

FIG. 22. *Dirham,* with plaited "*dāl,*" al-Shāsh, 941–42. New York. Courtesy American Numismatic Society

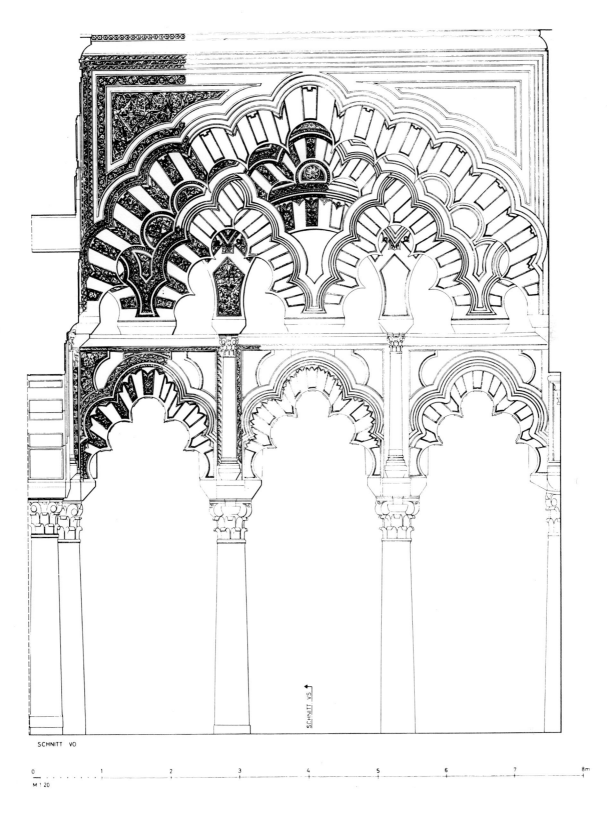

SCHNITT VO

SCHNITT VS

0 · · · · · · · · 1 · · · · · 2 · · · · 3 · · · · 4 · · · · 5 · · · · 6 · · · · 7 · · · · 8m

M 1:20

FIG. 23. Mosque of Cordova, screen of interlacing arches, 961 (drawing after C. Ewert, *Spanisch-Islamische Systeme sich Kreuzender Bögen,* 1, Cordoba, Madrider Forschungen, Bd. 2, Berlin [Walter de Gruyter & Co.], 1968)

The Iconography of Islamic Architecture

Oleg Grabar

OVER 950 years elapsed between the construction of the earliest fully documented monument of classical Islamic architecture (the Dome of the Rock in Jerusalem, completed in A.D. 691) (fig. 1) and its latest celebrated masterpiece (the Tāj Maḥāl in Agra, completed in 1654) (fig. 2). During the millennium that separates them, tens of thousands of monuments were built from Spain to China, from Siberia to sub-Saharan Africa. Archaeologists, art historians, and architectural lexicographers have made enormous progress in classifying buildings according to function (mosques, mausolea, palaces, houses, baths); geographical region (Egypt, Iran, Turkey, Central Asia, India); period (early Islamic, Saljuq or middle Islamic, Ottoman, Mughal); or any combination of these essentially taxonomic categories—that is to say, categories of definition and ordering. They are taxonomic because they are valid, incontrovertible, and, once established, definitive. Anyone among us can give examples of discoveries—a dated inscription, an excavation or sounding, the subject matter of a decorative program—that have permanently altered the history of a monument. An obvious recent example occurs in Galdieri's excavations in Isfahan.[1] These led to postulation of the architectural evolution of the parts of the Great Mosque that is clear up to the construction of a large dome in front of the *miḥrāb,* even though what happened later is still uncertain, and even though the rather incongruous visual impression provided by Galdieri's pictorial reconstruction still raises doubts about the architectural competence of the time. In a more general way, Creswell's enormous achievement is the demonstration of a noble concern for the establishment of "facts" and for their reasonable classification in sequences according to formal and temporal characteristics and relationships.[2]

Why not remain satisfied with the immense progress over the past fifty years in our knowledge

of facts about Islamic architecture and in our organization of this information into reasonably accepted categories?[3] Two reasons not to, I believe, have emerged over the past decade. One derives from my involvement over the past several years with the activities of the contemporary architects and planners, Muslim and non-Muslim, who are reshaping the face of the whole Muslim world. The questions they ask are never: Who built something? and Why?, but nearly always: What is Islamic in this? and How can I, a modern builder (frequently alien to Islamic culture), use the traditional past and its monuments to create something today? From the point of view of *real* contemporary interests, this is necessary information—like the knowledge of anatomy for a doctor. In other words, out of the taxonomic order of knowledge, something is expected that is not normally required. I shall return to this expectation in my conclusion, but let me now turn to the second reason for dissatisfaction with the taxonomic progress of the field. It lies in the monuments themselves.

Let me return to the Dome of the Rock and the Tāj Maḥāl. In both instances we are dealing with masterpieces remarkable for the fact that their continuing importance within Islamic culture has very little to do with the reasons for their actual construction. The Dome of the Rock has become a commemorative monument for the Prophet's mystical journey into the heavens, but it was built in 691–692 for the very ideological local purposes of sanctifying the old Jewish Temple according to the new Revelation and of demonstrating to the Christian population of the city that Islam was the victorious faith.[4]

The Tāj Maḥāl has always been considered the most romantic monument to a dead spouse, but a brilliant recent investigation has demonstrated that it was actually an extraordinary attempt to show God's throne *on earth* as it will appear at the time of the Resurrection.[5] In a fascinating contrast to what happened with the Dome of the Rock, the romantic *Western* vision of the Tāj Maḥāl was accepted by the Muslim world as a convenient explanation for a monument with an unorthodox purpose.

The reinterpretation of both monuments was based on two elements. One was historical logic demonstrating that the later view of the buildings could not have been imagined at the time of their creation. The other was that each monument contains a document neglected by previous investigators: Koranic inscriptions chosen to provide the immanent, concrete, specific meaning of the monument. Both historical logic and Koranic inscriptions are not architectural features but extrinsic sources of information and understanding.

Why, then, is it legitimate to consider the Dome of the Rock and the Tāj Maḥāl as masterpieces of *Islamic* architecture? Is it because they simply happen to have been sponsored by Muslim patrons, the great ʿAbd al-Malik (founder of the first coherent state outside of Arabia), and Shāh Jahān (the complex figure who ruled one of the last great Muslim empires)? Or is it because they both express, at a distance of almost a thousand years and in very different lands and political situations, a common idea, a shared thread, something which reflected the cultural needs and uniqueness of the Muslim world?

By raising the question in this fashion, I am immediately raising two subsidiary but fundamental questions of the history of art and of cultural history. Does something become Islamic because a Muslim builds it or uses it? In the case of the Dome of the Rock, for instance, all scholars agree that the shape of the building, its technique of construction, its decoration, and nearly all its physical attributes were not created by Islam but were part of the traditional—Christian—vocabulary of the eastern Mediterranean. To say this, however, is to indulge in academic pedantry. The origins of the forms used in the Dome of the Rock bear on the meaning given to it over the centuries only if one can demonstrate that a consciousness of these origins remained with the culture, or if one accepts a Jungian notion that every culture requires the same basic forms to

express its religious or social needs and that formal alterations are merely secondary.[6] The other question, or, rather, the other way of posing the problem, is this: Is there anything in the *forms* of these monuments—as opposed to their use—that makes them Islamic? And, if there is, what is it?

This second series of questions is the subject of this essay. My aims are to develop an intellectual strategy for further research on Islamic architecture, and to meditate on a key issue of contemporary thought: whether it is valid to apply the same investigative methods to the art of all cultures, or whether the very nature of artistic experience requires methods created by the culture itself.

One last introductory remark is in order. Much of what follows here is preliminary, and not all of it is my own work. It is the result of research, often still unpublished, by a half-dozen students at Harvard, MIT, and elsewhere, and it reflects what I can only call a collective laboratory effort at scholarship—to my mind the only way for research in the humanities to become true research.

It is, first of all, easy enough to demonstrate that Muslims quite consistently used certain forms, that courtyards with porticoes or with *īwāns*, domes, and towers became part of the setting in which Muslims live—but there is nothing intrinsically Muslim about a courtyard, an *īwān,* a dome, or a tower. Each one of these forms has a pre-Islamic history and non-Islamic functions. In these instances, the important issue is simply to discover the nature of the "charging" of forms that makes the towers of San Gimignano in Italy clearly non-Muslim but the towers of Fez or Cairo the minarets of a Muslim setting.

There are two kinds of more or less traditional methods of dealing with such issues. One approach I would like to call symbolic; its assumption is that there are features, perceptible visually, which, whatever their origin, possess or have possessed an immediately accepted cultural association. A most obvious example in Islamic architecture is the minaret, whose meaning as the place for the Muslim call to prayer is accepted by all, even though, as I shall suggest later, this was not always so. A less obvious but more important example is the *muqarnas,* that fascinating composition of three-dimensional units often called a stalactite or honeycomb. The *muqarnas* has two features lacking in the minaret: It is an entirely Muslim invention, almost never copied in a non-Muslim context except by Armenians in the thirteenth and seventeenth centuries, and it is a form used in nearly all kinds of Islamic monuments, not only in mosques. The symbolic approach would then be to say that the minaret or the *muqarnas* must have been uniquely meaningful to Islamic culture, and meaningful only in the Muslim world. They must *symbolize* something deep within the culture; they must stand for something essential to the purposes and existence of the *ummah* or community. Our task then is to study what within the culture was symbolized, and to explain the complex of meanings and references involved in a Muslim's reaction to a minaret or *muqarnas.* As in most symbolism, the proof of meaning lies less in the form itself than in the conscious or unconscious makeup of the viewer or user. For instance, purely optical observation, whatever the physiological or psychological reasons, tells us about the "projecting activism" in red or yellow and the "receding passivity" in blue or green, but only literary or ethnographic sources identify green as the color of the Prophet or as the color of the naked heart.[7] One cannot explain the symbolism of the colors of a Persian dome as a reflection of the mystical or even archetypical unity of creation, or the whiteness of a North African town as a reflection of the purity of the Prophet's message, without concrete textual or ethnographic evidence, that is, without the agreement of the culture itself.

The second approach is iconographic, meaning that in Islamic architecture certain forms denote or describe a Muslim idea or concept. A simple example would be the *miḥrāb*; its location in a religious building, its decoration, and its most common inscriptions (Koran 9:18 on the *masājid Allāh* (fig. 3) or 24:35–38, the verses on Light) indicate that an architectural form of no particular

significance—the niche found in thousands of buildings in classical architecture—has been transformed into a sign denoting very precise Muslim purposes: the direction of prayer, the commemoration of the Prophet's presence, and other even more complex meanings.[8] If, in any covered space, archaeologists find a niche directed to the *qiblah*, they decide that the building is a mosque. And the presence of a niche supported by columns (and sometimes including a lamp or a vegetal motif) on tiles, tombstones, rugs, and other media indicates that the *miḥrāb* form became an iconographic sign with some constant meanings and a number of variables. The extension of the iconography of the *miḥrāb*, however, is less an architectural phenomenon than a decorative one, as it appears in two-dimensional rather than three-dimensional space.

A related mode of iconographic interpretation can be demonstrated at Quṣayr ʿAmrah, at Khirbat al-Mafjar, possibly at the Aqṣā mosque or the Cordova *maqṣūrah*, the Cappela Palatina, and, I suppose, later monuments with which I am less familiar. These include the Chihil Sutun or the Hasht Bihisht, where paintings, sculpture, and other techniques of decoration provide the charge to architectural forms. It is, however, usually difficult to demonstrate that such meanings as are provided are an intrinsic part of the architectural forms themselves. The wealth and ubiquity of this type of iconographic charging through decoration has been amply demonstrated in Karl Lehman's great study of the Dome of the Heaven.[9] But, with a few exceptions such as the Pantheon,[10] Hagia Sophia, or the church described in a celebrated Syriac hymn,[11] it is not *in* the architectural forms that the complexities of meanings were found. Architecture here is iconophoric, not iconographic.

More complex instances of architectural iconography occur when one monument becomes a model for successive copies, imitations, and transformations or when a certain type of monument denotes something special in the culture. To my knowledge, there are few examples of the first type in classical Islamic architecture, but they do exist, as, for instance, the visual imitation of the Dome of the Rock in Qalāʾūn's mausoleum in Cairo, and I have no doubt that further studies will uncover iconographic derivations of the type that Richard Krautheimer described around the Holy Sepulchre in Christian architecture.[12] For instance, an iconographic sequence of the *ḥazīrah* in funerary complexes goes back to the Prophet's mosque in Madina in ways only barely sketched out up to now.[13] And I have tried elsewhere to construct a similar iconographic history for the Court of the Lions in the Alhambra.[14] The point in all these cases, as in all such instances of architectural iconography, is that some mechanism of cultural perception makes a genetic association between forms that may be quite different in detail. This kind of iconographic investigation can probably only be made through texts, for instance, by comparing Ibn Jubayr and Ibn Baṭṭūṭah's accounts of buildings.

More interesting are the meanings attached to specific architectural types. Let me give two examples.

One is a fairly simple one. Sometime in the sixteenth century the Ottoman mosque acquired its classical characteristics (fig. 4): a large central dome supported by half-domes, a porticoed courtyard, slender minarets, and a unique compositional logic based on the diameter of the cupola, with size, light, and decoration as variables. This type, almost certainly a creation of the Ottoman capitals, is best expressed in the great mosques of Istanbul, but it occurs in Algiers, throughout the Balkans, in Syria, and even in Muḥammad ʿAlī's Cairo. It does not occur in Morocco, Iran, India, or Central Asia because this type is tied to Ottoman supremacy. It serves an Islamic function, but its architectural forms signify a specific empire.

The second example is more complicated. It seems clear that in the seventh and eighth centuries, the central lands of Islam (primarily Iraq, if my conclusions are correct) developed a type of mosque based on a multiplicity of single supports known as the hypostyle mosque (fig. 5). This

type both served and reflected the characteristics of the early Muslim community and acquired a more elaborate regional variant with the mosque of Damascus. Nearly every early mosque in the new cities of the Muslim world—Cordova, Qairowan, Isfahan, Siraf, Nishapur—was hypostyle. What is interesting is what happened later. The hypostyle mosque with a single minaret and an elaborate *miḥrāb* area became characteristic of the entire Arab world until today, from Morocco to Iraq; it appears in all sizes, from huge buildings, as in Rabat, to small ones, neatly fitted within their urban setting, such as the Aqmar mosque in Cairo and any number of *masjid*s in Syria.

The hypostyle mosque was also often the first type of mosque built when a new area was conquered or converted. In Konya, the new congregational mosque of the thirteenth century is a hypostyle, and so are some of the earliest mosques in India. Most African mosques of any size tend to the hypostyle. It is as though at those moments and places when the important cultural objective was the strengthening of Islam, and not the extension of a state, the hypostyle mosque provided the architectural form through which the presence of the faith could most easily be expressed. Why? There may be practical reasons, for instance, the possibility of creating a space tailored to any size of community (the hypostyle is an unusually flexible form) or the absence of a hierarchy of parts reflecting the equality of the Faithful. But a more profound explanation is that the hypostyle form remained in the collective memory of Muslims and was associated with an early, unadulterated Islam, and that it expressed that view of itself that the Muslim world was particularly anxious to project.

Such revivals of early Islam are probably more numerous than we recognize. For instance, in the early fourteenth century, in the north central Iranian city of Bistam, two small cells were built in the sanctuary of the great mystic Abū Yazīd al-Biṣṭāmī.[15] They were probably meant for private meditation, but it is interesting that in an inscription they are called *sawmaʿah*,[16] an old word found in the Koran (22:41) but with unclear significance. It means "minaret" in North Africa for reasons elucidated by Creswell, but in some historical sources it also refers to the small rooms for hermits found in the towers of the mosque of Damascus at the time of the conquest. The term is rarely used in medieval literature, but its reappearance in the early fourteenth century to describe the setting of a pious function so reminiscent of the stories spun around seventh-century mosques in Syria seems to me to demonstrate the persistence of early Islamic concepts and their reappearance when an association was made, for whatever reason, with the first century of Islam.

These examples indicate the existence within the evolution of Islamic architecture of an *order of meaning* which is inherent neither to forms nor to functions, nor even to the vocabulary used for forms or functions, but rather to a relationship among all three. This relationship had a history, a development, almost certainly a number of constants and variants. That history, these constants and variants, still requires an extraordinary amount of research, not only in the monuments themselves but in the huge literature that deals with them or refers to them. But that there is (or was) an iconography of Islamic architecture seems clear to me. This is not surprising, for there is every reason to assume that Islamic architecture contains the same complex meanings as does classical, Christian, and Hindu architecture. It is simply that so little effort has been spent on the meanings of Islamic architecture that their depth has been overlooked.

How does one deal with this underappreciated area? The problem is that Islam does not possess the two vehicles through which Christian or Hindu architecture can be understood. One is a complex, codified liturgy that would affect architecture. (There are cases, known to me especially in the Mediterranean area, in Cordova or in Fatimid Egypt, where complex ceremonies did accompany Friday prayer and affected the shape and possibly the decoration of *minibar*s and *miḥrāb*s,[17] but as a rule the absence of a liturgy and of a clergy makes matters more difficult.) A

second traditional aid to the understanding of architectural meaning is the creation of decorative programs. Such programs actually existed, but the fact that they were not based on images makes them extremely difficult to approach, because the West-centered universal culture of today finds it difficult to understand anything without a system of representations. At this stage of research, all that can be done is to indicate some of the techniques that I believe will help to deal with the question of how to look for meaning in Islamic architecture.

I will use the two examples I mentioned at the beginning of this essay as apparently symbolic of something within Islamic culture: the minaret and the *muqarnas*.

Almost everyone agrees that the minaret derived from a specifically Islamic requirement, the *idhān* or call to prayer. There is little doubt that, from 1500 onward, and perhaps even as early as the middle of the fourteenth century, the call to prayer was the main official purpose of the minaret and most minarets were used for that purpose, as they are today. (Iran is the exception; some complexities were introduced there through the existence of a *guldastah*.) When minarets were provided with inscriptions, the most common one was Koran 62:9–10:

> O you who believe, when the call is made for prayer on Friday, then hasten to the remembrance of God and leave off trade; that is better for you, if you know. But when the prayer is ended, then disperse abroad in the land and seek of God's grace, and remember God much, that you may be successful.

There is a perfect coincidence between the purposes of this structure and the verbal sign of God's revelation inscribed on it.

When we turn to the beginning of Islam, matters are confused. Whereas the call to prayer is as early as Islam, the precise time, place, and manner of its association with the tower, a form known since time immemorial, are extremely unclear. (I have presented my own explanation of what happened elsewhere, but would be perfectly happy to be proved wrong.)[18]

The earliest consistent and authentic evidence we possess is of the eleventh to thirteenth centuries, a period from which nearly two hundred minarets have survived. A large number of them are provided with inscriptions, and at least twenty of these are Koranic passages. Only one, the Quṭb-minār in Delhi (fig. 6), uses Koran 62:9–10, and this passage is only one-thirtieth of the Koranic inscriptions on the minaret. All the other minarets, from Ḥākim's in Cairo to the minaret of Jam, in Afghanistan, are not merely inscribed with other Koranic passages but also with passages that differ from each other: at Jam the whole of the Sūrah 19 ("Maryam") appears, whereas the inscription on Aleppo's minaret is a passage (2:121–22 and 60:60) dealing with those who have erred from the straight path, and Delhi's minaret has not only the *Āyat al-Kursī* but the five *āyah*s that follow, which have little to do with prayer.[19] In Sangbast, the inscription is 41:33:

> Who is better in speech than one who calls (men) to God, works righteousness, and says I am of those who bow in Islam.[20]

If we add that an unusually large number of minarets are not even located near mosques (especially in Iran and the eastern part of the Muslim world),[21] we must conclude that the towers we call minarets fulfilled a broad range of functions within the architectural sign system of the time. My own explanation, very tentative at this stage, is that minarets at that time were still primarily expressions of power and wealth, of victory, and of Islamic presence in non-Muslim settings, or else were signals and signposts leading to major holy sites or to other significant mosques, rather than identifying them.

A fascinating example of the use of the minaret occurs in Jerusalem, where, until the Crusades, a physical balance had been established between a western Christian sector centered on the Holy Sepulchre and an eastern Muslim area around the Ḥaram al-Sharīf, with a small Jewish quarter probably to the North. No Muslim building, with one small and very temporary exception, was found in the western city and no Christian one remained in the east. After the defeat of the Crusader state in the thirteenth century and the development of a Jewish quarter to the south, two minarets were built in the Christian quarter equidistant from and framing the Holy Sepulchre.[22] Minuscule sanctuaries, which hardly fulfilled an important social role, are attached to them. But the minarets serve to emphasize the victory of Islam, just as the later towers of the Lutherans and of the Franciscans identified both the return of Western Christianity to Jerusalem and the competition there between Protestantism and Catholicism, whereas a Russian tower on the Mount of Olives showed the presence of Orthodoxy.

Several very different conclusions derive from these observations. One is that the single, collectively accepted source of Truth in Islamic culture, the Koran, is used in so many different fashions on minarets that we *must* assume that its message takes precedence over architectural forms; whatever use or explanation may have been given to these towers later on, they initially had a practical, specific, time-bound purpose, and it is only within the limits of the time that created them that their iconographic meaning can be securely established: *unless otherwise demonstrated, iconographic time is short.* The second point is that even though different local circumstances led to the creation of each of these minarets, when considered as a group they belong to two subsets. One is the subset of the tower, the strong, high unit, visible from afar and dominating its social setting; at this level, the minaret is today no longer "Islamic" (nor was it ever), since television towers, towers of silence, or even office buildings fulfill a universal human need for a vertical architectural focus. The other subset is stylistic, for instance, the treatment of brick on Iranian minarets can be related to the treatment of brick on Iranian mausolea of the time.

For us as historians of forms, the universal value of the tower, its more limited relationship to a period style, and whatever local need led to its creation are all essential categories, but they should not be confused in explaining monuments. One point, however, is clear: The tower form we call the minaret was not originally used in the whole Islamic world with the sole purpose of calling for prayer; this function emerged gradually. Now it has been superseded by the loudspeaker and tape recorder in its function, and by the office building in its form. It has lost its iconographic value both as a universal form and as a concrete expression of very varied functions, but it has retained the symbolic function of indicating the presence of Islam. As a sign in the past, its strongest meaning, its greatest change, lay not in its form but in the confluence between its form and decisions by several layers of the community that endowed the form with whatever needs the community had at any one time.

The implications of this point will emerge shortly. Before dealing with these, let me turn to the *muqarnas* (fig. 7), this ubiquitous combination of three-dimensional or curved shapes that can be used on anything from a flat wall, where it becomes a frieze, to a whole cupola.[23] The origins of the motif are not altogether clear, but it seems to have developed first in eastern Iran and then, perhaps independently and perhaps not, in Egypt and North Africa some time in the tenth century. Why did it develop? What does it or did it mean? For how can one possibly even begin to discuss the meaning of Islamic architecture when no explanation exists for its most uniquely original form?

External sources are, to my knowledge, of little help. A fourteenth-century manual by al-Kāshī[24] and a sketch discovered in the excavations of Takht-i Sulaymān[25] indicate that at least the plane geometry of the *muqarnas* had been worked out and was available in simple manuals. It is

also probably not an accident that the *muqarnas* appears at the time of al-Farabī and the first major school of mathematicians in the Muslim world. But the exact relationship between the *muqarnas* and scientific development is difficult to establish, because no source exists, at least to my knowledge, that would explain why a theory of numbers or advanced geometry should have found an application in the *muqarnas*. I am not aware of anything comparable to the celebrated Syriac hymn previously mentioned or a number of Greek texts that explain the symbolic and iconographic meaning of the domed church.[26]

If we turn to the *muqarnas* itself, some tentative answers may be suggested. First of all, there are instances when an inscription does provide a specific meaning to a *muqarnas*. The most remarkable instance is at the Alhambra, where Ibn Zamraq's poetry makes it legitimate to understand the cupola as a dome of heaven, in this instance even a rotating one. But this obviously does not mean that every *muqarnas* dome is a dome of heaven. In other words, the form itself may be considered as neutral, as simply a technical device of construction or decoration, unless a vector charges it with some meaning. The problem with this explanation is that it weakens, in fact even cheapens, the social effort necessary to make, for instance, a *muqarnas*-covered portal in stone; is it likely that the stupendous *muqarnas* of the Sulṭān Ḥasan Madrasah in Cairo was nothing but an ornament? Hence a second explanation may be provided that is broader than the first one and in fact does not exclude it. One peculiarity of the *muqarnas,* wherever it is found, is its ability to suggest almost infinite subdivision and, by modulating whatever surface or shape it occupies, to create the illusion that an architectural form—a wall, a ceiling, a doorway, a hall—is different from (usually larger than) what it is. This peculiarity can be understood as a game, which the *muqarnas* certainly was at times, but it can also be seen as an illustration of a profoundly Islamic notion of the immateriality of human creation, a notion often expressed through inscriptions like *al-mulk lillāh, lā ghālib illā Allāh,* or *al-bāqī huwa Allāh*. An architectural form serving to deny the materiality of forms would in the deepest sense be an affirmation of divine truth. And then, in monuments of secular architecture like the Alhambra, an inscription can charge the *muqarnas* in different fashion, but only superficially so, for whatever meaning is temporarily given to it, the fragility of human creation is always conveyed, for the other, endlessly repeated, Alhambra inscriptions refer to the eternal permanence of the divine alone.

It is tempting to understand the *muqarnas* as a visual metaphor for a certain traditional Muslim view of reality, as the abstract carrier of a message that also found verbal equivalents and often learned ones in the more elaborate Koranic and *hadīth* inscriptions on some monuments. Nevertheless, I must conclude that, whereas we know that some Islamic meaning is associated with the *muqarnas,* we do not yet know what it is; we may be compelled to follow the example of the minaret and argue that each *muqarnas* is an independent form, whose discrete meanings must be understood before pan-Islamic meanings are proposed.

These remarks and observations are in many ways inconclusive, for they clearly indicate the insufficiency of the information we possess and the absence of intelligent thinking about whatever information we *do* possess. But perhaps a few directions for work and thought can be suggested.

The first and most important one is that, regardless of how much pressure is put on us singly or collectively to generalize about Islamic architecture, we cannot do so without a clearer understanding of the meaning of any one monument in its time, in the fullness of its historical circumstances. This is essential if we are to deal usefully and meaningfully with the traditions of Islamic architecture. It is not simply a scholar's professional interest that is involved here but a contemporary's judgment that today's world can only be true to itself if it is aware of the immense complexity of its time past.

The second conclusion is that the forms of Islamic architecture, like those of any architecture, carry meanings that form systems of communication and of social relations. The carriers of these meanings, however, are, in architecture, less the forms themselves than signs added to these forms. The uniquely Muslim one is writing, Koranic inscriptions in particular, but also *ḥadīth,* poetry, and simple aphorisms or formulas, which served to define the precise aims of a monument, at least at the time of its creation. Other carriers are still incompletely understood—like geometry, for instance, the *muqarnas,* color, and perhaps certain formal orders. There is still some uncertainty as to whether these carriers were culturally distinctive or merely universal forms of honor or focus in architectural compositions. And we are only beginning to grapple with the infinitely more complex question of the time of art, that is, today, the duration of acceptance of synchronic meanings for any one monument. However we resolve these issues, the point remains that in order for the meanings of Islamic architecture to be understood, both a high level of literacy and an unusual power of abstract thinking were required.

Is it likely that these requirements were actually met in classical time? Here again, I cannot answer with a demonstration, for lack of preliminary studies, but I *can* argue that Islamic civilization with its many variants in time and space could not have existed and maintained itself if its message had not reached the kind of abstract sophistication that made it accessible to the Hinduist culture of Java, to the pagan Berbers, or to the Christians of Spain. What we do not know is *how* it worked, and this is what we have to find out.

If this were 1880, or preferably 1850, the way to answer these questions would be fairly easy, as Max van Berchem outlined in an extraordinarily perceptive paragraph in his modestly entitled "Notes d'archéologie arabe."[27] We would learn languages slowly and well, read what our predecessors had done, put it all down on cards and in our heads, travel without haste by boats and on horseback, take thousands of notes and a few intelligently chosen photographs, rework them in the evening, share them with each other in long letters full of references and comments, return to comfortable and properly endowed homes and institutions, and publish it all within six months of completing the writing.

But these are the 1980s and other ways must prevail. Beyond the obvious taxonomic task, I see three clear directions. One is the investigation of the historical vocabulary of architecture in all pertinent languages. Words like *dār, īwān, maqṣūrah,* or *buqʿah* have acquired such a range of meanings over the centuries that only a careful chronological investigation could bring out an approximation of their meaning at any one time; it is highly unlikely that they always had the confused sense they have now. The second direction is the more complicated one of identifying the mental processes and expectations of the environment of these structures as they developed in any one time or place. Of course, we shall never be able to reach the precision that texts and monuments allow for the nineteenth century in Europe, but we should be able to achieve the kind of precision found in Western medieval, Early Christian, or Byzantine art. Finally, we must be able to show that, by understanding and explaining Islamic architecture, we are doing more than explaining Islamic architecture, we are doing more than explaining a specific culture and its inheritance; we are also observing a unique way of creating an architecture that, because of its discrete and unique cultural setting, focuses on the relationship between men and buildings, not between buildings and buildings, not even between architects and buildings. This *is* a strikingly contemporary effort, and thus I return to my early remark about our role in the contemporary scene. We, as historians, *can* indeed bring something to the new world created in the Middle East and elsewhere, but only if we are allowed to do it with the secure knowledge of the past. This, as yet, we do not possess.

NOTES

1. E. Galdieri, *Isfahan: Masgid-i Gum'a*, II, Rome, 1973, and "Précisions sur le Gunbad-e Nizam al-Mulk," *Revue des Études Islamiques*, XVIII, 1975.

2. This is not to say that Creswell's volumes are free from deep-seated prejudices and preconceptions, but his system of identifying characteristic features and of seeking their prototypes bears all the external appearance of straightforward "scientific" rationality.

3. Two recent publications illustrated two ways of categorizing Islamic architecture. John Hoag's *Islamic Architecture*, New York, 1976, provides a historical survey with clearly indicated and, for the most part, acceptable temporal and regional subdivisions. The volume edited by George Michell, *The Architecture of the Islamic World*, London, 1978, catalogues monuments according to areas and provides broad thematic essays.

4. O. Grabar, "The Umayyad Dome of the Rock," *Ars Orientalis*, III, 1957. For different views, see Creswell, *EMA²*, 226 and ff., and W. Caskell, *Der Felsendom und die Wallfahrt nach Jerusalem*, Cologne, 1963. On the whole, I have not been swayed by most of these arguments, although the historical and cultural context of the last decades of the seventh century can now be explored in a sharper fashion than I had done.

5. Wayne Begley, "The Myth of the Taj Mahal and a New Theory of Its Symbolic Meaning," *The Art Bulletin*, LXI, 1979.

6. This approach permeates parts of N. Ardalan and L. Bakhtiar, *The Sense of Unity*, Chicago, 1972, as well as studies—less directly involved with the Muslim world—by scholars like M. Eliade.

7. Ardalan-Bakhtiar, 54. See also H. Corbin, *L'Homme de Lumière dans le soufisme iranien*, Paris, 1971, 164ff.

8. The history of the *miḥrāb* still needs to be written, as more energy has been spent investigating its origins than on the 1400 years of its development and use.

9. Karl Lehman, "The Dome of Heaven," *The Art Bulletin*, XXVII, 1945.

10. W. Macdonald, *The Pantheon: Design, Meaning and Progeny*, Cambridge, Mass., 1976.

11. C. Mango, *The Art of the Byzantine Empire, 312–1453: Sources and Documents*, Englewood Cliffs, 1972, 72–102, 57–60.

12. R. Krautheimer, "Introduction to an Iconography of Medieval Architecture," *Studies in Early Christian Medieval, and Renaisance Art*, New York, 1969.

13. L. Golombek, *The Timurid Shrine at Gazur Gah*, ROM Art and Archaeology Occasional Paper 15, Toronto, 1969.

14. O. Grabar, *The Alhambra*, London, 1978, especially chapter 3.

15. A definitive treatment of the sanctuary has not yet appeared. Pope, *SPA*, 1080; and D. N. Wilber, *The Architecture of Islamic Iran*, Princeton, 1955, 127–28.

16. *RCEA*, XIII, 1944, no. 5155.

17. Caroline Williams, "The Cult of Alid Saints in Cairo," *Muqarnas*, I, 1983, 37–52; and Jonathan M. Bloom, "The Mosque of al-Ḥākim in Cairo," *Muqarnas*, I, 1983, 15–36.

18. O. Grabar, *The Formation of Islamic Art*, New Haven, 1973, 118ff.

19. A. Maricq and G. Wiet, *Le Minaret de Djam*, Paris, 1959; all other inscriptions are taken from the *RCEA*.

20. D. Sourdel and J. Sourdel-Thomine, "A propos des minarets de Sangbast," *Iran*, XVII, 1979.

21. See a study of these minarets by Prof. R. Hillenbrand in his unpublished doctoral dissertation. In the meantime, see J. Sourdel-Thomine, "Deux Minarets," *Syria*, XXX, 1953.

22. A. Walls, "Two Minarets Flanking the Church of the Holy Sepulchre," *Levant*, VIII, 1976.

23. The most useful recent works in this also insufficiently studied form are D. Jones and G. Michell, "Squinches and Pendentives," *AARP*, I, 1972, and U. Harb, *Ilkhanidische Stalaktitengewölbe*, Berlin, 1978, with an excellent bibliography.

24. L. Bretanitsky and B. Rosenfeld, "Arhitekturnaia Glava," *Iskusstvo Azerbaidjana*, V, 1956, 125ff. See also M. S. Bulatov, *Geometricheskaia Garmonizatziia v Arhitekture Srednei Asii*, Moscow, 1978.

25. It is the subject of Harb's booklet, note 23 above.

26. Note 11 above.

27. Max van Berchem, "Notes d'Archéologie Arabe," *Opera Minora*, Geneva, 1978, I, 78–79.

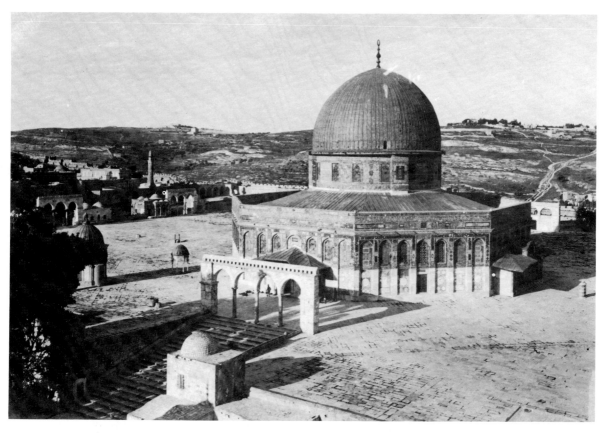

FIG. 1. Dome of the Rock, Jerusalem (photo: Fogg Museum, Harvard University)

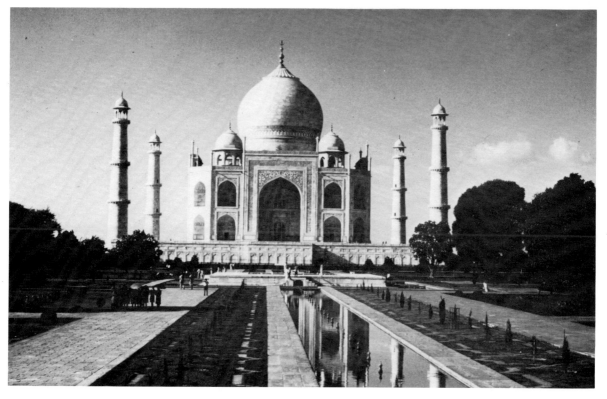

FIG. 2. Tāj Maḥāl, Agra (photo: Wayne Denny)

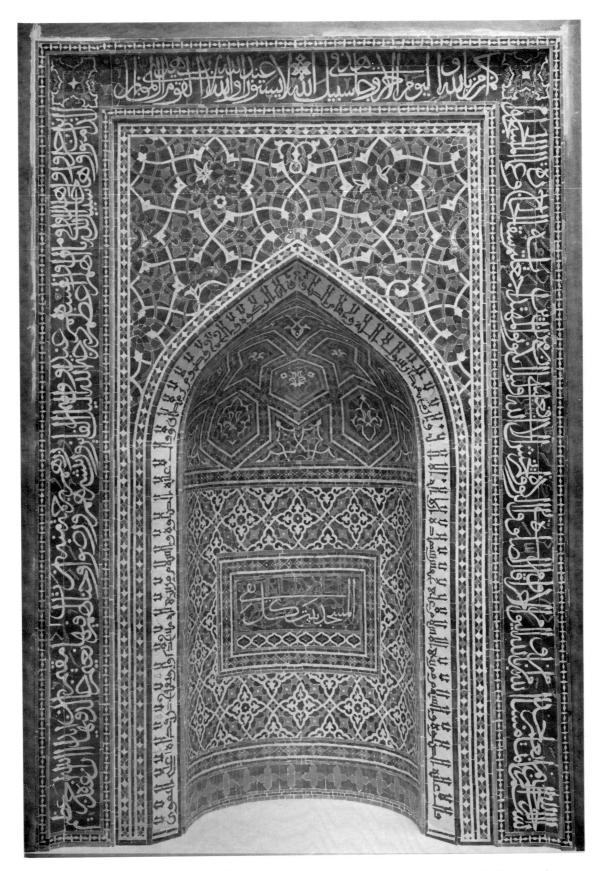

FIG. 3. Tile mosaic *miḥrāb*, Isfahan, dated 1354; outermost inscription is Koran 9:18–22, including *masājid Allāh*. New York, Metropolitan Museum of Art, Harris Brisbane Dick Fund, 1939. Courtesy The Metropolitan Museum of Art

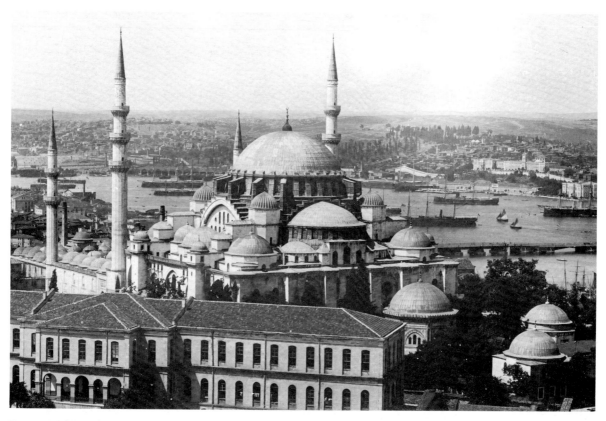

Fig. 4. Ottoman Imperial mosque: Süleymaniye, Istanbul (photo: R. M. Riefstahl Archives, Institute of Fine Arts, New York University)

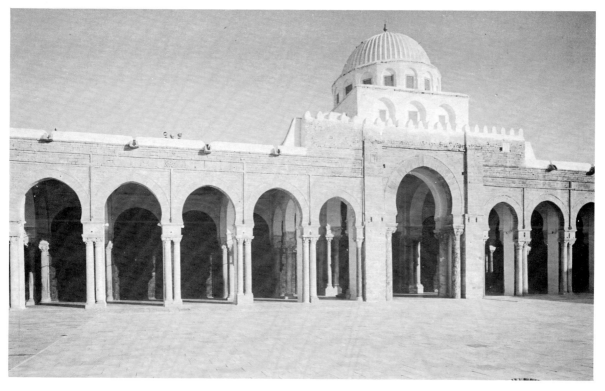

Fig. 5. Hypostyle Mosque: Great Mosque of Qairowan (photo: Oleg Grabar)

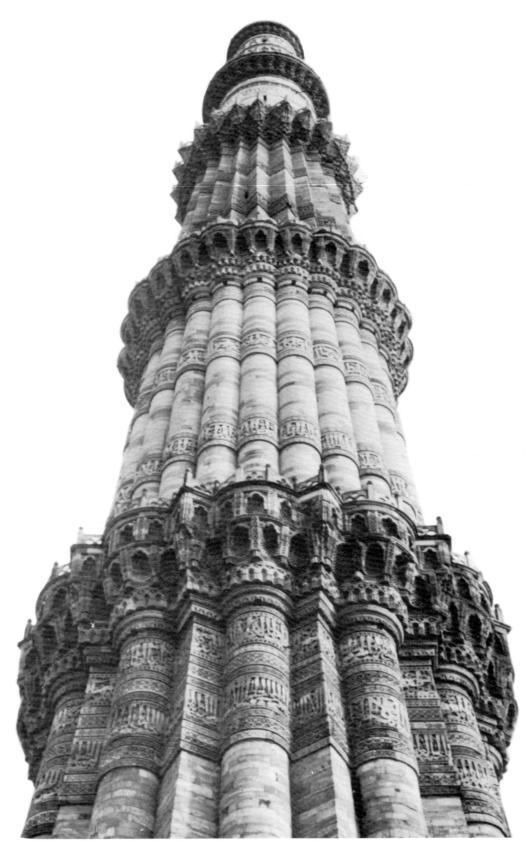

Fɪɢ. 6. Quṭb Minār, Delhi (photo: Wayne Denny)

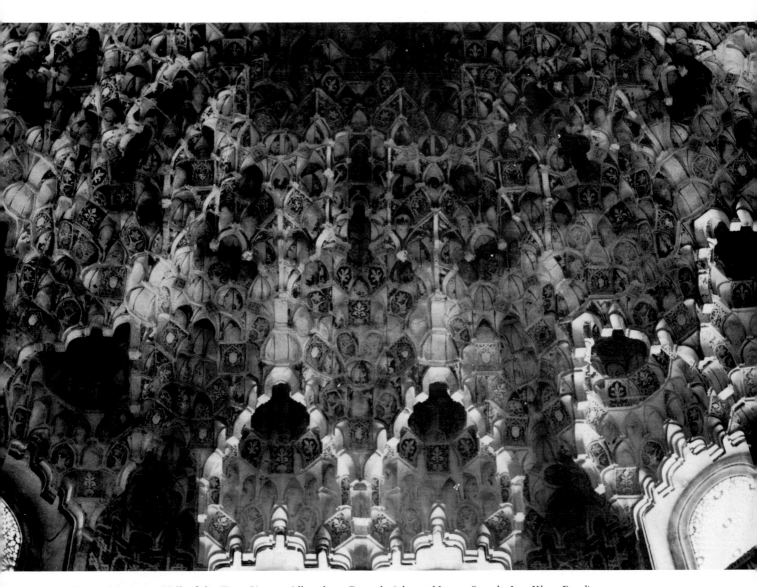

Fɪɢ. 7. *Muqarnas,* Hall of the Two Sisters, Alhambra, Granada (photo: Hazem Sayed, Aga Khan Fund)

Sa^cd: Content and Context

Marilyn Jenkins

SEVENTEEN years ago, I published an article on the Fatimid potter, Muslim, in which I dated this master ceramist's work to c. 1000. I compiled a pattern book of the iconography he preferred and the style he employed, based on a corpus of twenty whole or fragmentary pieces signed by Muslim.[1] A number of Islamicists subsequently encouraged me to date and define the work of another ceramist of the Fatimid period, a man named Sa^cd, whom Arthur Lane called "the most versatile and productive of the several (Fatimid) potters who signed their work."[2] This large body of material—forty-six complete or fragmentary objects bearing the word *sa^cd*—is the subject of this essay.[3]

In this case, however, the end result will not be a pattern book of a single potter's work. Instead, I will attempt to prove that *sa^cd* was not a potter, not a Fatimid artisan—not even a person—but simply a benediction meaning "good luck," "good fortune," or "good omen"; in other words, that an illustrious Fatimid potter named Sa^cd—considered one of the two best of the period—never existed, and thus that the precise attributions to Sa^cd, to his school, and to "the manner of Sa^cd" are no longer valid. Evidence will be presented for the dating of this material, and its provenance will be discussed.[4]

I

Forty-six whole or fragmentary objects bearing the word *sa^cd* form the basis of this study; the conclusions presented are based on this corpus in conjunction with seventy-two signed ceramic

objects belonging to the Fatimid period and forty-two datable to the Mamluk period (a comparison sample of one hundred and fourteen signed ceramic objects).[5]

It was the bowl illustrated in Figure 1a, b that first caused me to question the existence of the potter Sa'd, for the simple reason that the interior bears the word *sa'd* five times.[6] If it were the potter's name, this repetition would be unique in the annals of Islamic pottery of any period.[7] Furthermore, no medieval Egyptian potter among the 114 signed pieces surveyed signed his name prominently on the front of a ceramic vessel without the word *'amal*.[8] When a name does occur on the front of a vessel without *'amal*, it is placed very inconspicuously.[9] Also, even if a piece is signed twice, it is never signed on the same area of the vessel twice, that is, it is signed on the foot and the obverse but never twice on either of these areas.[10] On the other hand, a single benediction is often found on medieval Islamic pottery, either repeated by itself as the principal decoration[11] or with an adjective[12] or totally alone, as on a group of Nishapur pottery bearing the word *ahmad* as its central decoration. Ahmad is a very common Muslim name, being one of the names of the Prophet Muhammad, but in this case it means simply "most worthy of praise"—a fact recognized by Charles Wilkinson and subsequently confirmed by Lisa Golombek.[13]

On each of the forty-six pieces under consideration, the word is never found in a context; it is always simply, *sa'd*. It is never combined with any other word that would connote a person, e.g., it is never combined with *ibn*, *akhū*, *abū*, or a *nisbah* of any kind. Nor—perhaps most telling of all—is it ever in construct with *'amal*. In short, there is nothing about the word that would lead us to the conclusion that it is a name.[14] However, among the 114 pieces surveyed, which consist of the works of twenty-one potters, Muslim combines his name with that of his father—al-Dahhān—as well as with *'amal*; 'Alī al-Bayṭār combines his name with *'amal* and tells us that he was working *bi-Miṣr*; Mutraf tells us that he was Muslim's brother; Ja'far combines his name with *'amal* and follows it with al-Baṣrī; al-Ṭabīb combines his name with *'amal*, as does Aḥmad; al-Sharīf combines his name with *'amal*, and Abū al-'Ushshāq; another potter combines his name with *min ṣan'a* and calls himself Ibn Sājī; there is an Abū al-Faraj; and a man called Ibrāhīm combines his name with *'amal* and tells us he was working *bi-Miṣr*. When we pass into the Mamluk period, this practice continues: the man who calls himself al-Tawrīzī combines his name with *'amal*; Ghaybī calls himself al-Shāmī; his son identifies himself as such; the man who calls himself simply al-Shāmī combines his name with *'amal*, as does al-Faqīr, al-Mu'allim, and al-Hurmuzī; another calls himself al-Ustādh al-Miṣrī.[15] Thus, all of the twenty-one medieval potters surveyed have among their extant works some, and often many, pieces with words that by context bear evidence of their being names.

On each of the forty-six objects where the word *sa'd* appears, it is always executed in Kufic script in a manner that seems to be drawn, not written (fig. 2). This is neither what one would expect nor what one finds in the case of signatures. Also improbable in the case of signatures are the kinds of variations on each of the three letters. The twenty-one potters surveyed, on the other hand, except for one who combines his name with *'amal*,[16] use the expected cursive signatures, and each of these signatures has the consistent idiosyncrasies characteristic of signatures (figs. 3–5).[17]

On a fragment in the Islamic Museum, Cairo, the word *sa'd* is outlined in another color,[18] and in another single instance, this time on a fragment in the Museo de Bellas Artes, Málaga, the word is reserved in luster in the center of the interior of the bowl.[19] Both of the latter devices are much more characteristic of decorative elements than of signatures. None of the 114 signatures surveyed is outlined in another color, nor is any in reserve.

On two of the pieces bearing the word *sa'd* (one a fragment in the Islamic Museum, Cairo, and

the other a complete bowl in the Victoria and Albert Museum, London), the word (once in the case of the fragment and twice in the case of the priest bowl) is backward except for the letter *dāl* (fig. 6). This is certainly not consistent with a signature. Among the 114 pieces of signed pottery, there were no signatures written backward. There are, however, numerous examples of benedictions being written backward—especially in the western regions of the Islamic world.

The style employed in the decoration of those pieces bearing the word *sad* does not have the consistency it should have if *sad* were a signature, a consistency that is found repeatedly on those bowls bearing unequivocal signatures. A few examples have to suffice here. When Muslim ibn al-Dahhān drew an animal, he used conventions that he repeated whenever he drew a similar animal. The ears, beak, jowls, eyes, and collar are all treated in an almost identical manner on the eagle and the griffin in Figure 7. On the other hand, the treatment of the animals on two fragmentary bowls bearing the word *sad* is completely different, as can be seen, for example, in the shoulder joints, the bodies themselves, the juncture of head and body, and the treatment of the limbs (fig. 8). When al-Ṭabīb drew birds—and several other examples could be given as well—they all had the same body decoration, the same convention was used for the claws and upper leg, and they were often shown with a single spread wing such as can be seen in Figure 9. As to the style of the birds on objects bearing the word *sad,* two different types can be seen in Figures 21d and 22a. The birds differ in pose, style of drawing, and surface decorations. The human beings represented on these sherds also seem to have no stylistic features in common.[20]

One could argue that a great artist could and might have drawn animals, birds, and humans in several different ways. Even if this argument is accepted (although the evidence provided by the work of individual potters speaks against it), it is well known that artists have conventions for those minor motifs that they use often. Jafar inevitably made large leaves in the style seen in Figure 10. On those pieces bearing the word *sad,* calligraphy in cartouches is handled in three different ways, even when the same word, *al-yumn* (good fortune), is intended (fig. 11); the spandrels on bowls with radiating designs are handled in at least five different ways, and four different leaf types are employed (fig. 12). Pseudo-Kufic is written in at least two different ways, and at least two different Kufic styles are employed on the obverse (fig. 13). Also, the simplest of designs—circles with a single dot each in their centers—is handled in three different ways, two of which are illustrated in Figure 14. My final example of these stylistic differences is provided by those sherds bearing interlace designs. The design on the objects illustrated in Figure 15 is certainly not very similar; the design on a sherd in the Benaki Museum, Athens, as well as the one on a sherd in the Islamic Museum, Cairo,[21] is executed in a totally different technique (molded or carved)—*sad* being painted in luster on the reverse.

These forty-six objects encompass all the known ceramic types made during the Fatimid period, except for the provincial "Fayyūmī" colored-glaze painted wares and, of course, the lowly unglazed wares. Not only is the technique of luster painting used to decorate those pieces bearing the word *sad,* the technique is sometimes combined with a molded or carved design, as mentioned above, and at other times with an incised design. Again, unlikely though it seems, one could argue that a great artist would have been capable of executing ceramics in all these techniques, or that the objects could have been made in his atelier by a number of different potters versed in different techniques and merely signed by him. However, it is more difficult to explain the luster-painted *glass* fragment[22] bearing the word *sad.*

Further evidence in support of my thesis[23] lies in the fact that at least as early as the tenth century in Iran[24] and as late as the second half of the thirteenth century in Syria or Egypt (fig. 16), as well as in Fatimid Egypt itself (fig. 17), the word *sad* in conjunction with the definite article

was being used as one of several benedictions on ceramics and metalwork. The transition of *sa'd* from this usage to the isolated form in which it appears on the fragments examined is a logical one.

II

The ceramic objects bearing the word *sa'd* have, over the years, almost invariably been placed within the Fatimid period (969–1171), but they have been variously dated within those 200 years that the dynasty ruled Egypt and (a progressively smaller area of) Greater Syria.

As none of the forty-six objects bears either a date or a datable name, one must turn to stylistic criteria to place them in a time frame. The use of such criteria is often highly speculative. However, because some of the decorative motifs on these pieces are calligraphic, we can utilize the immense body of Fatimid textiles known as *turuz* (singular: *tirāz*) to date them. The calligraphic decoration of these *turuz* has a life of its own. The areas between the letters, as well as the letters themselves, exhibit a definite development during the Fatimid period; and, since many of these textiles are precisely dated or bear a caliph's name, the various stages in the development are datable. This, in turn, permits the dating of other Fatimid objects with calligraphic decoration.

It is on the *turuz* manufactured during the reign of al-Mustanṣir (1035–94) that we find precise parallels to the calligraphic decoration found on several of the pieces bearing the word *sa'd*. The decoration in the areas between the letters on the textile bearing the name of al-Mustanṣir illustrated in Figure 18 is identical to that on the complete bowl in the Freer (fig. 1a). On this textile we also find exact parallels for the use of extraneous curved lines, not attached to the letters at all, which are placed beneath the calligraphy wherever they are thought to be needed. Such lines are also found on the Freer bowl.

Fillers within the spaces between the letters were first used, in a very tentative fashion, on the *turuz* manufactured during the reign of al-Ḥākim (996–1021),[25] and this feature only gradually developed into the quite dense decoration seen here. The device of creating a rhythmic flow of curves beneath the inscription (a trend that would end in the total debasement of the inscription for decorative purposes) was first used on the *turuz* manufactured in the reign of al-Ẓāhir (1021–35), during which period these curves were attached to letters[26] and had not yet reached the stage seen on the *tirāz* in Figure 18 which bears his successor's name.

It is also on the *turuz* manufactured during the reign of al-Mustanṣir that we find exact parallels for the arbitrary manipulation of the spacing of verticals seen on two fragmentary pieces bearing the word *sa'd* (figs. 11b, 19, 21b). During this period, verticals were added for symmetry and eliminated for the same reason. This manipulation for decorative purposes had begun during the previous reign and during the reign of al-Mustanṣir reached a stage not far removed from the total debasement of the inscription.

The reduction of the rather dense vegetal interstitial decoration seen earlier to a single tendril curling back on itself and enclosing one large palmette leaf, such as can be seen on the same two ceramic fragments mentioned above and on another textile bearing al-Mustanṣir's name (fig. 20), is a further evolution of the interstitial designs found on *turuz* manufactured during this caliph's reign.

On the basis of this evidence, it would appear quite certain that the forty-six objects bearing the word *sa'd* should be dated to sometime during the sixty-year reign of al-Mustanṣir, that is,

between 1035 and 1094; there seems no reason to doubt that they were all made in the same general period.[27]

III

Over the years, the objects bearing the word *saʿd* have almost invariably been attributed to Egypt. However, as some of the pieces bearing this word appeared to me to have features that have come to be associated more with Syria than with Egypt,[28] and since one (until recently largely unnoticed) fragment has long been attributed to Spain,[29] there were enough questions about the traditional attribution to Egypt that scientific analysis (more specifically neutron activation analysis) seemed avisable.

Atıl, Philon, and Watson of the Freer Gallery, the Benaki, and the Victoria and Albert Museum, respectively, provided samples from the bodies of seventeen of the pieces bearing this word. These, plus the sample from the fragment at the Metropolitan Museum of Art, are equivalent to roughly forty percent of the total number of such pieces gathered for this paper.[30] For comparative purposes, fifty-one whole or fragmentary pieces in the Metropolitan Museum's collection and in the Madina Collection, New York, were sampled. All of these comparative pieces would universally be considered products either of Egypt or of Syria made between c. A.D. 1000 and 1250 (see Chart I).

The results of this sampling and analysis of sixty-nine whole or fragmentary ceramic objects can be seen in capsule form on the computer printout (Figure 25). Four major control points can be seen: (1) clay-bodied Egyptian ware; (2) composite-bodied Egyptian ware; (3) composite-bodied Syrian ware; and (4) composite-bodied, possibly Iranian, ware. These control points were obtained from the work of Frierman, Asaro, and Michel of the University of California.[31]

Although this provenance work is only in its preliminary stages, the results seen in Figure 25 provide additional evidence against *saʿd* being a potter. Thus, it serves to further strengthen my thesis that the man whose atelier has been said to have dominated the pottery production of the last one hundred years of the Fatimid period and whose innovative techniques are said to have influenced Syrian, North African, and Spanish ceramic production never existed.[32]

Figure 25 seems to indicate that, for those clay-bodied pieces bearing the word *saʿd,* there were two clay sources within Egypt. Furthermore, among the composite-bodied pieces, at least three sources—one of which is certainly in Egypt—appear to be indicated.

A single potter or workshop would tend to have a single clay source and when mixing a composite body would tend to use the same "recipe" over and over again once it was perfected. Thus, the apparent indication of multiple sources for both body materials is another argument against interpreting *saʿd* as a name. Moreover, the fact that both clay and composite bodies are employed and that both alkaline and lead glazes are used on each body type, when coupled with the information about the apparent multiple body sources, is further evidence in favor of my thesis.

Egypt appears to be the source of seven of the eighteen objects, but a question remains concerning the provenance of the other eleven objects until further analysis is done on the Jenkins-Carriveau samples. The questions have not yet been fully answered, but in seeking their answer, data have come to light that further serve to support my thesis that Saʿd, with a capital *S,* at least as far as the history of Fatimid ceramics is concerned, is a case of "the emperor's new clothes!"

Chart I Identification of Samples Tested by Jenkins and Carriveau

Each of the numbers 1–72 correspond to the same numbers on the Dendrogram in Figure 25. Numbers 6 and 56–72 are the eighteen pieces bearing the word *saᶜd*. Numbers 1–49, Metropolitan Museum of Art (MMA); 52–55, Madina Collection (MC); 56–63, Victoria and Albert Museum (V&A); 64–71, Benaki Museum; 72, Freer Gallery. Nos. 18, 50, and 51 have been omitted for technical reasons.

1. MMA 08.256.106	25. MMA 1975.40	49. MMA 1973.79.79
2. MMA 08.256.227	26. MMA 1978.546.9	52. MC 115
3. MMA 08.256.252	27. MMA X365	53. MC 445
4. MMA 08.256.357	28. MMA 07.238.58	54. MC 1060
5. MMA 10.44.8	29. MMA 08.256.107	55. MC 2265
6. MMA 13.190.225	30. MMA 08.256.296	56. V&A C826–1919
7. MMA 20.120.195	31. MMA 08.256.311	57. V&A C1608–1921
8. MMA 20.120.202	32. MMA 10.44.2	58. V&A C1612–1921
9. MMA 28.89.3	33. MMA 13.190.30	59. V&A C1614–1921
10. MMA 41.165.4	34. MMA 13.190.149	60. V&A C1691–1897
11. MMA 41.199.5	35. MMA 13.190.186	61. V&A C1746–1921
12. MMA 48.113.8	36. MMA 13.190.137	62. V&A C1792–1921
13. MMA 64.274.1	37. MMA 13.190.207	63. V&A C1827–1921
14. MMA 66.37	38. MMA 13.190.268	64. Benaki 245
15. MMA 1970.24	39. MMA 17.120.36	65. Benaki 349
16. MMA 1971.89	40. MMA 20.102	66. Benaki 350
17. MMA 1973.79.61	41. MMA 20.120.54	67. Benaki 350A
19. MMA 1975.31.6	42. MMA 20.120.191	68. Benaki 11382
20. MMA 1975.31.7	43. MMA 20.120.197	69. Benaki 11678
21. MMA 1975.31.8	44. MMA 20.120.201	70. Benaki 11381
22. MMA 1975.31.15	45. MMA 13.190.236	71. Benaki 22043
23. MMA 1975.31.17	46. MMA 28.89.1	72. Freer 36.2
24. MMA 1975.31.18	47. MMA 28.89.2	
	48. MMA 1973.79.75	

NOTES

1. M. Jenkins, "Muslim: An Early Fatimid Ceramist," *Bulletin of The Metropolitan Museum of Art,* May 1968, 359–69.

2. A. Lane, *Early Islamic Pottery,* London, 1957, 22.

3. *saᶜd* no. 1. New York, Metropolitan Museum of Art, 13.190.225 (fig. 22,b); *saᶜd* nos. 2–10. London, Victoria and Albert Museum, C1792–1921, C1614–1921, C1691–1897, C1746–1921, C826–1919, C1827–1921, C1612–1921, C1608–1921 (figs. 23 and 24), C49–1952 (Lane, *Pottery,* pl. 26A); *saᶜd* no. 11. Washington, D.C.,

Freer Gallery of Art, 36.2 (Freer Gallery of Art, *Ceramics from the World of Islam,* catalogue by E. Atıl, Washington, D.C., 1973, no. 60, and Freer Gallery of Art, *Art of the Arab World,* cat. by Atıl, Washington, D.C., 1975, no. 15); *saᶜd* nos. 12–20A. Athens, Benaki Museum, 222, 350, 350A, 22043, 11678, 11382, 349, 11381, 245 (H. Philon, *Early Islamic Ceramics, Ninth to Late Twelfth Centuries,* Kent, 1980, figs. 515, 533, 502, 552, 516, 507—no. 22043, no. 349, and no. 11381 omitted from Benaki catalogue [hereafter, Philon]), glass fragment (C. J. Lamm, *Oriental Glass of Medieval Date Found in*

Sweden and the Early History of Lustre-Painting, Stockholm, 1941, pl. XVIII/1 [hereafter, Lamm]); *saʿd* nos. 21–32 and 34–38. Cairo, Museum of Islamic Art, unnumbered except for no. 23, which is 5944 (A. Baghat and F. Massoul, *La céramique musulmane de l'Égypte,* Cairo, 1930, pl. VIII/1–9, IX/1–2, XII/4, G/47, 48, 50 (hereafter, Baghat and Massoul) and Musée de l'art Arabe du Caire, *La céramique Égyptienne de l'Époque musulmane,* Bale, 1922, pl. 23 (third row right and left) and *saʿd* nos. 40–43. 12438/3, 14952, 7019/4, 13674 (figs. 21, b–d, and 22, c); *saʿd* no. 33. Musée de Sèvres, unnumbered (Baghat and Massoul, pl. F/45); *saʿd* no. 39. Leningrad, Hermitage, ЕГ–426 (fig. 21, a). I am grateful to Dr. George Scanlon for providing me with the photographs of this fragment; *saʿd* no. 44. Formerly collection Edward Terrace (fig. 22, a). I am grateful to Ms. Louise Mackie for providing me with the photographs of this fragment; *saʿd* no. 45. Málaga, Museo de Bellas Artes, unnumbered (M. Gómez-Moreno, "La loza dorada primitiva de Málaga," *al-Andalus,* v, 1940, pl. 2a, no. 5 bottom, and M. Jenkins, "Medieval Maghribi Luster-Painted Pottery," in *La céramique médiévale en Méditerranée occidentale,* Coloques Internationaux C.N.R.S. no. 584, 1980, 283–92, fig. 23 bottom). The numbers on the multiple illustrations in the present article refer to the numbers assigned to individual pieces bearing the word *saʿd* listed above.

4. I would like to express my indebtedness to my collaborator on the provenance section, Dr. Gary Carriveau of the Metropolitan Museum's research laboratory, as well as to those private collectors and the directors and curators of public collections in the United States and abroad who made their material available to me. In this regard, I would like especially to single out Dr. Esin Atıl, Ms. Helen Philon, Dr. Oliver Watson, and Professor Maan Z. Madina for allowing samples to be taken from objects in their care.

5. ʿA. Yūsuf, "The Potters of the Fatimid Period and their Artistic Style," *Bulletin of the Faculty of Arts, Cairo University,* xx, pt. 2, Cairo, 1958, 173–279 (in Arabic), pls. 2–5, 7, 8 (Bayṭār); pls. 9, 10 (Mutraf); pls. 12, 14–18 (Jaʿfar); pls. 19–22, 26, 27 (al-Ṭabīb); pls. 30–35 (Aḥmad); pls. 36, 37, 39–41 (al-Sharīf); pls. 42, 44–48 (Ibn Sājī); pls. 84, 85 (Abū al-Faraj); pl. 87 (Muḥammad), (hereafter, Yūsuf, "Potters"); ʿA. Yūsuf, "Ghaban's Plate and Ancient Fatimid Pottery," *Kullīyat al-Ādāb,* XVIII, pt. 1, 1956 (in Arabic), pls. 30–32 (Ibrāhīm); pl. 33 (Haytham); Jenkins, "Muslim," Appendix, 366–69 (Muslim); Victoria and Albert Museum, C1718–1921, C1646–1921, C1598–1921, 1363–1897 (all unpublished) (Muslim); Metropolitan Museum of Art, 1973.79.61, 1971.89 (both unpublished) (Muslim); "Ceramics," Philon, figs. 402, 407, 408 (Muslim); Yūsuf, "Potters," pls. 12, 14 (Muslim); Hetjens Museum, *Islamische Keramik,* Düsseldorf, 1973, no. 106 (Muslim); Metropolitan Museum of Art, 1973.79.1,2 (al-Tawrīzī); 1973.79.3–14, 18–20 (Ghaybī); 1973.79.22–25, 27 (al-Shāmī); 1973.79.28–34 (Ghazāl); 1973.79.35 (al-Faqīr); 1973.79.36,37 (al-Ustādh al-Miṣrī); 1973.79.38,39 (al-Muʿallim); 1973.79.40–47 (al-Hurmuzī); 1973.79.20 (Ibn Ghaybī). See D. Fouquet, *Contribution à l'étude de la*

céramique orientale, Cairo, 1900, pl. VI/6, 18; VII/23, 35, 59; VIII/67, 77.

6. Both times this bowl has been published (see note 3, *saʿd* no. 11), the two words on its reverse have been read *saʿd* and were seen as the name of the potter. I read both words *khāṣṣ,* meaning, according to E. W. Lane, *An Arabic-English Lexicon,* London, 1863, I–II, 747, "particular; peculiar; special; distinct, or distinguished, from others; contr. of *ʿāmm* and hence, choice; select." The use of this word is well attested during the Fatimid period on *ṭuruz,* where it is used adjectively with *ṭirāz* to designate a textile as one woven in the royal workshop. In the fourteenth century, the same word is found drilled into the glaze or body of forty-nine Chinese porcelain vessels, in a context in which it also must be translated "royal." (E. S. Smart, "Fourteenth Century Chinese Porcelain from a Tughlaq Palace in Delhi," *Transactions of the Oriental Ceramic Society,* XLI, 1975–77, 203, pl. 73 a,b. I am indebted to Mr. Robert Skelton for this reference.) A number of fragmentary ceramic vessels illustrated in Yūsuf, "Potters" (pl. 76, 78, 80, 82, 83), appear also to bear the word *khāṣṣ* on the reverse. In addition to the Freer bowl, two other complete bowls, in Durham (England), Gulbenkian Museum, (Pen. 12 and Pen. 13), bear the word *khāṣṣ* on the reverse. The first of them also bears the word *saʿd* as the principal decoration on the obverse. I am grateful to Miss Venetia Porter, Oxford, for bringing these two bowls, which Miss Porter is publishing with Oliver Watson, to my attention. Dr. Atıl, in her second publication of the Freer bowl (see note 3, *saʿd* no. 11), stated that the style of that bowl was different enough from the others bearing the signature of Saʿd to suggest that there was more than one Saʿd. She also suggested that only the word on the reverse was a signature and that on the obverse was a good wish.

7. Corning Museum of Glass, *Glass from the Ancient World, The Ray Winfield Smith Collection,* Corning, N.Y., 1957, no. 500. A number of whole or fragmentary shallow glass bowls are discussed that are said to bear what "seems to be a proper name, approximately Hisham," repeated. The correct reading of this word is *hanī'an* (May it do you much good), which seems much more appropriate than a proper name. I would like to thank Professor Maan Z. Madina, Columbia University, for the correct reading of this word and Professor George Saliba of the same university for confirmation of the fact that there are medieval manuscripts in which the *hamzah* is placed at the end of the word (as on the glass examples) rather than where it properly belongs.

8. Jenkins, "Muslim," 366, Appendix no. 1.

9. Ibid., 360, fig. 2.

10. Ibid., 360, fig. 2. Philon, 82, 83, states that in her second Fatimid group (roughly placed in the second half of the Fatimid period) signatures are rarer and when they do occur are to be found on the outer wall of the bowl either alone or with *min ṣanʿah* (among the work of). She further states that *saʿd* is invariably found in decorative Kufic letters on the reverse. Thus, she assumes throughout her chapter 4 that *saʿd* is the name of a potter. How-

ever, as there is at least one example of the word *khāṣṣ* being found on the reverse of a bowl totally by itself (fig. 1b and n. 6), her theory that a word on the reverse just below the rim is a signature does not stand up to close scrutiny. In other words, placement alone cannot be used as proof of a word being a name on Fatimid pottery. As a matter of fact, of the 114 signed Egyptian ceramic objects surveyed for this study, only one has a signature on the outside wall without *ʿamal*, and this exception is problematic (see Yūsuf, "Potters," pl. 2). Otherwise, when a signature is found on the outside wall, it is accompanied by *ʿamal, min ṣanʿah,* or the area immediately preceding the signature is missing and, with one exception noted in n. 16, the inscription is cursive. Thus, the odds are overwhelmingly against a solitary word in Kufic on the outside of a bowl being a signature.

11. L. de Beylié, *La Kalaa des Beni-Hammad, une capitale berbère de l'Afrique du Nord au XIᵉ siècle,* Paris, 1909, pl. XXI, upper right.

12. Hayward Gallery, *The Arts of Islam,* London, 1976, no. 277.

13. C. K. Wilkinson, *Nishapur: Pottery of the Early Islamic Period,* New York, 1973, no. 24, a,b, 99 and 118 (hereafter, Wilkinson). Confirmed by Dr. Golombek in a private communication.

14. Lamm, 49, mentions a fragment in the Islamic Department of the Berlin Museums (now East Berlin) on which *saʿd* is combined with Ḥasan. I have not yet been able to secure a photograph of this sherd, but such a fragment could serve to support further the basic thesis of this essay.

15. See note 5 for complete reference to this material.

16. al-Ṭabīb. See note 5 for references to this potter's work.

17. These consistent idiosyncracies enabled me to read correctly the signature inside the footring on a bowl in the Keir Collection as al-Bayṭār, not Abū Saʿd, as was previously assumed (E. Grube, *Islamic Pottery, The Keir Collection,* London, 1976, no. 89).

18. See note 3, *saʿd* no. 25. I would like to thank Dr. George Scanlon for his confirmation of the technique involved.

19. See note 3, *saʿd* no. 45.

20. Compare the human being in Figure 9 with that in Lane, *Pottery,* pl. 26A.

21. See note 3, *saʿd* no. 17 and 35.

22. See note 3, *saʿd* no. 20A.

23. According to Professor S. D. Goitein in a letter to me dated 14 February 1980: "Among the many thousands of male persons in Egypt whose names I card-indexed there is not a single Saʿd. The names Abū Saʿd, Saʿdān, Saʿāda, etc., are extremely common. . . . The name Saʿd was common in earliest Islam but soon lost ground against other names derived from that root." As regards the use of Abū Saʿd, this does not presuppose the existence of a Saʿd, since a childless person could have a *kunyah* or a *kunyah* could express a characteristic other than paternity.

24. Wilkinson, no. 1, 146.

25. E. Kühnel and L. Bellinger, *Catalogue of Dated Tiraz Fabrics,* Washington, D.C., 1952, pl. XXIX, no. 73.573, and pl. XXXI, no. 73.72.

26. Metropolitan Museum of Art, 31.106.62 (unpublished).

27. A further substantiation, however, exists in the ceramic products of Málaga, Spain. The sixty-one luster-painted objects attributed to this Andalusian center (datable after 1063 and into the twelfth century) are very strongly influenced by pottery vessels bearing the word *saʿd.* (See my Ph.D. dissertation, "Medieval Maghribi Ceramics: A Reappraisal of the Pottery Production of the Western Regions of the Muslim World," Institute of Fine Arts, New York University, 1978.) These are influenced not only in major but also in minor motifs as well as in matters of design execution, such as the incising of spirals through the luster paint and often the execution of the decoration in reserve on a luster ground. Perhaps some of the potters who made the objects bearing the word *saʿd* were those spoken of in a text by a Cordovan doctor, Abū al-Walīd ben Janaḥ, who speaks of Eastern potters in Andalusia in the eleventh century who were able to teach some techniques to the local craftsmen or to make objects in their style with local materials. (Jenkins, "Medieval Maghribi Ceramics," 140–88, and pls. XLVI–LXXXIII.)

28. E.g., transparent glaze, greenish tint to glaze.

29. See note 3, *saʿd* no. 45.

30. See note 3, *saʿd* nos. 1–9, 11, 13–20.

31. J. D. Frierman, F. Asaro, and H. V. Michel, "The Provenance of Early Islamic Luster Wares," *Ars Orientalis,* XI, 1979, 111–26. These control points are designated in Figure 25 by those numbers preceded by "FA" that correspond to the data in Tables 2 and 3, pages 122 and 125, numbered consecutively FA01–FA10.

32. Philon, 88.

TECHNICAL NOTE *Gary W. Carriveau*

The results shown in Figure 25 were produced using elemental concentration determinations from 179 ceramic samples. These samples were from 55 objects in the collection of the Metropolitan Museum of Art, New York (1–55), eight each from the Victoria and Albert Museum, London (56–63), and Benaki Museum, Athens (64–71), and one

from the Freer Gallery of Art, Washington, D.C. (72). Additional results were taken from the papers of Frierman, Michel, and Asaro[1,2] (shown as FA series of 69 samples and MR series of 38 samples). Elements studied were Na, Cs, Ba, Sc, Ce, Eu, Hf, Lu, Th, CR, Fe, Co, K, Rb, La, Ta, Mn, U, and Ca. Experimental details are found in reference 3.

The samples were chosen to represent a variety of wares, including both clay and composition fabric from Egypt, Syria, and Iran and glazes characterized as either tin-opacified or alkaline-silicate. Eighteen objects containing the word *sa'd* were sampled.

Figure 25 is a representation of how the results cluster, called a dendrogram.[3] This tree structure illustrates how the points and clusters are tied together at junctions, whose distance, measured from left to right, is the value of *dissimilarity*. In this way, groups and subgroups can be identified through their varying nearness, from left to right.

It is clear from Figure 25 that objects with the word *sa'd* are distributed throughout the field, showing that the materials bearing the word come from differing geographical areas, including clay and composite fabrics and both glaze types.

References

1. Jay D. Frierman, Frank Asaro, and Helen V. Michel, "The Provenance of Early Islamic Lustre Wares," *Ars Orientalis,* XII, 1980, 111–26.

2. H. V. Michel, J. D. Frierman, and F. Asaro, "Chemi-cal Composition Patterns of Ceramic Wares from Fustat, Egypt," *Archaeometry,* XVIII, 1976, 85–92.

3. German Harbottle, "Activation Analysis in Archae-ology," *Radiochemistry,* III, 1986, 33–72.

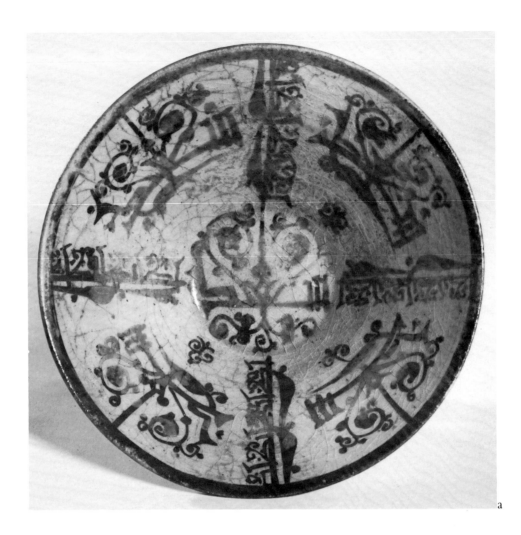

FIG. 1. (a) Luster-painted bowl, principal interior decoration consisting of *saʿd* repeated five times. Washington, D.C., Freer Gallery of Art, no. 36.2. Courtesy Freer Gallery of Art, Smithsonian Institution. (b) Luster-painted bowl (two views), outside with decoration consisting of *khāṣṣ* repeated twice. Washington, D.C., Freer Gallery of Art, no. 36.2. Courtesy Freer Gallery of Art, Smithsonian Institution

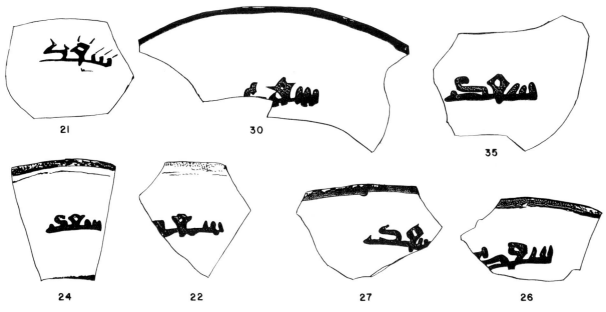

FIG. 2. The word *sa'd* as it appears on seven fragmentary objects: nos. 21, 22, 24, 26, 27, 30, 35 (drawing: Thomas Amorosi, after A. Baghat and F. Massoul, *La céramique musulmane de l'Égypte,* Cairo, 1930, pl. VIII, pl. IX, G/48)

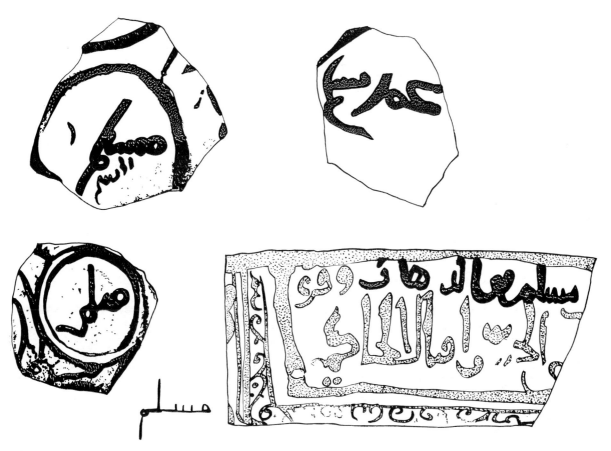

FIG. 3. Signature of Muslim (drawing: Thomas Amorosi, after M. Jenkins, "Muslim: An Early Muslim Ceramist," *Bulletin of The Metropolitan Museum of Art,* May 1968, fig. 1; Appendix nos. 5, 16, 18)

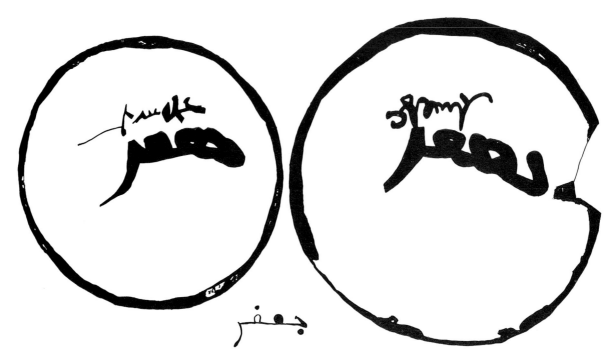

جعفر

FIG. 4. Signature of Jaʿfar (drawing: Thomas Amorosi, after A. Yūsuf, "The Potters of the Fatimid Period and Their Artistic Style," *Bulletin of the Faculty of Arts, Cairo University,* XX, part 2, 1958, pls. 12b, 14a)

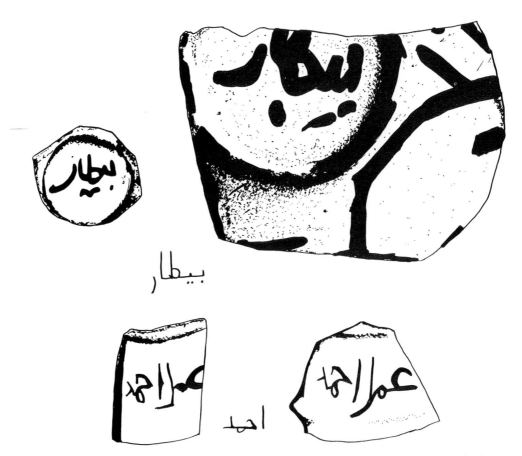

بيطار

احمد

FIG. 5. Signatures of Bayṭār and Aḥmad (drawing: Thomas Amorosi, after A. Yūsuf, pls. 5a, 7a; pl. A, 33, 34)

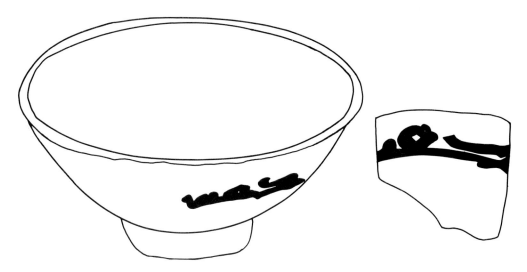

FIG. 6. The word *saʿd* (written backward, except for the letter *dāl*) on two fragmentary objects: no. 10 (drawing: Thomas Amorosi, after A. Lane, *Early Islamic Pottery*, London [Faber], 1957, pl. 26A) and no. 32 (drawing: Thomas Amorosi, after Baghat and Massoul, pl. XII)

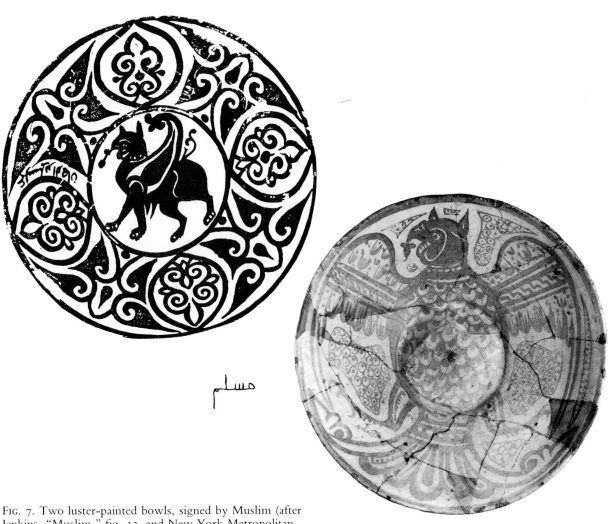

FIG. 7. Two luster-painted bowls, signed by Muslim (after Jenkins, "Muslim," fig. 13, and New York Metropolitan Museum of Art, Gift of Mr. and Mrs. Charles K. Wilkinson, 1963, 63.178.1, Courtesy The Metropolitan Museum of Art)

Fig. 8. Animals as they appear on two fragmentary objects bearing the word *saʿd:* nos. 30 and 31 (drawing: Thomas Amorosi, after Baghat and Massoul, pl. IX)

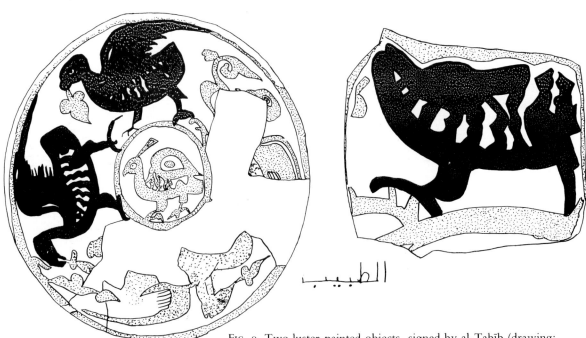

Fig. 9. Two luster-painted objects, signed by al-Ṭabīb (drawing: Thomas Amorosi, after Yūsuf, "Potters," pls. 21a, 26a)

جَعْفَر

FIG. 10. Two luster-painted objects, signed by Jaᶜfar (drawing: Thomas Amorosi, after Yūsuf, "Potters," pls. 12a, 16)

FIG. 11. Calligraphy in cartouches as it appears on three fragmentary objects bearing the word *saᶜd:* (a) no. 24 (drawing: Thomas Amorosi, after Baghat and Massoul, pl. VIII); (b) no. 14 (drawing: Thomas Amorosi, after H. Philon, *Early Islamic Ceramics, Ninth to Late Twelfth Centuries,* Kent [Islamic Art Publications], 1980, fig. 502); (c) no. 30 (drawing: Thomas Amorosi, after Baghat and Massoul, pl. IX)

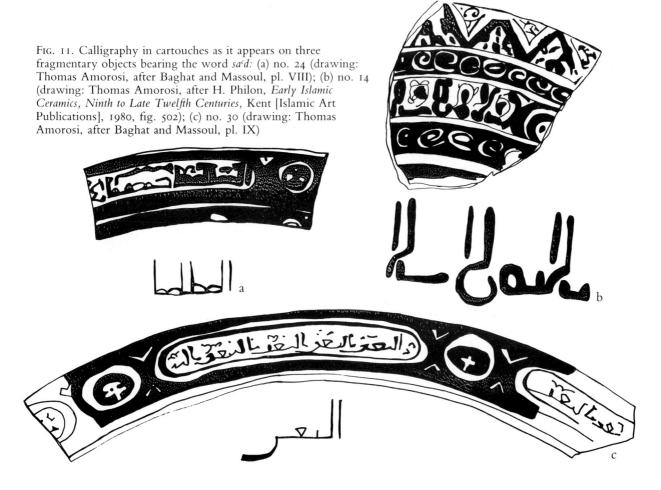

FIG. 12. Spandrel designs on fragmentary objects bearing the word sa'd: nos. 26, 27, 32, 33 (drawing: Thomas Amorosi, after Baghat and Massoul, pl. VIII; XII; pl. F/45); no. 1, New York, Metropolitan Museum of Art, 13.190.225. Courtesy The Metropolitan Museum of Art

FIG. 13. Kufic and pseudo-Kufic inscriptions on fragmentary objects bearing the word sa'd: no. 11 (drawing: Thomas Amorosi, after E. Atıl, *Art of the Arab World,* Washington, D.C. [Smithsonian Institution], no. 15); nos. 27 and 33 (after Baghat and Massoul, pl. VIII; pl. F/45); no. 39 (Leningrad, Courtesy State Hermitage, after George Scanlon)

FIG. 14. Design of circles with single dot in their centers on two fragmentary objects bearing the word sa'd: nos. 21 and 34 (drawing: Thomas Amorosi, after Baghat and Massoul, pl. VIII; pl. G/47)

FIG. 15. Interlace designs on two fragmentary objects bearing the word *saʿd:* nos. 22 and 24 (drawing: Thomas Amorosi, after Baghat and Massoul, pl. VIII)

FIG. 16. Silver-inlaid brass bowl (detail), Syria or Egypt, second half of thirteenth century, inscribed *al-saʿd fī ʿizz wa-iqbāl.* New York, The Madina Collection of Islamic Art

FIG. 17. Bronze finial, Egypt, eleventh–twelfth century, inscribed . . . *al-iqbāl al-zāʾid al-saʿd . . . ,* New York, Metropolitan Museum of Art, 1978.546.5, Gift of Nelly, Violet, and Eli Abemayor in memory of Michael Abemayor, 1978. Courtesy The Metropolitan Museum of Art

FIG. 18. *Ṭirāz* (detail),
inscribed . . . *maʿadd Abī
Tamīm* . . . , New York,
Metropolitan Museum of Art,
31.106.36, Gift of George D.
Pratt, 1931. Courtesy The
Metropolitan Museum of Art

FIG. 19. *Ṭirāz* (detail),
inscribed . . . *al-imām al-
Mustanṣir Billāh amīr* . . . ,
New York, Metropolitan
Museum of Art, 31.106.28B,
Gift of George D. Pratt,
1931. Courtesy The
Metropolitan Museum of Art

FIG. 20. *Ṭirāz* (detail),
inscribed . . . *tamīm al-imām
al-Mustanṣir Billāh amīr al-
mū'minīn* . . . , New York,
Metropolitan Museum of Art,
55.69.5, Rogers Fund, 1955.
Courtesy The Metropolitan
Museum of Art

Fig. 21. *Sample fragments (exterior and interior) bearing the word *saᶜd:* (a) no. 39 (Leningrad, Courtesy State Hermitage, after George Scanlon); (b) no. 42, (c) no. 40, (d) no. 41 (Cairo, Museum of Islamic Art)

FIG. 22. ★Sample fragments (exterior and interior) bearing the incomplete word *saʿd:* (a) no. 44 (Ex-Collection Edward Terrace; after Louise Mackie); (b) no. 1 (New York, Metropolitan Museum of Art, 13.190.225. Courtesy The Metropolitan Museum of Art); (c) no. 43 (Cairo, Museum of Islamic Art)

FIG. 23. *Sample fragments (exterior and interior) bearing the word *saᶜd:* (a) no. 2, (b) no. 3, (c) no. 4, (d) no. 5. London, By Courtesy of the Victoria and Albert Museum, Crown Copyright

Fig. 24. *Sample fragments (exterior and interior) bearing the word *sa‘d:* (a) no. 6, (b) no. 7, (c) no. 8, (d) no. 9 (exterior only). London, By Courtesy of the Victoria and Albert Museum, Crown Copyright

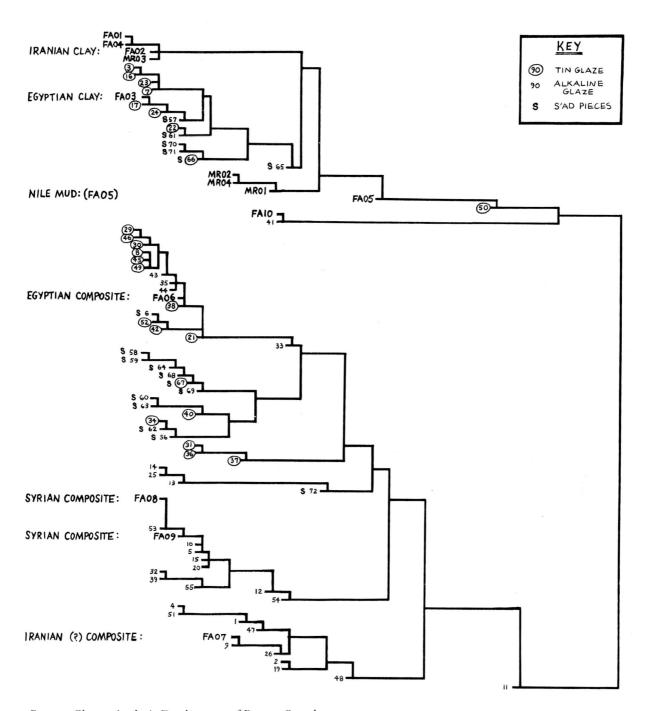

FIG. 25. Cluster Analysis Dendrogram of Pottery Samples

*For further reference to these objects, see note 3.

Two Illustrated Manuscripts in the Malek Library, Tehran

B. W. Robinson

THE Malek Library is situated off one of the outer alleys of the Tehran bazaar. It was originally a private collection of books, pictures, painted lacquer, and other works of art, but it is now semipublic, and its reading room is frequented by a few dedicated students. Its two exhibition rooms contain much valuable material for those interested in the arts of the Qajar period, but it is the enormous collection of manuscripts that forms its largest and most important section. Access to it is not readily obtained; on my last visit to Tehran (shortly before the current troubles broke out)—after two unsuccessful attempts—I succeeded. In the course of a general examination of the Library's contents, I was shown the two manuscripts forming the subject of the present article,[1] and they struck me as particularly interesting.

I

The first of these two manuscripts (MS No. 5932) is a small anthology measuring 13.5 by 9 cm and unfortunately in a very worn and damaged condition.[2] The outer faces of the binding, which is of brown leather with sunken medallions and pendants, may well be original. The text, on a written surface of 8.75 by 6 cm, is in an early *nasta'liq*, in two columns of seventeen lines, with a marginal column of twelve lines written diagonally. The colophon at the end of the first part gives the scribe's name as Maḥmūd, called Quṭb, but no date. The last folio, which might have supplied this and perhaps further information, is unfortunately missing.[3] The text consists of:

1. Poems on astronomical and astrological themes
2. The Black and Green Pavilion episodes and stories from the *Haft Paykar* of Niẓāmī
3. Part of the *Iskandar-nāmah* of Niẓāmī
4. The *Ghazaliyāt* of Jalāl al-Dīn Rūmī

There are three illuminated headings, the first only lightly tinted but the other two fully colored, and all are of the highest quality. Besides these, there are areas of decoration throughout the manuscript, filling in the space remaining on the page after the conclusion of a section of the text; these consist of geometrical and arabesque designs in gold, like those found in the British Library Miscellany (Add. 27261) and elsewhere.

 Three miniatures occupy the central text area in the usual way; all are badly damaged and rubbed. Their subjects are:

1. The man entertained by the fairies, from the story told by the Princess in the Black Pavilion (cf. British Library Add. 27261, fol. 159b) (fig. 1).[4]
2. Bashr, and the body of his friend in the well, from the story told by the Princess in the Green Pavilion (fig. 2).
3. Iskandar enthroned, surrounded by courtiers and attended by a man with an astrolabe (fig. 3).

In addition, throughout the Niẓāmī portions of the anthology, the triangular corner pieces at the top and bottom of the marginal column are occupied by tiny miniatures relating to the text—usually a single figure, or a figure with a dragon or other animal—and these sometimes spill out into the margin. They are generally colored in the usual way but sometimes take the form of tinted drawings, drawings in blue and gold, or drawings in plain blue. On one or two pages, where the text is written in couplets arranged diagonally, the resulting triangles in the main written surface are filled with similar little paintings and drawings; there must be something like two or three hundred of them throughout the manuscript.

 It will be clear from the above that this small volume has a close family relationship with certain other manuscripts known, or accepted, as having been produced for Iskandar Sulṭān b. Umar Shaykh at Shiraz, Isfahan, or Yazd, between about 1405 and 1415, and especially with the fragmentary *Iskandar-nāmah* in the British Museum (No. 1958–7–12–025). It is very similar to this last in dimensions—and the style of the miniatures, the combination of small marginal illustrations with miniatures of normal type in the text, and the script all tally—thus bringing the Malek anthology into the small but select group of manuscripts that can be associated with Iskandar Sulṭān, the early Timurid bibliophile and political stormy petrel.

 It may be well at this point to be reminded of this group, which consists of the following manuscripts (in chronological order):

1. 800/1397:
 Two companion volumes of epics in the British Library (Or. 2780) and the Chester Beatty Library (MS 114), respectively. They contain no dedication or *ex libris,* but the style of the illuminations places them firmly at Shiraz, and the style of the miniatures, derived from the Jalayrid school of Baghdad, is that found in later volumes dedicated to Iskandar Sulṭān, though on a slightly larger scale. The young prince (who acted as regent for his father at Shiraz for several years from 1393) was thirteen years old in 1397, and it seems not unlikely that this anthology of epics was made for him.[5]

2. 807/1405(?):

Iskandar-nāmah (fragmentary). British Museum 1958–7–12–025.[6]

3. 810/1407:

Anthology, copied "at Yazd." Topkapı Library H. 796. The style of the best miniatures in this volume corresponds exactly with that associated with the court of Iskandar Sulṭān (governor of Yazd at the time, appointed by Shāh Rukh in 1405).[7]

4. 812/1410:

Anthology. Gulbenkian Museum, Lisbon. Dedication to Iskandar Sulṭān.[8]

5. c. 1410:

Anthology. Rampur State Library, India, MS 742. Miniatures in Iskandar Sulṭān's court style, and the scribe was Naṣr al-Kātib al-Shīrāzī, one of the two copyists of British Library Add. 27261.[9]

6. c. 1410:

Two *masnavī* poems. Formerly in the Library of the Marquess of Bute. Miniatures in Iskandar Sulṭān's court style.[10]

7. c. 1410:

ᶜ*Ajā'ib al-Makhlūqāt* of Qazwīnī. Only three detached miniatures are known to survive from this pocket copy; two are at present in an English private collection (figs. 4 and 5 and the third in the Musée d'Art et d'Histoire, Geneva [ex Pozzi Collection]).[11]

8. c. 1410:

Astronomical anthology. Istanbul University Library F. 1418. One miniature and a number of tinted astronomical drawings in the court style of Iskandar Sulṭān.[12]

9. 813–814/1410–1411:

Literary miscellany. British Library Add. 27261. Dedication to Iskandar Sulṭān (fig. 6).[13]

10. 816/1414:

Encyclopedic work, of which some twenty-eight large folios are preserved in Topkapı Library Album B. 411 (fols. 138–66). Copied "at Isfahan" and dedicated to Iskandar Sulṭān. One large page of miniatures, several drawings, and a map of the world. Unpublished.★

All of these, from first to last, show a remarkable stylistic consistency in their miniatures—more so, for example, than do the manuscripts executed for Bāysunghur Mīrzā—and this may indicate the presence of an extremely able and, indeed, dominating figure among Iskandar's painters. Speculation about his identity is premature, but in an admirable study of the Fogg Museum miniature of Rustam and Tahmīnah, the late Eric Schroeder made a good case for Pīr Aḥmad Bāghshimālī as the leading artist at Iskandar's court.[14] Dūst Muḥammad, a reliable source, and almost our only one for this period, mentions this painter *after* Junayd of Baghdad (who illustrated the famous British Library Khwājū Kirmānī manuscript, Add. 18113, of 1396) and *before* the painters who worked for Bāysunghur in the 1420s and 1430s. Since his account is broadly chronological, it would be natural to place Pīr Aḥmad between them at the court of Iskandar Sulṭān. After describing Pīr Aḥmad as a pupil of Shams al-Dīn, Dūst Muḥammad merely says, "He was the zenith of his time. No one could rival him. He reached the age of fifty." Whoever this leading painter may have been, there can be no doubt that after the fall of Iskandar Sulṭān in 1415 he took service with Shāh Rukh, and some splendid paintings of his appear in the Topkapı Ḥāfiz-i-Abrū manuscript (B. 282, with a dedicatory inscription to Shāh Rukh on fol.

★Since this essay was written, a further manuscript dedicated to Iskandar Sultan has surfaced at the Library of the Wellcome Foundation, London. It is a horoscope of the prince with one splendid miniature closely resembling Kühnel, *Miniaturmalerei im Islamischen Orient* (Berlin, 1923), pl. 41.

10a, and a chronogram on fol. 296a that seems to give the date 818/1415).[15] He was not only a highly accomplished painter but the originator, in the British Library Miscellany, of several compositions that remained standard in manuscripts of Firdawsī and Niẓāmī throughout the Timurid period.

From this group of manuscripts I feel justified in inferring that Iskandar Sulṭān had a strong predilection for anthologies and pocket volumes. Of the twelve volumes considered here (including the Malek manuscript), eight come into the former category and six into the second. The very worn condition of the pocket volumes (or what remains of them) may be due to their having been constantly carried about and used by the prince in the course of his travels and campaigns. His natural fondness for the *Iskandar-nāmah,* in which the exploits of his great namesake are celebrated, may be assumed from its comparatively frequent appearance among the texts.

I conclude, then, by dating the Malek anthology to about 1405–10, and accepting it as an additional fruit of Iskandar Sulṭān's discriminating patronage.

II

The other manuscript (MS no. 5986), also unpublished, is a copy of the *Shāh-nāmah* measuring 32 by 20 cm. It is enclosed in a fine contemporary binding of dark leather; the outer faces, lightly tooled with arabesque medallions, contain designs of animals; the surfaces are somewhat worn and flattened, but the fine details of the work can be seen on the flap. The doublures are decorated with bold leather cutout work of medallions, pendants, and corner pieces. The whole bears a marked resemblance to the binding of Bodleian Library (Oxford) MS Pers. c. 4, another copy of the national epic, dating from 1448.[16] The text is *nastaʿlīq,* in four columns of twenty-five lines. There is no colophon. The illuminations, in a broad style and of good quality, consist of two rosettes on folios 1b and 2a, the first containing a dedication to a certain Sulṭān Salīm (so far unidentified) and the second with two seated figures, and fine headings in the same style for the preface and the beginning of the poem.

The miniatures, of which there are twenty-six in all (not counting the two figures in the rosette just mentioned), are in two very different styles. The first six, mostly damaged and repaired, appear on the lower portions of consecutive pages of the preface. They all represent gatherings of people (the court of Sulṭān Maḥmūd?), some wearing crowns, in outdoor settings. Their style is characterized by rather small figures and weak drawing (especially in the faces) and composition. They bear a certain resemblance to second-rate Bukhara work. The twenty miniatures illustrating the poem itself, however, are very different, with their large strongly drawn figures, confined as a rule to those essential to the incident depicted, as in early Timurid Shiraz painting. Rustam nowhere wears his leopard's-head helmet, but his tiger-skin cuirass, with plain black stripes, appears. The subjects portrayed are as follows:

1. Muḥammad and his companions in the Ship of Faith, as described in Firdawsī's prologue (fig. 7). This is a very rare subject for illustration, but it occurs in the Topkapı copy H. 1509 and the Leningrad Oriental Institute copy C. 822 (of which more below), as well as in the Houghton *Shāh-nāmah.*
2. The old warrior Qubād slain by the Turanian Barmān.
3. Rustam captures his horse, Rakhsh.
4. Rustam lifts the petrified King of Mazandaran (represented as a large mass of rock).

5. Rustam slays Zhandah Razm.
6. Suhrāb slain by Rustam.
7. Siyāwush playing polo.
8. Siyāwush captive before Afrāsiyāb.
9. Murder of Siyāwush.
10. Rustam dragging the Khāqān from his elephant.
11. Siyāmak led captive by Gurāzah (Battle of the Twelve Rukhs).
12. Shīdah slain by Kay Khusraw.
13. Isfandiyār shot by Rustam. He is pierced in only *one* eye with an ordinary *single-pointed* arrow.
14. Death of Rustam. The traitor Shaghad is shown *inside* a hollow tree (fig. 8).
15. Execution of Farāmurz by Bahman. He is suspended head downward from a gibbet and shot with arrows.
16. Encounter of Iskandar with Isrāfīl, the Angel of the Last Trump (fig. 9). The trumpet is unusual, with its bell curved sharply toward the mouthpiece. The same type of trumpet, but with twin bells, is shown in the corresponding miniature of Topkapı H. 1509.
17. Bahrām Gūr's master-shot. He is shown on foot, on a green hillside, while Azadah is seated on a carpet with refreshments near her; her face is badly damaged.
18. Bahrām Gūr hunting lions (fig. 10).
19. Bahrām Gūr and the jeweler's daughter.
20. Bahrām Gūr and the dragon.

The style of these miniatures, the unorthodox choice of subjects (such perennial favorites as Rustam and the White Demon and the Rescue of Bīzhan are not represented), and the unusual treatment of incidents such as the death of Isfandiyār and Bahrām Gūr's master-shot, combine to place this manuscript outside the mainstream of Persian painting. It seems to be a late member of a group that includes Topkapı H. 1509;[17] Leningrad Oriental Institute C. 822;[18] a copy of Jāmī's *Yūsuf u Zulaykhā,* formerly in the Kevorkian Collection (the date of the poem's completion, 1483, provides a *terminus post quem* here);[19] and a number of detached miniatures, some from a *Shāh-nāmah* characterized by very tall helmets,[20] and others assigned by Fraad and Ettinghausen to Sultanate India.[21] None of these is dated. The miniatures in Topkapı H. 1509 (figs. 11 and 12), by far the finest in the group, formed the subject of an interesting article by Güner Inal,[22] who noted in particular the large figures, a preference for outdoor scenes, and a certain rigidity. She dated the manuscript to c. 1460–90 after invoking parallels in costume details from the Garrett *Ẓafar-nāmah*; this manuscript is dated 872/1467, but the Bihzadian miniatures must be nearly a generation later. She obviously found the Topkapı volume puzzling and does not assign it to any particular place of origin. In spite of their occasional oddities, the miniatures in the Malek *Shāh-nāmah,* and indeed in the rest of the group, seem to be too basically Persian in character to be relegated to India. They have none of the spindly drawing, *horror vacui,* and general *gaucherie* that characterize much Indian painting of the fifteenth century. They certainly cannot be Turkish, nor can they be affiliated with Herat, Shiraz, or the Turkman school. However, there seems to be one outlying region to which they may be ascribed.

We are told that after the death of Shāh Rukh in 1447, his eldest son, Ulugh Beg, transported a number of artists and craftsmen from the Herat *kitāb-khānah* and settled them in his capital of Samarqand beyond the Oxus. But we have only three firmly documented manuscripts from his reign. The first, Topkapı Library H. 786, is a fine copy of the *Khamsah* of Niẓāmī dated 850/1447, the year of his accession, and inscribed as having been "copied in the reign of Ulugh Beg." But it

is a highly individual work, with the miniatures and illuminations ascribed in a final medallion to a certain Sulṭān ʿAlī al-Bāvardī, probably a recent arrival from Herat, to which his style clearly belongs,[23] and does not fit in with the other two. These are a detached double-page frontispiece and a fine copy of al-Ṣūfī's *Treatise of Fixed Stars*. The frontispiece (half in the Freer Gallery and half in the Keir Collection) shows Ulugh Beg himself sitting under an awning inscribed with his name and titles and surrounded by courtiers and ladies.[24] It has been pointed out that Ulugh Beg b. Shāh Rukh, the royal astronomer, was not the only Timurid prince of that name; there was another, a son of Abū Saʿīd, but he was a comparatively obscure person who ruled at Ghazna and Kabul between 1461 and the beginning of the sixteenth century. Such a date seems too late for the Freer frontispiece, and the tall and fantastic headdresses of the attendant ladies in it are a Mongol fashion more likely to be found in Central Asia than Afghanistan. Also, the manuscript to which the frontispiece originally belonged was evidently of a standard worthy of the cultured son of Shāh Rukh, but probably beyond the means of his lesser namesake. The copy of al-Ṣūfī's *Treatise of Fixed Stars* in the Bibliothèque Nationale, Paris (Arabe 5036), contains a dedication to Ulugh Beg, and after his death it passed through a number of distinguished collections, including the Ottoman Imperial Library, until it was finally acquired and transmitted to the Bibliothèque Nationale by Bouriant, director of the French Archaeological Mission in the first half of the nineteenth century.[25]

In both the Freer and Bibliothèque Nationale manuscripts, strong Herat influence is obvious, but the figures tend to be larger, and the faces to have a stronger Mongol cast, than those found in Herat work. One other miniature that might be placed beside them at Samarqand during the reign of Ulugh Beg is the extraordinary painting of "Cavalry in a Landscape" in the Keir Collection.[26] The fantastic landscape, with its bare trees and towering rocks, occupies most of the miniature, and the cavalry only appear at the bottom, which seems to have been trimmed. But the faces and figures of the riders recall the Ulugh Beg frontispiece, and there are certainly signs of Herat inspiration in the landscape (comparable bare trees appear in the Royal Asiatic Society's *Shāh-nāmah*, for example), though—also certainly—the miniature is not itself Herat work. It may even have come from a *Shāh-nāmah* to which the frontispiece originally belonged.

The Topkapı (H. 1509) and Leningrad (C. 822) *Shāh-nāmah*s seem to have a certain amount in common with the Ulugh Beg frontispiece and the Paris *Treatise of Fixed Stars* on the one hand, and, on the other, with the Malek Library *Shāh-nāmah* considered here. With the former they share the tall and rather stiff figures with a Mongol cast of features and a general appearance of Herat inspiration, and with the latter, in addition to these stylistic features, they share an unusual choice of subjects for illustration and some curious variations of treatment of more familiar themes. Thus both illustrate some rare subjects, such as the Prophet in the Ship of Faith, and Iskandar and Israfīl (the trumpets being of similar pattern in the two manuscripts, but unlike other representations); both show Isfandiyār shot in only *one* eye, and Rustam's treacherous half-brother *inside* a hollow tree. The drawing of both, like that in the Malek *Shāh-nāmah*, is firm and assured and could well derive, like the large figures, from the Herat-inspired style of Ulugh Beg's frontispiece; and the Mongol appearance of the faces certainly suggests Transoxiana.

It may be, then, that in this interesting manuscript we have the latest in a handful of examples of the late Timurid style of Transoxiana, on the eve of its rejuvenation under the Shaybanids by the importation of latter-day Herat painters trained in the school of Bihzād. The six inferior miniatures in the Malek preface might, indeed, be unskilled and untutored efforts to imitate the Herat style of the time, executed shortly before the Herat painters themselves arrived in Bukhara to teach it correctly. The manuscript may then be tentatively placed in Transoxiana and dated toward the end of the fifteenth century. If this date seems too late for the binding, consider that

the style could well have been learned about the middle of the century by a young craftsman of conservative habit, who saw no harm in practicing it more or less unchanged at an outlying center some forty years later.

NOTES

1. I had set aside ample time for a second visit, in order to take detailed notes and slides, but unavoidable circumstances cut this time down to about forty minutes, and some shortcomings may have resulted in what follows here.

2. I do not claim to have discovered this one; that distinction belongs to Dr. Eleanor Sims, who showed me slides of it some years ago.

3. Dr. Sims thought that there was a date elsewhere in the volume, but I did not see it.

4. B. W. Robinson, *Persian Miniatures,* Oxford, 1957, pl. IV.

5. B. W. Robinson, *Persian Miniature Painting from Collections in the British Isles,* London (Victoria and Albert Museum), 1967, nos. 9, 10.

6. B. W. Robinson, "The Earliest Illustrated Copy of Niẓāmī?" *Oriental Art,* Autumn 1957, 96–103; Robinson, *Persian Miniature Painting,* no. 11.

7. I. Stchoukine, "La peinture à Yazd au début du XVᵉ siècle," *Syria,* XLIII, 1966, 99–104.

8. Hayward Gallery, *The Arts of Islam,* London, 1976, no. 551. R. Hillenbrand, *Imperial Images in Persian Painting,* Edinburgh (Scottish Arts Council), 1977, no. 45ff. (and references there quoted). See also F. R. Martin, *Miniatures from the Period of Timur,* Vienna, 1926, pls. XIV–XVI.

9. I am grateful to my friend and colleague Robert Skelton for drawing my attention to this manuscript. Its inclusion in the group is based on an examination of slides taken at Rampur by Mr. Skelton while the Maharajah held his flash.

10. B. W. Robinson, "Two Persian Manuscripts in the Library of the Marquess of Bute, Part I," *Oriental Art,* Winter 1971, 1–4.

11. Robinson, *Persian Miniature Painting,* no. 12.

12. I am grateful to Miss Norah Titley of the British Library for drawing my attention to this manuscript and for lending me her slides of it. It is not mentioned in F. Edhem and I. Stchoukine, *Les MSS . . . de la Bibliothèque de l'Université de Stamboul,* Paris, 1933.

13. Robinson, *Persian Miniature Painting,* no. 13.

14. E. Schroeder, *Persian Miniatures in the Fogg Museum of Art,* Cambridge, Mass., 1942, 51–74.

15. F. E. Karatay, *Topkapı Sarayı Müzesi Kütüphanesi Farsça Yazmalar Kataloğu,* Istanbul, 1961, no. 138 (hereafter, Karatay). F. Öğütmen, *Miniature Art from the XIIth to the XVIIIth century,* Istanbul, 1966, nos. 7, 14. See also M. Ağa-Oğlu, "Preliminary Notes on Some Persian Illustrated MSS. in the Topkapu Sarayi Müzesi—Part I," *Ars Islamica,* I, 1934, 192, figs. 8, 9.

16. B. W. Robinson, *A Descriptive Catalogue of the Persian Paintings in the Bodleian Library,* Oxford, 1958, 74; L. Binyon, J. V. S. Wilkinson, and B. Gray, *Persian Miniature Painting,* London, 1933, no. 65.

17. Karatay, no. 340. Güner Inal, "Topkapı Müzesindeki Hazine 1509 numaralı Şehnamenin Minyatürleri" (with English translation), *Sanat Tarihi Araştırmaları,* Istanbul, 1970, 197–316.

18. L. Gyuzalian and M. Diakonov, *Iranskiye Minyaturi,* Moscow and Leningrad, 1935, 48–52, pls. 15–17.

19. Sotheby's (London), 1 December 1969 sale, lot 180.

20. Miniatures from this manuscript are reproduced in A. K. Coomaraswamy, *Les Miniatures orientales de la Collection Goloubew au Museum of Fine Arts de Boston,* Paris and Brussels, 1929, no. 19, pl. IX, and *Persian and Islamic Art,* London, 1977, no. 9. There are several more in the Museum of Fine Arts, Boston, and others have come up at auction from time to time. See also nos. 21 and 24.

21. I. Fraad and R. Ettinghausen, "Sultanate Painting in Persian Style," *Chhavi,* Benares, 1969, fig. 164. Figs. 145–47 in the same article illustrate miniatures from the *Shāh-nāmah,* to which note 20 refers.

22. See note 17 above.

23. I. Stchoukine, "Sulṭān ᶜAlī Bâvardî: un peintre iranien inconnu du XVᵉ siècle," *Syria,* XLIV, 1967, 403–8. Stchoukine thought that two different painters were involved.

24. Washington, D.C., Freer Gallery of Art, no. 46.26; B. W. Robinson et al., *Islamic Painting and the Arts of the Book,* London, 1976, no. III.76, color pl. 10. No. III.78 (pl. 23) is another miniature from the *Shāh-nāmah* to which note 20 refers.

25. E. Blochet, *Les enluminures des manuscrits orientaux . . . de la Bibliothèque Nationale,* Paris, 1926, 85–87, pls. XXXVIII–XL.

26. Robinson, *Islamic Painting,* no. III.77, color pl. 11.

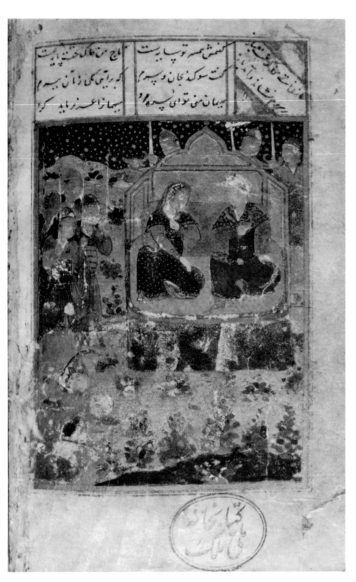

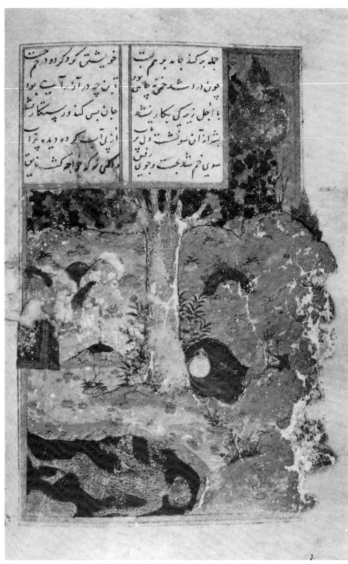

Fig. 1. Entertainment by the Fairies. Malek Library, MS 5932, no. 1.

Fig. 2. Bashr and His Friend in the Well. Malek Library, MS 5932, no. 2.

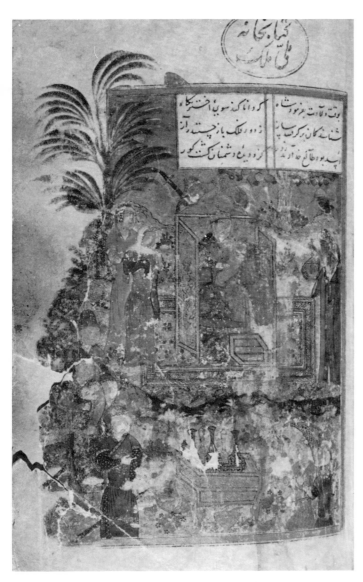

FIG. 3. Iskandar Enthroned. Malek Library, MS 5932, no. 3.

FIG. 4. The Mountain of Birds, from a Qazwīnī MS. Private Collection.

FIG. 5. The Magic Spring, from a Qazwīnī MS. Private Collection.

FIG. 6. Entertainment by the Fairies. British Library Add. 27261, fol. 159b.

Fig. 7. The Ship of Faith. Malek Library, MS 5986, no. 1.

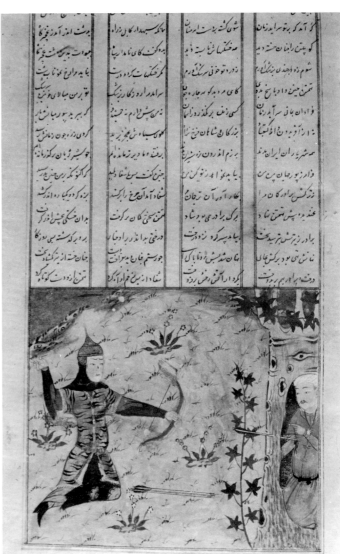

Fig. 8. The Death of Rustam. Malek Library, MS 5986, no. 14.

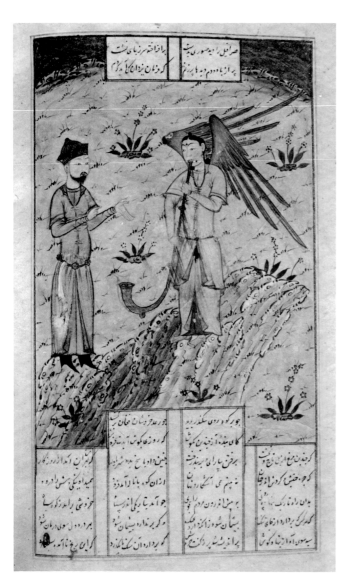

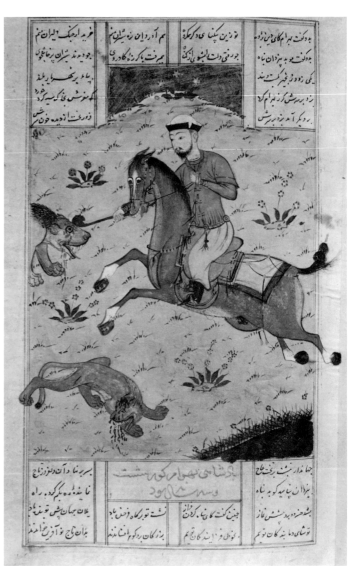

FIG. 9. Iskandar and Isrāfīl. Malek Library, MS 5986, no. 16.

FIG. 10. Bahrām Gūr Hunting Lions. Malek Library, MS 5986, no. 18.

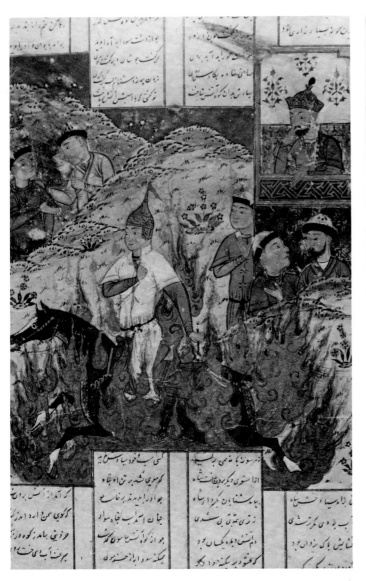

Fig. 11. The Fire-ordeal of Siyāwush. Topkapı Library,
H. 1509, fol. 77a.

Fig. 12. Bahrām Chubīnah in Female Attire. Topkapı
Library, H. 1509, fol. 368b.

Calligraphy and Common Script: Epitaphs from Aswan and Akhlat

J. M. Rogers

RICHARD ETTINGHAUSEN'S distinguished contributions to Islamic epigraphy far outran the reading of inscriptions.[1] In particular, he cogently argued, the errors and misconstructions that abound in monumental inscriptions must subordinate their visual form to their factual content—as even an illegible or misspelled signature may validate a document.[2] Not that Muslim craftsmen were necessarily negligent, for the fear of textual corruption (*tahrīf*), even in banal texts, was deeply rooted. Nor did literacy guarantee correctness. With lapidary inscriptions the carver was often too close to his text (compare writing on a blackboard) to detect errors of execution; the difficulty of correcting errors elegantly, or even unobtrusively, encouraged him to leave what he had done and hope that the mistakes would not immediately be detected. The survival of error must, therefore, reflect the absence of supervision of the craftsman or the powerlessness of the client. Manuscript texts, on the other hand, are easily, even if obtrusively, corrected, and there are remarkably few cases where, out of respect for the written word, errors remain uncorrected.

A more intractable, though less discussed, problem is the divergent relationship between lapidary and manuscript hands. To give an obvious example, rounded scripts appear as early, perhaps, as the Umayyad period, on papyri or on *ostraka,* and they evolve into fine book hands by A.D. 1000, as in the Koran of Abū al-Ḥasan Ibn al-Bawwāb in the Chester Beatty Library;[3] but their earliest known monumental use is at Qazwin in the early twelfth century, in the Great

Mosque.[4] The divergence is in part due to the extreme conservatism of lapidary hands. But even if one makes due allowance for conservatism, it is difficult to parallel lapidary inscriptions with earlier book hands.[5] This lack of relationship has not been considered, probably for want of a body of comparable stone inscriptions (few exist and fewer are published). In the past few years, however, enough inscriptions of Aswan and Akhlat have been published to make the topic worth investigating.

THE ASWAN INSCRIPTIONS

Though a history of Aswan remains to be written, the first volume of the collected tombstones of Aswan[6] and those inscriptions already published in the ten volumes of *Stèles funéraires* (as part of the *Catalogue du Musée Arabe*)[7] together form a remarkably homogeneous group that, though early, provincial, and of modest social status, is characteristically Islamic and forms an appropriate prelude to the more finished products of Akhlat. Typically the tombstones of Aswan are undecorated rectangular sandstone *tabulae* with plain raised margins, and they bear monoline scripts executed with a hollow chisel more or less adequate to carve the stone (though employed to deplorable effect on contemporary marble stelae in the southern cemetery of Cairo). The scripts are very conservative: neither chisel nor technique improved markedly between 172/789 and 255/869.[8] The chisel did much to minimize individuality of style, and letter forms showing indebtedness to book hands are the exception. There are no calligraphic sources for many of the hands, and for many of the Aswan inscriptions the term *calligraphy* is inappropriate.

Nevertheless, the Aswan masons show a certain basic competence. On some *tabulae* the masons have deliberately refrained from trespassing onto the left-hand margin, so that they must have given passing thought to the lineation of the inscriptions to be carved. However, this is offset by obtrusively scratched guide lines, quite often crooked, that were left unworked to serve as base lines for the inscriptions, which then appear top-heavy. Another characteristic feature is the splitting of words that contain letters without medial forms (*dāl, rā', alif,* etc.) at these letters when the lineation demanded it. This was a convenience in the case of names or numerals—for example, ar:ba'ah (more usually arba' at Aswan)—but, in the case of Koranic *āyah*s, the practice was to be condemned because of the obvious danger of textual corruption (*taḥrīf*). Such practices suggest lax supervision over format and little correction of errors in execution, and indicate that barely literate clients gave the masons virtually a free hand. The occupation of the clients, when these are recorded—*al-ṣayyād* (fisherman), *al-'assāl* (beekeeper), *al-najjār* (carpenter)—corroborate this theory.

Elongation of the letter forms, even the use of conventions like a double bow over the *ḍāḍ* of *riḍwānihi* to emphasize a word without disrupting the *ductus,* is so rare as to suggest some regard for the disapproval of elongated lettering of any sort, which is enunciated in standard manuals of penmanship from the tenth century onward.[9] However, the Aswan inscriptions also show some peculiarly lapidary features, including the elongation of certain letters to fill up lines or to end certain sections of inscriptions (for example, the *taslīyah*) so that the epitaph proper begins or ends a line.[10] Such is particularly the case with a group of stelae on which the introductory formula is cut with a different chisel, to produce "form" inscriptions with marked wedge-shaped terminals; these precede epitaphs, which are executed by other hands and are carved in the usual, undistinguished monoline script. This strongly suggests that some stelae were prepared in advance, an obvious precaution when the masons were provincial and relatively untutored. Strangely, there is

no evidence that this practice was general in ninth-century Aswan. However, these early "form" inscriptions foreshadow later Islamic practice.

A further peculiarity of these ninth-century inscriptions is the minimal importance of the Koran and the absence of *duʿā'* (that is, non-Koranic prayers). Of the hundred-and-fifty inscriptions published by S. Ory, only forty-seven bear any *āyah,* and of these, only sixteen bear two. The commonest are Koran 9:33 aand 23:7, which in twelve cases are used together to conclude inscriptions. The *Āyat al- Kursī* (2:255), so common elsewhere in Islam, is not recorded here at all. In their complete form, therefore, the inscriptions consist of: *basmalah;* a rather elaborate (Sunni) *taṣlīyah;* the epitaph proper (giving the name and patronymics of the deceased followed by a brief prayer for God's mercy, and the date, including the day of the week, calculated from the beginning or the end of the month); and the *shahādah* or an *āyah.* The smaller tombstones, or those of negligible clients,[11] bear only *basmalah,* the name, and the detailed date. Thus these, and not the prayers, were evidently the essential elements of the Aswan epitaphs.

The insistence upon the date, which is also characteristic of Fatimid inscriptions from the Aswan cemeteries, is a local peculiarity. But it is far from inexplicable. The collections of traditions on *janā'iz* of *muḥaddithin* like al-Tirmīdhī, al-Nasā'ī, and Ibn Māja all roundly condemn the marking of graves by inscriptions or in any other way, and the *ʿulamā'* distinctly proclaimed their disapproval long after public opinion had completely accepted the cult of graves. Monneret de Villard ironically cites[12] the epitaph of the mystic, Dhū al-Nūn al-Miṣrī[13] that boasts his piety in refusing burial under a domed mausoleum but is a boast nevertheless. The avoidance of Koranic citations on tombstones seems prompted by similar scruples. Hence the stress on dates rather than prayers at Aswan, where one can assume provincial conservatism and, doubtless, somewhat distant reminiscences of the orthodox prohibition. This minute legalism is not atypical of medieval Islam and seems indeed quite reasonable: if sin is inevitable, then it had better be venial. How far the Aswan formulary also reflects orthodox belief in the inefficacy, impossibility, or gratuitousness of prayers for the dead demands further documentation. But the material at hand suggests that the ninth-century inscriptions of Aswan predate the acceptance in the area of prayers for the dead or (which may come to the same thing) the appropriateness of certain Koranic *āyah*s, notably the *Āyat al-Kursī,* for funerary inscriptions.

Inevitably, it has been necessary to stress the provinciality of the Aswan epitaphs. How far they are atypical is extremely difficult to judge. So many of the great medieval urban cemeteries have been destroyed unrecorded that funerary inscriptions in large numbers must be collected from remote provincial sites; these have their own peculiarities which may make comparison misleading. However, the Aswan inscriptions provide a broad framework for the study of these epitaphs: the general social and economic condition of the deceased; the relationship of Koranic citations and prayers for the dead to the factual record of personal details; the status and methods of the corps of masons; and the sources for their repertoire of letter forms. It is in the light of this that the cemeteries of Akhlat are relevant, and it is to them that the remainder of this paper is devoted.

THE AKHLAT INSCRIPTIONS

The Historical Background

In contrast to the history of Aswan, the history of Akhlat can only be reconstructed to a limited extent, mainly from pre-Mongol sources—in other words, for the period preceding the vast

majority of burials in the main cemetery. The best account of Akhlat in the early thirteenth century is by V. M. Minorsky,[14] who deals ingeniously with the bewildering complexity of races, politics, and religions—Muslims and Christians of various sorts; Georgians, Syrians, Kurds, Armenians, and Turks; Ayyubids, Khwarizmshahs, Saljuqs, Mkhargrdzelis, and ultimately Mongols—involved in the political maneuvers that led to the annexation of the town by the Saljuq sultan, ʿAlāʾ al-Dīn Kayqubād in 629/1231, after his victory at Yassı Çimen. Even this study casts little light on the social and cultural milieu, which must have been correspondingly heterogeneous. But then too, it is strange that the Muslim cemeteries should have been so vast and that the non-Muslim cemeteries should have disappeared so completely. One possible explanation might be that Akhlat was the center of a Muslim cult, one which formed a nucleus for the cemeteries, as shrines so often do. But it is significant that there is no mention of Akhlat in the *ziyārah*-book of Abū al-Ḥasan b. Abī Bakr al-Harawī (died 611/1215),[15] the most assiduous of the early shrine seekers. In fact, the easternmost point of al-Harawī's journeys was Āmid/Diyarbekir, but had there been a further famous shrine beyond, it would not have gone unmentioned. His silence, therefore, is evidence that none was known.

After 1230, the history of Akhlat is extremely lacunary. Taeschner implies that most of the town was destroyed by an earthquake in 644/1246.[16] However, desertion of the site is incompatible with the many thirteenth- and fourteenth-century epitaphs in the cemeteries. There is, moreover, evidence that the remnants of Jalāl al-Dīn Khwārizmshāh's troops were still actively destructive in the area. This state of affairs may have continued until the Mongol occupation of Akhlat in late 641–642/spring–summer 1244, but the source, Saʿd al-Dīn b. Ḥamawiyah al-Juwaynī,[17] is silent on the history of Akhlat in the subsequent period. Following the Mongol occupation, a Mongol governor was evidently appointed, since Akhlat was an Il-Khanid mint city at least up to the reign of Abū Saʿīd. That Akhlat is not mentioned in fourteenth- and fifteenth-century histories as a source of *mamlūk*s to the Egyptian state[18] may be evidence that the town persisted as an independent provincial center during this time. The general pattern, in, for example, Anatolia in the Il-Khanid and post-Il-Khanid period, was for towns that had fallen into decline to export their surplus population as *mamlūk*s, a fact attested by the copious Mamluk historical and literary sources. The absence of references to Akhlat in them thus suggests that it was not in decline.

The history of the towns around Lake Van in the period from the death of Abū Saʿīd in 1336 and the subsequent breakup of the Il-Khanid state to the establishment of Ottoman control in the sixteenth century presents a chaotic picture of warring factions and tribal groups. The most detailed references to Akhlat in the early fifteenth century are in the treatise of c. 1425 by the Armenian historian, Thomas of Metsopʿ (d. c. 1448). Minorsky's review of this work[19] concludes that the whole region around Lake Van was in a state of feudal parcellation. Van was ruled alternately by a Kurdish family of Ostan/Vasṭān (modern Turkish: Gevaş) and by the Kurdish amirs of Hakkari. Archesh/Erciş formed the base of the Qaraqoyunlu Turkman. Artskhē/ʿĀdiljawāz/Adılcevaz was ruled on behalf of or in connection with Bitlis, which had a largely Armenian population governed by Kurdish lords of the Rōzikān/Rūzakī federation. There is positive evidence of the activity of a Christian Armenian population at Akhlat up to the 1470s, if not later, in the shape of manuscript colophons, mentioning Akhlat either as the place of execution or in connection with the patron or scribe.[20] Finally, the areas south and southwest of Lake Van, though similarly populated, were ruled by Kurdish lords of the Khizan tribe, though with considerable Turkoman infiltration.

Much less can be established regarding the history of the Kurds in the area in the thirteenth and fourteenth centuries, and the only documentary evidence comes from the infrequent occurrences of the *nisbah* al-RWSKI/RWShGI on the tombstones of Akhlat. This must be a form of the name

of the Kurdish Rūzagī/Rūzekī clan-confederation that, as Thomas of Metsop[c] demonstrates, controlled Bitlis. Minorsky,[21] largely on the authority of the *Sharaf-nāmah* (1003/1596) of Sharaf Khān Bidlīsī, identifies this clan as basically composed of two groups, the Qawālīsī and the Bilbāsī, who can be traced back to c. A.D. 1000, when they seized Bitlis and Ḥāzō/Ṣāsūn from the Georgian king, David the Couropalate. Their subsequent movements are difficult to follow;[22] it is perhaps significant that al-ʿUmarī's sketch of the Kurdish federations in the Jazira between Mosul and Kawār/Kēwar ignores them. None of the other recorded *nisbah*s from the cemeteries at Akhlat appears to be a Rūzagī clan name.[23] Nor is their status clear vis-à-vis the Turkoman tribes who periodically controlled the Van area, though, ultimately, the failure of the Aqqoyunlu in the later fifteenth century to accommodate themselves to the Bitlis Rūzagī had grave consequences.[24] Neither Turkoman nor Kurdish history in the fifteenth century therefore may be confidently read back into the history of thirteenth- and fourteenth-century Akhlat. It is from these centuries, however, and not from the twelfth or the fifteenth, that the majority of the extant tombstones in the Akhlat cemetery date.

The inadequacy of the literary sources is unfortunately paralleled by the lack of extant monuments of a nonfunerary character. The surveys of Gabriel and Sauvaget,[25] including a comprehensive bibliography of the relevant travelers; the work by Abdürrahim Şerif Beygu;[26] and the reports of more recent trial excavations by Beyhan and Halûk Karamağaralı,[27] concur in concluding that the only indubitably medieval monuments are all detached mausolea. This is rather as if one were to try to write the history of nineteenth-century Genoa from its cemeteries. Of course, there is something to be learned even from isolated mausolea.[28] It is also possible that work in the Istanbul archives and the Ankara section of the Vakıflar Umum Müdürlüğü will elaborate Abdürrahim Şerif Beygu's oblique and somewhat tantalizing remarks on the Ottoman *waqf* surveys of the area. In other parts of Anatolia these have been exploited to cast light on land tenure and *awqāf* in the pre-Ottoman period. However, optimism regarding their relevance to major thirteenth- and fourteenth-century foundations at Akhlat may be premature.

Such is the intrinsic importance of the Akhlat gravestones that even the dearth of historical and archaeological background is far from crucial. Beyhan Karamağaralı has published a very useful selection of them which forms the point of departure for this study.[29] One qualification to her generally painstaking and accurate publication is necessary. She has assumed that both the decorated faces and the epitaphs on these gravestones were executed by the same craftsmen whose signatures appear on the stones, so that the dated epitaphs reveal an unambiguous chronology. Indeed, such was sometimes the case. However, since I argue that there existed banks of carved stelae, and since it is often not evident that the same craftsman both carved the decoration and executed the epitaphs, the chronology is by no means so simple. For the purposes of this essay, therefore, it is prudent to consider the epitaphs as *termini ante quem* and to avoid arguments depending on precise chronologies or on the development of the styles of individual craftsmen.

The Main Cemetery

To judge from the extant epitaphs, the peak period of the principal cemetery of Akhlat (west of the present village and the Bayındır Türbe) covers about a century, from 1250 to 1350, with a concentration of burials in the period 1300–1350. There are remains of about five hundred stelae, though many of these have toppled over or survive merely as stumps. Of those still standing, a disconcerting number have epitaphs that are seriously damaged toward the base, so that the date of death and quite frequently the name of the deceased have been obliterated (fig. 6). This

considerably reduces their value as documentation and makes it difficult to judge whether the cemetery was more frequented in the later or the earlier period.

A striking number of the Akhlat stelae are of the higher *ʿulamā'* and their families, many of them buried in groups. *ʿĀlims*, here, as elsewhere in Islam, ran in families, though particular offices were not necessarily hereditary. And though the inevitable generation gaps and the occurrence of more than one craftsman's "signature" in certain groups make generalization hazardous, there is evidence that family relationship determined the choice of epitaphs.

One important factor, then, is the "family relationship," both decorative and anthropological, of groups of stelae—evidently family burials—where an important determinant of the decoration of the stones is their physical proximity and the relationship of the people they commemorate (figs. 1, 2). This factor validates the working hypothesis that the extant material is representative, for many now-isolated stelae are surrounded by the debris of similarly decorated "neighbors," generally unsigned and bearing more or less crude pastiches of the same motifs. Epitaphs from 1400 onward are markedly less frequent (fig. 3), except for a striking group of early sixteenth-century epitaphs of RWShGI/Rūzagī Kurds. The cemetery had been abandoned by 1500. Its fall is evidently related to the depopulation and decay of Akhlat itself, but its rise remains unexplained. As B. Karamağaralı points out, this was one of the most extensive cemeteries of Anatolia, and Muslim cemeteries do not normally grow up by accident.

The earliest dated epitaphs are of the twelfth century and appear on cenotaphs, typically in angular Kufic script on dense openwork scroll grounds, sometimes reminiscent even of the "post-Samarra" style. All the extant cenotaphs are of elongated pyrimidal form[30] set over high, carved curbs that sometimes form a hollow chest (*ṣandūq*) above ground. The standard Akhlat funerary monuments, however, are not cenotaphs but stelae, though it may be surmised that these were, initially at least, associated with cenotaphs, oriented roughly east–west. The earliest standing stela[31] bears an epitaph dated 585/1189, executed in flat relief but with an incised *nakshī* inscription. Henceforth the date customarily appears on the stelae, not on the cenotaph, which tends to atrophy into a low flat-topped curb that is not inscribed at all. Where they coexist, cenotaphs and stelae are decorated differently (fig. 1); none of the former bears any craftsman's "signature"; and they may well be the products of different workshops. As for stelae, some graves have head- and footstones. But if this had once been standard practice, for example, in the thirteenth century,[32] subsequent limits on burial space—especially the numerous fourteenth-century burials, including some possibly located over preexisting graves—tended to eliminate all commemorative monuments except headstones.

The Epitaphs

The epitaphs contain peculiar eulogies. Not one is Shiite, and names associated with the Shīʿah are rare.[33] Females get short shrift, the standard epithet being *al-maẓlūmah* (presumably "modest," not "oppressed," since the term is also applied to males). The standard masculine qualifications are *al-shābb qaṣīr al-ʿumr* (the youth who lived too short a time); it should thus follow that the cemetery was for the descendants of *ʿulamā'* who died young. But many of them had made the *ḥajj*, had fathers who were already dead (*al-marḥūm*), or were themselves members of the higher *ʿulamā'*—*ḥāfiẓ, muftī, qāḍī*, even *qāḍī al-quḍāh*. Reference to their youth must thus be a *topos*, which, Wheeler Thackston kindly informs me, accords with Persian literary usage. The tone is strikingly gloomy. The conventional, often proleptic, epithets for the dead and their blessed state—*al-saʿīd, al-shahīd* (not confined to those who died in battle)—are far outweighed by allu-

sions to their miserable state. For example, one finds epithets such as the following: *al-mafqūd ʿan* (or *min*) *aḥbābihi* (deprived of, rather than lost to, his beloved); *al-maḥṣur min ikhwānihi wa-aṣḥābihi* (deprived of his brothers and friends); *al-munaghghaṣ ʿan* (or *bi*) *shabābatihi* (made miserable by [the loss of] his youth); or *al-mufāriq* (separated from [his family, friends, those bearing his *nisbah*]). The very contortions of the grammar reflect the pessimism of those who composed the epitaphs. Only one recorded epitaph (fig. 4) suggests the possibility of intercession, that of Nūr al-Dīn Abū al-Ḥasan (died mid-Rabīʿ I 714/late July 1314): *wa-ghafara Allāh li-man ḥaḍara ʿalā hādhihi al-turbah wa-qara'a lahu fātiḥat al-kitāb,* the grammar of which still gives the clear sense "May God [also] forgive whoever visits this tomb and reads the *Fātiḥah* for him." Remarkably, this is paralleled by an epitaph, again a hapax, however, from the cemetery of al-Bāb al-Ṣaghīr at Damascus.³⁴ It may reflect a local, or an Iranian, idea, rather than Syrian practice (if practice it indeed was); but, all in all, the evidence that there were generally accepted prayers for the dead in Islam is not substantially augmented by the Akhlat epitaphs. Moreover, certain rather frequent grammatical contortions suggest that this was a culture in which perfectly standard Muslim formulas remained somewhat alien and liable to unwitting distortion (figs. 1, 5). For example, one finds the phrases *tawaffā ilā raḥmat Allāh taʿālā*³⁵ (from *intaqala ilā raḥmat Allāh wa-ghufrānihi* [he died, was transported to God's mercy], and *al-muḥtāj ilā raḥmat Allāh wa-ghufrānihi* [who needs, has hope in God's mercy and pardon]). These Akhlat inscriptions differ in their pessimistic tone and contortions of grammar from lapidary epitaphs recorded elsewhere in Islam and from the standard literary obituaries, as well as from the recorded epitaphs of Christian Armenia.

The Population

The names on the gravestones are standard Muslim, with a sprinkling of Turkish patronymics. One (*al-mawlā al-ṣadr*) Zayn al-Dīn Kurd³⁶ may be of a Kurd, though no distinctly Kurdish names are recorded.³⁷ The patronymic Ibn ʿAbd Allāh, which is often taken to indicate a convert to Islam, is recorded only once and is that of a traveler, Ḥusām al-Dīn Ḥasan al-Arzan al-Rūmī (from Erzurum).³⁸ All the rest have Muslim genealogies going back at least two generations. Those buried in the cemetery were thus not recent converts. The *laqab*s in *al-Dīn*³⁹ show a certain consistency, e.g., the use of Shams al-Dīn with Muḥammad,⁴⁰ though not to the extent noted by Van Berchem and by Ayalon⁴¹ in Mamluk Egypt and Syria or in the *ṭabaqāt* literature.

*Nisbah*s, on the other hand, are rare. Apart from the RWShGI Kurds already alluded to, the most important *nisbah*s seem to be local—al-Mūshī,⁴² al-Malājirdī (Malazgird),⁴³ or, some days' further journey away, al-Arzan al-Rūmī (Erzurum).⁴⁴ The most significant *nisbah,* as well as the most frequent, is al-Ghalaṭī (figs. 5, 26). Initially, this appears incongruous, since it seems to refer to Galata, the Western, largely Christian quarter of Ottoman and pre-Ottoman Constantinople. However, the consonance must be coincidental and may reflect, as indicated above,⁴⁵ one of the local Armenian pronunciations of Akhlat, Łèlat.

The abundance of clerkly titles (including *muqrī, faqīh, sayyid al-ḥajj al-islām wa-al-muslimīn,* and the like), particularly given the rarity of *nisbah*s suggesting birth or study elsewhere, all strongly suggest the existence of a large *madrasah* at Akhlat turning out numbers of educated officials. There is no record of this in the sources, nor are there any archaeological remains of it. However, the cemetery was not exclusively for *ʿulamā'*. Saʿd al-Dīn b. ʿAbd al-Ṣamad⁴⁶ was the son of *al-ṣadr al-ajall,* a notable, not necessarily an *ʿālim.* The title *khwājah,* which was used, *inter alios,* for grand merchants, occurs several times. Many individuals bear no titles at all. Others may well have been amirs. ʿIzz al-Dīn Amīr Yūsuf⁴⁷ is styled *malik al-shuʿarā'* (Prince of Poets), which, if it was

an office, was a secular one. Shihāb al-Dīn,[48] one of the numerous descendants of Muḥammad al-Ghalaṭī, is styled *ghāzī* (fig. 5); this was probably not just a literary convention since it is not a common title at Akhlat, where there were nevertheless numerous opportunities for battles for the Faith. Amīr Khiḍr[49] is styled *pahlawān* (champion). And ʿIzz al-Dīn Amīr Yūsuf b. Najm al-Dīn Aḥmad b. Amīr Khwājah (fig. 6)[50] was *al-maʿrūf bi-chāshnīgīr* [sic] (known as the Taster), taster being a high office in many Muslim courts. If *al-maʿrūf bi-* is a deliberate qualification and not just a quaint locution, it may be because the (presumably) Il-Khanid governor of Akhlat at the time had no use, or money, for a *chāshnīgīr* (taster), which office ʿIzz al-Dīn had held previously there or somewhere else. Official titles at Akhlat are in fact few; it is even possible that Amīr is a name, not a rank (cf. the frequent use of Malik and Sulṭān in composite Turkish female names). Thus Amīr Khiḍr's brothers, Shams al-Dīn Muḥammad and Pīr Ḥusayn,[51] bear no title; whereas a second Amīr Khiḍr (fig. 9)[52] was not only *sayyid al-ḥuffāẓ* and *muqrī* but also the son and grandson of *muqrī*s and hence both by education and descent a trained Koran reader. However, if epitaphs were carved as "form" inscriptions (see page 119ff.), it was doubtless less compromising to refer to an *ʿālim* (which would blur the distinction between *ʿulamā'* and *umarā'*). Though the preponderance of presumptive amirial burials come from the middle decades of the fourteenth century, intermarriage between the two groups must have been as frequent there as elsewhere in Islam.

Though much intermarriage can be expected in a remote provincial center, the family relationships are striking. For example (figs. 4, 7), *al-fatā* Rashīd al-Dīn Rashīd,[53] who was the son of *Mawlānā . . . qāḍī al-quḍāh* Zayn al-Dīn Ṣāliḥ,[54] was the uncle of an Imam (*malik al-umarā' wa-al-khuṭabā'*).[55] His brother also was an Imam, *qāmiʿ al-bidʿah* (extirpator of heretical innovation) Sharaf al-Dīn . . . Abū Yūsuf,[56] who predeceased his son, also an *ʿālim* (*al-mawlā al-imām . . . qāḍī al-quḍāh*) Fakhr al-Dīn Maḥmūd[57] and his granddaughter, Nāṣiḥah Malik.[58] Especially important was the Muḥammad al-Ghalaṭī already mentioned (see above and fig. 5). He appears in an epitaph dated Ṣafar 668/October 1269[59] as the (deceased) grandfather of a *muftī*, ʿAlā' al-Dīn . . . ʿUthmān. He and his son, Abū al-Qāsim, who is *al-marḥūm* (deceased) in this epitaph, are the only personages regularly qualified as *al-ghāzī*, though their status remains unclarified. Their descendants continue to appear in dated epitaphs up to the 1340s.

A special case is the title *ustādh*, which occurs on three inscriptions recorded from the Akhlat cemeteries. The title is unspecific. Thus in the case of *Ustādh* ʿAlī b. Mawdūd[60] *al-maʿrūf bi-al-Mūshī*, apparently the son of Amr (?) al-Dīn Mawdūd b. Nūr al-Dīn Muḥammad,[61] the title *ustādh* tells us only that he was not just born at Mūsh/Muş but studied there.

Another inscription,[62] curiously chaotic, refers to an *ustādh* ʿAlam al-Dīn Sanjar *al-Ṣā'igh* (the metal caster) b. ʿAbd al-Raḥīm *al-Nāṣirī*. *Al-Nāṣirī* here is a *nisbah* of *tamlīk* (i.e., indicating a *mamlūk* of some sovereign, *al-Malik al-Nāṣir*—presumably a local Ayyubid—or of some master, *Nāṣir al-Dīn*). Were he a freeborn metal caster, the *nisbah al-Nāṣirī*, either for himself or for his father, would be improbable. In this inscription it seems appropriate to take *ustādh* as a contraction of *ustādh al-dār* (Major Domo), which was also a high office at many Muslim courts, and *al-Ṣā'igh* as a sobriquet.

B. Karamağaralı[63] observes that none of the epitaphs containing the word *ustādh* refers to any of the stonemasons attested on other tombstones. This raises questions regarding the status of the masons involved. However, one tombstone bearing the word *ustādh*[64] is in fact that of a stonemason, or the son of one. The epitaph, with the standard initial formulary, is for *al-saʿīd al-shahīd al-ustādh al-shabb al-*[sic] *qaṣīr al-ʿumr . . .* Mīrān b. *al-marḥūm al-ḥajjī* Mīr Ḥusayn *al-ḥajjār* (the stone mason); its inscription is "signed" *ʿamal* Yūsuf b. Mīrān *shāgird* Jumʿah. The name Mīrān is attested elsewhere at Akhlat in a mason's inscriptions, both as *ism* and patronymic (though these "signatures" cannot be tied to the man mentioned in this inscription).

What can be concluded from this tombstone about the status of the Akhlat masons? It is certainly significant that the title *al-Ḥājj/al-Ḥājjī/Ḥājjī* occurs frequently in mason's "signatures" (fig. 8), as it does in this epitaph, for this suggests that the Akhlat masons were rich enough (or found it expedient for their reputations) to make the *ḥajj*. But it is imprudent to speculate further. *Ustādh* may designate the head of a corporation or a master craftsman, but too little is known of the corporations in medieval Islam, least of all in remote provincial centers like Akhlat, to determine what claim a craftsman would have to burial in what is primarily a cemetery of *ʿulamā'* and *umarā'*.

The Craftsmen

Of the recorded names of masons[65]—more than twenty occur over a 200-year period—none has an obvious non-Muslim patronymic. HAWND b. BRGI[66] (the first name may be a local misspelling of Persian *Khāwand*) presents an apparent difficulty (fig. 7), but *Birgī* is an attested Turkish name. Nor are there any obviously Armenian names.[67] This is significant in view of the relation between the carved decoration of the stelae and of Armenian *khachkar*s, for which I shall argue below. Nor, with the exception of HWYNG[68] (possibly a miswritten version of Persian *Hūshang*), are the names even nonstandard: the relative frequency of *Asad* might suggest Armenian Łewōn (Leo), but it is just as likely to be a contraction of *Asad Allāh* or *Asad al-Dīn,* shortened to fit the space available.

The "signatures" furnish important data for consideration of the role of heredity in the masons' craft (fig. 12). Thus Aḥmad al-Muzayyin (the decorator) (fig. 16)[69] was evidently the father of Uways b. Aḥmad,[70] the grandfather of Aṣīl b. Uways[71] and Muḥammad b. Uways[72] and (though the chronology of the epitaphs makes this appear somewhat improbable) the great-grandfather of Jumʿah b. Muḥammad.[73] Another group is formed of Ḥājjī/al-ḥajj Yūsuf b. Mīrān,[74] evidently the father of Ḥājjī Mīrān b. Yūsuf (fig. 8),[75] and the grandfather of Ḥājjī/al-ḥajj Mīrcheh b. Mīrān (figs. 9, 10)[76] and Muḥammad b. Mīrān.[77] These genealogies are, admittedly, somewhat speculative, since, as is evident from the names listed here, the possibility of homonyms cannot altogether be dismissed. Nor, obviously, does the time span implied by the epitaphs give any more than a vague guide to the period of the activity of these masons: a priori, one would expect more overlap, not the rather marked generation gaps. Moreover, in the case of those "signatures" that exist in different versions and therefore imply a workshop, the chronology is further complicated, since the "goodwill" associated with an enterprise tends to delay a change of name until well after the change of proprietor. But when so little is known, it seems gratuitous to introduce such complications.

The hereditary transmission of crafts is not surprising. What is more striking is that there was also transmission by apprenticeship and that this cut across kinship—that is, a son might not necessarily learn the craft from his father. Thus, Asad b. Ayyūb—also known as *al-ustādh Asad b. Ayyūb ghulām Uways* and *Asad al-Muzayyin* (the decorator)[78]—was evidently the apprentice of Uways b. Aḥmad, hence the term *ghulām*. Aṣīl b. Uways (fig. 1)[79] was the apprentice/*shāgird* (the distinction, if any, between the two terms for apprentice is unclear to me) of Asad b. Ayyūb, who had another *ghulām,* HAWND b. BRGI (cf. fig. 7).[80] The above-mentioned al-ḥājj Mīrcheh b. Mīrān with his numerous aliases (figs. 9, 10)[81] appears as *shāgird Yūsuf,* therefore not of his father but, presumably, his grandfather, who himself was the *shāgird*[82] of Jumʿah b. Muḥammad.[83] This double transmission, by apprenticeship outside the family and by heredity, appears characteristic of the later thirteenth century and must have resulted in a rapid increase in output.

It is thus clear that the *ustādh*s did not work alone, but with assistance from their apprentices and others. A further demonstration of this is a signature, read by B. Karamağaralı[84] as *ʿamal Muḥammad b. Uways wa-muʿīdihi* (made by Muḥammad b. Uways and his assistant). One might suggest that such unnamed assistants of the "great names" were responsible for most of the unsigned stelae in styles and designs imitating the signed works. Another possibility is to follow B. Karamağaralı's method of attributing unsigned works to specific craftsmen on the basis of style. However, the repertoire is circumscribed and the same motifs appear on tombstones with different "signatures" so that it is imprudent to infer even house-styles, let alone individual styles. Hence the necessity, at the present stage, of considering primarily signed stelae.

The Decoration

The ornament on these gravestones is of greater interest than one might suppose, considering its rather narrow repertoire of paneled decoration, which often varies only in the format of the panels.[85] A noticeable stylistic and technical evolution occurred during the period from 1250 to 1300. Up to 1300 there is a clear distinction between the reverse, which bears the epitaph and which is generally undecorated, and the decorated obverse, which generally faces west. The decoration is incised or flat-cut on a single plane and almost invariably consists of a single panel of angular interlacing strapwork (star-hexagons and -octagons) set on a horizontal grid with a vertical axis, with the polygons left undecorated (fig. 11). Decorative borders and niche surrounds for the strapwork begin to appear toward 1300 (fig. 12). Thereafter, all-over decoration predominates, consisting of contrasting panels, occasionally in rounded relief and often on two planes. Angular strapwork retains the horizontal-vertical axes of the basic rectangle-grid, but the centers are crowded together and the result is densely woven;[86] or else the ground is carved to produce a contrast of texture and cut.[87] Decorative features particularly exploited after 1300 include a composite foliate tree, often carved almost as if it were openwork (figs. 9, 10),[88] and panels of pseudo-Kufic, the plaited shafts of which have feathered tips that form polylobed arcading,[89] though such elaborate conceits rarely appear on more than one panel per stone. Some contemporary motifs—for example, hanging mosque lamps on long chains suspended from complex lobed keyhole arches (figs. 8, 13), or double-headed dragons used as an auxiliary flat molding for cornices—become unrecognizably stylized[90] and are then abandoned. Although in certain, very limited respects the Akhlat decorative repertoire can be compared to that of thirteenth-century Saljuq Anatolia, it is essentially a local style, and the influence of either one upon the other must have been minimal.

Technically the repertoire cannot have been demanding; so much was repetition, either of standard motifs or of standard cuts (figs. 9, 10). Prior indications to the masons remain in the shape of clearly scratched margins and the outlines of panels and even of star-polygon systems (fig. 11). The regularity of scroll grounds, like the repetition of panels, is *pro tanto* evidence for mechanical copying (figs. 9, 10), though the frequent recourse after 1300 to carving in multiple planes of relief eliminates all traces of the preliminary sketched design (fig. 5), and numerous stones of different heights bear similar panels reduced to scale—which is evidence of the masons' competence (figs. 1, 2, and 13). Yet with all this evidence of forethought, no standard inscription formulas were evolved, nor is there any trace of lettering being sketched out before it was carved.

Certain features of the Akhlat stelae suggest that they are a deliberate adaptation of Armenian *khachkar*s (cross stones).[91] These are used for a variety of commemorative purposes; for example, one was erected in 1200 at the Armenian fortress of Anberd to commemorate its conquest by

Zakʿare Mkhargrdzeli. They may also appear as the foundation stones of bridges or other monuments, as boundary stones, as votive plaques commemorating grants of land, or as the footstones of cenotaphs, and as ordinary gravestones, often set on freestanding plinths. The essential decorative and symbolic element is the cross, generally surmounting a globe or a stepped pedestal; these designs are evidently stylized calvaries. The cross normally faces east, and the inscriptions are on the reverse. Through the thirteenth century there is a stylistic progression from the traditional linear style, exemplified by a *khachkar* at Sanahin[92] dated 1215, to something much closer to the Akhlat style, exemplified by the stela dedicated to Mkhitar Gosh, the founder of the monastery of Nor-Getik, dated 1291 and signed by a craftsman Bołos/Paul.[93] In some late thirteenth-century specimens, for example, that in the courtyard of the chapel of the Holy Cross at Haghpat[94] dated 1273, the cross becomes a crucifixion, but in general the tradition of nonrepresentational ornament persists. Craftsmens' signatures, with Armenian names, are common from the twelfth century onward.

These features find significant parallels at Akhlat. First, there is the sharp distinction between the carved obverse and the inscribed reverse. Armenian calvaries face east; at Akhlat burials are oriented roughly east–west. The Akhlat custom of setting stelae with their decorated obverses facing *west* must therefore be a deliberate gesture to distinguish them from Christian tombstones. (When, exceptionally, a footstone is used, its inscription faces inward, or west, and its decorated obverse faces outward or east [fig. 1]. This arrangement by which the inscribed surfaces of head- and footstones face each other may simply show a concern for neatness.) Second, the prominent cornices, particularly of later thirteenth- and fourteenth-century *khachkars*, are above the cross and are often inscribed. At Akhlat, similar cornices are almost invariably created above the epitaph on the reverse; they are uninscribed and decoratively distinct (figs. 1, 6, 8); again this must be a deliberate inversion. Third, there are the relatively abundant craftsmens' "signatures" on the decorated obverses of the stelae at Akhlat (figs. 3, 5, 7, 9, 10)[95] (which seems downright impertinent, for whose tomb was it?). These "signatures" parallel the Armenian practice of signing *khachkars*, which itself bears witness to the characteristically Armenian practice of signing works of art, from manuscript colophons to metalwork.

These parallels become particularly significant when one considers that not one of them is characteristic of Muslim funerary practice elsewhere in Islam. The names and patronymics at Akhlat make it clear that Armenian craftsmen did not work there. The similarities to Armenian practice may simply demonstrate the absence of an accepted vocabulary of decorative motifs for Muslim tombstones—and the craftsmen's circumscribed imagination. However, in view of the formal parallels between the Akhlat stelae and the Armenian *khachkars*, it is tempting to consider whether the decorative repertoire is a deliberate adaptation of the symbolic decoration of the *khachkars* to Muslim ends.

Two possible formal equivalents to the cross are the foliate tree and the mosque lamps on long chains within *miḥrāb*-like niches, which appear on many decorated obverses (figs. 14, 15). Not that *miḥrāb*s associated with tombs need have any symbolic sense. They were not to be used for prayer, since prayer over tombs is expressly forbidden by the *ḥadīth*, but since a Muslim is customarily buried facing the *qiblah*, *miḥrāb*s could appropriately appear on or in a tomb.[96] Due to the general east–west arrangement of the Akhlat cemetery, the *miḥrāb*-like niches on the stelae must be at ninety degrees to the *qiblah*. Even if one concludes that the *miḥrāb* motif was symbolic (since it could not be of practical use), it does not follow that the masons had any clear symbolism in mind. Nor is there any evidence that the composite foliate tree (fig. 5), which includes a trefoil-palmette surmounting a globe with winglike foliate motifs below (which also appears at the base of the cross on earlier thirteenth-century *khachkars*), has any precise symbolic sense. The foliate

designs on tombstones appear to derive from those in the margins or at the head of Armenian manuscript illuminations. These are distantly derived from calvaries that by the late thirteenth century had lost their original symbolic content.[97]

On the other hand, the other stock decorative motifs—for example, the panels of highly decorated pseudo-Kufic (figs. 9, 10) that were so popular in the early fourteenth century—cannot be presented, a priori, as the formal parallels of any decoration on the *khachkar*s. Thus, while it is clear that the Akhlat craftsmen were reacting to the Armenian *khachkar*s, one cannot find a one-to-one correspondence between the two groups of monuments.

It seems relevant at this point to discuss the use of Koranic *āyah*s on the decorated obverses of the stelae. The choice of Koranic verses is consonant not with the choice of decoration but with the function of the tombstone. Thus, on those stelae with mosque lamps that also bear inscriptions, the *āyah* is either 3:18 (sometimes with the beginning of 3:19, though never beyond *al-Islām*) or else part of the *Āyat al-Kursī*, 2:255.

The *Āyat al-Kursī* was the most popular inscription, although it was far too long to fit on the stelae, and no solution was found to avoid arbitrary truncation. It was customary to squeeze in as much of the text as possible and then stop, without concern for the sense. Strangely, no standard lineation appears to have been devised to spare the mason the labor of starting from scratch with each stela. Even stelae "signed" by the same craftsman have barely two inscriptions that are exactly similar. There is not even consistency in the disposition of the Koranic *āyah* when it is relegated from the obverse to the sides of the stela (it is never placed at the top of the stela or where it would be too high to be visible), since the text may start from either side (figs. 1, 2). (The sides as well as the face of cornices are also normally decorated as separate units.)

The Koran is not the only source for inscriptions on the stelae. Many stelae have *duʿāʾ*, of which the commonest is *al-dunyā sāʿah wa-jaʿalahā ṭāʿah;* in this class one should probably include *kull nafs dhāʾiqat al-mawt,* though it is Koranic. One stela[98] has both of these and the remains of two others as well: *al-mawt bāb wa-kull al-nās dākhilah* and *al-mawt kās wa-kull al-nās [shāribah].* (It is exceptional for so many inscriptions to appear on one stela. Normally one or the other of the first two are repeated to fill the available space.) None of these inscriptions need be taken other than literally.

The Scripts

It is not always easy to relate the epitaphs to the inscriptions on "signed" decorated obverses. Quite apart from the difficulty of identifying individual hands, the local tufa available was exceptionally easy to carve when freshly quarried,[99] and, insofar as lapidary scripts are largely determined by the tools at hand, it is highly probable that the Akhlat masons had the appropriate tools for a variety of letter forms—engraved, flat-cut champlevé, and rounded relief. Moreover, much depended upon whether a stone was carved flat or erect. Nor is the content of the inscriptions a reliable guide to the individual craftsman. The inscriptions on the head pieces are as stereotyped as the inscriptions on the decorated panels below, so that their selection gives little or no scope for individuality.

Nevertheless, it is possible to speak of an Akhlat style of lapidary inscription. Earlier inscriptions are generally incised with a chiseled V-cut that allows a variety of line and gives due emphasis to the tips of ascenders and to terminal letters.[100] This technique had the added advantage of saving space, in contrast to the flat-cut champlevé that was used briefly in an (unsuccessful) experiment.[101]

By the fourteenth century, a standard layout for epitaphs had also evolved, whatever the script; this is a commemorative or panegyric border with a scratched or prominently carved inner margin, the *ductus* of which, in incised inscriptions, moves freely without being too markedly suspended from the edge or too close to the lower margin. The titulature and date of death are generally confined to a central panel and disposed between ruled lines.

Though the border and the personal details are often in similar hands, it is misleading to conclude that the craftsman who signed the obverse must also have executed the reverse or even that the margins and the central panel of the epitaph are necessarily the work of the same hand. The same caution should be applied to inscriptions in flat relief.[102]

One early "signature" (epitaph dated Jumādā I 660/March–April 1262), *ʿamal Aḥmad al-Muzayyin,* is an exceptionally skillful adaptation of a given formula to a predetermined space, a distinct rarity in contemporary Islamic epigraphy. The ascenders, *alif* and *lām,* occupy only about two-thirds of the height of the panel, and the *dāl* is basically a *lām* inclined; but the letters of each of the three words are distributed rhythmically over the panel, so that the "signature" almost takes on the appearance of an *ʿalāmah,* the grand heading of a chancery rescript, even if the wedge-cut line is rather thinner than a pen-drawn inscription.

The Koranic border is more boldly wedge-cut (2:255, but only as far as *mā khalfa[hum]*). There are some swash initials (for example, the *ʿayn* of *ʿindahu*), but the natural curves and inclination of the successive words have been inexpertly flattened (cf. *sinnatun wa-lā nawm*), as if determined by a rather slovenly imaginary base line. This Koranic inscription tails off rather miserably in mid-*āyah,* not even stopping at an appropriate caesura. Obvious epigraphic solutions would have been to develop the nonlinear arrangement of the "signature," where breaks in words containing nonjoining letters are used to achieve vertical compression without distorting the horizontal *ductus;* to arrange the inscriptions as a double or triple line (a procedure unknown at Akhlat); or, the commonest resort of Muslim stonemasons, to fit in the canonical inscription by progressively crowding and diminishing the letters. Aḥmad al-Muzayyin has adopted none of these solutions. He seems therefore to be deliberately flouting the prescription of the *ʿulamā'* in giving primacy to form (i.e., a uniformly spaced inscription border) over content.

A very similar, possibly unfinished stela[103] (year obliterated) bears Koran 2:255 to *ilā bi-idhnihi,* which is broken at *nawm* and then again in the middle of *samāw:āt* (with *alif māddah,* as usual at Akhlat) (fig. 18). The border was marked by fine scratches, but the stela tapers from the top and the inscription thus falls slightly outside it. Though the terminals of the ascenders are conscientiously marked, the cut is not wedge-shaped, and evidently a simple hollow chisel was used. Certain letters are rather ineptly elongated (notably the *tā'* of *samāwāt* and the occurrences of *lām-alif*), which suggests that this inscription was actually designed to end at *bi-idhnihi.* There is, as usual, no *tashkīl,* though a V-shaped ornament, possibly derived from the breathing mark in Koranic scripts used to reinforce *sukūn,* is used at random over certain letters.[104]

A comparable script appears on the stela of a *muftī* and *qāḍī al-quḍāh,* Abū al-Barakāt Ṣāliḥ (died 3 Ṣafar 659/8 January 1261), where the ascenders appear suspended and an artificially horizontal line pushes forward (fig. 11). The text is Koran 2:255, up to *wasiʿa kursīyuhu al-samāwāt,* but it breaks off before *wa-al-arḍ,* the "natural" caesura. Even so, many letters are squashed, and the initial *shahādah* reads *Lā l'illāh ilā huwa* (!). The mason may have been distracted by the experimental strapwork panel that occupies most of the surface of the stela. The epitaph on the reverse is carelessly executed, with a final elegy in Persian, which can only be described as a "scribble."

The script of the footstone of ʿAlā' al-Dīn ʿUthmān (died Ṣafar 668/October 1269), with an eight-line Persian elegy[105] inscribed between heavily carved lines and designed as a column of

written text (fig. 17), is outstanding. It bears almost full *tashkīl,* though still without *ḥarakah* but for the occasional random V-shaped *sukūn* (see note 104 and fig. 19). Letters with striking swash terminations include *kāf* and *rā',* formed with a wedge-shaped cut of variable width, strongly evoking pen strokes though not imitating any documented manuscript hand. It is perhaps the only inscription at Akhlat that can properly be described as "calligraphy," and its exceptional character, like its content, suggests that the urgency of carving epitaphs generally precluded careful design. ᶜAlā' al-Dīn ᶜUthmān's epitaph is inscribed on his headstone; this elegy is therefore in every way an epigraphic luxury (fig. 26). The champlevé heading, in contrast, is poor and contains two solecisms, *muftī al-fāriqī* (for *fāriqīn*) and ᶜ*Alāī* (for ᶜAlā').

The scripts of the epitaphs differ from those of the decorated obverses in their completeness. Unlike the Koranic *āyah*s, the epitaphs were not truncated. If in fact the detailed epitaphs at Aswan were an attempt to circumvent the orthodox prohibition against memorials, the Akhlat epitaphs indicate a curious evolution of thought: from the view that detailed epitaphs were permissible to the belief that they were necessary. This evolution is not without parallel, but the result is paradoxical. It affected the scripts, since, for the most part, epitaphs needed to be carved in a simple, adaptable hand that could accommodate long inscriptions without making them appear squashed. Hence the use of a simple hollow chisel, which, as on the obverse of Figure 14 (bearing Koran 3:18–19, up to *al-Islām*), leaves the letters looking unfinished.

Hollow-cut letters and unvarying lines persist through the fourteenth century. Nevertheless, there are significant developments. With taller stelae came less truncated inscriptions, or at least better-spaced standard formulae, which observe a fairly regular ratio between the height of their ascenders and their horizontal *ductus.* In theory, a competent writer should be able to fill any oblong space without conspicuous crowding or blanks. The fact that the most successful of the Akhlat inscriptions are on the tallest stones thus demonstrates the masons' limitations; professional calligraphers would have been able to work equally well within any of the extant Akhlat formats. The adoption of incised margins and lined central panels for epitaphs also brings improved letter forms. Take the case of the gravestone of a son of al-ḥajj Muḥammad b. Maḥfūẓ (fig. 18). This concludes rather strangely, with *fī shahr Allāh al-muᶜaẓẓam,* but without the actual date. The following six lines, which are partly illegible, are later additions, not chance obliteration. Evidently, the whole epitaph, except for the date, was executed *ante mortem* and an appropriate space was left. Then, as it was not needed, the blank was used for the epitaph of a stranger. The swash lettering of the epitaph of the imām Maᶜtūq b. al-marḥūm Nūr al-Dīn Muḥammad (fig. 19), with his name and patronymic to terminate the border, is reminiscent of the Persian elegy to ᶜAlā' al-Dīn ᶜUthmān. What follows is also curious: there are two dates. The upper one (Ṣafar 723/January–February 1323) is monoline, without marked terminations and lacking the freely composed lineation of the surround; it also ends with *wa,* probably indicating that a blank was left for the name of a relative. There follow two lines, partially obliterated, then a second date, 675 (perhaps a mason's error for 775, since the second date cannot be earlier). This second date, executed in yet another cut, was evidently made after the stone was already standing. *Ante mortem* epitaphs have more general implications (see note 62) that I will discuss later in this essay.

An important epigraphic innovation must be noted: a champlevé script, defined by S. Ory as the creation of letters in relief by excision of the ground. On the stela depicted in Figure 20, compare the section incised with Koran 3:18–19 (up to *inna al-dīn*) with the bold champlevé head piece, *kull nafs dhā'iqat al-mawt,* the familiarity of which made legibility a secondary consideration. Another example is an epitaph (c. 1300) of ᶜIzz al-Dīn Amīr Yūsuf b. Najm al-Dīn Aḥmad (fig. 6),[106] where champlevé margins contrast with an incised central panel.

Champlevé inscriptions posed problems that the Akhlat masons could not solve. They are space-consuming, stiff in horizontal *ductus,* and generally lack the freedom and variety of even unsophisticated scripts. The predetermined margins leave no room to maneuver, and the resultant unwavering base line is only appropriate to Kufic or to the most mechanical copyist's *naskhī,* but not to *thuluth* or *muḥaqqaq.* The inclusion of *ḥarakah* and *tashkīl* would have crowded such inscriptions even more, so it is doubtless fortunate that the champlevé inscriptions omit them.

The restricted use of champlevé in the fourteenth century is thus quite comprehensible. Nor did high-relief lettering improve things, for it also lacks the freedom of the earlier incised inscriptions, as comparison of two stelae, each signed Aṣīl b. Uways,[107] demonstrates. On both, the miserably short fragment of the *Āyat al-Kursī* in rounded relief contrasts strikingly with the more elegantly incised epitaph. There is a further contrast between the epitaph of Nūr al-Dīn Abū al-Ḥasan[108] (died mid-Rabīʿ I 714/late June 1314) and the incised request for prayers for him that follows it (fig. 4). Only this part of the carving exhibits freedom of calligraphy, even if the final words were necessarily cramped to accommodate the whole imploration. The champlevé lettering of the epitaph may well be the work of HAWND/Khāwand b. BRGI (fig. 7), whose signature appears on the decorated face; here a cramped section of Koran 2:255 is inscribed on a scroll ground so dense that it is difficult to decide where the text breaks off, at *yuḥīṭūn* or *bi-shay'in.*

To the obvious visual disadvantages of champlevé must be added the additional time it took to execute. It must therefore be understood as an evolutionary cul-de-sac.

Banks and "Form" Inscriptions

The labor of carving well-lineated inscriptions (not necessarily even champlevé), however stereotyped in form, favors the probability that, when they could, the craftsmen prepared the inscriptions beforehand, sometimes including even the client's name and titles, and leaving only the date of death blank. In other cases, as at Aswan, they experimented with "form" inscriptions.

Evidence of the use of stones at all stages of completion, from barely blocked-out stelae to stelae with scratching to indicate the placing of borders and panels and even partially completed stones, is abundant. Why uncompleted stones were erected is unclear. (The slabs must have been worked flat, so it is highly improbable that the craftsmen completed the decoration after the stones were erected.) Nor is it clear why there was such inconsistency of practice. It is possible that stones lying unfinished or partially botched in masons' yards were sold cheaply to clients.

In a particularly important group of fifteenth- and sixteenth-century inscriptions,[109] the arrangement of decorative motifs and their cut contrast markedly with those of the epitaphs. The contrast could be explained as the result of a revival of earlier motifs or, much more probably, as the result of the use of a bank of earlier decorated stelae on which the epitaph reverse was left completely blank. These stones were used by the RWShGI/Rūzagī Kurds, who also imitated the formulary of earlier gravestones. There are few signs that these older stones were otherwise changed for these later clients.

If "form" inscriptions were to be used, they needed careful planning. The evidence, as at Aswan, is sparse but conclusive. One such formula is found in two inscribed epitaphs that bear inscription borders carved in ignorance of the sex of the deceased. The first (fig. 23), with a scratched date (1 Rabīʿ II 737/7 November 1336), is of flat-cut champlevé script invoking, as usual, God's mercy (*ʿalā sākin hādhā al-ḥadd: al-saʿīdah al-shahīdah, . . . Malikah Khātūn*).[110] The *dāl* of *ḥadd* elegantly terminates the vertical border; *al-saʿīdah al-shahīdah* is horizontal. Since the

final consonants were *dāls*, the feminine ending was easily added to the basic formula. Above the *dāls* of *saʿīdah* and *shahīdah* are bold *shamsah*s that would have been left as decoration in the case of a male client (who was evidently envisaged, for the eulogy is much more generous than those normally accorded to females). In this example, the first *shamsah* has been ingeniously carved into a *tā' marbūṭah*. (It follows that the word *sākin* is an oversight.) Further on, the left-hand margin with *al-marḥūm* and *al-muḥtāj* theoretically poses insuperable problems, for the medial and terminal forms of *mīm* and *jīm* differ markedly; indeed, the adaptation to the feminine looks rather artificial. But fortune favored the mason. The rigid champlevé *ductus,* which left no space "below the line," made the full terminal forms of *mīm* and *jīm* impossible. Had they been properly formed in the first place, it would not have been possible to adapt them even artificially to the feminine. The mason has thus made a virtue of necessity. He doubtless also carved the name and personal details of Malikah Khātūn that occupy the central panel. But even his ingenuity could not cope with the date. Once the month, Rabīʿ al-Ākhir, had been carved, only two lines remained. In champlevé the rest of the inscription would have taken three lines, so the remainder had to be scratched on at the end.

The end of the first vertical section of a similar inscription (fig. 24)[111] is a prayer for God's mercy (ʿalā sākinah hādhā al-ḥadd al-saʿīd: not al-saʿīdah, though the inscription continues in the feminine (al-shahīdat, etc.). This is aberrant, since al-saʿīd (blessed) qualifies the deceased, not the gravestone or the tombs. Here grammar has been saved at the cost of the sense. Even more conclusive is an inscription[112] beginning, as usual, hādhā qabr . . . followed by a complete border of masculine eulogies (fig. 25). In the inscription of the central panel, however, the feminine is used: hādhihi rawḍat: al-marḥūmah ʿĀshūrah: bint Maḥmūd. This seems to be in a different script, and the evident pleonasm, hādhihi rawḍah, after hādhā qabr, must have been used to balance the abrupt change of gender. (Here, ironically, the lady has far more of an epitaph than any of her peers. Despite the sharp distinction between masculine and feminine eulogies, there was apparently not thought to be any incongruity in alloting a "masculine" gravestone to a female client. Or perhaps epitaphs for women were shorter because their families paid for less?) That such changes of gender are not limited to those enumerated here is strongly suggested by the regular use of al-saʿīd al-shahīd to fill the horizontal section of border eulogies. Should there be no alternative client, the inscriptions could easily be adapted to the feminine.

CONCLUSIONS

In this essay, the tombstones from Aswan and from Akhlat have been studied from various points of view. Clearly it is inappropriate to treat such inscriptions as if they were mere paleography, in which content and disposition are theoretically irrelevant. In the case of Akhlat, the epitaphs have been used to reveal the general social and economic status of the deceased as well as to document the use of Koranic citations and other prayers. Both the epitaphs and the tombstones yield information about the masons, their training, and their status. It has been suggested that the rigidly circumscribed rectangular *tabula* of the tombstones was not only instrumental in determining decorative schemes but also influenced the character of the scripts used.

It seems likely that the overall decoration of the Akhlat tombstones was a reaction to the traditional decoration of Armenian *khachkar*s. However, there is no evidence that Armenian funerary tradition stimulated symbolic retorts from the Akhlat masons. Furthermore, in both

cases the inscriptions are commemorative, but there is no consonance of thought or expression between them.

Craftsmen's "signatures" occur only on the decorated obverses of tombstones. The chisel tends to eliminate individuality, but epitaphs on the reverses are often clearly by other hands. An examination of those "signatures" demonstrates that the stonemason's craft was hereditary, though there may also have been apprenticeship outside the immediate family circle. Variations in craftsmen's styles and their titles suggest that in any case the "signatures" are those of workshops, not individuals. Furthermore, the free use of a common vocabulary of ornament tends to eliminate differences between various house-styles.

Strikingly, even on "signed" obverses, the inscriptions vary considerably in execution. Even the conventional local repertoire of Koranic āyahs or du'ā' does not conform to standard texts or lineation. Each time these were executed by the mason, they were carved apparently without any sketches, and with an absence of planning that cut the text off as soon as the available space had been used up. This contrasts with normal custom in the Islamic world, where the inscription is progressively squashed if it does not easily fit into the space available, in order to accommodate the complete text and to avoid the charge of textual corruption (taḥrīf).

The labor that would result from the absence of standard texts, as well as the commonsense consideration that productive workshops generally work steadily, not just to order, favored the accumulation of banks of stelae in various stages of completion. This practice extended, at least in the fourteenth century, to epitaphs carved ante mortem; these, in contrast with the Koranic āyahs, do employ a standard formulary, though it is local, peculiar, and pessimistic in tone. The final details of the death were filled in later, often in a different script, whenever necessary. As one might expect, inscriptions prepared in advance were occasionally readapted for clients, since the original client might well have moved in the interim or died elsewhere. A further aspect of ante mortem epitaphs is that shorter "form" inscriptions were developed; they were lineated for adaptation to clients of either sex—though, inevitably, not all the letter-forms lent themselves elegantly to such changes, and some alphabets, particularly those in champlevé, did not allow enough space. (The erection of unfinished or barely carved stelae suggests that those with botched decoration or those, for example, with geological faults in the tufa, were sold off cheaply.)

The Akhlat craftsmen's reactions against the Armenian models available to them, I have alleged, were not those of iconographers. Similarly, their solutions to the problems of "form" inscriptions were not those of calligraphers. Though the inscriptions show occasional flashes of brilliance in overcoming the restrictions of the medium, in general the craftsmen made only limited use of the possibilities available. Their failure to realize that champlevé was a dead end shows obstinacy, not common sense. But this, also, is unsurprising.

Workshops could evidently not afford to employ calligrapher-designers. Nor does it appear that their clients were competent to judge inscriptions, or (except for 'Alā' al-Dīn 'Uthmān) even allowed their say. Hence the general divergence between lapidary scripts and calligraphers' hands, which applies at Akhlat no less than at Aswan. Indeed, architectural inscriptions that do seem to be the work of calligraphers, like that of the Mustanṣiriyyah Madrasah at Baghdad, may not be suitable for the monuments on which they appear. It is notable, for example, that the architectural evolution of thuluth under the later Timurids, to permit the erection of long texts in conspicuous form, bears little relation to the evolution of contemporary manuscript hands.

In considering the role of script in Islamic culture, it is therefore important to establish a genre intermediate between calligraphy and common script. It is to this genre that the Akhlat epitaphs, with their experiments, their occasional failures, and their striking successes, belong.

NOTES

1. A preliminary version of this paper was read at a seminar at Oxford organized by James Allan and Julian Raby in February 1980. During the Ettinghausen Memorial Colloquium I profited from the remarks of Elizabeth Ettinghausen and David King and have subsequently become indebted for advice and information to Professors Klaus Brisch, Charles Dowsett, and Wheeler Thackston. I am particularly grateful to the Trustees of the British Museum, a grant from whom made possible a survey of the cemeteries of Akhlat in 1977.

2. R. Ettinghausen, "Arabic Epigraphy: Communication or Symbolic Affirmation?" in *Near Eastern Numismatics, Iconography, Epigraphy and History. Studies in Honor of George C. Miles*, ed. D. K. Kouymjian, Beirut, 1974, 297–317; cf. my qualifications in *Bibliotheca Orientalis*, XXXII, 1975, 337–44.

3. D. S. Rice, *The Unique Ibn al-Bawwāb Manuscript*, Dublin, 1955.

4. J. Sourdel-Thomine, "Inscriptions seljoukides et salles à coupoles de Qazwin en Iran," *Revue des Études Islamiques*, XLII, 1974, 3–43. The Great Mosque bears an inscription dated 509/1116; cf. the Masjid-i Ḥaydārīye (Sourdel-Thomine, 42) datable post-515/1121–22.

5. The Qāḍī Aḥmad's treatise on calligraphy, *Calligraphers and Painters*, trans. V. Minorsky (Smithsonian Institution, Freer Gallery of Art Occasional Papers III/2, Washington, D.C., 1959, 53), indeed gives, in a list of scripts known to "the historians," *ḥajarī*, literally, "lapidary." However, the examples he mentions are so mixed, including archaic scripts like Nabatean and Himyaritic; "contemporary" scripts like Georgian, Coptic, Chinese, and *rūmī;* Kufic and *maʿqilī* (a Basran script of the early Islamic period), that nothing is to be made of it. Minorsky plausibly conjectures that *ḥajarī* is actually a dittography of *jafrī,* a name covering various sorts of magical scripts, which appears later in the list. And, whatever the case, the Qāḍī Aḥmad had no detailed concern with lapidary scripts in his own time.

Furthermore, the Qāḍī almost entirely ignores monumental scripts of historical (as opposed to archaic or legendary) times. As an exception, he cites (Qāḍī Aḥmad, 60) the son of Shaykh Suhrawardī who wrote the Sūrat al-Kahf (Koran 18), which was then reproduced in relief in brick in or on the main mosque of Baghdad.

Other pupils of Yāqūt al-Mustaʿṣimī wrote texts that were reproduced or enlarged in glazed tiles on buildings in Baghdad, in particular on/in the Marjānīyah Madrasah (Qāḍī Aḥmad, 61), at Tabriz and in Shiraz (Qāḍī Aḥmad, 62–63). The Marjānīyah/Mirjānīyah Madrasah (F. Sarre and E. Herzfeld, *Archäologische Reise im Euphrat- und Tigris-Gebiet,* Berlin, 1920, I, 45–50) was founded in 758/1357.

In Baghdad, Sarre acquired two fragments from an inscription in glazed relief on an elaborate terra-cotta ground (Sarre and Herzfeld, III, Pl. XII a–b) bearing part of the Sūrat al-Kahf (18:105), which suggests that the calligrapher, Arghūn Kāmil (Qāḍī Aḥmad, 61), took his inspiration from Shaykh Suhrawardī's son. The script is markedly calligraphic, not only with *tashkīl* and *ḥarakah* but also with Koranic breathing marks, and there can be little doubt that this is the very inscription referred to by Qāḍī Aḥmad.

This suggests that his further references to the work of Jalayirid calligraphers on the monumental inscriptions of Tabriz, Shiraz, and elsewhere should be taken seriously. Though not one of the Persian buildings he mentions is standing, Jalayirid painting and calligraphy are now recognized to be fundamental to the development of the arts of the book in fifteenth-century Islam, and the inscription from the Marjānīyah Madrasah is thus a precursor of the monumental *thuluth* inscriptions on extant Timurid buildings at Mashhad, Samarqand, Khargird, and Herat.

These Jalayirid inscriptions were not, however, an invention *ex nihilo,* though the Qāḍī Aḥmad evidently thought so. Around the outside of the Mustanṣirīyah Madrasah at Baghdad, founded by the Abbasid Caliph, al-Mustanṣir, in 630/1232–33, runs an impressive monumental *thuluth* inscription in terra-cotta (Sarre and Herzfeld, I, 42–43, with a text of the inscription incompletely copied by Niebuhr, which disappeared in the restoration of 1282/1865–66). This also is plainly a copy of a calligraphed inscription (cf. Sarre and Herzfeld, IV, pl. CXXX; for a more recent photograph, see *Baghdad: An Illustrated Historical Survey,* Baghdad, 1969, 261). Though somewhat experimental and leaving rather too much of the ground bare, it is unquestionably the earliest grand monumental inscription in Islam and testifies to the tastes and attainments of Baghdad calligraphers by the thirteenth century.

The Jalayirids must thus have been consciously reviving a tradition established at Baghdad before the fall of the Abbasid caliphate. Outside their immediate sphere of influence, such calligraphers' inscriptions were not popular; the elaborate inscriptions of the fourteenth-century tile revetments of the mausolea in the Shāh-i Zindah at Samarqand are still far from book hands.

6. ʿAbd al-Raḥmān M. ʿAbd al-Tawwāb, *Stèles islamiques de la nécropole d'Assouan,* rev. and ann. S. Ory (to whom the major credit for the work should go), I, nos. 1–100, Cairo, Institut Français d'Archéologie Orientale, 1977 (hereafter, ʿAbd al-Raḥmān). See also my review of the work in *Bibliotheca Orientalis,* XXXV, 1978, 386–92.

7. Gaston Wiet et al., *Stèles funéraires,* Cairo, 1932 onward.

8. ʿAbd al-Raḥmān, nos. 2, 147.

9. N. Abbott, *The Rise of the North Arabic Script,* Chicago, 1939, s.v. *mashq.*

10. For example, ʿAbd al-Raḥmān, no. 39, line 2

(dated 240/855); and no. 115, line 5 (dated 17 Ramaḍān/ 1 October 866).

11. For example ʿAbd al-Raḥmān, no. 123, dated 253/867.

12. Monneret de Villard, *Introduzione allo Studio dell'Archeologia Islamica,* Venice and Rome, 1966; 1968, 271.

13. Died 245/859. Van Berchem, *CIA,* I, no. 562.

14. V. M. Minorsky, *Studies in Caucasian History,* Cambridge and London, 1953, 146–56 (hereafter, Minorsky, *Studies*).

15. Abū al-Ḥasan b. Abī Bakr al-Harawī, *Guide des lieux de pèlerinage,* trans. and ann. J. Sourdel-Thomine, Damascus, 1957.

16. F. Taeschner, "Akhlāṭ," *EI²,* s.v.

17. C. Cahen, "Une source pour l'histoire ayyoubide: Les mémoires de Saʿd al-Dīn Ibn Ḥamawiya Djuwaynī," *Bulletin de la Faculté des Lettres de Strasbourg,* 1950/57, 320–37; rep. *Les peuples musulmans dans l'histoire médiévale,* Damascus, 1977, 457–82, especially 467–69.

18. Cf. D. Ayalon, "The Wāfidiyya in the Mamlūk kingdom," *Islamic Culture,* 1951, 91–104; rep. *Studies on the Mamlūks of Egypt 1250–1517,* London, 1977, possibly associated with the deliberate Mamluk discrimination against their Ayyubid predecessors and their Kurdish troops, for which he argues in "Aspects of the Mamluk Phenomenon: B. Ayyūbids, Kurds and Turks," *Der Islam,* LIV, 1977, 1–32; rep. *The Mamluk Military Society,* London, 1979. B. Karamağaralı's assertions that in the late thirteenth century some 12,000 families migrated with a certain Shaykh Ḥusayn to Cairo and that they founded a quarter there known as 'Akhlat' remain to be substantiated in the Mamluk sources. The numbers in any case must be a wild exaggeration; for at almost any period in the existence of the town the migration of 12,000 families would have depopulated it. ("A Ceramic Oven Discovered in Ahlat," *Fifth International Congress of Turkish Art,* G. Fehér, ed., Budapest, 1978, 479–91 [hereafter, Karamağaralı, "A Ceramic Oven"]).

19. Minorsky, "Thomas of Metsopʿ on the Timurid-Turkman Wars," *Festschrift Muḥammad Shafīʿ,* Lahore, 1955, 1–26, and especially 5; rep. *The Turks, Iran and the Caucasus in the Middle Ages,* London, 1978.

20. A. K. Sanjian, *Colophons of Armenian Manuscripts, 1301–1480: A Source for Middle Eastern History,* Cambridge, Mass., 1969, passim. For important supplementary sources, see D. K. Kouymjian's review of this work in *International Journal of Middle East Studies,* III/1, 1971, 81–89. The Armenian orthography of Akhlat (Arabic: Khilāṭ) is variable, between Khlat and Łelat where ł is more or less the phonetic equivalent of Arabic *ghayn* and è is the standard neutral epenthetic vowel separating Armenian consonants. This form is evidently the source for the *nisbah,* al-Ghalaṭī, attested in the Akhlat stelae.

21. Minorsky, "Kurds," *EI¹,* s.v., cf. "Ahlat," "Kürtler," *Islâm Ansiklopedisi,* s.v.

22. The earliest occurrences of the *nisbah* al-RWShGI at Akhlat appear to be no. 104, with an obliterated date, probably to be read 7–7; and no. 106, where an epitaph dated 78–/1380s refers to an RWShGi great grandfather (B. Karamağaralı, *Ahlat Mezartaşları,* Ankara, 1972 (hereafter, Karamağaralı, *Ahlat Mezartaşları*)).

23. Minorsky, *Studies,* 124–30, demonstrates the irrelevance of the Rawādī/Rawwādī Kurds, from whom Saladin traced his descent, to the ethnogenesis of the Rūzagī confederation.

24. J. E. Woods, *The Aqquyunlu: Clan, Confederation, Empire,* Minneapolis and Chicago, 1976, especially 123; cf. also "Kurds," *EI¹,* s.v.

25. A. Gabriel, *Voyages archéologiques dans la Turquie orientale,* Paris, 1940, I–II, 241–51 (hereafter, Gabriel, *Voyages*), J. Sauvaget, "Inscriptions Arabes," in Gabriel, *Voyages,* 346–50.

26. A. Ṣ. Beygu, *Ahlat kitabeleri,* Istanbul, 1932.

27. The most accessible account is B. Karamağaralı's "A Ceramic Oven," 480, n. 4.

28. Less, however, than from the tombstones to be discussed. The inscriptions from the mausolea, collected by Sauvaget (Gabriel, *Voyages,* 346–50), possibly because of the very limited space offered by the lintels on which they appear, conform much more to the stock foundation-inscriptions of Anatolia and Transcaucasia in the thirteenth and fourteenth centuries. When, exceptionally, they do not, as on the (Aqqoyunlu) Bayındır Türbe (*Voyages,* 349, no. 139), completed in 897/1491–92, they still differ considerably from the epitaphs on the tombstones. It is notable, however, that the section of the inscription relating to Mubāriz al-Mulk wa-al-Dīn Bāyındır Beg (spelled Bīk), died Ramaḍān 886/October–November 1481, concludes with detailed prayers for him.

29. B. Karamağaralı, *Ahlat Mezartaşları.* References to inscriptions published here will be preceded by the abbreviation *BK.* The work could easily be augmented, since her principle of selection was that, as far as possible, stelae should bear both craftsmen's signatures and legibly dated epitaphs. However, what she has done is well done, and her readings only occasionally need emendation. Since the primary aim of the present essay is not to offer new epigraphic material but to analyze what is already available to scholars, it is to her publication that reference will be made in the first instance. The *JMR* numbers refer to the photographic archive in the Department of Oriental Antiquities in the British Museum.

30. *BK* no. 18, epitaph dated Shawwāl 556/October 1161. This is surmounted by a slender elongated pyramid bearing a deeply incised bold *naskhi duʿā'*, which may be a later addition.

31. *BK* no. 19.

32. For example, the grave of ʿAlā' al-Dīn ʿUthmān (*BK* no. 30; *JMR* no. 124), epitaph dated Ṣafar 668/ October 1269.

33. Perhaps, to judge from his name, Abū ʿAbd Allāh

Ḥusayn b. ʿAlī b. Abī Ṭālib al-Iṣfahānī (*BK* no. 20), epitaph dated Muḥarram 607/September 1210, but this has made no substantial difference to the terms of the inscription.

34. The tomb of Abū Manṣūr Altuntāsh, with a strikingly similar formula, . . . *wa-raḥima man taraḥḥama ʿalayhi* (may God [also] pardon whosoever invokes His mercy upon him). This is dated 11 Ṣafar 514/12 May 1120. See K. Moaz and S. Ory, *Inscriptions arabes de Damas: Les stèles funéraires. I. Cimetière d'al-Bāb al-Ṣaġīr*, Damascus, 1977, 28–30, no. 4. But the formula does not occur on later monuments, and it is unclear how far it can be taken as indicative of current practice in the eleventh and twelfth centuries. As with the Akhlat occurrence, its very explicitness perhaps speaks against it.

35. *BK* no. 66; cf. also *JMR* no. 6, 23, 25–26.

36. *BK* no. 67, epitaph dated Dhū al-Ḥijjah 711/April 1312.

37. Cf. the names cited in Ayalon, "The Wāfidiyya" and "Aspects" (cited in note 18 above).

38. *BK* no. 64. The epitaph states that he died at Akhlat (date obliterated) while returning from Baghdad.

39. A. Dietrich, "Zu den mit *ad-dīn* zusammengesetzen islamischen Personennamen," *ZDMG*, cx, 1960–61, 43–54.

40. For example, *BK* no. 56, epitaph dated Muḥarram 687/February–March 1288; no. 88, epitaph dated Jumādā II 744/November 1343.

41. Ayalon, "Names, Titles and 'Nisbas' of the Mamlūks," *Israel Oriental Studies*, v, Tel Aviv, 1972, 189–232; rep. *The Mamlūk Military Society*, London, 1979. This uses both Van Berchem's epigraphic material and the sources (historical and biographical).

42. *BK* no. 47 Ustādh ʿAlī b. Mawdūd al-maʿrūf [bi-] al-Mūshī, epitaph dated Jumādā II 660/March–April 1262.

43. *BK* no. 61, epitaph dated Rabīʿ I 697/December 1297–January 1298.

44. See note 38 above.

45. See note 20 above.

46. *BK* no. 74, died Dhū al-Ḥijjah 725/November–December 1325.

47. *BK* no. 73, death date obliterated.

48. *BK* no. 66, died Jumādā I 701/January 1302.

49. *BK* no. 100, died mid-Shaʿbān 731/May 1331.

50. *JMR* no. 70, year obliterated, but c. 1300.

51. *BK* no. 88, died Jumādā II 744/November 1344; no. 91, died early Ramaḍān 743/January 1343.

52. *BK* no. 102, died 22 Ṣafar 727/17 January 1327.

53. *BK* no. 49, epitaph dated Ṣafar 668/October 1269.

54. *BK* no. 46, epitaph dated 3 Ṣafar 659/7 January 1261.

55. *BK* no. 57, epitaph dated 1 Muḥarram 690/4 January 1291.

56. *BK* no. 77, year partly obliterated, epitaph dated to 71–/1310s.

57. *BK* no. 80, epitaph dated Ṣafar 721/March 1321.

58. *BK* no. 98, epitaph dated early Ṣafar 727/December 1326.

59. *BK* no. 30, and see note 17 above.

60. *BK* no. 47, died Jumādā II 660/March–April 1262.

61. *BK* no. 48, died Dhū al-Ḥijjah 664/September 1266.

62. *BK* no. 114. The disarrangement evidently resulted from the need to alter ʿAlam al-Dīn's own epitaph to accommodate that of his son, Shams al-Dīn Shīrīn (?), who died in 69–/1290s *bi-maqām-i Īrān* (while *en poste* in Iran [?]). Because his son predeceased him, ʿAlam al-Dīn's epitaph must have been prepared, at least in part, *ante mortem*. The son's epitaph was then given primacy of place. Below, deeply scratched, is *al-madhkūr* ʿAlam al-Dīn (the aforementioned . . .) and the record of his death, now illegible.

63. Karamağaralı, *Ahlat Mezartaşları*, 256.

64. *BK* no. 83, year obliterated.

65. Even though craftsmen's signatures contain personal names and are regularly preceded by ʿamal (the work of), they vary more than they should if they were simply those of the same individual at different stages of his career (figs. 9, 10). For example, Mīrcheh b. Mīrān (*BK* nos. 96–102, with dated epitaphs covering the period Rajab 719/August 1319 to Shaʿbān 731/May 1331) appears as (no. 96) Mīrchā shāgird Yūsuf; (no. 97) Mīrcheh shāgird Yūsuf; (no. 98) al-ḥajj Mīrcheh b. Mīrān; and (the remainder) Mīrcheh b. Mīrān. *Mīrchā* is an odd error: it suggests a name dictated and transcribed phonetically; but then, paradoxically, it would follow that the "signature" was executed by someone else and that it was the *ustādh* who did the decoration. The variation is pointless, hence, in spite of the use of the term *shāgird*, an indication that different craftsmen from the workshop were involved. Some at least appear to be more like trademarks of workshops than individual signatures. This casts some doubt on the appropriateness of the term "signature." It is better therefore to use it in quotation marks.

66. *BK* nos. 75–78, the only fully dated epitaph being no. 76, Rabīʿ I 714/July–August 1314.

67. I am greatly indebted to Professor Charles Dowsett for the following comments:

> One would certainly expect a few Armenians to have been at Khlatʿ in the 13th–16th centuries, but I should not like to lay any firm claims to H'WAND and HWYNK, which is the way I think I might transliterate your re-transliterations of the transcriptions

in your sources. If one had H'WNK (i.e., if -D is mis-read) one might be dealing with HAWANAK, male name attested A.D. 1433 (H. Ačaṙyan, *Hayocʿ anjnanunneri bararan* III, Erevan 1946, 96); or, given that Arm. *Y-* at that time would be pronounced *H-*, possibly *YAWANAK, diminutive of *YAWAN* attested 1343 (Ačaṙyan, 525), or, if the first vowel was pronounced very broadly, *YO-VANAK*, 17th century? (Ačaṙyan, 534, re Dashian, catalogue of the Vienna Mekhitarist manuscripts 386). The third character of HWYNK is a nuisance (though YOYNKᶜ, pronounced *HUYNKᶜ*, means "Greeks," "Greece"); one might just think of YOVHANIK, attested diminutive of YOV-HANNES, "John" (Ačaṙyan III 538); *YOVNANIK (in case *Y* is another *N*) is not attested as a diminutive of YOVNAN "Jonah," though it would be a very possible form, as a hypocorisma. So you see one would have to be pretty determined to identify your mysterious pair as Armenians.

In these circumstances, and given the lack of even superficially Armenian patronymics for these, or for any others, it is advisable to read the names as local distortions or errors for Persian *Khāwand* and *Hūshang*.

68. *BK* no. 62, reading clearly ᶜamal Jumᶜah b. Muḥammad shāgird HWYNK, epitaph dated 6–7/?late thirteenth century.

69. *BK* nos. 42–47, epitaphs covering the period Rajab 647/November–December 1249 to Jumādā II 660/March–April 1262.

70. *BK* nos. 30, 32, 48–51, epitaphs covering the period Ṣafar 668/October 1269 to Rabīᶜ II 674/September 1275.

71. *BK* nos. 63–70, epitaphs covering the period Ṣafar 695/December 1295 to Rabīᶜ II 728/February–March 1328.

72. *BK* nos. 71–74, epitaphs covering the period Ṣafar 714/May 1314 to Dhū al-Ḥijjah 725/December 1325.

73. *BK* nos. 61–62, epitaphs late thirteenth century.

74. *BK* nos. 83–86, epitaphs covering the period Dhū al-Ḥijjah 717/February–March 1318 to 737/1336.

75. *BK* nos. 31, 88–94, epitaphs covering the period 720–1320 to Ramaḍān 743/January 1343.

76. *BK* nos. 96–102, epitaphs covering the period Rajab 719/August 1319 to Shaᶜbān 731/May 1331.

77. *BK* no. 95. Date of epitaph obliterated.

78. *BK* nos. 52–60, epitaphs covering the period Muḥarram 676/June–July 1277 to Shawwāl 691/September 692.

79. *BK* nos. 63–70, epitaphs covering the period Ṣafar 695/December 1295 to Rabīᶜ II 728/February–March 1328.

80. *BK* no. 75, 69–/1290s.

81. See note 56.

82. *BK* no. 83, date obliterated.

83. *BK* nos. 61–62, the former with an epitaph dated Rabīᶜ I 697/December 1297. He himself was the *shāgird* of HWYNK/*Hūshang.

84. *BK* no. 71, date of epitaph obliterated. It should be noted that the use of *al-ustādh* is inconsistent.

85. I do not intend to deal in detail with the various decorative motifs, which are adequately discussed by B. Karamağaralı and of which the illustrations to this article give an overall idea.

86. Cf. *BK* no. 57, epitaph dated 1 Muḥarram 690/ 4 January 1291.

87. For example, *BK* no. 67, epitaph dated Dhū al-Ḥijjah 711/April 1312, where the overlying triangle grid is lopped at the sides, evidently because an equilateral-triangle grid was planned but did not fit the particular space available. Though the case is so far exceptional, it suggests strongly that the craftsman mechanically copied a preexisting design (either from a stencil or from a stone already standing) and was either unwilling or unable to reduce it to fit a somewhat smaller space.

88. First datable occurrence *BK* no. 52, epitaph dated Rabīᶜ II 676/October 1277.

89. *BK* no. 52; also *BK* no. 65, epitaph dated 23 Ṣafar 700/7 November 1300.

90. Cf. *BK* no. 72, epitaph dated Ṣafar 714/May 1314.

91. The following account is based on L. Azarian *Khatchkar (Croci di Pietra)* (Documenti di Architettura Armena 2), Milan, 1969, with the reservations expressed by S. Der Nersessian in her review of the work in *Revue des Études Arméniennes*, NS VI, 1969, 418–31. The functional diversity of *khachkar*s was first noted by S. K. Barkhudarian in *Armenian Architects and Sculptors* (in Armenian), Erevan, 1965.

92. N. Stepanian and A. Chakmakchian, *Dekorativnoye iskusstvo srednevekovoi Armenii*, Leningrad, 1971, pl. 69, built into the west wall of the Oratory of the Virgin.

93. Ibid., pl. 79, now in the State Historical Museum, Erevan.

94. Iconographically termed *Amenaprkich* (Christ, the Saviour of all). K. Kafadarian, *Haghpat: The Buildings and Lapidary Inscriptions* (in Armenian), Erevan, 1963, 203–5, no. 74.

95. With one exception, *BK* no. 32, c. 1275, the work of Uways b. Aḥmad. This is a bizarre piece of work with, *inter alia*, a cornice on both faces.

96. Dr. David King has pointed out to me that the east–west orientation of the Akhlat cemetery indicates burial of the corpse with the right side facing the *qiblah*,

however this was determined locally. See "Ḳibla," *EI²*, s.v.

97. These are *khoran*s and canon tables, mostly Cilician; there is much less Greater Armenian material extant. For references, see J. M. Rogers, "Architectural Decoration at Sivas," in *The Art of Iran and Anatolia from the 11th to the 13th centuries A.D. (Colloquies on Art and Archaeology in Asia)*, IV, ed. W. Watson, London, 1975, 13–27.

98. *BK* no. 50, epitaph dated Dhū al-Qaʿdah 670/June–July 1272.

99. First observed by I. A. Orbeli, "Musulmanskiye izraztsy. Ocherk," reprinted in *Izbrannyye Trudy*, Erevan, 1963, 252–68, with the implication that alleged similarities between Armenian and Saljuq stone carving owe as much to the similar materials used. While this assertion needs qualification, it provides further grounds for reserve in associating the carving of the Akhlat gravestones with the stonecarving of Saljuq Anatolia.

100. *BK* no. 44, epitaph dated 5 Shaʿbān 652/20 September 1254.

101. *BK* no. 48, epitaph dated Dhū al-Ḥijjah 664/September 1266.

102. *BK* no. 83, year obliterated, early fourteenth century, signed ʿamal Yūsuf b. Mīrān shāgird Jumʿah.

103. *BK* no. 43, epitaph dated Rabīʿ II 649/August 1251 is a virtual duplicate.

104. The only discussion of these breathing marks to date is in A. Grohmann, *Arabische Paläographie II. Teil. Das Schriftwesen. Die Lapidarschrift*, Vienna, 1971, 42–44, under the section "Die Differenten." The V-sign is evidently a shortening of *lām-alif*, i.e., *lā waqfa* (no pause), hence equivalent to, though not replacing, *sukūn*. There seems to be no occurrence at Akhlat where it is used as a breathing mark, but nor is there much consistency in its use in Koranic manuscript hands. In Mamluk *thuluth* or *muḥaqqaq* it is often used with *sukūn* over the *sīn* of *basmalah*. But in *naskhī*, basically a copyist's, not a calligrapher's, hand, *ḥarakah* is rarely so complete as to include it. *Ḥarakah* is almost nonexistent in the incised hands at Akhlat, but *shāddah/tashdīd* is equally rare. There are analogies for the ornamental use of the V-sign in the filling of certain monumental Kufic alphabets so as to give a rhythmic sequence of ascenders in a line, should *alif-lām* and *lām-alif* not occur in the right place. Cf. the inscriptions of the *masjid* of the audience hall at Lashkarī Bazar and the list of comparative material for the eleventh and twelfth centuries given in J. Sourdel-Thomine, *Lashkari Bazar: Une résidence royale ghaznévide et ghoride* (Mémoires DAFA XVIII) I B, Paris, 1978, 49, and n. 3; pl. 135.

105. The meter, Professor Wheeler Thackston kindly informs me, a mixture of *qiṭʿa* and *rubāʿī*, is, like its very conventional worldly sentiments, less distinguished than the script.

106. See note 50 above. The date of the epitaph has been obliterated.

107. *BK* nos. 65–66, epitaphs dated 23 Ṣafar 700/7 November 1300; Jumādā I 701/January 1302.

108. See page 111 and note 34 above.

109. *BK* nos. 106–12, though bearing craftsmen's "signatures" not obviously related by patronymic to the main group. Particularly relevant is *BK* no. 111, epitaph dated Rabīʿ II 912/August–September 1506.

110. She was the daughter of Nāṣir al-Dīn Shādbak, whose gravestone also may bear a "form" inscription.

111. *JMR* no. 41. The horizontal section here has *al-saʿīdah al-muḥtājah*, but since the script is normal hollow-cut incised, the *jīm* of *al-muḥtāj* in the masculine is obtrusively in the final form, to which the tail of the *tāʾ marbūṭah* is rather weakly attached.

112. *JMR* no. 53.

FIG. 1. Group of epitaphs; *JMR* no. 6. Tallest (center, background) = *BK* no. 68, epitaph dated Shaʿbān 712/November 1312; (center, front) = *BK* no. 66, epitaph dated Jumādā I 701/January 1302. Both signed ʿamal Aṣīl b. [U]ways. The "complete" funerary monument, with headstone, footstone, and cenotaph, was eliminated in most areas of the cemetery by pressure on space. The difference in style in the decoration of cenotaphs suggests, anyway, that they were continually reused.

FIG. 2. Group of epitaphs with keyhole-arched niches; *JMR* no. 272. Cf. *BK* no. 85, epitaph dated 9 Dhū al-Qaʿdah 725/28 July 1325, with "signature" of Yūsuf b. Mīrān. The present group includes "signatures" of Muḥammad b. [U]ways and Aṣīl b. Uways (*JMR* nos. 276, 274).

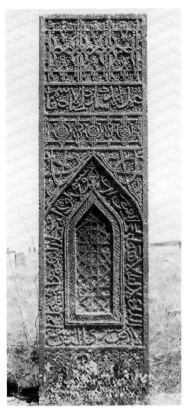

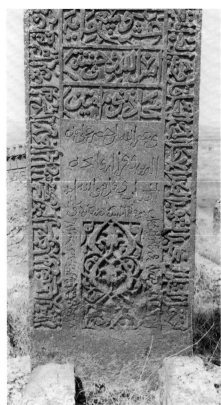

Left: FIG. 3. Stela of a Muqrī, Khwājah Muḥammad b. al-marḥūm Ḥusayn . . . inscribed *ʿamal Aḥmad shāgird al-Ustādh Qāsim,* epitaph dated Jumādā I 823/May 1420; *BK* no. 76, *JMR* no. 85. Decorated obverse bears Koran 2:255 *alladhī yashfaʿa.* Type associated with Mīrcheh b. Mīrān (cf. *BK* no. 100, epitaph dated Shaʿbān 731/May 1331; see also Figures 8–10).

Right: FIG. 4. Stela of Zayn/Nūr al-Dīn b. Abū al-Ḥasan, great grandson of Muḥammad al-Ghalaṭī (detail), epitaph dated mid-Rabīʿ 714/late July 1314; *BK* no. 76, *JMR* nos. 12, 11. Champlevé, flat cut, with, exceptionally, *tashkīl* and some *ḥarakah.* The incised imploration has no pointing whatsoever. Toward the end (lower left) the script becomes deformed by pressure on space, resembling archaizing Kufic. At the end in figs. 71[4].

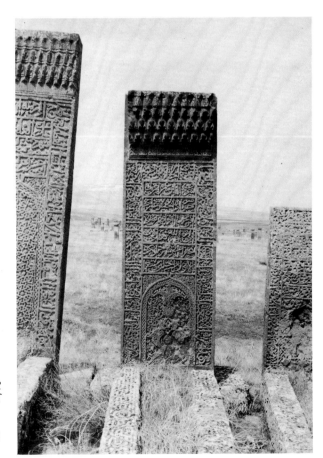

FIG. 5. Stela of Shihāb al-Dīn Amīr Ghāzī b. al-marḥūm Sharaf al-Dīn ʿUmar, great grandson of Muḥammad al-Ghalaṭī, dated Jumādā I 701/January 1302, inscribed *ʿamal Aṣīl b. [U]ways; BK* no. 66, *JMR* no. 23. Rounded champlevé on lower relief ground of dense springy scrolls. To left (*BK* no. 68) is the tomb of his brother, Aṣīl al-Dīn ʿAlī, epitaph dated mid-Shaʿbān 712/November 1312, also inscribed *ʿamal Aṣīl b. [U]ways.* Flat-cut champlevé.

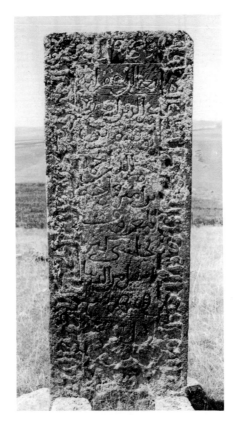

Fig. 6. Stela of ʿIzz al-Dīn Amīr:
b. Yūsuf b. Najm al-Dīn
Aḥmad: b. Amīr Khwājah: al-
maʿrūf: bi-chāshnīgīr [sic], date
of epitaph obliterated; *JMR* no.
70. Champlevé border eulogy;
epitaph incised between lightly
scratched lines, hollow-cut with
freely expanded letters, e.g., *al-
maʿrūf* occupying the whole of a
line.

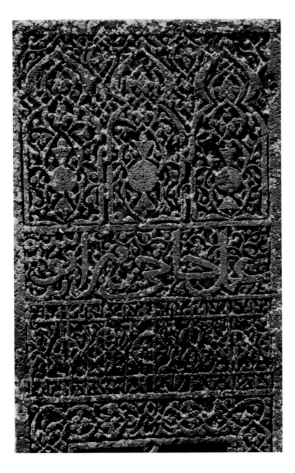

Fig. 8. Stela (detail)
inscribed ʿamal Ḥājjī
Mīrān b. Yūsuf in flat-
cut champlevé on
distracting scroll
ground; *JMR* no. 171.
Inscription
conspicuously better
lineated than Koran
2:255 below. Panel of
mosque lamps shows
mason's marks
indicating layout.

Fig. 7. Stela, epitaph dated Rabīʿ
I 714/July-August 1314; *BK* no.
76, *JMR* no. 115. Decorated
obverse inscribed ʿamal HAWND
[Khwānd] b. BRGI, rather
exceptionally with stalactite
cornice on this face. Ornament
comparable to Figure 10. Koran
2:255 in squashed rounded
champlevé, ending abruptly at
al-samāwāt wa.

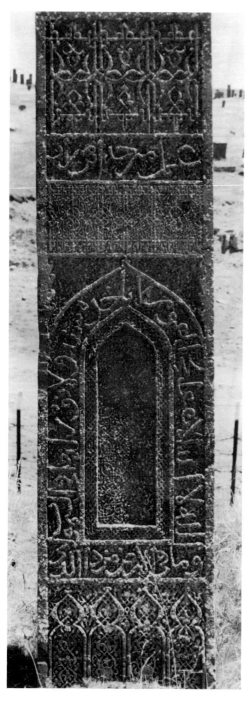

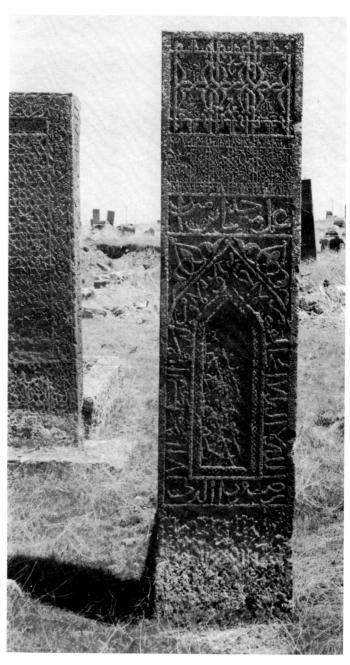

FIG. 10. Stela of ʿAlāʾ al-Dīn b. Sadīd al-Dīn (fourteenth century, year obliterated), inscribed ʿamal Mīrcheh b. Mīrān; BK no. 101, JMR nos. 173, 175. Koran 2:255, breaking off at alladhī. But for spandrels and filling of niche a straight duplicate, panel for panel, of Figure 9. Though Koranic inscription is identical, lineation is markedly different. Left: stela of Nūr al-Dīn Aḥmad b. Muḥammad al-Malājirdī, epitaph dated Rabīʿ I 697/December 1297–January 1298, inscribed ʿamal Jumʿah shāgird . . . (BK no. 61). There is no obvious family relationship here between the two craftsmen.

FIG. 9. Stela of sayyid al-ḥuffāẓ al-muqrī: Amīr Khiḍr b. al-ṣadr: al-ajall al-muqrī ʿAlāʾ: al-Dīn ʿAlī, epitaph dated 22 Ṣafar 727/17 January 1327, inscribed ʿamal Mīrcheh b. Mīrān; BK no. 102, JMR no. 195. Koran 2:255, breaking off at alladhī.

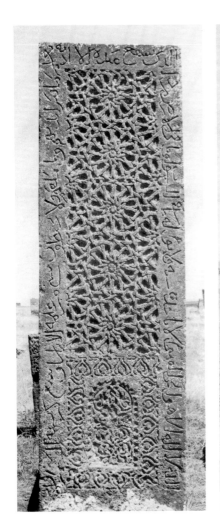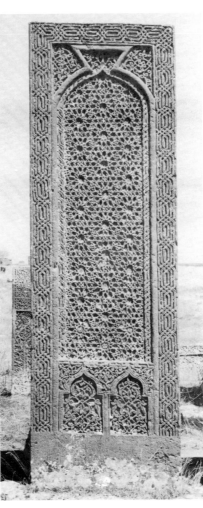

Left: FIG. 11. Stela of Abū al-Barakāt Ṣāliḥ b. Abī'l-Qāsim; *BK* no. 46, *JMR* no. 96. Koran 2:255 to *al-samāwāt,* final word squashed in. The decorative niche at the base is repeated on the epitaph obverse, dated 3 Ṣafar 659/11 January 1261.

Right: FIG. 12. Stela of (*laqab* obliterated) ᶜUmar b. Sharaf al-Dīn Yūsuf, epitaph dated 1 Muḥarram 690/4 January 1291; *BK* no. 57, *JMR* no. 108. Epitaph in champlevé, filling border and upper part of central panel. Below this is incised eight-line Persian elegy, with craftsman's "signature" in sunken panel at base, *ᶜamal Asad al-Wās[Wāsh];* possibly for al-[U]ways[ī]?

Below: FIG. 13. Group of stelae decorated with mosque-lamp motif. *JMR* no. 13. From left to right, three stages of evolution: headpiece with *Kull nafs dhā'iqat al-mawt,* but inscription frame left blank; fully worked without headpiece, but Koran 2:255, incised, to *ilā bi-idhnihi;* unworked but for relief of main motif.

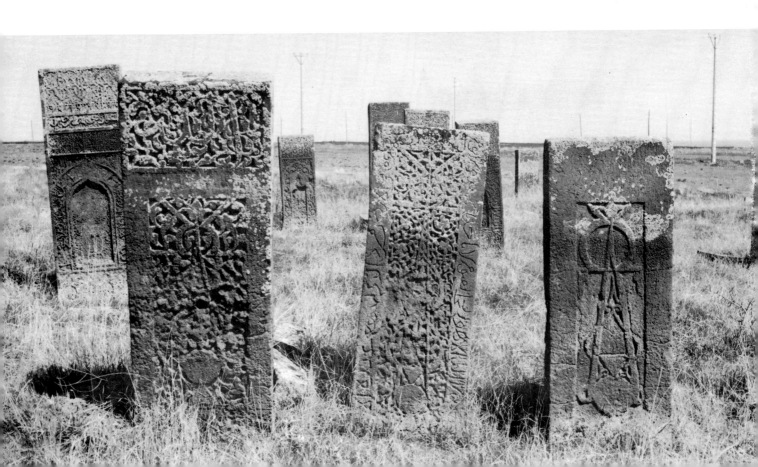

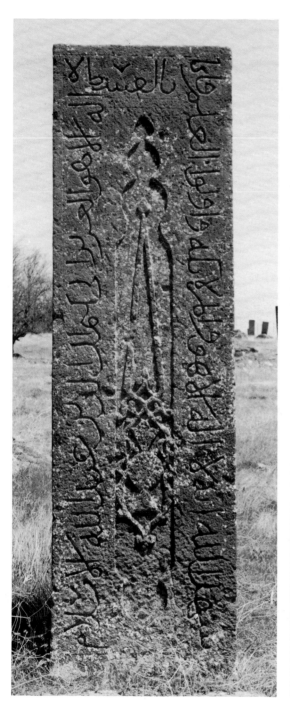

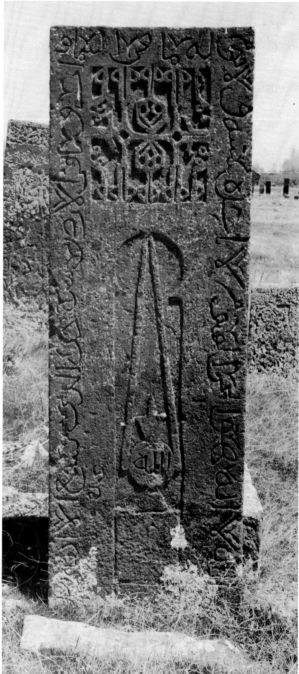

FIG. 14. Stela with mosque lamp (detail) showing mason's marks; *JMR* nos. 179–80. Koran 3:18–19 to *al-Islām,* incised, final word elongated to coincide with "natural" caesura.

FIG. 15. Stela with mosque lamp, unsigned, epitaph dated Rabīᶜ II 649/August 1251; *JMR* nos. 154–55, virtual duplicate of *BK* no. 43. For plaited pseudo-Kufic, cf. *BK* no. 42, inscribed ᶜ*amal Aḥmad al-Muzayyin,* epitaph dated Rajab 647/November–December 1247; and Figure 16 opposite. Koran 2:255 to *ilā bi-idhnihi,* and possibly an additional word.

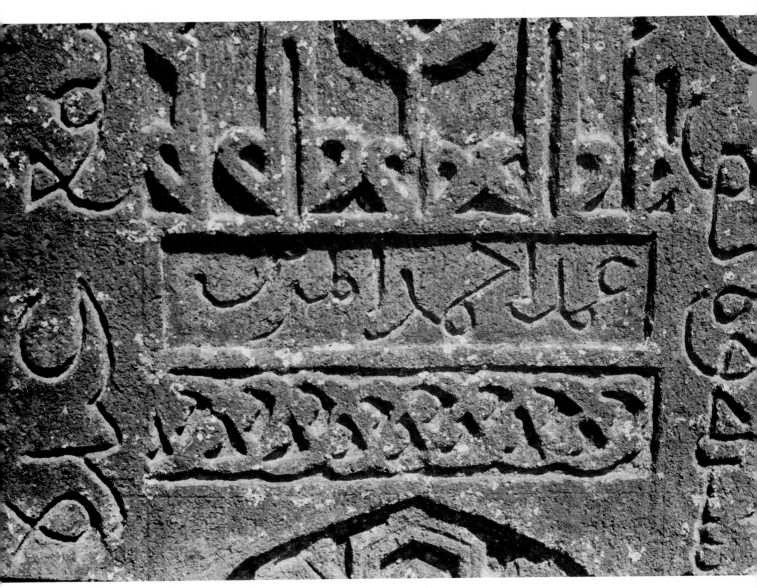

FIG. 16. Stela inscribed *ʿamal Aḥmad al-Muzayyin* (detail); *JMR* no. 145. Koran 2:255, [*yash*]*faʿa ʿindahu*, on left, carved similarly to "signature."

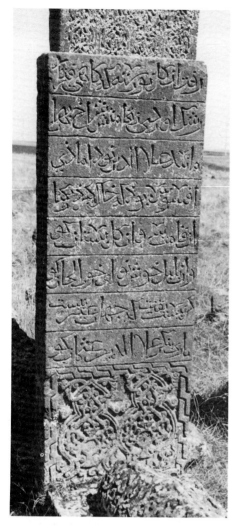

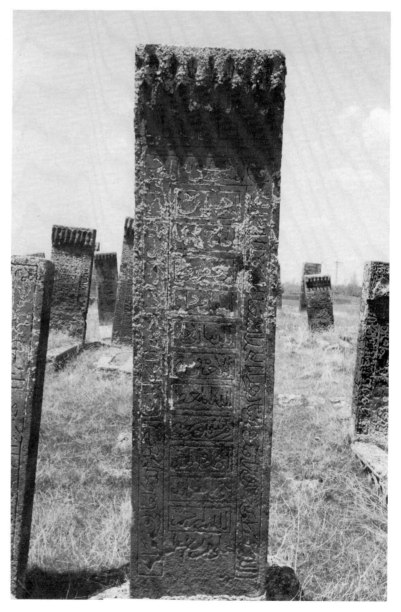

FIG. 18. Stela of a son of al-ḥājj Muḥammad b. Maḥfūz (*JMR* no. 55) buried at his father's right (*JMR* no. 54). *Intaqala min dār al-dunyā ilā dār al-ākhira fī shahr*. No month or date follows and the inscription continues on another tack.

FIG. 17. Stela of *muftī al-fāriqī* ([*sic*], read *fāriqīn*) ʿAlāī ([*sic*]: read ʿAlāʾ) al-milla wa-al-Dīn ʿUthmān b. al-marḥūm Sharaf al-Dīn ʿUmar, a great grandson of Muḥammad al-Ghalaṭī, died late Ṣafar 668/late October 1269; *BK* no. 30, *JMR* no. 124. Headstone inscribed (see fig. 26) ʿamal Uways b. Aḥmad. Between headstone and footstone is a cenotaph inscribed in different style with a *ḥadīth: al-dunyā ḥaram ʿalāʾ ahl al-ākhirah wa-al-ākhirah ḥaram ʿalāʾ ahl al-dunyā wa-al-ākhirah ḥaram ʿalāʾ ahl Allāh* ([roughly] "this world is barred to the other world and the other to this, and the other world is barred to God's people" [sense obscure]). Footstone with eight-line Persian elegy between carefully incised lines.

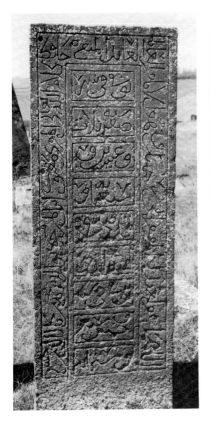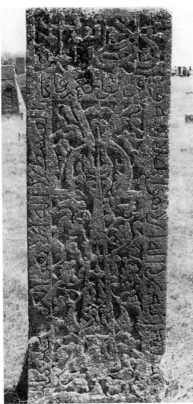

Left: FIG. 19. Stela of Maʿtūq b. al-marḥūm Nūr al-Dīn Muḥammad b. Kamāl al-Dīn Ḥusayn, dated Ṣafar 723/February-March 1323; *JMR* no. 199. Second date below 675 (mason's error for 775). Border is atypical: *allahumma ghafara li-ʿabdika al-mufaqqar* ([*sic*]: possibly read *faqīr*) *ilā raḥmatika wa-huwa al-imām al-ʿālim: al-ʿabid al-mutaqqī*(?): *ḥāfiẓ kalām Allāh taʿālā al-muqrī* . . . The fine swash terminals and varying line of the name that follows on this are imaginatively set and may indicate a change of hand after *taʿālā*, which would thus end a "form" inscription.

Right: FIG. 20. Stela with champlevé inscription *Kull nafs dhāʾiqat al-mawt*, not completely worked, cf. area above *lām* of *kull*; *JMR* no. 289. Koranic inscriptions are a mishmash of *āyah* fragments, ending *lā ilāh ilā huwa al-ʿazīz al-ḥakīm*. Dittography of *wāʾ* at upper right.

Left: FIG. 21. Unworked stela; *JMR* no. 209. Dentation of cornice and inverted niche added with stone already erect.

Right: FIG. 22. Stela, partially worked, headpiece of *Kull nafs dhāʾiqat al-mawt* in champlevé on heavy scroll ground; *JMR* no. 104. Inset niche and margins ruled but left blank.

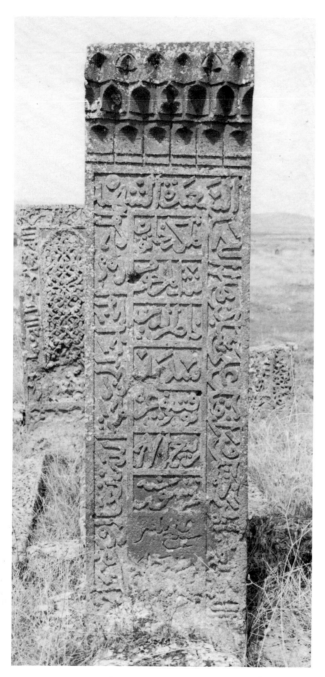

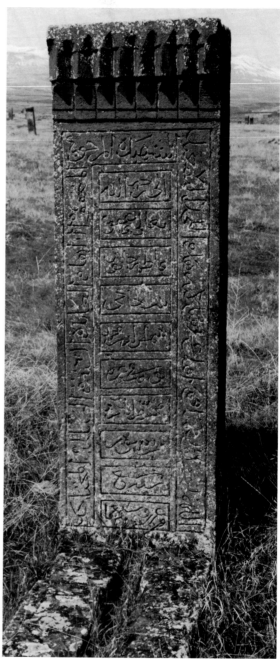

FIG. 23. Stela of Malikah Khātūn bint al-marḥūm Nāṣir al-Dīn Shādbak, died 1 Rabīᶜ II 737/7 November 1336; *JMR* no. 14. Champlevé with scratched end.

FIG. 24. Stela of Fāṭimah Khātūn bint al-ḥājjī Shams al-Dīn Muḥammad, died 717/1317–18; *JMR* no. 41. Incised hollow-cut monoline.

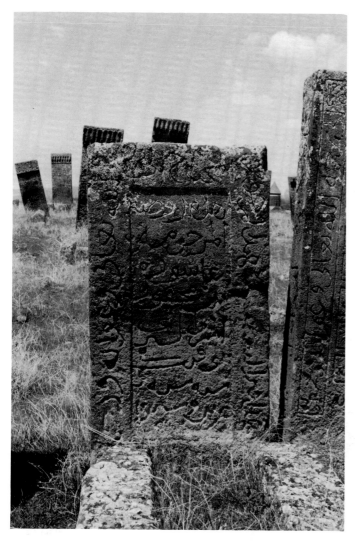

FIG. 25. Stela of ʿAshūrah bint Maḥmūd, died 626/1288–29; *JMR* no. 53. Incised, hollow-cut central panel with freer lettering.

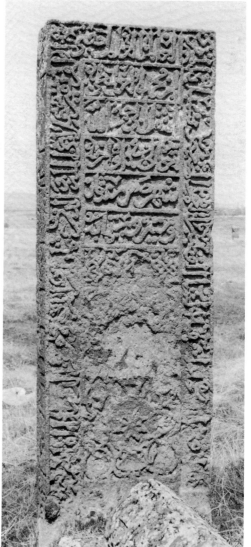

FIG. 26. Stela of ʿAlā al-Dīn ʿUthmān, great grandson of Muḥammad al-Ghalaṭī (see fig. 17); *JMR* no. 31. Epitaph. Champlevé of mediocre cut.

The "Iconography" of the Internal Decoration in the Mausoleum of Ūljāytū at Sultaniyya

Eleanor Sims

THE MONUMENT

THE mausoleum of the seventh Ilkhanid ruler of Iran, Ghiyāth al-Dīn Muḥammad Ūljāytū Khudābandah, Sulṭān Ūljāytū, has been called the greatest architectural monument of the fourteenth century in Persia, and the one that best summarizes the Ilkhanid resources of architecture and its decoration.[1] At the same time, this celebrated structure is also one of the most poorly known and least studied of all of Iran's Islamic buildings. It has never been fully recorded in architectural drawings and measured plans. Those drawings that do exist in the literature of the West—by Texier, Coste and Flandin, Dieulafoy, and Godard—do not agree with each other in many minor or even major details.[2] The monument has not yet been completely photographed. It has been "quarried" several times in its history for its building materials, and by the early twentieth century it had fallen into alarming disrepair (fig. 1), its dome severely cracked and its tile revetment gone, its interior staircase fallen away completely. Despite its condition, Ūljāytū's mausoleum remains one of Islam's most magnificent funerary structures. That its treatment in scholarly writing of this century is less than complete is understandable, given the difficulties that confront anyone setting out to study it: its size, for the building is immense,

measuring 50 meters (approximately 165 feet) from interior pavement to dome, with walls of 7 meters (23 feet) at their base, and an internal diameter of 24.5 meters (just under 75 feet); its physical condition, deteriorated drastically over the more than five centuries of its existence, while the *fiat*-city around it has crumbled away almost completely; its location, not actually on, although near, both the Tabriz-Qazwin-Tehran road and one of Iran's few railways; and finally, the expense required to organize and sustain a campaign of study and restoration, and to publish the results and interpret their significance.

Nevertheless, the mausoleum's superb brick construction (especially of the immense dome), and the extraordinary variety of its interior decorative techniques, along with that decoration's two, almost contemporary, layers in totally different materials, have already more than assured the importance of Ūljāytū's mausoleum in the history of Iranian Islamic architecture and Islamic architecture in general, even though the mausoleum's place in that written history has yet to be fully recorded. This state of affairs may be epitomized by the fact that until 1977,[3] neither much new information nor any really useful reformulation of previous research has been published since André Godard's and Arthur Pope's essays in *A Survey of Persian Art,*[4] except for Donald Wilber's *Architecture of Islamic Iran.*[5]

Since 1970, however, the mausoleum has been the subject of an extensive and coordinated campaign of repair, consolidation, cleaning, and restoration (fig. 2). The work done between 1975 and 1979 was especially useful in bringing the monument to a state of repair that permitted an assault on the principal problem it presented, a problem recognized, whether or not implicitly stated, by all who have ever described the building: two nearly contemporaneous layers of interior decoration, one canceling the other completely (figs. 3, 5, 7, 17, 31). This curious fact raises an important question: *Why?* and the only slightly less important questions, *Who?* and *When?* These questions, of course, represent far more than problems for the history of Islamic art, since the mausoleum and its history have significance for Islamic political, religious, social, economic, and numismatic history as well. The following inquiry, however, focuses on an art-historical examination of the problems presented by the decoration of Ūljāytū's mausoleum, with particular reference to the iconographical approach that is the theme of these essays. Erwin Panofsky has defined iconography as "that branch of the history of art which concerns itself with the subject matter or meaning of works of art . . ."[6] If Panofsky's definition seems curious in relation to a huge Islamic funerary monument, let me counter by recalling that Richard Ettinghausen once counseled a student to read Panofsky in order to understand the significance and ramifications of Islamic iconography. In this context it seems appropriate to search for the *meaning* of Ūljāytū's mausoleum by examining in some detail that part of the building where the principal problems appear to reside—the interior.

That this may now be done is largely thanks to the efforts of a team of architects, engineers, workmen, and scholars, and I must emphasize that the suggestions proposed in this essay are firmly based on their work, however little of it has yet been published.[7] The initial restoration project was directed by the late Italian architect Piero Sanpaolesi and executed on site by another Italian architect, Enrico D'Errico. From 1975 to 1979, the direction of the entire project was in the hands of Marco Brambilla, formerly in the Department of Architecture and Urban Planning at the National University of Iran in Tehran. In 1975, Brambilla extended an invitation to Ernst Grube (then on the faculty of the Universities of Naples and Padua, now at the University of Venice) and to me, to collaborate on a descriptive analysis of the interior decoration of Ūljāytū's mausoleum. This study was to be part of a larger examination of this structure from many points of view, in which a number of scholars from Iran, Italy, England, and the United States were to participate. Among them was Sheila Blair, then working on a doctoral

degree at Harvard University. Her reading of the mausoleum inscriptions has been of fundamental importance for this study, as it will be for any future work on the monument.[8]

Two final caveats must be noted before proceeding. The first is that all further study of the mausoleum's interior may be based on *both* decorative phases but on approximately *half* of each. Certain parts of the Phase II painted plaster had been removed in order to repair a severe crack in the dome, visible in photographs of the 1930s. Furthermore, at the beginning of the restoration, it was assumed that the second phase of decoration was Safavid (and thus was removed in order to reveal the fourteenth-century layer underneath it).[9] Unfortunately, the complete set of record-photographs of the entire interior, said to have been made before the plaster of Phase II was removed, has never been made available. Consequently, only portions of the decorative programs are visible today. Parts of Phase II remain in Bays Two, Three, and Five (figs. A, 6, 33), and some sections in Bays One and Eight (figs. A, 5, 7, 17, 18, 31); these can be augmented by prephotographic illustrations, travelers' accounts, and photographs in archives.[10] The decoration of Phase I has been almost completely laid bare in Bays Four, Six, and Seven (figs. A, 3, 4, 11, 12, 14, 19–23, 26–30, 36), and partially exposed in Bays One and Eight (figs. A, 5, 7, 17, 18, 31) and in other scattered places where the plaster of Phase II has fallen away or been removed in soundings (figs. 7, 31). Thus, hypotheses may be generated from the visible evidence, but they can never be entirely confirmed, either because the material has not been preserved or is, for the moment at least, inaccessible.

The second caveat, we hope, is temporary. It is that there are still huge gaps in our photographic record of the monument. The photographing of all decorative surfaces in the mausoleum was, of course, interrupted by the events of 1979 and thereafter. At best, the task would be a major one, since there may have been at least two hundred decorative patterns in the program of Phase I, some but partially visible, and only in small areas accessible by scaffolding. Others may not yet have been exposed. It is to be hoped that someday the visual record of the mausoleum will be completed.

Interrupted and incomplete as it is, the photographic survey of the mausoleum has, nevertheless, begun to fill prodigious gaps in our collective knowledge of Ūljāytū's mausoleum. We have worked out a system of recording decoration by breaking up the entire interior into surfaces numbered 1 to 8 (figs. B, C, 6), moving inward in each bay to the rear wall. We have made field descriptions of all interior surfaces, and we have identified almost all of the numerous photographs accumulated prior to 1978. For the first time, the inscriptions have been completely read, a tremendous contribution, inasmuch as Charles Texier, in his 1842 publication, was satisfied to substitute an inscription found "dans un manuscrit coufique du même caractère . . ."[11] for what he saw in the mausoleum! Thus, it is now possible to locate any decorative passage precisely, wherever it occurs in the program of either phase of the decoration. It is also possible to develop certain working hypotheses from this material concerning the meaning of this mausoleum's decorative program: why it was decorated twice within the period of a decade, and why the often-recounted story of the "sudden change in the intent of the whole undertaking,"[12] from Shiite shrine to Sunni mausoleum, can be seen as having no basis whatsoever.

THE STRUCTURE AND ITS EXTERIOR DECORATION

A domed octagonal structure of the canopy-tomb type, Ūljāytū's mausoleum is built of brick and oriented to the compass. Contemporary sources, decidedly vague on details, reveal that it did not

stand alone. The Ottoman traveler, Naṣūḥ al-Silāḥī al-Maṭraqī has left a stylized, though reasonably detailed picture of Sultaniyya as it was in 1535 (fig. 8).[13] Remains of a lower, vaulted structure whose purpose has not been established can be seen today, and excavations continue to the monument's north, south, and, especially, to the east.[14]

A lower chamber abuts the octagon on the south (figs. A, 1, 29, 36): it has a *miḥrāb* and was originally domed.[15] It is unclear whether this chamber was originally part of the mausoleum, and opinions differ as to whether it is actually bonded to the brick wall of the domed octagon.[16]

At present, there are entrances to the mausoleum on the west, north, and east (figs. A, 1, 2), although only those at the east and west appear to have been originally external. Their decoration is in ceramic and brick, or terra-cotta (fig. 9), whereas that on the north is in molded and applied stucco (fig. 10). On the west portal, little decoration survives except for a geometrical pattern of ceramic strapwork on the spandrels, executed in turquoise and cobalt blue (which are the colors of the entire Phase I decorative scheme). The east portal (fig. 9) is more elaborate: a broad frame of turquoise-and-cobalt strapwork surrounds the doorway, while the spandrels carry what appears to be a different strapwork pattern that is, in reality, a significant statement. Blair has identified it as a highly stylized Kufic inscription proclaiming the Shiite version of the *shahādah*, further embellished with glazed ceramic hexagrams reading "Muḥammad" and "ᶜAlī."[17] Here, too, are the remains of a date, which she has interpreted as the "10" of what would have been 710/1310–11. These texts and the date were never covered or removed, not even in the period when the interior was being redecorated. The same is true of the *bannā'ī*-technique inscriptions on the dome and the eight "minarets" that encircle it; the names "Allāh," "Muḥammad," and "ᶜAlī" were never intentionally obliterated, although weather has certainly exacted its toll (figs. 1, 2).

THE INTERIOR

If the greater part of the exterior is now naked brick, articulated only by shallow buttresses and pointed windows, the opposite is true of the inside: every available interior surface was completely "draped," covered with an elaborate decorative revetment. The huge domed octagon is articulated by eight deep and wide bays of complex profile (figs. A–C, 6). The outer frame soars to a high, pointed arch set into a squared frame with spandrels (figs. 6, 11); further into the bays, the vertical space is divided into two stories. On the ground story, or alcove, the arch cuts deeply into the brick fabric of the building and creates a sort of secondary recess with a balustrade, a loggia (figs. 11, 14). The deep pointed recess itself is articulated in one of two ways, depending on its location on the cardinal or the subsidiary axes (figs. 4, 11).

The bays on the cardinal directions—north, west, south, east (fig. A)—all had doors at the ground-story level. Those on the subsidiary compass-axes also appear to have had doors (figs. 4, 6), leading into what it is presently impossible to say (although the surrounding structures that no longer stand may eventually be identified by excavation). The second-story loggias were screened by wooden openwork balustrades about a meter high (figs. 6, 12). The recesses behind the balustrades were all linked by a low, narrow passage cut through the brick fabric (figs. A and 13), so that originally the monument could be circumambulated entirely (although with some difficulty, since the point of each of the ground-story arches obtrudes from the floor of the second story of each bay) (fig. 6). A third story, technically on the exterior rather than the interior, could also be circumambulated, and with far more ease. This ring of twenty-four vaults, three to each side of the octagon, encircles the building like an outward-facing loggia, and its often-reproduced

painted-stucco ceilings were, for many years, the only accessible decoration in Ūljāytū's mauso-leum.[18] Their importance here is that among the carved and painted motifs and designs are a number of polygrams that include the name "ᶜAlī,"[19] in addition to "Allāh" and "Muḥammad," and a number of pious phrases, none of which was obliterated in the second decorative campaign.

Inside the mausoleum, the first phase of decoration has been exposed on some of the eight bays to reveal an incredibly varied program of decoration. Phase I is composed of unglazed brick in combination with pieces of glazed ceramic (fig. 26), carved or molded terra-cotta elements (figs. 3, 20, 27), carved and molded stucco (figs. 17, 36), and a few areas of glazed ceramic mosaics (figs. 24, 25). As has already been noted, Phase I is completely or partially visible on the walls of Bays One, Four, Six, Seven, and Eight, and these surfaces have been discretely restored. Phase II, the painted phase, was executed in blue on white stucco, as if on an immense canvas (figs. B, at right, and 6), and its most complete remains are in Bays Two, Three, and Five, with partial remains in One and Eight. Above a new dado of hexagonal tiles (now almost all removed from the thick mortar in which they were embedded) (figs. 3, 6), the new surface was applied and decorated. It consisted of fields of small-scale geometrical or floral ornament that owes much to contemporary manuscript illumination (fig. 34).[20] The scheme is punctuated by large *shamsahs* and elaborate polygons (figs. 5–7, 33, 35) and given definition by framing or linking bands of inscriptions (figs. 3, 5, 6, 15, 16, 34, 35). These are in a great variety of styles—*naskh* of many sizes (figs. 3, 16), sometimes decoratively written as polygrams (figs. 7, 33), and Kufic that is variously relief-molded (fig. 16), intricately knotted (fig. 15), written in an archaic manner (figs. 5, 35), or as seal-script incongruously extended in a band (fig. 34). This phase of the decoration was also gilded at key points (fig. 36). It was further enriched with huge molded curvilinear ornaments of coarse cloth stiffened with plaster and tacked with nails to both the soffits of arches (fig. 18) and to the dome, now the only place where these huge ornaments still remain.

PHASE I

In the original decorative scheme of Ūljāytū's mausoleum, a large area of interior wall surface was decorated in *bannā'ī* technique. Usually an exterior decorative mode,[21] here it is a skin, or veneer, consisting of small square turquoise-glazed ceramic pieces set in a neutral brick matrix to form geometric patterns that may also be epigraphic. In Bay One, for example, it is found on the large framing walls, surfaces 3 and 4, and sometimes on surface 7 (figs. B, C). The outer walls, 3 and 4, bear a repeating interlocking pattern reading "ᶜAlī," whereas the pattern on surface 7 reads "Muḥammad" (fig. 17). In the alcove, the intrados is still largely covered with Phase II decoration—and it is here that the name "Sulṭān Muḥammad Ūljāytū" is painted in repeating phrases along its border (figs. 5, 35), although soundings made at certain points reveal the *bannā'ī* decoration that lies underneath (fig. 7).

The loggia of Bay One (surfaces 7–8) has a "canopy" of *muqarnas,* the units of which are quite large and somewhat maladroitly executed (fig. 18). Their Phase I decoration is of rectangular glazed ceramic tiles, suggesting brick, although again they are applied as a veneer. Similar tiles are found in the same area of each bay on the NE–SW and NW–SE axes and are part of the program by which the subsidiary axes are differentiated from the principal, or N–S and E–W, axes.

Because of the depth of the bays in the mausoleum of Ūljāytū and the size of the *muqarnas* cells, however, this canopy actually strikes a relatively minor note in the overall program of decoration and differentiation. The major notes are sounded by the decoration of surfaces 1–4, the outer

frames of the bay that sweep upward and enclose its two stories. In Bay Six, for example, *bannā'ī* technique reading *ḥamdulillāh*, "praise God!," covers the walls of the alcove, our surface 7, and the intrados of the arch (fig. 11). But the outer decorative revetment of the bay, on surfaces 3 and 4, carries a complex and amply scaled strapwork pattern that is studded along its central vertical axis with composite ten-pointed stars of molded lacelike stucco and cobalt ceramic tile (fig. 19). The strapwork is executed in what appears to be brick but is actually brick-shaped terra-cotta pieces, and it is outlined with strips of glazed tile of a penetrating turquoise hue (fig. 20). The interstices are filled with molded terra-cotta polygons in a variety of shapes generated by the strapwork. At roughly eye level on both the right and left sides of surface 3 are decagons containing pentagrams formed by a name written five times and interlaced to form a five-pointed star. Facing the bay, the inscription on the right reads "Muḥammad" (fig. 20) and that on the left "ᶜAlī" (fig. 19).

Analyzing the decoration of the inner recesses of Bay Six, facing east, adds much to an appreciation of the complexity of Phase I decoration in the mausoleum. The inscription provides a frame for the back wall, which unfortunately retains practically nothing of its original structure or revetment. Much of it was probably occupied by a portal that is now destroyed, and the space is now blocked with a modern screen-wall of brick and cinder block that is not bonded to the surrounding walls. The loggia, however damaged and altered by the cutting of a narrow pointed window high in the tympanum (at what date it is now impossible to say), nevertheless retains a great deal of its elaborate but small-scale revetment of ceramic, stucco, and terra-cotta (fig. 22).

Up to the springing of the arch, the surfaces of 7 and 8 have lost nearly all of their original ceramic "skin," (fig. 22), and only by "reading" the shadowy remains on the wall can the disposition of the elements be appreciated. On the surface 8 tympanum, a pattern of interlocking six-pointed stars is organized in staggered registers. Below this level, however, the decoration is reasonably preserved in enough places to allow a reconstruction of the subtly varied series of small-scale patterns serving as the background for two large inscriptions executed in spiky, attenuated Kufic letters. The first, identified by Blair as Sūrah 112 (*Ikhlāṣ*),[22] runs along surfaces 7 and 8, just at the springing of the arch (figs. 21–23). The Kufic letters are executed in raised terra-cotta, and they have knotted pairs of *hastae* with foliated ends. They stand out in low relief against a background of interlocking composite hexagons and octagons arranged in staggered rows and composed of polygonal elements of ceramic glazed turquoise and cobalt (fig. 21). Each panel is framed by a simple band of ceramic tile squares, alternately cobalt and turquoise.

Both the Bay Six tympanum and the intrados of the arch, surface 7, have small-scale patterns executed in glazed ceramic, but they are distinguished from those behind the large Kufic inscription in the partial scratching, or gouging, away of the glazed ceramic surface for decorative effect. On the intrados surface nearest the tympanum (fig. 21 on the right, fig. 22), the pattern is composed of staggered rows of composite interlocking stars having triangular cobalt points shared by each of the three surrounding stars. The hexagonal body of these stars has a cobalt center from which radiates a smaller six-pointed star gouged from the tile matrix. Originally the interstices were filled with turquoise elements, but most have fallen away, and only the cobalt centers and the cobalt triangles of the shared points remain. On the tympanum and the outer framing panel of the intrados (figs. 21, 22), the pattern is one of composite interlocking octagons in two sizes. The larger octagons have round cobalt centers with eight-pointed stars gouged from the surrounding matrix. A larger eight-pointed star is developed between the points of the gouged star by means of turquoise lozenge-shaped elements; the frame of the octagon is supplied by narrower lozenge-shaped elements in cobalt placed between the points of the turquoise star. These latter elements are shared by the larger and smaller octagons alike. It is curious that far

more of the ceramic decoration has remained on these panels of surfaces 7 and 8 than on the surface 7 panel nearest the tympanum.

The central panel of the arch intrados carries a pattern of niche shapes, like the outline of *muqarnas* cells (figs. 21, 23). Here the revetment is damaged, and very little of the original surface remains to provide the original colors and the articulation of the pattern. Enough does remain, however, to show that tiny cobalt rectangles were among its components.

The arch soffit in Bay Six, surface 3, carries the most complex surviving Phase I inscription. Raised terra-cotta letters of knotted Kufic encircle the intrados as if it were a long rectangle. The letters share their *hastae* throughout the entire length of the panel, meeting in a curious tangle of overlapping lozenge forms (figs. 11, 23). This *tour de force* contains a Koranic quotation, the Throne Verse of Sūrah 2, a blessing, and a date: 713/1313–1314.[23] Where the surface is preserved, the inscription stands out against a background similar to the other panels of "incomplete mosaic" in the upper story of this bay.

The final decorative element of this loggia is the area above the springing of the arch. Each panel is framed both by a brick outer border and an inner one of glazed-tile mosaic, alternately cobalt and turquoise, like the guard-stripe on a carpet. This simple border contrasts with the subtle complexity of the field patterns. Indeed, contrast between borders and larger fields is generally characteristic of the Phase I decoration in Ūljāytū's mausoleum. It is, moreover, rare to find the same pattern repeated from one bay to the next, even when it comes to such insignificant and virtually invisible parts of the scheme as the borders under discussion.

This detailed analysis of certain fields of the ceramic/stucco/terra-cotta decoration of Phase I serves to make two important points. First, it reveals the immense variety of techniques and the inventiveness of pattern and texture used in only one high and inaccessible part of the interior. This complexity must stand as a paradigm for the entire decoration of Phase I, inasmuch as a considerable portion of this phase will probably never be recovered. The variety of this decoration is all the more remarkable because of its limited colors and materials—essentially turquoise and cobalt played against dun-colored brick and whiter stucco. And second, comparing the minute scale of these panels with the different textures and the entirely different conception of the designs found in other parts of the same bay begins to suggest the many origins of the workmen who actually executed these vast fields of brilliant ceramic revetment. They must have come in vast numbers and from all over the Ilkhanid realm, since the time in which this project was accomplished was so very short.

An examination of any other exposed portion of Ūljāytū's mausoleum confirms the incredible variety of decorative patterns. Consider a bay on a subsidiary axis, Bay Seven (figs. 4, 14). Although nothing survives on surface 1 (which has been cleaned down to the structural brick), surfaces 3 and 4 are covered, up to the springing of the arch, in a *bannā'ī* pattern of interlocking "I" shapes (fig. 14). The arch intrados has lost most of its original "skin," but where it survives (midway down the right side of the soffit), the pattern is yet another subtle variant on the theme of the small-scale "incomplete mosaic" patterns already examined at length in Bay Six.

Surface 2 of Bay Seven—which is really a shallow corner angle—still retains parts of the framing colonnettes that are built of brick and cement and covered with complete mosaic of turquoise and cobalt interlaced against a white ground (figs. 24, 25). The polyhedral capital survives at the left (northwest) side of the bay (figs. 14, 25). Above the colonnettes, on both sides, the surface is either cleaned down to the structural brick or still retains its Phase II decoration. The same is true of surfaces 5 and 6, the narrow framing links (or bands of transition) between the broader surfaces 4 and 7 that in Phase II are combined to make one wider, but less articulated, border up to the springing of the alcove arch. A small section of surface 5 remains both right and

left of the alcove. This narrow and almost invisible band of decoration (figs. 14, 26) suggests the inventiveness and the variety of the Phase I decoration. The principal motif is a composite five-pointed star of brick and turquoise ceramic, with a turquoise five-pointed star at its center. But this star is never seen in its entirety, and it is presented so that it stands neither on two legs nor balances on a single point; instead, it sits askew, wobbling its way up the narrow band in staggered rows, leaning first right and then left. In the interstices is a six-pointed cobalt star, equally tipped askew and seen only partially.

Turning to the alcove, the Phase I decoration of the surfaces presently exposed can now be seen as another, overall scheme of decoration, varied in its many different patterns but coherently scaled in relation to each other and related to the spandrels of the outer frame in scale, color, and materials. On the alcove arch, both the inner tympanum and the doorway are, at present, modern restorations and have no trace of their original structure or decoration (fig. 4). On surface 7, the revetment is a simple "square-within-a-square" of *bannā'ī* technique (fig. 4); but on surface 8, the rear face of the alcove, is an elaborate pattern of stucco strapwork framing a pointed doorway and enclosing a substantial panel that surmounts the now-blocked door. The patterns of both frame and inner panel are technically similar: composite stars, with glazed cobalt ceramic elements, placed in staggered rows and generating extended strapwork designs of glazed turquoise ceramic, the interstices filled with mold-carved stucco. The strapwork of the outer register, however, is of terra-cotta and outlined in turquoise, resulting in a larger grid and a larger composite star, with a turquoise element placed between two cobalt elements. Geometrically, too, the stars differ: those in the outer frame have twelve points, whereas those in the inner frame have the highly unusual number of nine. Above the niche, but still within the outer framing panel, is a long rectangle containing four blind windows with the broken profile known from other Ilkhanid monuments, such as Bistam.[24] Here at Sultaniyya they are outlined in cobalt strips and separated from one another by short panels with four-pointed stars outlined in turquoise, the interstices of all save the "window"-openings filled with mold-carved stucco. Finally, because this bay is on a subsidiary axis, the loggia was crowned with the same large and inelegant *muqarnas* already noted in Bay One. The surface was revetted with glazed brick and the interstices filled with tiles of cobalt or turquoise on which much of the surface has been scratched away. The designs are tiny in comparison with the glazed brick and they hardly mitigate the coarseness of the *muqarnas* surface, whose interest lies in its rare note of yellow. Otherwise this loggia decoration is in great contrast with the refined splendor of the alcove decoration of the same bay.

Such a brief and partial explanation of the decoration of Bays Six and Seven, although necessarily subject to the caution that only half of the evidence is available, has disclosed the clear axial organization of the Phase I internal decoration. In fact, the N–S and E–W axes have already been referred to as "primary" and the NE–SW and NW–SE axes as "subsidiary." Within this scheme there is a further emphasis on the N–S axis that runs between Bays Eight and Four, almost certainly related to the fact that Bay Four lies on the *qiblah* for Sultaniyya.[25]

The Phase I decoration of Bay Four is clearly related to that of Bay Six, for it has on its surfaces 3 and 4 the same, somewhat loping turquoise and terra-cotta strapwork as on those surfaces in Bay Six (figs. 3, 12). The patterns, however, are subtly varied. The primary vertical axis of Bay Four is a row of interlaced strapwork ten-pointed stars, instead of the composite stars with cobalt points of Bay Six; while the complex strapwork pattern that sweeps up to the top of Bay Four has hexagons in its subsidiary vertical axis instead of the pentagons of Bay Six (compare figs. 11, 12, and 20, 27). As in Bay Six, a decagon is placed at eye-level in this surface; inside it is a five-pointed star of raised Kufic letters and turquoise glazed interstitial elements, larger than in Bay Six, and having at its center a pentagram of mold-carved stucco (figs. 20, 27). In fact, only the

decagon at the left (east) side of the bay, reading "Muḥammad" (fig. 20), remains intact, for all that survives of its pendant at the right (west) are noncalligraphic fragments.

On the right (west) side of the bay on surface 7 is found the magnificent and well-known panel of turquoise ceramic and stucco and terra-cotta, like an immense, discontinuous wheel studded with spiky arrows (fig. 28). In the course of restoration, the Phase II plaster remaining over the surface of the panel was removed to reveal the entire design. The innermost borders partially survive on the right side of this panel, that on surface 7 being a crisp frame of turquoise and cobalt arabesques set in a bed of very hard, white stucco or plaster (figs. 28, 29). On surface 8, flanking the panel and nearest to the "mortuary chamber," is a border of true ceramic mosaic (fig. 29). Its pattern is made up of staggered rows of ten-pointed stars that share their points with slightly off-center five-pointed stars, and a double pentagon, executed in turquoise, cobalt, and white. The larger, wheeling spiky star is echoed in the border of the loggia (figs. 12, 30), whose walls are covered with a different geometrical *bannā'ī* pattern extending up to the intrados, which bears the remains of yet another interlaced pattern. The variety of framing patterns in Bay Four is as profuse as those elsewhere in the monument.

Bay Eight, the north terminus of the mausoleum's main, or N–S, axis, also displays large-scale patterns (fig. 31). The brick-and-tile strapwork of surfaces 3 and 4 is more complex than that in Bays Four and Six. In this bay, composite eight-pointed stars set on their points mark the central vertical axis of both surfaces. Five-pointed stars are found in the interstices of the surface 4 designs. The decoration of surface 7 in Bay Eight, although smaller in scale than that found on the comparable surface of Bay Four, is nearly as stunning in effect, and its more angular interlaced border makes the overall composition of surface 7 in Bay Eight somewhat more harmonious. The spandrels below the loggia, surface 5, have patterns executed in the same techniques as those used on surface 5 of Bays Four and Six, although the designs on each are different. Finally, the spandrels of Bay Eight and its axial complement, Bay Four, both have elaborate but differently patterned frames.

Thus, although the entire program of Phase I has not been laid bare, enough is now accessible for several observations to be made. The first concerns the orientation of the first decorative scheme. Pope had already pointed out the original axial emphasis of the mausoleum, which must, therefore, have been evident inside the mausoleum in the 1930s.[26] What has become clearer with the work of the past two decades is that the N–S axis is established as major and significant through its decoration, especially the glazed-tile-and-stucco revetment of surfaces 7 in Bays Four and Eight. That Bay Four, the *qiblah*-bay, was the more important of the two may be deduced by the greater scale of its design. Bay Eight's revetment also lacks a pentagram or other sacred polygram such as those found on surface 3 in Bays Four and Six, whose decoration is appropriately differentiated along the building's major and minor axes. Where the decoration of Phase I has been exposed on these axes, surfaces 3 and 4 show the same type of revetment that is varied only in pattern and then only subtly so. Hence, though the original decoration of the west bay, Bay Two, is still largely hidden under the plaster of Phase II, enough of Phase I has emerged to confirm that the compass orientation was clearly stressed in the first, brilliant phase of the interior decoration of Ūljāytū's mausoleum.

A second observation is the relative sparsity of inscriptions within the original program of Phase I. Very few areas of the monument appear to have been decorated with inscriptions, other than the polygrams already noted, or single words or simple phrases of blessing. These areas are the lower part of surface 1 and the soffits of the upper story in Bay Six, on the minor principal axis. It is, of course, impossible to comment on the Phase I decoration of Bay Two, but Bay Six contains Koranic verses, the Throne Verse, and *Ikhlāṣ*, along with a date and a general blessing.

Aside from the single words or phrases such as "Allāh," "Muḥammad," and "ʿAlī," other inscriptions from Phase I have been revealed only in two areas so far laid bare, on the lower frame of surface 1 in Bays Three and Eight. The Phase I decoration in Bay Three has been exposed only by the vicissitudes of the past five centuries, but one corner shows a *basmalah;* the same corner in Bay Eight has a highly decorative panel of ceramic and terra-cotta that is the beginning of the Throne Verse (fig. 32).[27] It is difficult, admittedly, to discern any kind of axial pattern from these few instances, especially given the arbitrary survival of Phase I. Hazarding a guess, however, it would be that what survives on the lowest walls of Bay Eight is the remains of a ceremonial entryway from some adjacent (and no longer extant) building that afforded an interior entrance from a passageway that would have had molded stucco, as on the present north portal, as decoration (fig. 10).

Whatever may prove to be the ultimate interpretation of this structure and its relation to Bay Eight and its decoration, the paucity of verbal decoration in Phase I—aside from the single words of blessing, the polygrams and sacred monograms, and the absence of Koranic quotations save one of the shortest of Sūrahs and the rather ubiquitous Throne Verse—is striking. Striking also is the absence of Ūljāytū's name in this phase of the decoration—a statement subject of course to the usual caution that it may have existed but not have survived, or it may not yet have been laid bare. Had it been present, it could hardly have been very prominent, as indeed most inscriptions in this phase of the decoration were not. Those that were so are remarkable for their decorative de-formation, for the virtual illegibility of many, and the real inaccessibility of some. Erica Dodd, following Oleg Grabar, has pointed to the development of a highly stylized, decorative Kufic script as a significant part of the symbolic religious decoration, the true iconography, of Muslim religious buildings;[28] Ettinghausen, also addressing himself to the question as it related to Islamic religious constructions, wondered whether it was not the very presence of such an inscription, rather than its legibility, that made it significant within the decorative program of a mosque, a tomb, or a *madrasah*.[29]

Finally, certain peculiarities of the entire ceramic, terra-cotta, and stucco ensemble of Ūljāytū's mausoleum should be noted. The first is that mosaic is used only for some frames and borders, whereas there is a substantial use of "incomplete mosaic," confirming the importance of this monument not only as a summary of previously developed decorative techniques but also as a training ground for the next generation of workman.[30] The second is the remarkable quantity of odd-numbered geometrical figures in the mausoleum's Phase I decoration. Polygrams of Sacred Names are developed on, or inside of, pentagons, and pentagons and their multiples are dominant in many areas of the decoration. Even more unusual are the nine-pointed stars of surface 4 in Bay Seven.

The effect of the high, sweeping panels framing the bays that make up the octagon of Ūljāytū's mausoleum, balanced by the many fields of pattern in subtle, beautifully modulated juxtapositions in a masterfully composed scheme contrasting glittering sufaces with softer, matte passages, is a powerful and an extremely beautiful one, even in its present state of preservation. It must have been overpoweringly magnificent when it was pristine and new.

The parallels for this spectacular ensemble, however, appear to be found on the exterior of buildings rather than on their interiors, as Pope had already noticed.[31] To begin with, *bannā'ī* technique is used both on the dome and the "minarets" of Ūljāytū's mausoleum as well as on the interior. On the minaret of the *khanaqah* in Natanz, the recessed squares of glazed ceramic tile exactly parallel those on the bays at Sultaniyya, except that at Natanz cobalt glaze is added to the palette.[32] Many exterior parallels for interlaced strapwork come to mind: the Gunbad-i Qabud at Maragha of 593/1196,[33] where brickwork stands out in relief against a turquoise ceramic ground,

reversing the usage at Sultaniyya; at the Gunbad-i Surkh, in the same city, built half a century earlier, where the patterns in the tympanum recall those on all the surfaces 7 so far exposed in Ūljāytū's mausoleum;[34] the early thirteenth-century Shrine of Yaḥyā Abū al-Qāsim, in Mosul.[35] The two-story arched form of the interior bays at Sultaniyya, with a *muqarnas* canopy in the second-story niches on the subsidiary axes, is also adumbrated on the exterior of the Gunbad-i Qabud.[36] Blair has noted that the closest parallel for the raised and knotted Kufic letters of the arch soffit in Bay Six is the inscription circling the base of the minaret at Natanz,[37] but it is about a decade later than Sultaniyya. Also from Natanz, from the portal of the *khanaqah,* comes a parallel for the combination of ceramic elements with an unglazed but carefully worked section making a complex geometrical figure out of one element of a larger, overall pattern, as seen at Sultaniyya in terra-cotta instead of in stucco.[38]

It is especially curious that the parallels for the interior use of the decorative techniques and patterns in Ūljāytū's mausoleum are found to the west of Iran, in the ceramic decoration of certain thirteenth-century Anatolian buildings. They date from about 1213 through 1280, and even on into the fourteenth century. Many were decorated by master craftsmen from Iran who are known to have worked in Anatolia during the twelfth century, or who had fled there during the invasions of the early decades of the thirteenth century.[39] Anatolian monuments relevant to Sultaniyya include the facade of the tomb of Kay Ka'us, in the Şifaiye Madrasah in Sivas, dating from between 614/1217 and 617/1220,[40] and a series of *miḥrāb*s in Konya: in the Alaettin Cami of 617/1220–21,[41] in the Sahip Ata (or Laranda) Cami of 656/1258,[42] in the Sadrettin Konyavi Cami of 673/1274–75,[43] as well as in the Külük Cami in Kayseri,[44] and in the Süleyman Bey Cami in Beyşehir, dating from the turn of the fourteenth century.[45]

This group of buildings offers striking parallels to the decorative program at Sultaniyya, beginning with a limited ceramic palette, and the use of *bannā'ī* technique in an interior setting as, for example, in the Sahip Ata Turbe.[46] In the Anatolian structures can be found the same overall compositions, with the same varied decorative passages framing a niche, in perfect harmony despite the clashing of scale and pattern, as in Sultaniyya; the same passages of almost purely geometrical ornament relieved by unusually sparse areas of foliate arabesque; or the foliated ends of an otherwise severe Kufic inscription.[47] In both Sultaniyya and these Anatolian buildings occur the combinations of bold ceramic strapwork with lacelike stucco interstices; in both occur the framing bands of beautifully drawn arabesques or interlace executed in "incomplete mosaic," where the hard white mortar of the setting is necessary to the *éclat* of the design. In both too there is a profusion of five-pointed stars, often set at an angle. Finally, there is also an Anatolian parallel for the pentagrams composed of Sacred Names that clearly predates an often-cited Iranian example in Ashtarjan (a monument that in any case is later than Sultaniyya).[48]

The set of technical and stylistic parallels between the internal decoration of thirteenth-century buildings of the Rum Saljuqs in Anatolia and the decoration of an imperial Ilkhanid tomb of the fourteenth century in Iran is fascinating to consider from many points of view. Among them is that the parallels are not confined to the use of similar materials or of a similar scheme for their disposition on interior walls. Many historians of Anatolian Saljuq art have noted that the content of building inscriptions on major architectural monuments is also limited to statements about patronage and date.[49] In Ūljāytū's mausoleum the Koranic content of the inscriptions in Phase I is limited either to one of the shortest sūrahs, or to parts of the verse most frequently used on Muslim tombs, the Throne Verse of Sūrah 2.[50] Even when it is completely quoted, its presence is countered by the extreme complexity of the script in which it is written and by its placement high in the structure, hardly readable even from the upper story of the interior bays. The absence of any reference to Sulṭān Ūljāytū himself in the surviving inscriptions of Phase I has already been

noted. While it is true that his name and titles may still lie underneath a part of the Phase II decoration still on the mausoleum walls, it is reasonably certain that they were not especially important in the scheme of mausoleum decoration.

No other names, apart from "Muḥammad" and "ᶜAlī," appear in the program of Phase I that might afford a clue to the original purpose of this monument. The usual explanation is that the mausoleum was at one point planned as the final resting place for the martyrs of Najaf and Karbala', but in this case the names of the martyrs should have been found or at least there should have been inscriptions in the domed octagon that testified to their intended presence: Shiite prayers, ḥadīth, and phrases of praise or supplication, such as are known from Mashhad and Qum.[51] It would have been equally expected that the decorative treatment common to all the medieval Shiite shrines of Iran and Iraq, luster-painted tiling,[52] would have been used in the Phase I decoration of Ūljāytū's mausoleum. Whether luster-painted tiles covered the interiors of the tomb chambers at Najaf and Karbala' in 709/1309, when Ūljāytū visited these shrines, is difficult to ascertain, for the tomb chambers now have revetments of āyinah-kārī (mirror-mosaic)[53] and only a single luster miḥrāb from Najaf, possibly to be dated around 1265, has been published.[54] What is more certain is that there are no luster tiles anywhere in what remains of the Phase I interior program at Ūljāytū's mausoleum; few have turned up in the debris in or immediately surrounding the mausoleum, nor have any been mentioned in the most recent excavation accounts.[55]

In fact, aside from the octagonal form of the mausoleum (and in so vast a monument it is easy to lose a sense of orientation despite the differentiation of the eight sides), the impression remains that in its original state, and up to 713/1313–14 at least, Ūljāytū's mausoleum was more like a palace than a funerary monument: a huge, glittering, resplendent, domed palatial chamber with equally splendid galleries for promenades cut high into both its interior and its exterior walls. Could the reason for its "drastic but thorough" redecoration have been just this, that the building's interior was considered inappropriate as the final resting place of a Persianized Muslim Sultan?

PHASE II

The redecoration of Ūljāytū's mausoleum was not only achieved quickly, by covering interior surfaces with a thick coat of plaster, but it had an entirely different program, for the most part painted, which entirely reorganized the internal space of the vast building. The mausoleum was thus brought into line with the most traditional scheme for the decoration of Persian mausolea other than those of sainted Shiite personages, blue-painted decoration on a white ground (figs. 3, 5, 6, 7, 15, 33–35).[56] At Sultaniyya, of course, this painted program is as elaborate as the interior of the eleventh-century tomb tower at Kharraqan is simple. But far more significant is the fact that the inscriptional component of the redecoration was vastly increased. Not only are there Koranic verses, including the majestic naskh inscription (fig. 16), circling the base of the dome, and the Victory Sūrah echoing the circle at the dado level (figs. 3, 6), there are also numerous ḥadīth as well (fig. 6), in addition to the usual formulas of blessing and praise, and the polygrams composed of the names of ᶜAlī, Muḥammad, the rashidūn, and other divine epithets (fig. 33). In fact, calligraphy and its messages become the dominant component of the Phase II decoration. The Phase II decoration also leaves little doubt that the intended occupant of the tomb was Ūljāytū, for his name appears five times in the decoration of this phase (figs. 5, 35).[57] The single date so far discovered in this decorative phase is "720,"[58] which might conceivably suggest that

the redecoration of the mausoleum was not undertaken by Ūljāytū himself but by his son and successor. As Abū Saʿīd acceded in 716/1316 at the age of twelve, the redoing of his father's mausoleum would have seemed a dramatic, if also a willful, gesture for the new sultan to make, and it is more likely that the date represents that of a repair.

Whatever eventually proves to be the case, it is virtually certain that the usual explanation for the change of internal decoration in the mausoleum—Ūljāytū's reversion to Sunni Islam toward the end of his life, necessitating the eradication of any traces of Shiite allegiance—is quite unfounded, for all of the reasons discussed. Too, the name "ʿAlī" is often found in the Phase II decorative program: there are painted shamsahs composed of his name as a polygram,[59] and others in which "ʿAlī" is surrounded by the names of the rashidūn and of Ḥasan and Ḥusayn (fig. 33). Furthermore, the name "ʿAlī" was never obliterated from the dome and the painted stucco decoration of the exterior galleries.[60] Finally, numismatic evidence demonstrates Ūljāytū's continuing adherence to Shiite Islam, since the coins minted in his name after 709/1309 all bear the Shiite shahādah, while those struck after 713/1313–14 have, in addition, the names of the Twelve Imams on their borders.[61]

CONCLUSIONS

Ūljāytū's mausoleum, then, was surely conceived of by its sponsor in direct response to the magnificence of that of his brother, Ghāzān Khān, in Tabriz, and in its pristine state it appears to have been a glitteringly resplendent chamber fit more for a living prince than a buried one. Its decoration was largely anepigraphical. Its religious content, moreover, as expressed in writing, was limited to single words monogrammatically rendered, and the most frequent of Koranic quotations so highly stylized that they could not really be read even were they accessible. It had none of the acoutrements of Shiite shrines, nor anything in its epigraphic program to suggest that it had ever been meant as one. Moreover, it drew upon modes of decoration for its interior program that are quite unlike any known from other contemporary tombs or tomb-complexes in Iran, such as at Maragha, or in the tomb of the Pīr of Bakran, in Linjan.[62] Instead, the mausoleum of Ūljāytū appears to have looked to the decoration of mosques, madrasahs, and tombs of the previous century in Saljuq Anatolia for its models.

Its alteration, therefore, might well have been due to the sheer inappropriateness of its architectural and decorative iconography for a mausoleum. Its calligraphic decoration was not only inadequate but at odds with the palatial splendor of the building, and its entire style and the materials of which it was made—its abstract iconography, in sum—wrong for the place and time. And so it was altered on the interior, made into a more conventional, if not less resplendent and imperial, Persian-style mausoleum for the ruler whose name is mentioned at various places within it. To the south, a domed mortuary chamber was added by cutting through the rear face of Bay Four; that chamber was given a partial ceramic revetment, as in the main octagonal room, and a stucco frieze bearing inscriptions more appropriate to a tomb.[63] The frame of Bay Four was enriched with more elaborate gilding than any other, underscoring its importance and reemphasizing the qiblah-axis within an ensemble that had lost its original axial definition. That Ūljāytū himself ordered the redecoration is suggested by the fact that the Phase I decoration was never completed on the intrados of the lower story of Bay Four (figs. 28, 34), where the outline alone has been sketched in with blue, as if capturing the moment at which the alteration was decided upon. The actual date at which this redecoration was effected will no doubt be better defined by

subsequent scholarship; all that may now be said is that this formidable task occurred between 713/1313–14, the date recorded in Bay Six (fig. 22) and the end of Ramaḍān 716/December 1316, when Ūljāytū died in his thirty-sixth year.

As usual, however, suggesting answers to some questions raises others. The state of the dome's decoration, together with the evidence in Bay Four, probably indicates that the Phase I decoration was not entirely completed before Phase II was begun. How the redecoration was actually effected is another point worth examining. The strong Anatolian element of Phase I is rife with fascinating points on which to speculate, among them the *miḥrāb*-like niche carved from the living rock at Viar, near Sultaniyya, further evidence of an Anatolian presence on the plain of Qungur-Ulung.[64] And more attention should be paid to the many craftsmen who actually executed these magnificent ensembles of ceramic and stucco and terra-cotta: their role in the formation and refinement of these compositions may prove to be significant. More work on these, and related, questions will contribute greatly to our understanding of the development of these revetments, so integral a feature of the shrines and tomb-complexes of the fourteenth century in Iran.

I return, then, to the question posed at the beginning of this essay: Who was responsible for the drastic but thorough redecoration of one of Islam's mightiest funerary monuments within a decade of its completion? As to the "why," I have tried here to suggest that the mausoleum was redecorated because the interior of its first version was perceived as inappropriate for a sultan ruling in Ilkhanid Iran in the early fourteenth century. At present, I can see no reason why the will behind the redecoration should not have been that of Ūljāytū himself; indeed, given the evidence for changes in Bay Four, I think it is the only possibility.

NOTES

1. A. U. Pope, "Architectural Ornament: Some Fourteenth-Century Ensembles," in Pope, *SPA*, 1339 (hereafter, Pope, "Architectural Ornament").

2. A. Godard, "The Mausoleum of Oljeitu at Sultaniya," in Pope, *SPA*, 1107–17 (hereafter, Godard, "Mausoleum").

3. The date of publication of Brambilla's useful summary of the work undertaken on the congregational mosques in Sava and Qazwin, and especially on the mausoleum of Ūljāytū, in which are published a plan of the quarter, several sections and elevations, and some photographs, along with a very brief essay: *Marammat-i Bannāhā-yi Tārīkhī: Arāmgāh-yi Sulṭān Muḥammad Khudābanda, Masjid-i Jāmiʿ-i Sāva, Masjid-i Jāmiʿ-i Qazwīn*, Tehran, 2535/1977.

4. Godard, "Mausoleum," 1339; Pope, "The Fourteenth Century," in Pope, *SPA*, 1052–77, and Pope, "Architectural Ornament," 1339–45, and other relevant text figures and plates in addition to pls. 381–84, 385A and C, in Pope, *SPA*.

5. D. Wilber, *The Architecture of Islamic Iran: The Il-khanid Period*, Princeton, 1955, and New York, 1969 (hereafter, Wilber). Perhaps *the* basic catalogue for the study of the architectural monuments of Ilkhanid Iran (based on extensive travel between 1934 and 1943), the work with which one begins and returns to, many times, in studying any major fourteenth-century Iranian building. Marco Brambilla has kindly drawn to my attention one further article published during these years: Piero Sanpaolesi, "La cupola di Santa Maria del Fiore ed il mausoleo di Soltanieh," *Mitteilungen des Kunsthistorischen Institutes in Florenz*, XVI (1972), Heft 3, 221–60.

6. In *Studies in Iconology*, Oxford, 1939, 3.

7. Much of the research done before 1977 by Brambilla, and by members of the University of Venice, has been published in issues of the *Quaderni del Seminario di Iranistica, Uralo-Altaistica e Caucasologia dell'Università degli Studi di Venezia*, nos. 5 (1979), 9 (1982), and 10 (1981).

8. S. Blair, "The Epigraphic Program of the Tomb of Uljaytu at Sultaniyya: Meaning in Mongol Architecture," in *Islamic Art*, II 1987, 43–96. All further refer-

ences to inscriptions are given according to the catalogue of this important work (hereafter, Blair).

9. Pope, *SPA*, pl. 381, and Wilber, fig. 69 and especially fig. 72. I want to thank M. Brambilla for drawing this problem to my attention.

10. The best collections of European travelers' accounts of Sultaniyya are still to be found in the entry on Sultaniyya, *EI*[1], and in the notes to Godard's essay in Pope, *SPA*, 1103–12. Notices of Ūljāytū's mausoleum from many travelers' accounts were being compiled for the Department of Architecture and Urban Planning of the National University of Iran's publication of the monument, which has been suspended; the present group research campaign should allow further compilation and publication of these source materials. J. M. Rogers has illuminatingly discussed the perceptions and the kinds of interest in the mausoleum of those travelers who make serious mention of it, from Pietro della Valle, in 1619, to Coste and Flandin, in the middle of the nineteenth century, in "From Antiquarianism to Islamic Archaeology," *Quaderni dell'Istituto Italiano di Cultura per la RAE*, n.s. 2 (1974), 37–43 (hereafter, Rogers).

11. Rogers, 43.

12. Pope, *SPA*, 1342.

13. Blair, "Phase I: The Original Mausoleum," 61–64 and passim; H. Yurdaydin, *Beyān-i Menāzil-i Sefer-i ʿIrāqkeyn*, Ankara, 1963, 31b–32a.

14. S. Gandjavi, "Prospection et fouille à Sultaniyeh," *Akten des VII. Internationalen Kongresses für Iranische Kunst und Archäologie: München, 7.–10. September 1976, Archäologische Mitteilungen aus Iran*, VI, Berlin, 1979, 523–26.

15. Pope, *SPA*, pl. 385C.

16. See Blair, cat. 59 and 60, n. 3, summarizing the differences of opinion. In E. Sims, "The Internal Decoration of the Mausoleum of Öljeitü Khudabanda: A Preliminary Re-Examination," *Quaderni del Seminario di Iranistica, Uralo-Altaistica e Caucasologia dell'Università degli Studi di Venezia*, IX (1982), 93 and 102 (hereafter, Sims, "Preliminary Re-Examination"), I follow earlier writers, principally Godard, "Mausoleum," 1114, and Wilber, 139–40.

17. Blair, cat. 6.

18. Wilber, figs. 80, 81, 83–84; D. Hill and O. Grabar, *Islamic Architecture and Its Decoration AD 800–1500* London, 1964, pls. 238–41 (hereafter, Hill and Grabar); A. U. Pope, *Persian Architecture*, London, 1965, pls. V (in color), 171–72, 227, 230a–b (hereafter, Pope, 1965); H. and S. P. Seherr-Thoss, *Design and Color in Islamic Architecture*, Washington, D.C., 1968, pls. 40–43 (the best of all color reproductions) (hereafter, Seherr-Thoss); A. U. Pope, *Introducing Persian Architecture*, London, 1969, 65; J. Sourdel-Thomine, B. Spuler, et al., *Die Kunst des Islam (Propyläen Kunstgeschichte, IV)*, Berlin, 1973, pl. 260.

19. Blair, cat. 13, 16, 21; Pope, *SPA*, fig. 497; Seherr-

Thoss, pl. 40, at the left of the vault at the top of the picture, where a hole in the plaster revetment has obliterated part of the final *yāʾ*.

20. Sims, "Preliminary Re-Examination," 105–9, summarizes the argument, the literature, and the new material from the painted phase of Ūljāytū's mausoleum.

21. The phrase seems to have been coined by L. Golombek, *Timurid Shrine at Gazur Gah, ROM Art and Archaeology Occasional Paper* 15, Toronto, 1969, 58, following L. Hunarfar, *Ganjīna-yi Āthār-i Tārīkhī-i Isfahān*, Isfahan, 1965–66: *khatt-i bannāʾī*.

22. Blair, cat. 37.

23. Blair, cat. 36.

24. For a technical description, Wilber, 69, and Diagram J on pl. 71; the best color photograph is in Seherr-Thoss, pl. 49, and Pope, *SPA*, pl. 395.

25. According to a personal communication from David King, the mausoleum of Ūljāytū is not aligned with Mecca in the modern sense, but it does lie on one of the *qiblah*-directions accepted in that period—namely, due south. For further information on the medieval *qiblah*, see D. A. King, *The World About the Kaʿba: A Study of the Sacred Direction in Islam*, to be published by the Islamic Art Foundation.

26. Pope, *SPA*, 1339–40.

27. Blair, cat. 44.

28. "The Image of the Word: Notes on the Religious Iconography of Islam," *Berytus*, XVIII, 1969, 35–67, passim; and her more recent *The Image of the Word: A Study of Qurʾanic Verses in Islamic Architecture*, written with S. Khairallah, 2 vols., Beirut, 1981, essays in I, passim (hereafter, Dodd and Khairallah).

29. "Arabic Epigraphy: Communication or Symbolic Affirmation," *Near Eastern Numismatics, Iconography, Epigraphy and History: Studies in Honor of George C. Miles*, ed. D. K. Kouymjian, Beirut, 1974, esp. 302–7.

30. Recent research, both theses, S. Blair, *The Shrine Complex at Natanz, Iran*, (Cambridge, Mass., 1986), and R. Holod, "Architecture, Patronage and Setting: The Case of Yazd 1300–1450," Ph.D. diss., Harvard University, 1972, and articles, such as those gathered in *Quaderni . . . di Venezia*, X (1981), has refined the documentation for the situation described by Pope, "Architectural Ornament," and by Wilber, 42–47 and 79–94.

31. Pope, *SPA*, 1340.

32. Hill and Grabar, pl. 271; Seherr-Thoss, pl. 55 (in color).

33. A. Godard, "Notes complémentaires sur les tombeaux de Maragha," *Āthār-é Īrān*, I, 1936, 138–43 (hereafter, Godard, "Notes"); Pope, *SPA*, 342 and 530; Hill and Grabar, pl. 225; Seherr-Thoss, pls. 34–36 (in color).

34. Godard, "Notes," 125–35; Pope, *SPA*, pls. 341–42; Hill and Grabar, pl. 223; Pope, 1965, pl. 92; Seherr-Thoss, pls. 30–33 (in color).

35. A. S. Melikian-Chirvani, "Paroles d'or et de turquoise," *L'Oeil,* 228–29 (July–August 1974), 42; also R. Pagliero, "Conservation of Two Islamic Monuments in Mosul," *Sumer,* XXI, 1965, 41–68.

36. Best seen in Seherr-Thoss, pls. 34 and 36.

37. Best illustrated in Seherr-Thoss, pl. 55; Blair, cat. 36.

38. As in pl. 265, Hill and Grabar, to be compared with Figure 22 in this essay.

39. A situation described by Wilber, 88–92, and explored at great length by M. Meinecke, *Fayencedekorationen seldchukischer Sakralbauten in Kleinasien,* DAI, Istanbuler Mitteilungen, Beiheft 13, 2 vols., Tübingen, 1976, I, 12–92, passim (hereafter, Meinecke). Workmen from Marand and Arran, in Azarbayjan, and from Tus, in Khurasan, are documented in the Anatolian ensembles of Divriği, Tokat, Sivas, Amasya, and Konya between 1180 and the middle of the 13th century, and Wilber suggested that, as usual, the documentary evidence we have is only the tip of the iceberg in calculating the numbers of Iranian craftsmen who would have found opportunities to follow their profession under the Rum Saljuqs.

40. Hill and Grabar, pl. 373; O. Aslanapa, *Turkish Art and Architecture,* London, 1971, fig. 66 (hereafter, Aslanapa); Meinecke, kat. 108, taf. 47.1.

41. Meinecke, kat. 61, taf. 22.4 and 23.1.

42. Aslanapa, fig. 32; Meinecke, kat. 77, taf. 32.4.

43. Meinecke, kat. 85, taf. 36.4.

44. Meinecke, kat. 52, taf. 20.1.

45. Meinecke, kat. 23, taf. 9.4 and 10.1.

46. Hill and Grabar, pls. 433–34; Meinecke, kat. 89, taf. 39.1–3 and 40.1–3.

47. The following list of illustrations includes one or all of these decorative features: E. Akurgal, C. Mango, and R. Ettinghausen, *Treasures of Turkey,* Geneva, 1966, 132, illustrating yet another thirteenth-century ceramic and stucco *miḥrāb,* from the Mosque of the Arslan Hane, in Ankara, whose parallels with the decoration on the interior of Üljäytü's mausoleum are many; Hill and Grabar, pls. 346–48, 352, 360–61, 378–79, 427, 452; Seherr-Thoss, pls. 107–8, 117–20; Aslanapa, figs. 23–25, 27, 29, 78, 83; Meinecke, I, 86–87, and taf. 1.1, 3.1, 8.3, 9.3, 11.1, 17.1–4, 20.2–4, 26.1–2, 27.3, 28.1–2, 30.1, 31.1–4, 35.1–3, 39.1, 40.1, 44.3.

48. G. C. Miles, "The Inscriptions of the Masjid-i Jāmiᶜ at Ashtarjān," *Iran,* XII, 1974, 89–98, inscription 18, pl. IVa.

49. For example, Dodd and Khairallah, I, 63; and K. and H. Erdmann, *Das anatolische Karavansaray des 13. Jahrunderts,* II–III, Berlin, 1976, 55–59, speaking specifically about caravansarays and related structures.

50. See Dodd and Khairallah, II, Index 3, 239–61.

51. See D. M. Donaldson, "Significant Mihrabs in the Haram at Mashhad," *Ars Islamica,* II, 1935, 118–27; some of the inscriptions on tile revetments from the complex at Qum are published by Y. Godard, "Pièces datées de céramiques de Kashan à decor lustré," *Āthār-é Īrān,* II, 1937, 309–24.

52. O. Watson, "Persian Lustre Ware, from the 14th to the 19th Centuries," *Le Monde Iranien et L'Islam,* III, 1975, 68.

53. Or so may be deduced from the lack of precision of most descriptions, whether historical or modern: "Meshhed Husain," in *EI¹,* s.v., translating Nöldeke, *Das Heiligtum al-Husains zu Kerbela',* Berlin, 1909, 25ff., speaks of "light . . . reflected . . . from the innumerable small crystal facets"; a tomb-chamber illustrated in *Archaeological Aspects of Iraq,* published by the Directorate General of Antiquities and the Ministry of Information, Baghdad, 1971, only identifies pl. 26 (which shows a sarcophagus in a metal(?) *ṣandūq,* with screening of the *mashrabīyah* type, standing in a low, vaulted chamber that appears to be revetted with mirror-mosaic) as being the tomb (or the supposed tomb) of Muslim b. ᶜAqil.

54. By M. Aġa-Oġlu, "Fragments of a Thirteenth-Century Mihrab at Nedjef," *Ars Islamica,* II, 1935, 128–31.

55. See note 14 above; I have seen large fragments of a figural luster-painted tile with rather wide cobalt borders in the fields around Sultaniyya, at a distance of two to three kilometers from the mausoleum.

56. As, for example, at Kharraqan, in the two eleventh-century mausolea, see G. Öney, "The Interpretation of the Frescoes in the I. Kharragan Mausoleum Near Qazwin," VIIth International Congress of Iranian Art (see note 14 above for publication data), 400–408; and Pope, *SPA,* pl. 536B, for one of the more elaborate of these unassuming mausola, the Tomb of al-Ḥasan b. Kay Khusraw. On the other hand, the interior of the mausoleum of Shaykh ᶜAbd al-Ṣamad al-Iṣfahānī in Natanz, dating from 707/1307, is all white, with no color other than the tonality given by the dust that seeps in through the brick screening, see Seherr-Thoss, pl. 56; whereas the extraordinary palette of the interior of the Tomb of ᶜImād al-Dīn at Qum of 792/1389, see Pope, 1965, pl. XXI, or of the earlier tomb of ᶜAlī b. Jaᶜfar, 740/1339, are justly cited as examples of a highly developed taste for what the first publications of these buildings call "polychromy," see *Bulletin of the American Institute for Persian Art and Archaeology,* IV, 1, 1935, 35–38.

57. Blair, cat. 55, in Bay One, and 57, in Bays One, Two, Three, and Five.

58. Blair, cat. 49f, in Bay Five.

59. Blair, cat. 58a.

60. See note 18 above.

61. Reviewed by Sims, "Preliminary Re-Examination," 101, and nn. 35–38.

62. L. Golombek, "The Cult of Saints and Shrine Architecture in the Fourteenth Century," *Miles Fest-*

schrift (see note 29 for details), 419–30; the "little cities of God" include Natanz, Pir-i Bakran, Bistam, and Ardabil, most of which are variously illustrated in the works on Persian architecture consistently cited throughout this work. In the light of the veritable corpus of wall-revetments, both of styles and materials, and of the ingeniousness of their combination in these monuments, as well as others such as in the environs of Ishfahan and Yazd, a comment by O. Grabar seems especially apposite: "It is as though the closer one comes to the little-known secular art of the time or to the more popular cult of saints the more brilliant and overbearing becomes the decoration . . ." *Cambridge History of Iran, 5: The Saljuq and Mongol Periods,* Cambridge, 1968, 640.

63. Blair, cat. 59, 60; cf. Dodd and Khairallah, II, Index 3.

64. Meinecke has pointed out that both Ūljāytū and Abū Saʿīd sponsored buildings in the Anatolian provinces (Meinecke, I, 78–89). Whether or not Anatolian craftsmen worked on the decoration of Ghāzān Khān's Lofty Tomb in Tabriz, or in the Rabʿ-i Rashīdī, it seems certain that teams of them were working on Phase I of the decoration of Sultaniyya, and thus, that the vigorous ceramic quality of Phase I is directly due to their presence. This might, in turn, help to explain the curiously Anatolian look of the unfinished *miḥrāb*-like niche, with tall, narrow *muqarnas* and projecting bosses, carved out of the living rock at the site called Viar, about ten kilometers east of Sultaniyya (see Giovanni Curatola, "The Viar Dragon," *Quaderni . . . di Venezia,* IX, 1982, pl. I, fig. 1). Finally, J. M. Rogers, discussing carved stone tomb-markers during his own presentation to this Symposium, showed a number of stones from Akhlat, west of Lake Van, whose decoration is surprisingly similar to the patterns and schemes seen in Phase I of Ūljāytū's mausoleum: see B. Karamağaralı, *Ahlat Mezartaşları,* Ankara, 1972, fig. 108, for a general view of the burial fields, and figs. 85, 87, 190 (dated 670/1272), 192 (dated 674/1275), 247 (dated 720/1320), and 287 (dated 731/1330–31).

Political events in Iran have continued the hiatus imposed on the appearance of the international study of the mausoleum of Ūljāytū, which was to have included the publication of measured drawings and exact plans and sections of the mausoleum and of its decorated interior surfaces. The plan in Figure A, therefore, was adapted from one published in M. Brambilla's Marammat-i Bannāhā-yi Tārīkhī: Arāmgāh-yi Sulṭān Muḥammad Khudābanda, Masjid-i Jāmiᶜ-i Sāva, Masjid-i Jāmiᶜ-i Qazwīn, *Tehran, 2535/ 1977, unnumbered fig. 2. It, and Figures B and C, were drawn by Lionel Bier, who accepted an unsatisfactory task with grace, executed it quickly, and provided helpful advice. I wish to thank him for his immense help; without his clear diagrams, this paper would be more difficult to read. I also wish to emphasize that any faults in them are entirely my own responsibility. Unless otherwise stated, all photographs were provided by Marco Brambilla in 1977 and 1978, as part of the project undertaken and executed by the National University of Iran's Department of Architecture and Urban Planning; the one exception is Figure 1, kindly furnished by the Herzfeld Archive, the Freer Gallery of Art.*

 NB: In the captions, as well as in the text, left *and* right *refer to the position of the viewer facing the bay.*

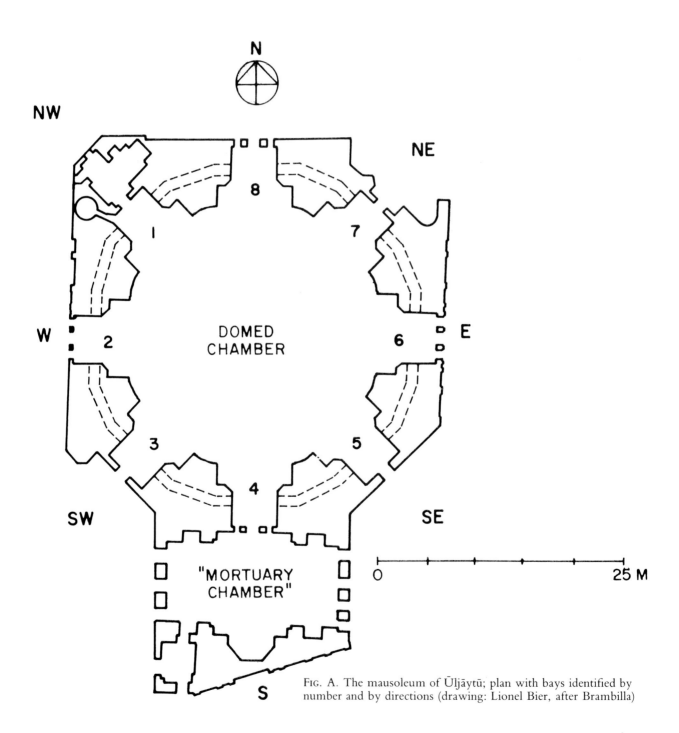

Fɪɢ. A. The mausoleum of Ūljāytū; plan with bays identified by number and by directions (drawing: Lionel Bier, after Brambilla)

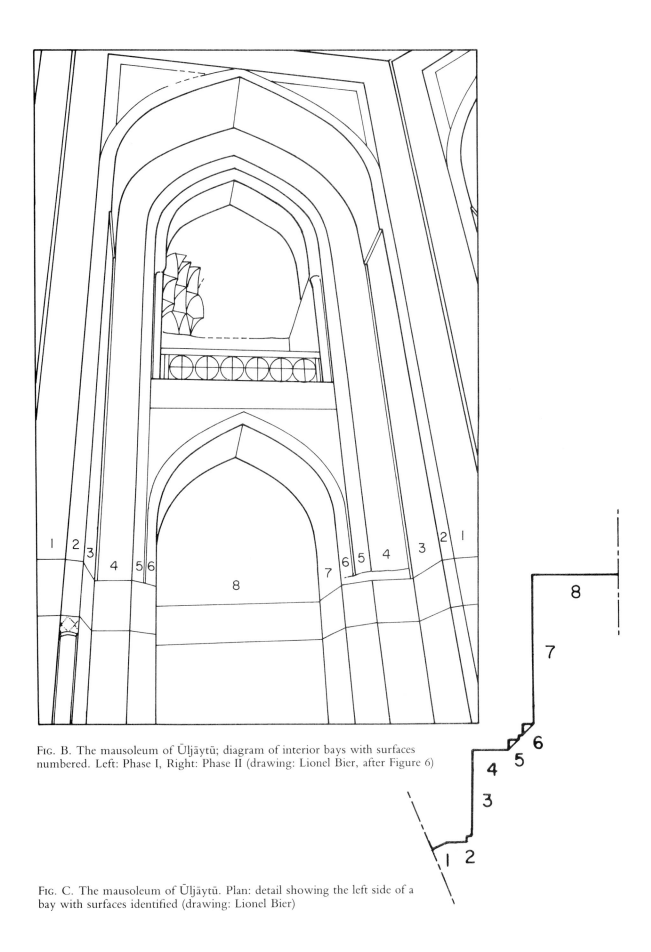

FIG. B. The mausoleum of Ūljāytū; diagram of interior bays with surfaces numbered. Left: Phase I, Right: Phase II (drawing: Lionel Bier, after Figure 6)

FIG. C. The mausoleum of Ūljāytū. Plan: detail showing the left side of a bay with surfaces identified (drawing: Lionel Bier)

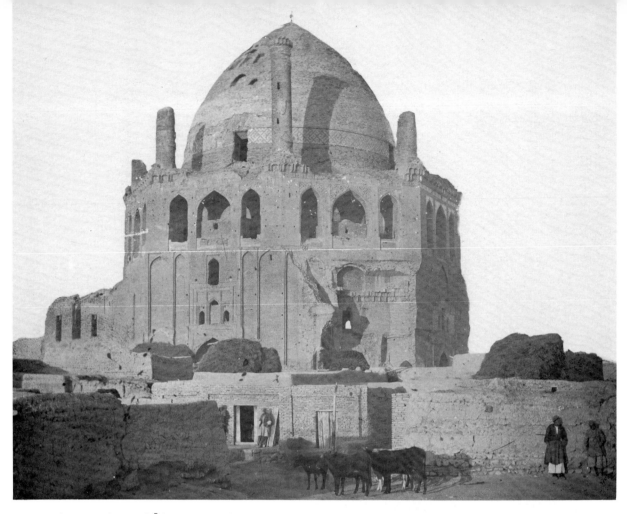

FIG. 1. The mausoleum of Ūljāytū, from the east, between about 1870 and 1890. Washington, D.C., Courtesy Herzfeld Archive, Freer Gallery of Art, Smithsonian Institution (albumin photograph: Antoine Sevruguin)

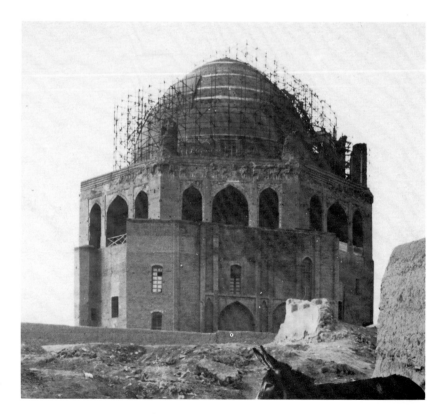

FIG. 2. The mausoleum of Ūljāytū, from the north, about 1970

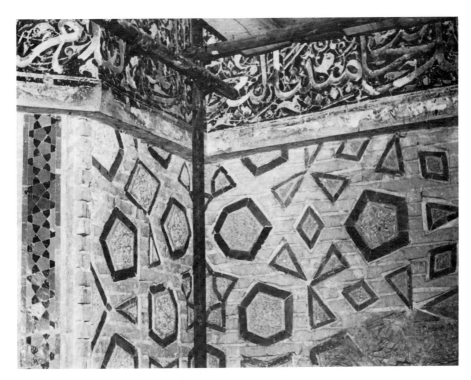

FIG. 3. The mausoleum of Ūljāytū. Interior, Bay Four, left (west) side, surfaces 3–5, with Phase II inscription Koran 48, (Victory Sūrah) above the Phase I decoration below

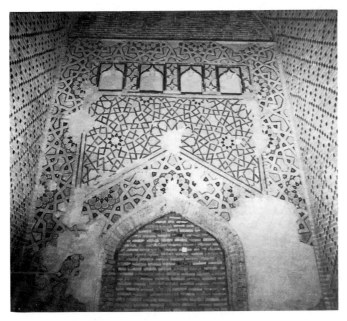

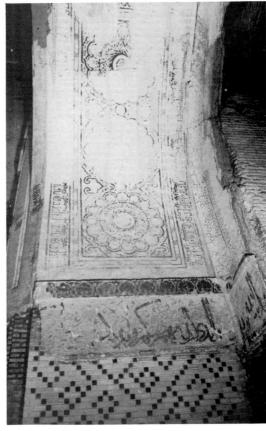

FIG. 4. The mausoleum of Ūljāytū. Interior, Bay Seven, ground-story alcove, Phase I decoration on surfaces 7 and 8

FIG. 5. The mausoleum of Ūljāytū. Interior, Bay One, left (southwest) side, surface 7. Phase I below, Phase II decoration of the dado and intrados with the name "Sulṭān Muḥammad Ūljāytū" painted in repeating phrases in the border

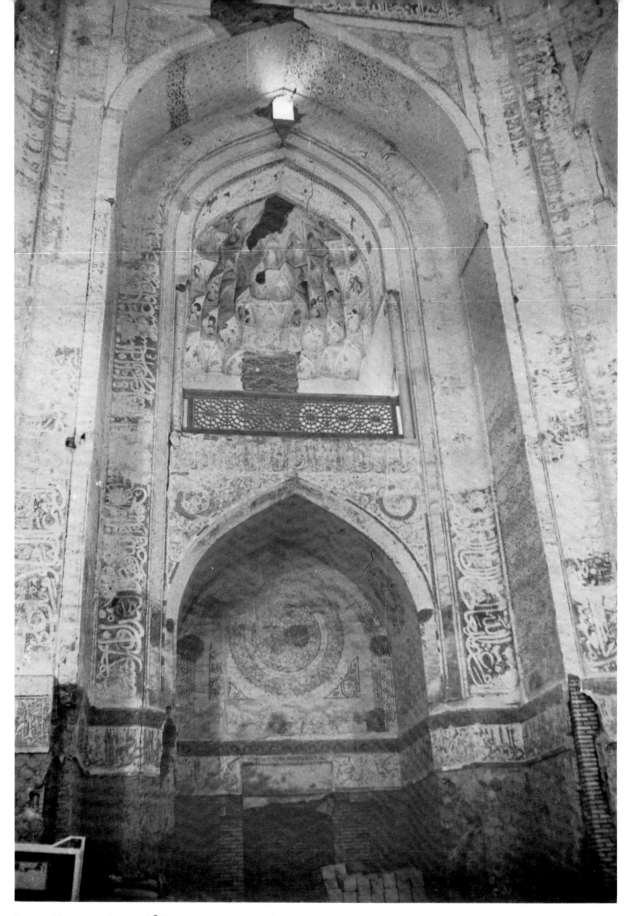

FIG. 6. The mausoleum of Ūljāytū. Interior, Bay Three, Phase II decoration

FIG. 7. The mausoleum of Ūljāytū. Interior, Bay One, right (northeast) side, surface 7 intrados, Phase II painted *shamsah;* portion of Phase I visible in sounding

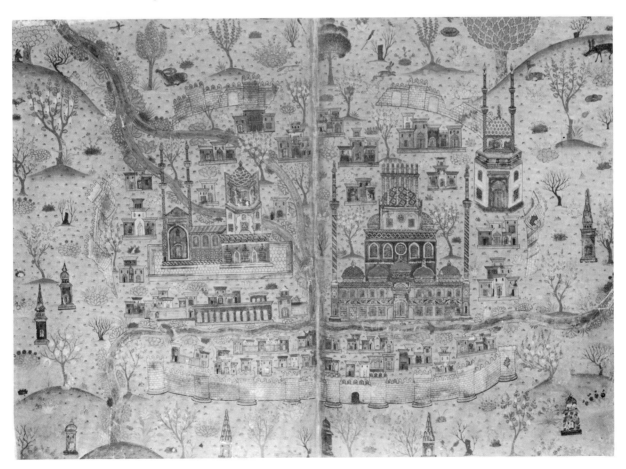

FIG. 8. Naṣūḥ al-Silāḥī al Maṭraqī, "View of Sultaniyya," *Bayān-i Manāzil-i Safar-i ʿIrāqayn,* Istanbul University Library, T. 5964, 944/1537–38, fols. 31v–32r

Fig. 9. The mausoleum of Ūljāytū, exterior of the east portal with ceramic decoration

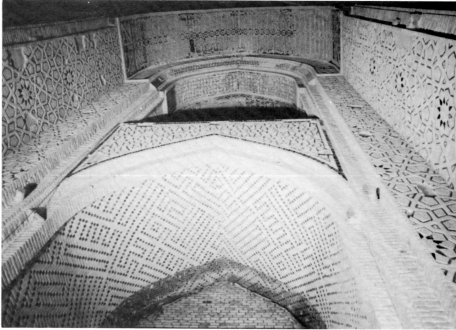

Left: Fig. 10. The mausoleum of Ūljāytū; north portal, detail, with raised and molded stucco decoration

Right: Fig. 11. The mausoleum of Ūljāytū. Interior, Bay Six, Phase I decoration on surfaces 3–7

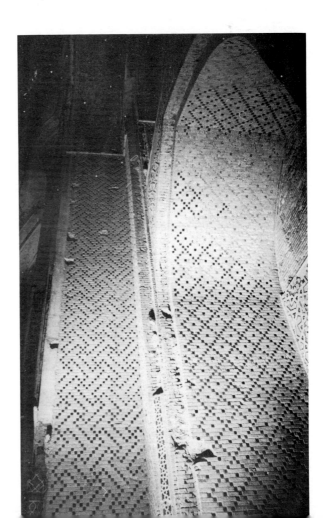

Top left: Fig. 12. The mausoleum of Ūljāytū. Interior, Bay Four, right (west) side, Phase I decoration on surfaces 3, 4, 6, and 7 and openwork balustrades of Bay Three and Four

Top right: Fig. 13. The mausoleum of Ūljāytū. Interior, Bay Six, loggia, left (north) wall with the door to the second-story passageway that encircles the mausoleum

Bottom: Fig. 14. The mausoleum of Ūljāytū. Interior, Bay Seven, left (northwest) side, Phase I decoration, surfaces 3, 5 and 6, 7 and part of 8

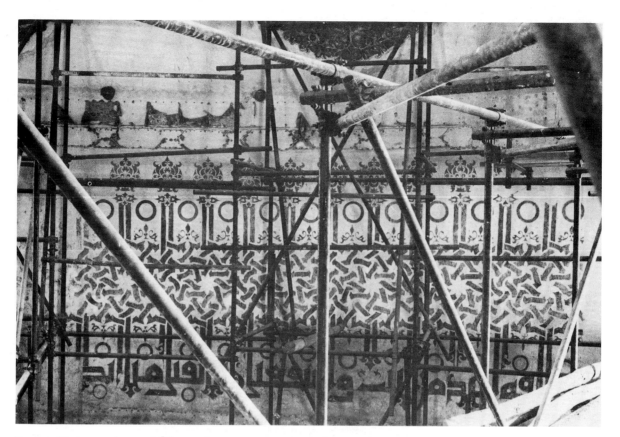

FIG. 15. The mausoleum of Ūljāytū. Dome, interior, detail of Kufic inscription with knotted *hastae*

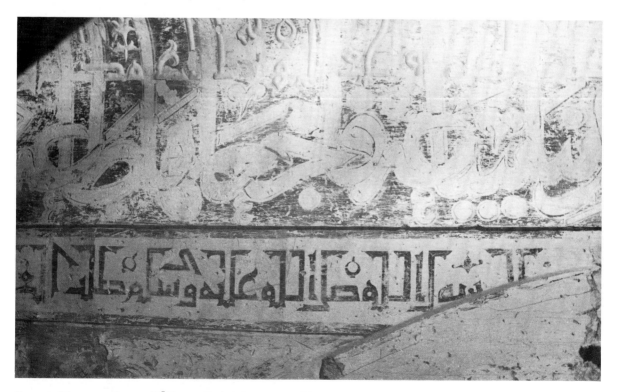

FIG. 16. The mausoleum of Ūljāytū. Dome, interior, *naskh* inscription with a smaller, molded Kufic inscription inserted among the *hastae* and a painted Kufic inscription below it

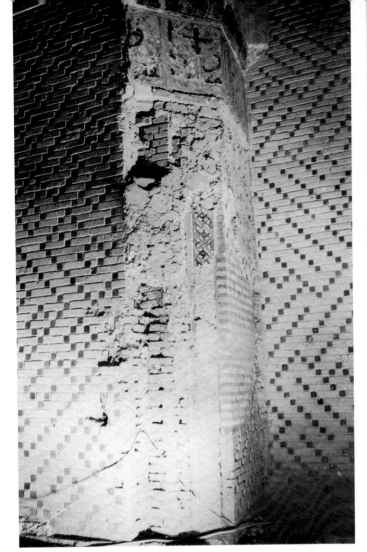

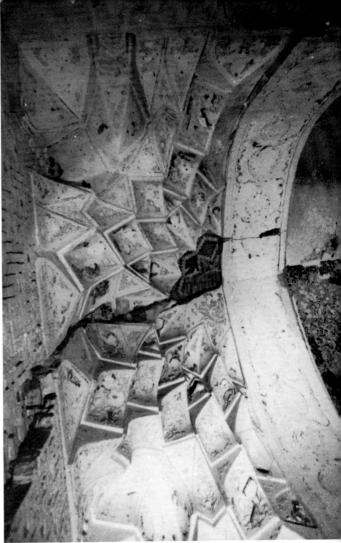

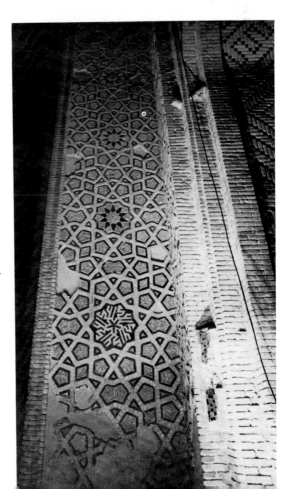

Top left: FIG. 17. The mausoleum of Ūljāytū. Interior, Bay One, right (northeast) side, Phase I decoration, surfaces 3, 5 and 6 and 7, and a fragment of the Phase II dado-inscription on surfaces 5 and 6

Top right: FIG. 18. The mausoleum of Ūljāytū. Interior, Bay One, the *muqarnas* at the top of the loggia, with Phase II decoration and a small portion of Phase I visible just right of the peak, and the tacks of the stiffened cloth decoration on the intrados of the arch

Bottom: FIG. 19. The mausoleum of Ūljāytū. Interior, Bay Six, left (north side), surface 3, pentagram reading "ʿAlī"

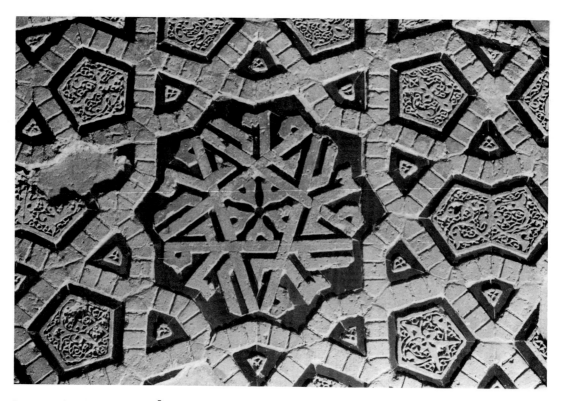

FIG. 20. The mausoleum of Ūljāytū. Interior, Bay Six, right (south) side, surface 3, pentagram reading "Muḥammad"

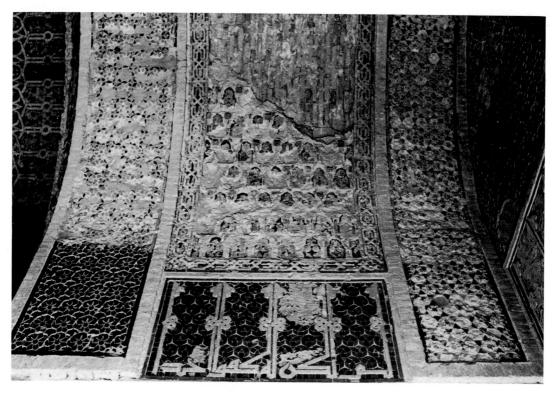

FIG. 21. The mausoleum of Ūljāytū. Interior, Bay Six, left (north) side surface 7, Phase I decoration with the end of Sūrah 112

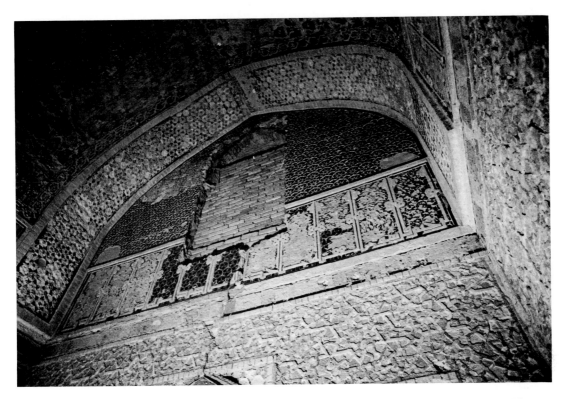

Fig. 22. The mausoleum of Ūljāytū. Interior, Bay Six, Phase I decoration of loggia tympanum with Sūrah 112 and surface 7

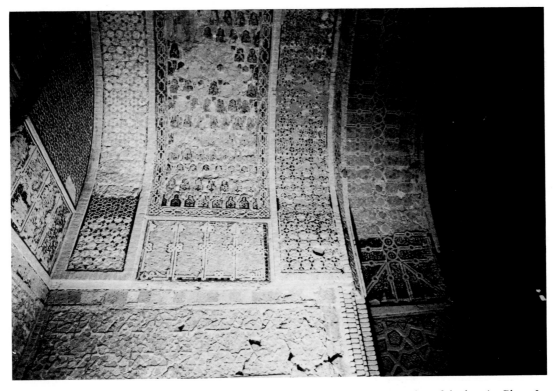

Fig. 23. The mausoleum of Ūljāytū. Interior, Bay Six, right (south) side, intrados of the loggia, Phase I decoration, with the beginning of Sūrah 112, and the soffit of the arch with the Throne Verse (2:255)

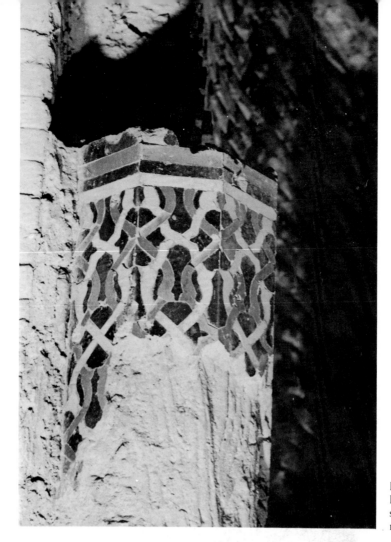

FIG. 24. The mausoleum of Ūljāytū. Interior, Bay Seven, right (east-southeast) side, colonnette with a complete ceramic mosaic in turquoise, cobalt, and white

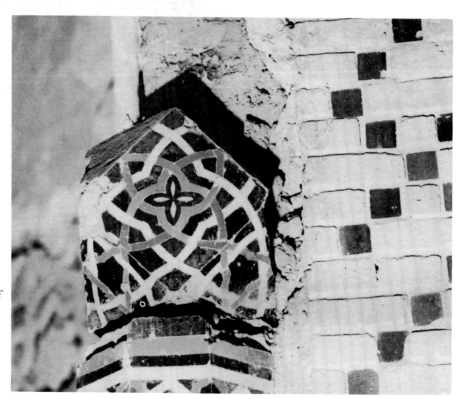

FIG. 25. The mausoleum of Ūljāytū. Interior, Bay Seven, left (north-northeast) side, polyhedral colonnette capital with a complete ceramic mosaic in turquoise, cobalt, and white

FIG. 26. The mausoleum of Ūljāytū. Interior, Bay Seven, left (north–northeast) side, surface 5, Phase I decoration

FIG. 27. The mausoleum of Ūljāytū. Interior, Bay Four, left (east) side, pentagram reading "Muḥammad" in the center of surface 3

FIG. 28. The mausoleum of Ūljāytū. Interior, Bay Four, right (west) side, surface 7, Phase I decoration below transitional, unfinished decoration of intrados; soundings at right of picture beneath bare wall

FIG. 29. The mausoleum of Ūljāytū. Interior, Bay Four, right (west) side, surfaces 7–8, Phase I mosaic border and carved plaster dado leading to the mortuary chamber, extreme left

FIG. 30. The mausoleum of Ūljāytū. Interior, Bay Four, right (west) side loggia, Phase I decoration, surfaces 3, 6, and 7

FIG. 31. The mausoleum of Ūljāytū. Interior, Bay Eight, left (west) side, alcove, surfaces 3 and 7. Below, Phase I decoration, above Phase II decoration and showing soundings Phase I underneath

Fig. 32. The mausoleum of Ūljāytū. Interior, Bay Eight, left (west) side, surface 1, Phase I ceramic and terra-cotta decoration with a part of the Throne Verse (Koran 2:255)

FIG. 33. The mausoleum of Ūljāytū. Interior, Bay Eight, right (east) side, surface 7 intrados, Phase II, *shamsah* with polygram composed of the names of Muḥammad, ʿAlī, and the *rashidūn* (drawing: Thomas Amorosi)

FIG. 34. The mausoleum of Ūljāytū. Interior, Phase II decoration (no longer extant) of bay above dado inscription; exact location uncertain

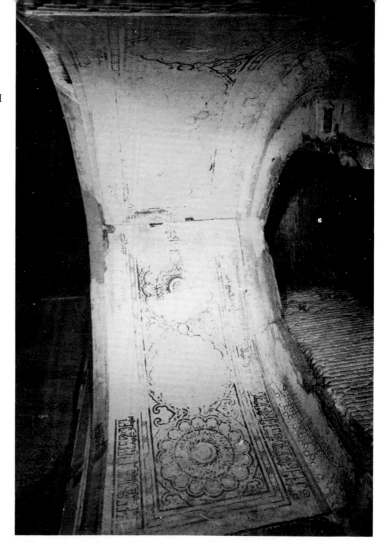

Fig. 35. The mausoleum of Ūljāytū. Interior, alcove arch of Bay One, Phase II decoration, borders repeating "Sulṭān Muḥammad Ūljāytū" in archaic-looking Kufic

Fig. 36. The mausoleum of Ūljāytū. Interior, alcove arch of Bay Four leading to the mortuary chamber; Phase I decoration, surfaces 3–5 and 7, with raised and gilded palmettes on surface 6

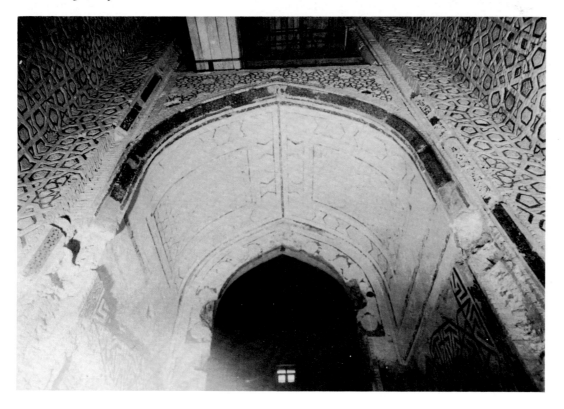

Imperial Symbolism in Mughal Painting

Robert Skelton

IN early 1961, when I was preparing a lecture entitled "The Grand Mogul," Richard Ettinghausen generously sent me photographs and part of his draft text from a volume he was due to publish later that year[1] concerning a remarkable series of allegorical paintings in the Freer Gallery of Art. One of the Freer paintings (fig. 1) was very relevant to another allegorical painting (fig. 2) in the Chester Beatty Library, which had previously been discussed by Sir Thomas Arnold[2] and which I considered at length in my lecture.

In both paintings, the Emperor Jahāngīr stands upon the globe (appropriately, in view of his title "World Seizer"), although in the Freer Gallery's painting he shares it with Shāh ᶜAbbās I of Iran, who, according to a verse written on the painting, had come to Jahāngīr in a dream. Each of the kings stands on a symbolic animal. It is interesting to note that the body of the lion on which Jahāngīr stands not only covers, rather generously, the extent of his ancestor Tīmūr's empire, but that its head also extends over most of the territory, whose label "Iran" appears beneath its paws. The sheep supporting Shāh ᶜAbbās, edged westward, just manages to maintain its head above the label of the former Safavid capital, Tabriz. This placement of the animals perhaps hints at a certain Mughal nostalgia for former dynastic boundaries.

Whether or not this is so, it is certainly clear, as Ettinghausen pointed out, that "the symbolic animals on which the sovereigns stand indicate Jahāngīr's wishful thinking about their relative strength"; Ettinghausen goes on to say that "at the same time, the peaceful association of lion and sheep shows that the Messianic age has arrived in the world."[3] This image of the divinely appointed emperor standing on the globe or on a map of his territory is one that can be found in several other examples of Mughal painting.[4] It is also not unfamiliar in contemporary Europe.

Thus the globe is near at hand in Queen Elizabeth of England's famous "sieve portrait," now in Siena,[5] and we find her standing on it, silhouetted like Jahāngīr against the heavens, in the great Ditchley portrait in the National Portrait Gallery, London. The inscription to the right of this picture is partly missing, but in view of the brightness emanating from the queen as she stands against a background of stormy darkness, it is not surprising that the verses begin by calling her "the prince of light" and then equate her with the sun and with the glory of heaven.[6] (The emphasis placed on solar symbolism by Jahāngīr is also apparent in both Mughal pictures and will be considered further, below.) One of the many places where the Ditchley portrait is reproduced is the cover of Frances Yates's book *Astrea,* subtitled *The Imperial Theme in the Sixteenth Century.*[7] In her book, Yates shows how the prophecy made by Virgil in his fourth Eclogue was taken over by the apologists of European imperialism from the time of Constantine onward and reached its greatest elaboration under Charles V and those who emulated his imperial propaganda. One need hardly repeat the opening words of this pastoral poem:

> We have reached the last era in Sibylline song. Time has conceived and the great sequence of Ages starts afresh. Justice, the Virgin [i.e., Astrea], comes back to dwell with us, and the rule of Saturn is restored. The Firstborn of the New Age is already on his way from high heaven down to earth.[8]

Then, in describing the fruits of this golden age, the poet continues:

> The goats, unshepherded, will make for home with udders full of milk, and the ox will not be frightened of the lion, for all his might. Your very cradle will adorn itself with blossoms to caress you. The snake will come to grief, and poison lurk no more in the weed.[9]

As we already know from Ettinghausen's description of the dream picture, this type of symbolism can be demonstrated in Mughal painting by the peaceful association of lion and sheep, but in the Chester Beatty painting (fig. 2) every single one of the creatures mentioned by Virgil is depicted. We find them all—the ox, the lion, the goat, and the snake—at which point it may be suspected that their inclusion only goes to prove the popularity of Virgil's works at the Mughal court! It would be overcautious, in view of Jahāngīr's many conversations with educated Europeans, to suppose that they never satisfied his curiosity about contemporary European regal symbolism, but there is certainly no need to postulate his acquaintance with Virgil. It is well known that Virgil's imagery is closely paralleled in that famous passage from the eleventh book of Isaiah, in which we are told of the Messiah's coming, when

> the wolf also shall dwell with the lamb, and the leopard shall lie down with the kid; and the calf and the young lion and the fatling together; and a little child shall lead them.

If we want to bring this ancient motif nearer to the Islamic world—and indeed locate it in the Imperial Library built up by Jahāngīr's father—we need only turn to that indispensable compendium of royal legend, Firdawsī's *Shāh-nāmah.*[10] Niẓāmī ʿArūḍī draws our attention to the appropriate verse in his discourse on the poetic art:

> Maḥmūd, the Great King, who such order doth keep,
> That in peace from one pool drink the wolf and the sheep.[11]

Whether or not such imagery was reinforced in Jahāngīr's mind during his many discourses with the Jesuits and others, I shall not speculate, nor shall I suggest that the very idea of allegorical paintings was necessarily stimulated by the many emblematic prints that Europeans brought to the court, although copies of these in the borders of Jahāngīr's picture album and elsewhere are, to say the least, provocative.[12]

Instead of pursuing this tempting but perhaps chimerical topic of European parallels, let us turn to the most elaborate of all Jahāngīr's allegorical paintings, which was only mentioned in passing by Ettinghausen in his writings on this subject.[13] As in the case of the two paintings of Jahāngīr with Shāh ᶜAbbās in the Freer Gallery,[14] this painting (fig. 2) reflects Jahāngīr's attitude toward a difficult neighbor, but this time his feelings are much less ambivalent. Malik ᶜAmbar, whose portrait was also copied by Jahāngīr's artist Hashim,[15] was an Abyssinian officer in the service of the Niẓāmshāhī rulers of Ahmadnagar. After the Mughal invasion of this kingdom at the end of Akbar's reign, ᶜAmbar successfully fought back, and in acquiring the Mughals' grudging respect he also earned their hatred.

The complicated allegory of Jahāngīr's hoped-for vengeance on Malik ᶜAmbar is by Abū al-Ḥasan, who also painted the dream picture for Jahāngīr and was evidently a specialist in such subjects. Like the dream picture, it is also covered with minute inscriptions; fortunately these have been carefully studied by Sir Thomas Arnold in the catalogue of the Indian miniatures in the Chester Beatty Library.[16] With their aid, one can unravel a great deal of the program of the picture, which is concerned with Jahāngīr's pretensions as a universal sovereign. However, before its symbolism is considered, it must be asked how the picture came to be painted in the first place. Why does it commemorate Jahāngīr's destruction of Malik ᶜAmbar, when in fact the Abyssinian died of old age in 1626, just five months before Jahāngīr himself?

Sir Thomas Arnold concluded that this work celebrated either the bitterness of Jahāngīr's hatred or else Malik ᶜAmbar's actual death. In Ashok Das's book *Mughal Painting in Jahāngīr's Time,* published in 1978—some forty years after Arnold's catalogue—Das took a similar view, suggesting two possible occasions when it might have been painted. The first, in 1621, was when news was brought of Prince Shāh Jahān's victory over the Deccani sultanate; the second, following Arnold, was the occasion of ᶜAmbar's death.[17] Apart from these two suggestions I am not aware of any attempt at solving this problem,[18] but in fact the answer is quite simple. What we have here is not merely an example of wish fulfillment but—surprisingly—the representation of an actual event. It occurred on the evening of 29 October 1616, when the royal camp was at Ajmer. On this day, as an illustration in Shāh Jahān's own regnal history shows,[19] the emperor's favorite son bade farewell to his father and left Ajmer with a vast army to crush Malik ᶜAmbar. Hopes that night were running high, and while the emperor was sitting with his companions, an owl came and perched on a terrace above the palace. In the darkness it was hardly visible, but the emperor wrote in his memoirs:

> I sent for a gun and took aim and fired in the direction that they pointed out to me. The gun, like the decree of Heaven, fell on that ill-omened bird and blew it to pieces.[20]

The dead owl and the gun are both shown in the picture—the owl transfixed by the spear and the gun resting against it—but why, apart from the departure that day of the royal army, was the owl connected with ᶜAmbar? The answer lies in the color of ᶜAmbar's complexion. Elsewhere in his memoirs, Jahāngīr refers to ᶜAmbar's army as "those owlish ones" and "the army of darkness."[21] A verse inscribed nearby reads: "The arrow that lays the enemy low, sent out of the world ᶜAmbar, the owl, who fled from the light."[22] The fact that ᶜAmbar is shown being

dispatched by an arrow would appear to contradict his equation with the owl shot at Ajmer with the gun, but this change is necessary to the symbolism of the verse. ᶜAmbar, the owl, "fled from the light," and this, as Sir Thomas Arnold points out, is clearly a play on the name Nūr al-Dīn ("Light of the Faith") that the emperor adopted on his accession. This epithet is explained by Jahāngīr in his memoirs, as follows:

> When I became king it occurred to me to change my name because this [i.e., Salīm] resembled that of the Emperor of Rūm. An inspiration from the hidden world brought it into my mind that insomuch as the business of kings is the controlling of the world, I should give myself the name of Jahāngīr (World Seizer) and make my title of honor (*laqab*) Nūr ud-Dīn, insomuch as my sitting on the throne coincided with the rising and shining on earth of the great light [the Sun].[23]

This, of course, resembles the conceit of Queen Elizabeth as "the prince of light," but in Jahāngīr's case the concept was carried to extremes, as shown by the immense halos remarked upon by Ettinghausen in his studies of the allegorical paintings.[24]

Was Jahāngīr's identification of himself with the light of the sun just an idea that he had on his accession, as he claimed, or does it have a longer history? According to the thirteenth-century author of the *Ṭabaqāt-i Nāṣirī*, writing of the first Sultans of Delhi, the court was like heaven, with the Sultan as the Sun,[25] and, of course, this notion goes back to Sasanian times. In the case of Jahāngīr's immediate ancestors, such solar symbolism became an obsession. We are informed in several sources that his grandfather, Humāyūn, who dabbled in occult sciences, had pavilions and tents constructed on astrological principles to imitate the heavens.[26] Also, like the eighth-century heretic al-Muqannaᶜ, who veiled himself to spare his followers the dazzling and insupportable effulgence of his countenance,[27] Humāyūn used to put a veil over his crown and then raise it to the acclaim of his courtiers, who would cry out "Light has shined forth."[28] Badā'unī tells us that this once earned Humāyūn the rebuke of a pilgrim in the sacred enclosure at Mashhad, who whispered in his ear, "So, you are again laying claims to omnipotence."[29] The practice also elicited the severe criticism of Shāh Tahmasp, in a letter said to have been written to Sulaymān I:

> Humāyān, one of the greatest kings in the world, had 500,000 troops and 12,000 war elephants. Then Satan sowed the seeds of sedition in his brain and he became so vain as to claim divine powers. His occasional appearance to the people was described as divine effulgence![30]

If Jahāngīr's grandfather dabbled somewhat foolishly in this type of thing, his father, Akbar, also took solar symbolism very seriously. Thus it was claimed on Akbar's behalf that, like certain Rajput princes, he was actually descended from the sun. To demonstrate this, Abū al-Faḍl recounts Akbar's genealogy, laying great stress on the Mongol line from Ālānqūwā, daughter of the king of Mughulistan. One night, he tells us,

> a glorious light cast a ray into the tent and entered the mouth and throat of that fount of spiritual knowledge and glory. The cupola of chastity became pregnant by that light as did her Majesty (*Ḥazrat*) Mariyam.[31]

Her three sons, who are pictured with her in Akbar's copy of the *Chingīz-nāmah*,[32] were called *Nayrūn* ("light produced"), and it was from this line that Chingīz Khān descended.

In the case of Akbar, Abū al-Faḍl says:

> that divine light, after passing without human instrumentality, through many eminent
> saints and sovereigns, displayed itself gloriously in the external world. That day of
> Ālanquwā's conception was the beginning of the manifestation of his Majesty, the
> King of Kings [Akbar] who after passing through divers stages was revealed to the
> world from the holy womb of her Majesty Miryam Makānī for the accomplishment of
> things visible and invisible.[33]

Akbar's personal devotion to the sun and to fire is, of course, well documented and has caused
some controversy among modern writers.[34] Abū al-Faḍl justifies it—his view is that

> royalty is a light emanating from God, and a ray from the sun, the illuminator of the
> universe. . . . It is communicated by God to kings without the intermediate assistance
> of anyone and men, in the presence of it, bend the forehead of praise towards the
> ground of submission.[35]

This justification of *sijdah* in the royal presence supports a practice under Humāyūn, Akbar,
and Jahāngīr that caused much offense among the orthodox. In a later passage of the *Aʿīn-i Akbarī*,
where he describes Akbar's devotions, Abū al-Faḍl denies that Akbar deified the sun or practiced
fire worship, and he explains that the reason Akbar venerated fire and paid reverence to lamps
was that

> we should show gratitude for the blessings we receive from the sun . . . this is espe-
> cially the duty of kings, upon whom the sovereign of the heavens sheds an immediate
> light.[36]

I could go on with more evidence of this kind, but I think that enough has been said to show
that there is ample precedent in Jahāngīr's immediate background to explain his adoption of solar
symbolism even though there is no evidence that he seriously believed in it as an element of
personal faith. Given these circumstances, the main theme of the picture is clearly the opposition
between divine light—as represented by Jahāngīr—and the evil of darkness, appropriately symbol-
ized by that owl, ʿAmbar.

This duality is, of course, a Zoroastrian concept, but I do not have to cite Akbar's contacts with
the Parsees to explain it here.[37] Similar ideas turn up, for example, in the famous "strife poems"
of Firdawsī's contemporary, Asadī, of which one deals with the opposition of night and day in
the form of a conversation between the two. In this poem, we find that owl mentioned as the
representative of darkness and the night is described as a "dusky negro."[38] Jahāngīr's equation of
ʿAmbar with the owl does not, therefore, betray much original thought.

To return to the question of the gun versus the arrow, it is quite clear that—by whatever means
the notion was transmitted—it stems from the ancient Near Eastern belief that the Sun God
discharges shafts of light from his bow in order to drive away darkness.[39] But, if the picture
mythologizes an actual event in order to glorify Jahāngīr as a divine ruler, it also attempts to
influence fate by sympathetic magic. Besides the dead owl pierced by the spear, there is another
one, very much alive, perched on Malik ʿAmbar's head. The inscription has been read as "The
face of the rebel has become the abode of the owl."[40]

This old idea that the owl destroys the person above whom it sits was certainly known to

Jahāngīr, since it occurs in Book I of Sa'dī's *Gulistān,* of which at least one illustrated copy was made for him.[41] As Ettinghausen pointed out, Jahāngīr was particularly devoted to Sa'dī and quotes extensively from the *Gulistān* in his memoirs.[42] At a later date we learn from the Venetian traveler Manucci that Jahāngīr's grandson, Dārā Shikūh, promoted an officer who killed an owl that perched above the prince's room.[43]

Having now considered the basic theme of the picture, I will turn to other details, which magnify its main protagonist. The sword proferred by a *putto* in the sky is a familiar emblem of the just king, and lower down the scales of justice appear, hanging from a chain of bells. The just king is always accessible to the petitions of his subjects and for this reason Jahāngīr, after his accession, arranged for a chain of sixty golden bells to hang from his private apartments near the Shah Burj of Agra fort and to be attached to a stone post sited on the bank of the river. Although Jahāngīr tacitly gives the impression that this was his own idea,[44] it was actually attributed by Niẓām al-Mulk in the *Siyāsat-nāmah* to the Sasanian king Anūshīrvān, who wanted to make sure that people would not be prevented by officials from gaining access to his ear.[45]

We see this chain in a miniature from the *Tūzuk-i Jahāngīrī,*[46] in which Jahāngīr is making one of his sunrise appearances at the *Jharokha,* high above those who have assembled to catch a glimpse of him as the sun rises. Apart from the obvious solar symbolism of these daily appearances, the Sasanian kings (we are further informed by Niẓām al-Mulk in the *Siyāsat-nāmah*) used to look down from a high platform in order to be sure of seeing all those who came for the redress of grievances.[47] Unfortunately, as one sees from a detail near the bottom of the chain, Jahāngīr's concern for his subjects' welfare was more symbolic than real, since men with rods were stationed to prevent petitioners from disturbing the "Exalted Presence."

If this miniature from the memoirs shows the ugly truth, the allegorical painting is more complacent. Beneath the scales of justice hanging from the chain is a verse that reads:

> Through the justice of Shāh Nūr ud-Dīn Jahāngīr,
> The lion has sipped milk from the teat of the goat.[48]

Looking carefully at the globe, we find that in the center the lion actually takes milk from the udder of a cow. And since, as I have already noted, this represents the golden age, the beasts mentioned by Virgil and Isaiah appear, together with others such as the cat who sits in peace with some mice. To the left, the snake is shown with its traditional enemy the goat,[49] a hawk flies together with a dove, and the lion and goat lie down in each other's company.

A lower inscription that suggests the king's Messianic role:

> By the good fortune of the coming of the shadow of God
> The earth has become firmly placed on the back of the fish.[50]

This seems rather audacious because Farīd al-Dīn 'Attār in his praise of the creator that opens the *Mantiq al-Tayr* makes it clear that the fixing of the earth in place is one of the mysteries of God's creative power. 'Attār writes:

> At the beginning of the centuries God used the mountains as nails to fix the earth; and washed Earth's face with the waters of Ocean. Then he placed the Earth on the back of a bull, the bull on a fish, and the fish on the air.[51]

Not wishing to venture further in that direction, I will now turn to the regal symbols to the right of the picture, which balance the spear in a way that is curiously reminiscent of the pillars of Hercules in an engraving of Elizabeth I by Crispin van de Passe.[52] In the case of Crispin's engraving, there are shields bearing the emblems of the royal houses surmounted by crowns on which symbolic birds perch. In Jahāngīr's picture, the symbolic bird is the *Humā* (bird of paradise) and the head over which it flies is destined to wear the royal crown shown beneath it. This is clearly an auspicious pendant to the inauspicious bird and head depicted opposite it.

Beneath the crown is found the series of inscribed discs that appeared above Jahāngīr's head in one of the Freer pictures studied by Ettinghausen.[53] Arranged together in this form, they resemble his accession seal on which, as here, the names of his ancestors back to Tīmūr are recorded.[54] This then is the imperial crown of Tīmūr, which the conqueror holds in some Mughal miniatures and which is passed down through the first five members of the Mughal family in a pair of well-known miniatures from an album of Shāh Jahān now divided between the Chester Beatty Library and the Victoria and Albert Museum.[55]

The remarkable miniature to which I have devoted so much attention exemplifies almost every aspect of Mughal imperial symbolism. A concern for dynastic legitimacy is indicated by the genealogical seal and the imperial crown. Many other Mughal allegorical pictures provide us with variations of these motifs. In some of these pictures, such as the two album pages just mentioned, the message relates only to temporal succession; but two other paintings in the same album in the Chester Beatty Library give this question of succession a different slant.[56] When viewed together (figs. 3 and 4), they show a bearded shaykh passing the Timurid crown to Jahāngīr, but this time the crown sits on the globe. At the top of the globe is an escutcheon plate surmounted by a key. The globe is inscribed, and Sir Thomas Arnold has read the inscription as "The key of the Victory over the two worlds is entrusted to thy hand."[57] In my view, this translation takes no account of what the key symbolizes: a key is for opening locks and, although the word *fath* does mean "victory," its primary meaning is "opening." We have a parallel use of the word by seventeenth-century Quakers, when they refer to divine revelation as "openings of the spirit." *Fath* is, of course, an Arabic word, but its Persian equivalent, *gushādan,* has a similar range of meaning and is exploited in a punning verse on a Safavid inkwell cited by A. S. Melikian-Chirvani.[58]

In the facing picture, a resplendent Jahāngīr stands holding the globe, but this time the crown is missing and the key that was perched on top of the escutcheon plate is now inserted in the lock. Clearly Jahāngīr has unlocked the secrets of the visible and invisible worlds, since, as the Regent of God, he shares his Creator's omniscience. As the Koran says:

> With him [i.e., God] are the keys of the secret things; none knoweth them besides himself: he knoweth that which is on the dry land, and in the sea; there falleth no leaf but he knoweth it. (6:59)[59]

This time the succession is spiritual rather than temporal and raises the question: Who is this mysterious shaykh able to pass on this precious key? The portrait is an impressive one, for the features are individualistic and yet at the same time appropriate for one able to pass on both worldly shrewdness and otherworldly wisdom. Can we find him among the contemporary shaykhs of India recorded elsewhere by Mughal artists? Sir Thomas Arnold thought he could: in the Chester Beatty catalogue you will find his name given as Shāh Dawlat,[60] patron saint of the rat-eared children, who lived at Gujerat near Lahore—although this identification is in fact negated by the inscribed portrait of Shāh Dawlat in the same collection,[61] which has a quite different face. In any case there is no reason why Shāh Dawlat should occupy such an exalted role.

The haloed figure is clearly much more important and, although the portrait is so convincingly lifelike, it would be a waste of time to seek him among Jahāngīr's contemporaries. To find his name one only need only look at the third sentence of Jahāngīr's memoirs, where the emperor speaks of his own birth. It is well known that prince Salīm (the future Jahāngīr) was born following the prophecy of Shaykh Salīm Chishtī, but it is not to Shaykh Salīm that Jahāngīr attributes the miracle that ended Akbar's search for a successor. In Akbar's view this blessing was conferred on him by India's most famous saint, who lived four centuries earlier, at the time when Muslim power was first being established by the invading Ghurids. He is, of course, Khwājah Muʿīn al-Dīn Chishtī.

Once this is recognized, any number of inscribed portraits can be identified that distort Bichitr's brilliantly convincing portrayal, exemplified in the Chester Beatty album, into a conventional mask of sainthood.[62] Even in Shāh Jahān's great manuscript of the *Pādshāh-nāmah,* the face of Muʿīn[63] completely lacks the profundity of Bichitr's original, although there are details that prove the identification. Shāh Jahān is shown visiting the town of Ajmer, where the *Dargāh-i Sharīf* of Muʿīn al-Dīn is clearly depicted. This, therefore, is the appropriate setting for the saint to proffer the globe marked with continents and thus confer temporal sovereignty upon the emperor; Shāh Jahān was evidently too orthodox to claim more than this.

In view of the importance that the Safavids placed upon their spiritual succession from Shāh Ṣāfi' to bolster dynastic legitimacy,[64] it is hardly surprising that the Mughals appropriated Shaykh Muʿīn in order to play the same game. Just as the Safavids frequently paid visits to the sacred precinct at Ardebil and showered pious donations upon it, so at Ajmer today one can still find the candlestick and drums given by Akbar on one of his visits and the cauldrons presented by both Jahāngīr and Shāh Jahān. After Prince Salīm's birth, Akbar fulfilled his vow by making a pilgrimage on foot to the *dargāh,* just as Shāh ʿAbbās on a later occasion proceeded on foot to Mashhad.[65]

Jahāngīr, as might be supposed, was a frequent visitor to the shrine, and between 1613 and 1616 his court was stationed at Ajmer and he visited the *dargāh* nine times.[66] During this period he fell seriously ill and he attributed his recovery to Muʿīn's intervention. In gratitude he had his ears pierced in order to show that outwardly as well as inwardly he was the Khwājah's earmarked slave.[67]

Although Jahāngīr was particularly devoted to Khwājah Muʿīn al-Dīn, it is apparent from the visit of Shāh Jahān to Ajmer that the idea of the saint conferring legitimacy upon the Mughals was still current in Shāh Jahān's reign. An additional example of this is the existence of the painting from the *Pādshāh-nāmah* already mentioned, in which Prince Khurram, the future Shāh Jahān, takes leave of his father before going off to fight Malik ʿAmbar. Under the throne balcony in the painting, one sees a mural of the saint, offering the globe to the monarch above, and there above his head are two angels, whose presence signifies divine approbation of an act that theoretically, at least, fulfills the destiny of mankind. In this picture, the features of the saint are a little different from those standardized by Bichitr, but since the painting refers to an event of Jahāngīr's reign at Ajmer itself, there seems little difficulty about the identification.

There is, however, another separate miniature of Shāh Jahān's reign[68] that shows a variation of the concept, in which the emperor stands upon the globe receiving a cup from an old gentleman of respectable appearance. In the border above are winged figures bearing a canopy—a motif that E. Whelan refers to in her essay in this volume (page 219) discussing the Cleveland Ewer. But this cupbearer has nothing to do with the iconography of the servant. It is, in fact, Khwājah Khiḍr offering Shāh Jahān the Elixir of Life.

In other illustrations from the *Pādshāh-nāmah*—such as Bichitr's picture of Shāh Jahān receiving his sons[69]—a mural depicting men of religion is also painted on the wall below the throne

balcony. I suspect that they simply represent the *ʿulamā'* conferring their spiritual endorsement upon the just and orthodox emperor—his justice, like that of his father, symbolized by the chain of golden bells tied to the post by the Jumna, and the sheep unafraid of two carnivores.

One last example of a painting beneath the throne in an illustration from the same manuscript introduces a new problem.[70] In this illustration Jahāngīr is receiving the victorious prince, who has now been given, a little prematurely, the title "Shāh Jahān" on returning from the Deccan war. Here painted beneath the throne is a mural that, in the context of royal justice, seems rather strange. A self-satisfied and corpulent *mullā* is offered a bag of gold by an obsequious court official. Below this group another member of royal officialdom drives away starving supplicants with a long staff. I have already mentioned the similar treatment accorded those who approached the chain of bells too closely. Yet according to the *Pādshāh-nāmah* illustrations, Jahāngīr, the Just King, was commemorating such injustice as part of the imperial propaganda, beneath the very throne itself where the fat man and the beggar should be able to lie down in safety together. What does the emperor have to say for himself? Right at the end of his reign in 1624, he remarks in his memoirs that he had given orders for the sick, the blind, etc., to be kept away from his sight.[71]

In this case, Jahāngīr does not say that it was his own idea, and since we know he was very familiar with the works of Ḥāfiẓ, it seems very likely that he had the opening *bayt* of one of the *ghazal*s in mind:

> Who will carry this petition to the attendants of the king, That, in gratitude for kingship, "Drive not the beggar from sight."[72]

Clearly, for the king to see such people was thought to be inauspicious; perhaps their contagious misfortune would jeopardize the very prosperity of the realm.

This brings us to the last allegorical picture for discussion here (fig. 5).[73] It is clearly modeled on the earlier picture by Abū al-Ḥasan (fig. 2) in its general conception, but in this instance there is a new enemy—equally black—to be overcome by Shāh Nūr al-Dīn's victorious bow. If the banishment of the poor seemed unjust, the banishment of a personification of poverty is not. The emperor again stands on the animals of the Golden Age and under his just rule the earth is firmly established on the back of the fish. The ox is gone; instead a little old man appears like some sibyl to read the prophecy of the Golden Age. But who is this apparent prophet and where does he fit into the scheme of Islamic legend? The answer is that he has nothing whatever to do with Islam, but he does have very much to do with both kingship and justice. He is in fact Manu, the legendary Hindu lawgiver (bearing the *Mānavadharmashāstra,* on which the whole functioning of Hindu society is firmly based) who was saved from the great flood by the god Vishnu in his first incarnation as Matsya, the fish. Under the Just King, then, even Hindu laws are respected; to confirm this, the now-familiar testimony of a chain of bells is found, alternating with the old Mongol emblems of horsehair. This time, however, it descends to the pillar, not from the walls of the Agra fort, but from Heaven itself. Beneath the *putti* bearing a thoroughly European crown is inscribed:

> The auspicious likeness of his Exalted Majesty, who casts economic sickness [meaning the man of penury] from the universe with his beneficent arrow and refashions the world with his Justice and Equity.

The optimism of these sentiments was unfortunately not borne out by subsequent Mughal history, but we cannot fail to be interested in the fact of their expression and the circumstances in which Near Eastern, Western, and Indian images were amalgamated in this allegory. Richard Ettinghausen saw the genesis of Jahāngīr's dream picture in the emperor's anxieties about tensions between India and Iran over Qandahar (fig. 1). In the present case, an economic historian may provide a clue to the cause of imperial doubts or pride. A tantalizing question will then remain. In exactly what intellectual hothouse among the coteries of the imperial court were such exotic hybrids brought to flower?

NOTES

1. R. Ettinghausen, *Paintings of the Sultans and Emperors of India in American Collections,* New Delhi, 1961, pls. 11–14 (hereafter, Ettinghausen, *Paintings*); see also R. Ettinghausen, "The Emperor's Choice," *De Artibus Opuscula XL: Essays in Honor of Erwin Panofsky,* Millard Meiss, ed., New York, 1961, 98–120 (hereafter, Ettinghausen, "Emperor's Choice").

2. T. W. Arnold and J. V. S. Wilkinson, *The Library of A. Chester Beatty: A Catalogue of the Indian Miniatures,* London, 1936, I, 31–32, III, pl. 62 (hereafter, Arnold and Wilkinson).

3. Ettinghausen, *Paintings,* pl. 12.

4. Arnold and Wilkinson, III, pls. 63, 86.

5. R. Strong, *The English Icon: Elizabethan & Jacobean Portraiture,* London, 1969, 157, no. 105.

6. Ibid., 289, no. 285.

7. F. Yates, *Astrea: The Imperial Theme in the Sixteenth Century,* London, 1975 (illustrated cover of undated Penguin edition).

8. Virgil, *The Pastoral Poems,* trans. E. V. Rieu, London, 1954, 53.

9. Ibid., 53–54.

10. Akbar's copy of the *Shāh-nāmah,* mentioned by Abū'l-Faẓl ᶜAllāmī, *The Āᵢn-i Akbarī,* trans. H. Blochmann, I, Calcutta, 1873, 103 (hereafter, Abū'l-Faẓl, *Āᵢn-i Akbarī*), appears not to have survived.

11. Niẓhāmī-i ᶜArūḍī-i-Samarqandī, *Chahār Maqāla,* trans. E. G. Browne, London, 1921, 49.

12. M. C. Beach, "The Gulshan Album and Its European Sources," *Museum of Fine Arts, Boston, Bulletin,* LXIII, 332, 1965, 76–77. Since this paper was written, E. Koch published a valuable contribution: "The Influence of the Jesuit Mission on Symbolic Representations of the Mughal Emperors," *Islam in India,* ed. C. W. Troll, New Delhi, 1982, 14–29.

13. Ettinghausen, "Emperor's Choice," 117.

14. Ettinghausen, *Paintings,* pls. 12 and 13.

15. I. Stchoukine, *La peinture indienne à l'époque des grand Moghols,* Paris, 1929, pl. XXIX, and Victoria and Albert Museum, I.M.21–1925.

16. Arnold and Wilkinson, I, 31–32.

17. A. K. Das, *Mughal Painting during Jahangir's Time,* Calcutta, 1978, 221.

18. Since my paper was written, it has been suggested that the painting can be connected with an event of March 1616—seven months earlier than that proposed here. See M. C. Beach, *The Imperial Image: Paintings for the Mughal Court,* Washington, D.C., 1982, 185.

19. Royal Library, Windsor, *Pādshāh-nāmah,* fol. 191v.

20. (Jahāngīr), *The Tūzuk-i Jahāngīrī* trans. A. Rogers, I, London, 1909, 337–38 (hereafter, [Jahāngīr]).

21. Ibid., 313–14.

22. Arnold and Wilkinson, I, 31.

23. (Jahāngīr), I, 2–3.

24. Ettinghausen, *Paintings,* pl. 14; Ettinghausen, "Emperor's Choice," 100–101.

25. Juzjānī, *Ṭabaqāt-i-Nāṣirī,* trans. H. G. Raverty, Calcutta, 1873–81, II, 858.

26. Gul-badan Begum, *Humāyūn-nāma,* trans. A. S. Beveridge, London, 1902, 118; Abū'l-Faẓl, *The Akbar-nāma,* trans. H. Beveridge, Calcutta, 1907, I, 649–50 (hereafter, Abū'l-Faẓl, *Akbar-nāma*).

27. E. G. Browne, *A Literary History of Persia,* I, London, 1902, 319.

28. Al-Badaoni, *Muntakhabu-t-tawarikh,* trans. G. S. A. Ranking, I, Calcutta, 1898, 573.

29. Ibid., 573.

30. Riazul Islam, *Indo-Persian Relations,* Tehran, 1970, 35–36.

31. Abū'l Fazl, *Akbar-nāma*, I, 179.

32. *The Arts of India and Nepal: The Nasli and Alice Heeramaneck Collection,* Museum of Fine Arts, Boston, 1966, fig. 202b.

33. Abū'l-Fazl, *Akbar-nāma*, I, 180.

34. A. A. Rizvi, *Religious and Intellectual History of the Muslims in Akbar's Reign,* New Delhi, 1975, 388–89.

35. Abū'l-Fazl, *Aʿīn-i Akbarī,* I, author's preface, iii.

36. Ibid., I, 155.

37. B. P. Ambashthya, *Contributions on Akbar and the Parsees,* Patna, 1976.

38. A. J. Arberry, *Persian Poems,* London, 1954, 98.

39. In the case of the Indian sun god, Surya, the darkness is driven away by Ūshā and Pratyūshā with bows and arrows.

40. Arnold and Wilkinson, I, 31.

41. Saʿdī, *The Gulistan or Rose Garden,* trans. E. Rehatsek, ed. W. G. Archer, London, 1964, 102 (bk. 1, story 26).

42. Ettinghausen, "Emperor's Choice," 114.

43. N. Manucci, *Storia do Mogor,* trans. W. Irvine, London, 1906, I, 227.

44. (Jahāngīr), I, 7.

45. Nizām al-Mulk, *The Siyar al-Mulūk or Siyāsat-nāma* (*The Book of Government or Rules for Kings*), trans. H. Darke, London, 1960, 40 (hereafter, Nizām al-Mulk, *Siyāsat-nāma*).

46. A. Welch and S. C. Welch, *Arts of the Islamic Book,* Ithaca and London, 1982, 208–12.

47. Nizām al-Mulk, *Siyāsat-nāma*, 14.

48. Arnold and Wilkinson, I, 31.

49. R. Ettinghausen, "The Snake-eating Stag in the East," *Late Classical and Medieval Studies in Honor of Albert Mathias Friend, Jr.,* ed. K. Weitzmann, Princeton, 1955, 272–86.

50. Arnold and Wilkinson, I, 32.

51. Farid ud-din Attar, *Mantiq Ut-tair,* trans. C. S. Nott, London, 1954, 3.

52. R. Strong, *Portraits of Queen Elizabeth I,* Oxford, 1963, no. E.23.

53. Ettinghausen, *Paintings,* pl. 13.

54. See B. N. Goswamy and J. S. Grewal, *The Mughals and the Jogis of Jakhbar,* Simla, 1967, 87, n. 1, 94–97, also S. C. Clarke, *Thirty Mogul Paintings of the School of Jahāngīr,* London, 1922, pl. 23.

55. R. Skelton et al., *The Indian Heritage: Court Life and Arts under Mughal Rule,* Victoria and Albert Museum, 21 April–22 August 1982, London, 1982, nos. 52, 53 (hereafter, Skelton, *The Indian Heritage*); Arnold and Wilkinson, III, pl. 65.

56. Arnold and Wilkinson, III, pl. 57, and I, frontispiece.

57. Ibid., I, 28.

58. A. S. Melikian-Chirvani, *Islamic Metalwork from the Iranian World,* London, 1982, no. 119.

59. *The Koran,* trans. G. Sale, London, 1836, 105.

60. Arnold and Wilkinson, I, 30.

61. Ibid., III, pl. 68.

62. E.g., the Large Clive Album, Victoria and Albert Museum, (I.S. 133–1965), fol. 86r.

63. *Pādshāh-nāmah,* fol. 205r.

64. See R. Savory, "The Safavid State and Polity," *Iranian Studies,* VII, nos. 1–2, pt. 1, 183–84, 186ff.

65. Abū'l-Fazl, *Akbar-nāma,* II, 510–11; Savory, 197.

66. (Jahāngīr), I, 249–340.

67. Ibid., I, 267.

68. London, Sotheby, 1 December 1969 sale, lot 151.

69. *Pādshāh-nāmah,* fol. 50v; see B. Gascoigne, *The Great Moghuls,* London, 1971, 145.

70. *Pādshāh-nāmah,* fol. 49r.

71. (Jahāngīr), II, 294.

72. Hāfiz, *Dīwān,* ed. N. Ahmad and S. M. Ridā Jalālī Naʿīnī, Tehran, 1976, 4.

73. Los Angeles County Museum of Art, M.75.4.28 (from the Nasli and Alice Heeramaneck Collection); Skelton, *The Indian Heritage,* 20, no. 48. For a diluted version of the subject of the painting, see Sotheby's *Catalogue of Fine Oriental Miniatures,* Manuscripts, Qajar Paintings and Lacquer, 24 April 1979, lot 29 (illustrated).

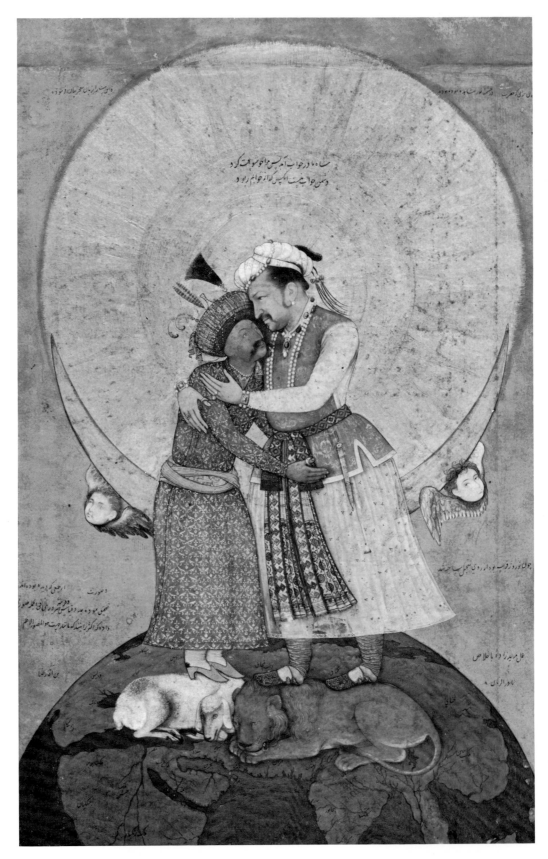

Fig. 1. Jahāngīr embracing Shāh ʿAbbās in his dream. By Abū al-Ḥasan, c. 1618–22. Washington, D.C., Freer Gallery of Art, no. 45.9. Courtesy Freer Gallery of Art, Smithsonian Institution

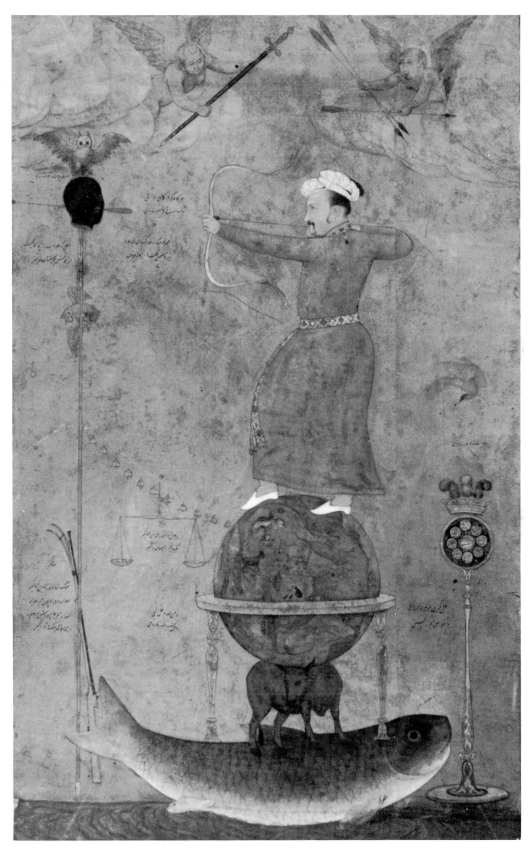

FIG. 2. Jahāngīr shoots the severed head of Malik ʿAmbar. By Abū al-Ḥasan, c. 1617. Dublin, Chester Beatty Library, MS 7, no. 15. Courtesy The Trustees of the Chester Beatty Library

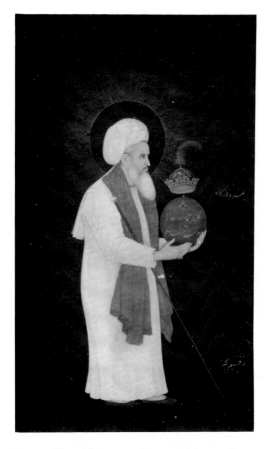

FIG. 3. Khwājah Muʿīn al-Dīn Chishtī profers
the Timurid crown and globe. By Bichitr, c.
1620. Dublin, Chester Beatty Library, MS 7,
no. 14. Courtesy The Trustees of the Chester
Beatty Library

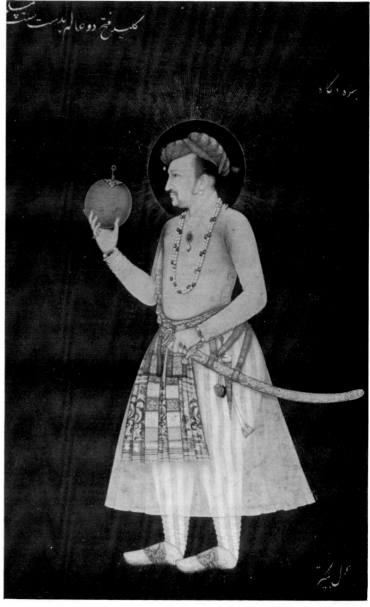

FIG. 4. Jahāngīr holding the globe. By Bichitr,
c. 1620. Dublin, Chester Beatty Library, MS
7, no. 5. Courtesy The Trustees of the
Chester Beatty Library

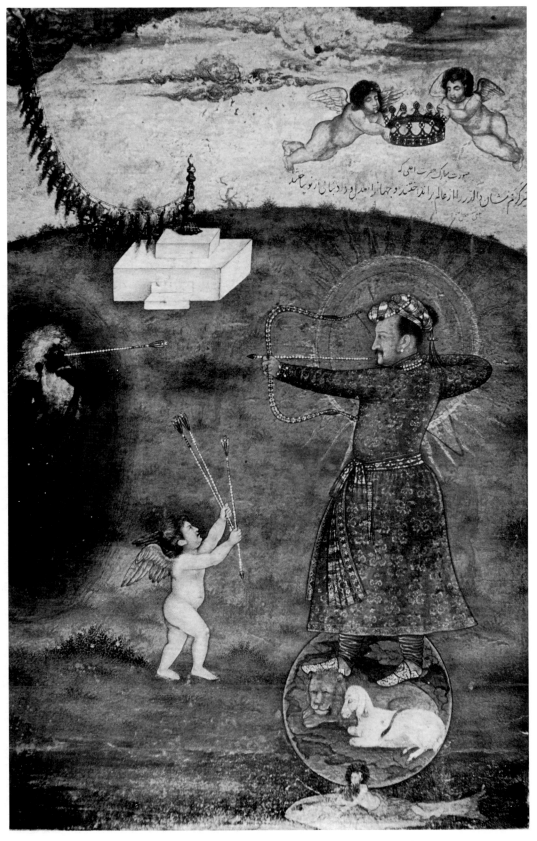

Fig. 5. Jahāngīr shoots poverty. Probably by Abū al-Ḥasan, c. 1625. Los Angeles County Museum of Art, M.75.4.29, from the Nasili and Alice Heeramaneck Collection. Courtesy Los Angeles County Museum of Art

The Life of the Prophet: Illustrated Versions

Priscilla P. Soucek

S EVERAL manuscripts produced in Iran during the thirteenth and fourteenth centuries contain cycles of illustrations depicting events from the life of the Prophet Muḥammad. The purpose of this essay is to consider the significance of such paintings for the evolution of Islamic art and for the light they shed on the cultural and historical environment in which they were produced.

Pictorial antecedents for these paintings are obscure, although earlier literary references to portraits of Muḥammad are known. In his *al-Akhbār al-Ṭiwāl,* the ninth-century scholar Dīnawarī describes a set of portraits said to have been seen in Constantinople by an envoy of the Caliph Abū Bakr. These portraits, which at the time belonged to the Byzantine emperor, had been made for Alexander. Included were portrayals of Adam, Noah, Abraham, Moses, David, Solomon, Jesus, and Muḥammad.[1] According to Masʿūdī (d. 346/956), another set of portraits—this one belonging to the Emperor of China—included one of Muḥammad sitting on a camel surrounded by his companions.[2] No extant paintings can be linked to these descriptions. More closely linked to the pictorial tradition is the legend of a painting said to have belonged to Abraham in which Muḥammad prays, flanked by Abū Bakr on his right and by ʿAlī on his left. These three figures were surrounded by a group of the Prophet's companions on horseback.[3] This description, in a sixteenth-century text, Mīrkhwānd's *Taʾrīkh Rawḍat al-Ṣafāʾ* and credited to Kaʿb al-Aḥbār (d. 32/652), resembles compositions found on Persian ceramic vessels of the thirteenth century where an enthroned figure is surrounded by a group of retainers on horseback.[4]

The earliest extant paintings of Muḥammad appear to be those that show him with his

successors, the first four caliphs. Just as it was customary to open literary works with a eulogy of the Prophet, so too by the late thirteenth century some manuscripts contained paintings of him in their initial pages. Representative of these paintings is one in a late thirteenth- or early fourteenth-century *Shāh-nāmah* manuscript now in the Freer Gallery, Washington (fig. 1).[5] It shows Muḥammad enthroned under a canopy held by angels and flanked by four men identifiable by their attributes or physiognomy as Abū Bakr, ʿUmar, ʿUthmān, and ʿAlī. Their identification comes from descriptions in various Islamic sources rather than from Firdawsī's text, where only Muḥammad and his family are mentioned.[6] The two figures seated on the Prophet's right are ʿAlī (above) and Abū Bakr (below). Distinctive for Abū Bakr is his white beard, mentioned in various sources.[7] ʿAlī is shown with a double-pointed sword, a conventional manner of representing the *dhū al-faqār,* a weapon the Prophet is said to have given him.[8] Seated to Muḥammad's left is a man with a sword, probably ʿUmar, and one with an open book, probably ʿUthmān. ʿUmar's association with a sword may reflect traditions alleging that his conversion to Islam occurred when he was armed with a sword to kill Muḥammad, or that allude to the physical prowess for which he was renowned.[9] Sometimes he was also depicted carrying a whip.[10] ʿUthmān's role in preparing and distributing a standard version of the Koran made an open book a logical attribute for him.[11]

The origin of this composition with Muḥammad and the caliphs is unknown, but it must have been current by the middle of the thirteenth century, when a related scene was used to illustrate a meeting between the Prophet and a Syrian ruler in the poem of *Warqah wa-Gulshāh.*[12] There the Prophet and his throne are in the middle of the painting, but all four of the caliphs have been moved to the Prophet's left in order to accommodate the Syrian ruler and his page. Variants of this composition are also known in which Muḥammad is flanked by his descendants, Ḥasan and Ḥusayn, or by other members of the Islamic community. Some of these probably depict the Prophet with the elect in Paradise.[13]

In addition to these isolated portrayals of Muḥammad and his companions, more extensive cycles illustrating his life had developed by the late thirteenth or early fourteenth century. Five manuscripts from this period are known that contain depictions of events from his life. Eight examples are found in a late thirteenth- or early fourteenth-century copy of Balʿamī's translation of Ṭabarī's *Ta'rīkh al-Rusul wa-al-Mulūk,*[14] seventeen occur in three different manuscripts of Rashīd al-Dīn's *Jāmiʿ al-Tawārīkh,* and four scenes are included in the 707/1307 copy of Bīrūnī's *al-Āthār al-Bāqiyah.*[15]

A significant feature of these cycles is the diverse aspects of Muḥammad's life presented in them. It is my thesis that such illustrations are essentially selective interpretations of the Prophet's biography. If this is so, the analysis of paintings in a given manuscript should reveal which facets of his life are being stressed and may lead to a clearer understanding of why these paintings were created.

Interpretations given to events in the Prophet's life were affected by debates over religious and political issues within the Islamic community. Of particular importance was the question of how Muḥammad's successor, as leader of the Islamic community, should be chosen. Some of the paintings under discussion here reflect arguments advanced by various factions in this controversy. Others stress the superiority of Islam over not only paganism but also Judaism and Christianity. In the following discussion, the paintings illustrating the texts of Balʿamī, Bīrūnī, and Rashīd al-Dīn will be considered in turn. Subsequently, certain features of each manuscript will be compared to those of the others and suggestions made as to the context in which these manuscripts were produced.

THE BALᶜAMĪ MANUSCRIPT

Events from Islamic history illustrated in Balᶜamī's translation of Ṭabarī focus on moments of action and high drama in the life of the Muslim community. Emphasized is Muḥammad's triumph over enemies of the faith through his own heroism and by means of angelic assistance. Incidents that demonstrate his divine mission are also presented. Of particular interest is this manuscript's depiction of ᶜAlī b. Abī Ṭālib. Incidents when he battled for the faith are included, as well as events when he suffered political humiliation. This manuscript appears to stress ᶜAlī's role as a hero in the early struggles of the Islamic community but minimizes his importance as a political leader.

Five paintings record the four major battles that occurred between the Muslims and their pagan neighbors and kinsmen. Two show the triumph of the Muslims at Badr, and others illustrated the battle of Uḥud, the aborted conflict at Medina known as the "Battle of the Ditch," and the defeat of the pagan Arabs at Ḥunayn.[16] All paintings stress Muḥammad's role in the conflict both by the choice of episodes to be illustrated and by the arrangement of the composition. The Prophet is the only figure given a consistent and distinctive physiognomy; he is recognizable by his dark beard and by locks of dark hair that hang over his shoulders (figs. 3–9). He is said to have had thick black hair, which he sometimes divided into four braids of curls.[17] Although the texts do not stress this aspect of his appearance, the curls become a nearly standard feature of his depictions. Occasionally, his cousin ᶜAlī and his grandsons Ḥasan and Ḥusayn have their hair arranged in a similar fashion. In this manuscript, however, ᶜAlī is most easily identified by the double-pointed sword that he carries (figs. 3, 8).

In describing the battle of Badr, Balᶜamī gives a wealth of picturesque detail emphasizing the aid given to Muslims by angels sent in response to the Prophet's prayers for assistance. He stresses that both the victory itself and the manner in which it was achieved were viewed as a vindication of Muḥammad's claims that the Muslim community was divinely protected.[18] Chosen for illustration in this manuscript are the first episodes of the conflict—when three of the Prophet's supporters battle three leading members of the Meccan forces—as well as its final stage, when Muḥammad surveys the battlefield and orders the execution of Abū Jahl, one of his principal foes among the Quraysh (figs. 5, 6).

In depicting the opening stages of this battle, the painter has combined a combat between the two groups with an indication of the Prophet's invocation of divine assistance to aid the Muslims (fig. 5). As the battle began, three of the Quraysh (ᶜUtbah b. Rabīᶜah, his son Walīd, and his brother Shaybah) invited the Prophet's supporters to combat. A group of Medinan volunteers were considered unsuitable as foes and the Meccans appealed to the Prophet to send them more appropriate adversaries. At Muḥammad's instigation, ᶜAlī (his cousin), Ḥamzah (his uncle), and ᶜUbaydah b. Ḥārith (another cousin) entered the fray. According to Balᶜamī, ᶜAlī killed his adversary by splitting him in two. Ḥamzah also killed his opponent, but ᶜUbaydah received a mortal wound.[19]

During the battle, the Prophet prayed, requesting divine intervention to prevent the destruction of his supporters.[20] In response, a host of angels was sent to reinforce the ranks of the Muslims, an event recorded in the Koran:

> Remember ye implored The assistance of your Lord, And He answered you: "I will assist you With a thousand of the angels, Ranks on ranks."[21]

This revelation is alluded to in the upper section of the painting, where the Prophet on horseback is shown turning as if to listen to the angel swooping toward him (fig. 5). Below, the two armies are locked in combat. Among the warriors only ʿAlī can be identified, for he uses a double-pointed sword to bisect an opponent.

The painter has also created a dramatic tableau depicting two different episodes from the final stages of the battle at Badr: the execution of Abū Jahl and the burial of the pagan dead in an abandoned well (fig. 6).[22] Among the Prophet's enemies none was more determined than ʿAmr b. Hishām, known as Abū Jahl. In various incidents reported by Islamic authors, his opposition to Islam assumes a satanic dimension. Even after the Prophet attempted to save Abū Jahl by teaching him the profession of faith, the latter persisted in his efforts to defame, injure, and even kill the Prophet.[23] At Badr he was the leader of the Meccan forces and is described as forcing his compatriots to battle their kinsmen, the Prophet's supporters.[24] At the conclusion of the battle, Muḥammad asked his followers to find Abū Jahl. In Islamic sources more than one version of his death is given. The Freer manuscript illustrates his beheading by ʿAbd Allāh b. Masʿūd, who was formerly Abū Jahl's shepherd.[25]

Above this execution there is an illustration of a subsequent incident when the Prophet directed his followers to place the pagan dead in a dry well. After the corpses, including that of Abū Jahl, had been placed in the well, Muḥammad addressed them, reminding them that both his victory and their defeat had been divinely ordained.[26] The painter has placed three angels in the sky above the Prophet's head, perhaps as evidence of this divine intervention. They also serve as visual reminder of his role in this combat as intermediary between the angelic and human participants.

Further stress on the role of Muḥammad is given in other illustrations of battles between the Muslims and their pagan opponents. In seeking vengeance for their defeat at Badr, the Meccans marched toward Medina and the two armies clashed in a valley known as Uḥud. At this encounter the Muslims suffered a disastrous defeat; many of their number were killed, including Ḥamzah, and the Prophet himself was wounded. The Meccan army was accompanied by women who urged their men to kill the Muslims and then desecrated the bodies of the slain. Particularly violent was Hind, the wife of Abū Sufyān, who brutally mutilated Ḥamzah's body.[27]

The illustrator of Balʿamī's text has evoked different aspects of this story in a compact fashion, but once again it is Muḥammad who dominates the scene (fig. 7). The role of women in the battle is indicated by the placement of two of them on the left behind a mountain. The main incident depicted, however, is the Prophet's attack on Ubayy b. Khalaf, which occurred toward the end of the battle.[28] Wounded and exhausted, Muḥammad was sitting in the middle of the battlefield when Ubayy appeared on a camel to fulfill a vow he had taken to kill him. At this moment the Prophet was guarded by Saʿd b. Abī Waqqāṣ, who used a bow and arrows to keep the enemy at bay. Saʿd prepared to attack Ubayy, but Muḥammad dissuaded him and picked up a lance in order to defend himself. After being struck on the neck, Ubayy retreated, claiming that Muḥammad had given him a mortal wound, and indeed he died shortly thereafter.

Visual emphasis is also given to Muḥammad in depictions of the "Battle of the Ditch" and of that at Ḥunayn (figs. 8, 9). In the latter instance, Muḥammad did in fact rally his fleeing troops, thus preventing a defeat of the Muslim armies.[29] In his account, Balʿamī stresses the heroism of ʿAlī in protecting Muḥammad. In particular, he crippled the camel of a pagan Arab who was attempting to attack the Prophet.[30] In the Freer manuscript, the person on the far left attacking a camel may well be ʿAlī, but in this instance he is not shown with the double-pointed sword he wields elsewhere in the manuscript. Here, greatest prominence is given to Muḥammad, shown riding another camel.

Another instance where Muḥammad is given greater physical prominence than ʿAlī is in the

scene of the "Battle of the Ditch" (fig. 8).[31] When a Meccan force threatened to attack Medina, the Muslims protected the city by digging a *khandaq* (ditch) around it.[32] Most of the Meccans were unable to cross the barrier, but finally ᶜAmr b. ᶜAbd al-Wudd entered it and challenged the Muslims to combat. ᶜAlī answered the call and after a fierce combat killed his opponent.[33] Although Muḥammad exhorted his supporters to resist the Meccan army, he is not described as participating in ᶜAlī's conflict with ᶜAmr. Here, however, Muḥammad is shown beside the ditch, gesticulating toward the combatants—an arrangement that makes him appear to be directing the battle.

Illustrations in the Balᶜamī manuscript do present ᶜAlī as an active participant in the early battles of the Muslim community, but other paintings also show his humiliation. One depicts his role in ᶜUthmān's election to the caliphate and another shows the battle of his army with that of Muᶜāwiyah at ᶜAyn Ṣiffīn.[34] Also illustrated is the accession to the throne of the first Abbasid caliph, ᶜAbd Allāh al-Saffaḥ.[35] This trio of subjects suggests that the illustrator wished to stress the Sunni view of the caliphate.

Most unusual of the Balᶜamī illustrations is a scene where Muḥammad is depicted along with various prominent Muslims (fig. 3).[36] Located in a textual passage containing the Prophet's genealogy, this painting is framed by a list of his ancestors beginning with his father, ᶜAbd Allāh, and concluding with Adam. The genealogies of eleven members of the Quraysh are also given.[37] Often these are linked to the appropriate ancestor of Muḥammad in the encircling inscription. First come the descendants of ᶜAbd al-Muṭṭalib: Ḥamzah, ᶜAbbās, and ᶜAlī b. Abī Ṭālib. After ᶜAlī's name a later hand added the title "Amīr al-Mu'minīn," along with the names of his sons, Ḥasan and Ḥusayn, also followed by this title. The names of ᶜAbd Manāf's descendants: ᶜUthmān b. ᶜAffān, Muᶜāwiyah b. Abī Sufyān, ᶜAbd al-Malik, and ᶜAbd al-ᶜAzīz b. Marwān are part of the original inscription. He is also given the title "Amīr al-Mu'minīn," which is not used with the names of Muᶜāwiyah and ᶜAbd al-Malik. Representing the descendants of Qusayy are ᶜAbd Allāh and Musᶜab b. al-Zubayr. Also linked with the names of their ancestors are Abū Bakr b. ᶜUthmān descended from Murra b. Kaᶜb, and ᶜUmar b. al-Khaṭṭāb, a descendant of Kaᶜb b. Luᶜayy. Both also have the title "Amīr al-Mu'minīn."

Unfortunately a portion of this page is now missing. From remaining fragments presently covered by a later repair, it appears that the area contained an inscription written on a green ground. Corrosive ingredients in this pigment must have contributed to the page's destruction.[38]

Within the framing inscription are two groups of figures. In the upper one, the Prophet appears to be discussing the contents of a book with Abū Bakr and ᶜAlī.[39] An angel hovers to the right, suggesting a divine source for Muḥammad's statements. In front of these three men are two children, probably Ḥasan and Ḥusayn. ᶜAlī and his sons are all depicted with curls hanging over their shoulders. More enigmatic is the lower group of five, who appear to be considering the contents of a second book resting on a stand. From the placement of this illustration in Balᶜamī's text, it is probable that both groups are discussing the Prophet's genealogy. Muslim scholars were in general agreement about his ancestors as far as Maᶜadd b. ᶜAdnān, but differing views were held about the generations linking ᶜAdnān with Ismāᶜīl.[40]

Despite the many reminding questions about this painting and its accompanying inscriptions, certain aspects of its message can be determined. The genealogies stress both the Prophet's descent from Ismāᶜīl and other biblical figures and the importance of his kinsmen the Quraysh. Among the latter, prominence is given not only to the four caliphs but also to the Umayyads and the descendants of Zubayr. Most of these individuals played a role in the transmission of the Prophet's religious heritage, and many played a major role in Muslim political affairs.[41] Also notable is the treatment accorded to ᶜAlī and his descendants. ᶜAlī's name is placed after that of

ʿAbbās and Ḥamzah, both those of Ḥasan and Ḥusayn were probably not originally mentioned despite their portrayal in the painting. Taken together, these elements suggest that the painting reflects the generally Sunni tone revealed in this manuscript's other illustrations. Perhaps the Prophet's genealogy was viewed as a confirmation for his claims of a divine mission.

The theme of Muḥammad's prophetic mission is stressed by two other illustrations in the Balʿamī manuscript. Most significant is his purification carried out by three personages who descended from the sky, an incident that was considered to have prepared him for a prophetic role.[42] Typically, the manuscript's illustration presents a vivid and dramatic version of this event (fig. 2).[43] The three strangers are depicted as an elderly man with two youths—a grouping that recalls scenes of physicians and their assistants in other Islamic manuscripts, and their actions give the incident the atmosphere of a surgical procedure.[44] The white-bearded man holds the Prophet's heart cupped in his hands while one assistant pours a liquid over it and another holds a golden basin below it. The painter includes the Prophet's wet nurse, Ḥalīmah, as witness to the event, thereby providing a human context for it. Also illustrated is the conversion of seven angels to Islam through hearing the Koran, a theme that emphasizes the power of the Koran and provides another occasion for including angels, one of this painter's favorite subjects (fig. 4).[45]

In general, the Balʿamī illustrations stress events that dramatize the Prophet's heroism or his ability to communicate with supernatural beings. Other topics illustrated in later sections of the text suggest that the painter followed the Sunni conception of Islamic history and of the evolution of the caliphate.

THE BĪRŪNĪ MANUSCRIPT

A pictorial and ideological contrast to the Balʿamī manuscript illustrations is provided by those in the 707/1307 copy of Bīrūnī's *Chronology of Ancient Nations*.[46] Those illustrating his discussion of Muslim festivals are particularly relevant. Despite this section's brevity, numerous events involving the Prophet's descendants are mentioned.[47] The martyrdom of Ḥusayn b. ʿAlī at Karbalā' is treated at greatest length.[48] Selected for illustration, however, are two incidents of which Bīrūnī gives only a brief account: the Prophet's confrontation with the Christians of Najrān, known as "The Day of Cursing," and the moment when Muḥammad is said to have designated ʿAlī as his successor at Ghadīr Khumm.[49]

Bīrūnī's text suggests that this author felt particular affection for the Prophet's family, but the subjects selected for illustration appear to go beyond his emphasis and underscore the religious and political importance of ʿAlī and his descendants for the Islamic community. ʿAlī's investiture was celebrated by Shiite communities, but its commemoration was much less significant for popular Shiism than that of Ḥusayn's martyrdom.[50] Even less important, on the popular level, was the anniversary of the Prophet's dispute with the Christians of Najrān.[51] Both of these events were, however, used by Shiite theologians as evidence for the Prophet's designation of ʿAlī as his rightful successor.[52] Thus despite their emotional immediacy, the illustrations of Bīrūnī's text are more closely linked to legalistic and intellectual traditions of Shiism than to its popular manifestations.

Details of these paintings highlight their symbolic aspects. Dramatic cloud formations placed over the Prophet and his relatives may have been intended as emblems of sanctity. Parallels for this use of clouds can be found in the Edinburgh University Library manuscript of Rashīd al-Dīn's *Compendium of Histories* (considered below).[53] The symbolic aspects of these two subjects is also suggested by the cloak placed over the Prophet's head and by the arrangement of his hair in

two braids. ʿAlī, Ḥasan, and Ḥusayn also wear their hair in braids.[54] Other depictions of Muḥammad and his family in this same manuscript lack this feature.[55] The illustrator of the Bīrūnī manuscript appears to support the Shiite interpretation of Islamic history, by presenting events of symbolic importance to that community.

RASHĪD AL-DĪN'S *HISTORY*

Yet another interpretation of the Prophet's life is seen in three fourteenth-century manuscripts of Rashīd al-Dīn's historical compendium, *Jāmiʿ al-Tawārīkh*. Two of them, one in the Edinburgh University Library (MS Arab 20) and another formerly in the possession of the Royal Asiatic Society, London, are closely related in both style and thematic approach. The third, now in the Topkapı Sarayı Library (Hazine 1653), differs from the others in both the conception and execution of its illustrations. The Edinburgh manuscript illustrates events from the Prophet's life prior to his flight from Mecca, whereas the other two copies depict events of the Medinan period.

A common approach toward illustration of the Prophet's life links the Edinburgh manuscript, probably copied in 706/1306–7, and the one formerly in London, which is dated to 714/1314. Their illustrations have a more cerebral and intellectual quality than those in the Balʿamī manuscript. Particular emphasis is given to topics that demonstrate the place of Islam within the larger context of Near Eastern religious traditions. Some affirm the Prophet's role in a tradition initiated by Abraham, whereas others demonstrate the relation of Islam to Christianity and Judaism. Also included are scenes of conflicts with the pagan community of Mecca. Paintings also dramatize the Prophet's mission within a purely Islamic frame of reference. Missing are events demonstrating the Prophet's relationship with members of his immediate family, although one incident gives prominence to Abū Bakr.[56]

A contrast to these manuscripts is provided by the Istanbul copy, Hazine 1653, which has a colophon date of 714/1314. Its four illustrations of events from the Prophet's life have a direct narrative quality closer in spirit to the Freer Balʿamī than to other fourteenth-century copies of Rashīd al-Dīn's text.[57] The significance of this difference has yet to be determined.

The portion of Rashīd al-Dīn's work describing the Prophet's life awaits publication, but in general this text presents abbreviated versions of events described at greater length by Ibn Isḥāq/Ibn Hishām, Ṭabarī, Balʿamī, Wāqidī, and Ibn Saʿd; some passages are, however, of uncertain origin. Rashīd al-Dīn presents the Prophet's life as an integral unit—an arrangement also found in the *sīrah* of Ibn Isḥāq—rather than employing the scheme followed by Ṭabarī, whereby events concerning the Prophet are juxtaposed with Sasanian history. Rashīd al-Dīn's text also agrees with that of Ibn Isḥāq—rather than with that of Ṭabarī—in placing the Prophet's Nocturnal Journey just prior to his departure for Medina rather than at the beginning of his prophetic career.[58] It is unknown, however, whether Rashīd al-Dīn himself composed this portion of *Jāmiʿ al-Tawārīkh* or whether he used the compilation of an earlier author.

In the Edinburgh manuscript, ten events from the Prophet's biography are illustrated in sixteen consecutive folios of the text, whereas the remaining folios of the text describing his life in Medina are not illustrated. Key events from his later years are, however, depicted in the manuscript formerly in London. Customarily the Prophet's biography opens with a listing of his ancestors going back to Ismāʿīl and, ultimately, Adam. The Edinburgh manuscript illustrates an event linking Muḥammad with the heritage of Ismāʿīl and Ibrāhīm: his grandfather's rediscovery of the Zamzam spring within the Kaʿbah precinct. Rashīd al-Dīn's text is very similar to that

given by Ibn Isḥāq and describes a sequence of dreams giving ever more precise instructions on how the well can be identified.⁵⁹ Illustrated is the moment before the actual excavation, when ʿAbd al-Muṭṭalib stands, pick in hand, beside his son, al-Ḥārith, watching the raven on an ant hill. Rashīd al-Dīn does not stress the theological implications of this event, but others such as Ṭabarī explain how the rediscovery of this spring was considered to renew the traditions of Ismāʿīl. ʿAbd al-Muṭṭalib's vow taken at the Kaʿbah to sacrifice one of his sons also recalls Ibrāhīm's deeds.⁶⁰

A connection between the Prophet and Ibrāhīm's heritage is created by Muḥammad's role in rebuilding the Kaʿbah. During his thirty-fifth year, a decision was taken to rebuild and roof the Kaʿbah in order to better protect its treasures. Accordingly, the walls were pulled down to their foundations, considered to be the work of Ibrāhīm and Ismāʿīl. Various portents persuaded the Quraysh to leave these foundations in place, but a dispute arose over who should be allowed to place the Black Stone within the rebuilt walls. This stone, said to have been given to Ismāʿīl by Jibrāʾīl during the building's original construction, was its most sacred element. Finally, the Prophet resolved the dispute by having representatives of the four main branches of the Quraysh lift the stone on his cloak and then placing the stone within the wall himself. The Edinburgh illustration shows this culminating event, although it is found in a section of the text describing the preparation of the building's foundations. Rashīd al-Dīn's text contains a condensed and simplified version of the narrative given by Ibn Isḥāq and Ṭabarī.⁶¹

Other topics illustrated in the Edinburgh manuscript that are linked to earlier religious traditions are the Prophet's birth and his recognition by the Christian monk Baḥīrā. In describing the Prophet's birth, Rashīd al-Dīn follows the precedent of earlier Islamic authors such as Ibn Isḥāq, Ṭabarī, and Ibn Saʿd in concentrating on two aspects of the event: its date and the miraculous occurrences associated with it. Miracles described include a dream received by Amīnah during her pregnancy, in which she is instructed to name the child Muḥammad, and various visions of light emanating from the child both before and after birth. Little attention, however, is given to the moment of birth itself or to the setting in which it occurs. Despite the brevity of his historical narrative, Rashīd al-Dīn may have had a personal interest in this subject. The *Waqf-nāmah* of Rabʿ-i Rashīdī makes special provision for festivities to be held on the anniversary of the Prophet's birth.⁶²

As D. T. Rice and others have noted, the composition used in the Edinburgh manuscript probably derives from depictions of the Nativity in Christian art. It is clear from other paintings executed in Iran during the early fourteenth century that Christian manuscripts were available in Mongol court circles.⁶³ Here the use of Christian elements may underscore the Prophet's links to the past.

Muḥammad's role as the culminating figure in the Judeo-Christian tradition is stressed in another incident illustrated in the Edinburgh manuscript: his above-mentioned encounter with the Christian monk Baḥīrā. Rashīd al-Dīn gives a description of this event deriving it from Ibn Isḥāq's account, omitting some anecdotal detail, and making one significant addition. When Muḥammad, his uncle Abū Ṭālib, and other members of a caravan traveling to Syria pass near the hermitage of Baḥīrā, the latter notices a cloud that hovers over the tree by which the caravan had stopped to rest. The tree also bends over its branches to form a shelter for the travelers. Baḥīrā invites the travelers to a meal but sends them back to bring Muḥammad, who had originally been left behind to guard their baggage. When Baḥīrā finally meets the youth, he recognizes in him the person of whom he has read predictions. After interrogating Abū Ṭālib about Muḥammad's genealogy, he warns against taking the youth to Syria, where the Jews and Christians might try to harm him. (Their antagonism would presumably be aroused by the Prophet's gift of revelation which would challenge their previous monopoly of it.) Whereas other Islamic authors refer only

to danger from Jews, Rashīd al-Dīn specifies that both the Christians and the Jews would seek to harm Muḥammad.[64]

In depicting this event, the painter has combined elements from various stages in the story to form a dramatic tableau. Baḥīrā gesticulates toward Muḥammad from a building on the far right, and the latter is shown below a cloud being anointed by an angel who also holds a scroll. Muḥammad is framed by two groups of men, and the context of the event is provided by kneeling camels and stacked baggage.[65]

In theological debates Christians often contested the Prophet's claim to superiority, insisting that if his message were valid his coming would have been predicted by earlier prophets.[66] Baḥīrā's assertion that Muḥammad fulfilled predictions given in earlier texts appears designed to counter these criticisms. The message of the Prophet's divinely ordained mission is also conveyed by the inclusion of the anointing angel. This motif is reminiscent of some Armenian depictions of Christ's baptism, in which an anointing angel replaces the dove of the Holy Spirit normally present in such scenes.[67] Here the angel also holds a scroll, perhaps an allusion to future revelations. These various elements appear designed to affirm the superiority of Islam over the antecedent faiths.

An even more explicit condemnation of the Jews is found in two incidents selected for illustration in both the manuscript formerly in London and the one in Istanbul. Both illustrate the Prophet's conflict with two Jewish communities near Medina, the Banū Qaynuqāᶜ and the Banū Al-Naḍīr. In both instances they had treaties with the Muslims that were abrogated by the Prophet. After being besieged by the Muslims, both were defeated and forced to abandon their homes. Occurring in two manuscripts copied during Rashīd al-Dīn's lifetime, these subjects probably belonged to the original illustrative scheme of his text.[68] By selecting these incidents for emphasis, he may have wished to demonstrate his support for Islam and his rejection of Jewish traditions. Perhaps his zeal in this regard was designed to counter accusations of Jewish sympathies made by his enemies at the Mongol court.[69]

Although sharing illustrative themes, the Istanbul and former Royal Asiatic Society manuscripts have a different pictorial emphasis. Paintings in the Istanbul manuscript give a straightforward narrative of events, whereas those in the former Royal Asiatic Society manuscript are elaborated with symbolic details. In his text, Rashīd al-Dīn summarizes the dispute between each group and the Muslims. He also names those individuals given the honor of carrying the Prophet's banner (liwā') in battle. Most of the information he gives is also found in the narratives of both Wāqidī and Ṭabarī.[70]

When the Banū al-Naḍīr plotted to kill the Prophet, he decided to subdue them by force and led an army from Medina to besiege them. As the Muslims continued their siege, they also destroyed the community's palm groves. The Jews then capitulated, asking permission to emigrate, a request granted on the condition that they abandon their worldly goods except for what they could carry on camels. Rashīd al-Dīn also cites a passage from Sūrah 59, traditionally understood to refer to this conflict.[71]

The Istanbul manuscript illustrates the destruction of the settlement. A group of horsemen look toward some burning logs, beside which stand two palm trees. Over the painting is cited a passage from Sūrah 59: ". . . hands of the Believers. Take warning, then, O ye with eyes [to see]."[72] It is also possible that the painter intended to depict the later passage in Sūrah 59, where destruction of the palm groves is specifically mentioned.[73] Rashīd al-Dīn does not cite that verse, but the incident is described in his narrative.

The siege itself is depicted in the manuscript formerly in London, but visual emphasis is placed on the Prophet, who is on horseback. As he approaches the Jewish fortress, he is anointed by an

angel. This elaboration has no textual basis in Rashīd al-Dīn's narrative, nor is such an occurrence mentioned by Ṭabarī or Wāqidī. The arrangement here recalls the depiction of Muḥammad in his encounter with Baḥīrā from the Edinburgh manuscript.[74] Angels were believed to have aided the Muslims at various critical moments, so perhaps this one was included to suggest divine sanction for the Prophet's actions. Even the besieged Jewish community appears to be welcoming the Prophet, giving this scene more the appearance of a triumphal welcome than of a battle.

Equally striking is the divergence between the Istanbul and former Royal Asiatic Society manuscript in illustrating the conflict with the Banū Qaynuqāᶜ, another Jewish community in the vicinity of Medina. There, too, the Jews were besieged in their fortress and forced to capitulate. Once again, Rashīd al-Dīn summarizes the conflict, giving the names of both groups' leaders. He specifies that the Prophet's white banner (liwā') was carried by his uncle, Ḥamzah b. ᶜAbd al-Muṭṭalib.[75] The moral implicit in this event is provided by citation of Sūrah 8, where the revocation of the Banū Qaynuqāᶜ treaty is justified.

> If thou fearest treachery from any group, throw back [their covenant] to them, [so as to be] on equal terms; For God loveth not the treacherous.[76]

To illustrate this event, the Istanbul manuscript shows a siege scene in which the attackers cannot be identified either as Muslims or as specific individuals.[77] The painting appears to show a Mongol force negotiating the surrender of a fortress. The manuscript formerly in London depicts an earlier moment in the conflict. As the Muslim force marches toward the Jewish settlement, its leader is dramatically isolated by an area of blue sky around which clouds cluster.[78]

The presence of both clouds and angels around this figure suggests that he was divinely protected. Comments in religious literature demonstrate that angels were sometimes thought to be concealed in clouds. For example, one of the participants in the battle of Badr describes the angelic host sent to aid the Muslims as concealed in a cloud.[79] A marginal notation over the rider's head describes him as Ḥamzah b. ᶜAbd al-Muṭṭalib. This identification may have been based on the fact that this rider carries a staff with its top missing, and Ḥamzah is known to have carried the Prophet's battle flag on this expedition. Ḥamzah's association with angels might derive from his status as one of the Prophet's earliest and most important supporters. After his death in the battle of Uḥud, angels are said to have washed his body for burial and Jibrā'īl was believed to have announced his entry into Paradise to Muḥammad.[80]

Despite these factors that may have led the anonymous scribe to identify this rider with Ḥamzah, a closer examination of the painting leads to a different conclusion. One of the riders behind the leader carries a staff to which a banner has been tied, suggesting that he is Ḥamzah. In addition, the first rider wears his hair in two braids or curls that hang over his shoulders, a trait customarily associated only with Muḥammad or members of his immediate family. In the Edinburgh manuscript only the Prophet himself is so depicted.[81] Furthermore, in this manuscript and its companion in Edinburgh only the Prophet is shown protected by clouds or angels.[82] All of this evidence suggests that the anonymous identification of the first rider with Ḥamzah b. ᶜAbd al-Muṭṭalib is erroneous and that he is actually the Prophet Muḥammad.

Despite its emphasis on the Prophet's divine protection in his conflict with the Jews, the manuscript formerly in London illustrates the conflict at Badr without reference to angelic supporters. The moment chosen for illustration is the one just before the battle at a time when the Prophet exhorts his kinsmen to defend Islam. In this section, Rashīd al-Dīn's text closely parallels that of Wāqidī.[83] None of the persons depicted is identifiable as the Prophet, although the white-

haired rider on the left may be ᶜUbaydah b. al-Ḥārith, the eldest of the three Muslims who first engaged the pagan army.

Also devoid of symbolic references is the depiction of this battle in the Istanbul manuscript. According to its location in the text, the illustration shows the initial combat between Ḥamzah, ᶜAlī, ᶜUbaydah, and three Meccans.[84] All are, however, represented as Mongol warriors, and none can be specifically identified.

Exceptional among the paintings in the Istanbul manuscript is that of the battle of Uḥud. Rashīd al-Dīn's text summarizes the Wāqidī's version of the incident. Selected for illustration is a passage describing how the Muslims attacked and killed a series of men who were carrying the banner (liwā') of the Meccan forces. Several of the latter were brothers, sons of Abū Ṭalḥah.[85] Depicted are three Muslims in pursuit of fleeing horsemen in Mongol armor. Among the Muslims, the first, carrying a double-pointed sword, must be ᶜAlī; the second, with a cloak over his head, is apparently the Prophet. The identity of the third Muslim is uncertain, although Ḥamzah is mentioned in the portion of the text that immediately precedes the painting. The particular incident depicted here may be ᶜAlī's killing of Arṭāt b. Shuraḥbīl, described in the text below the painting.[86] Even though ᶜAlī is identifiable by his special sword, the emphasis here is on action rather than on religious symbolism.

Among the most pictorially effective of the illustrations in the Edinburgh copy of Rashīd al-Dīn's text are three of particular religious significance: the Prophet's first encounter with Jibrāʾīl, his miraculous "Night Journey," and his departure for Medina in the company of Abū Bakr.[87] For the first incident, Rashīd al-Dīn gives a condensed summary of events discussed at greater legnth by Ṭabarī and Ibn Saᶜd. Mentioned are Muḥammad's hearing of voices, the appearance of Jibrāʾīl, and Muḥammad's seeking comfort with Khadījah.[88] Also stressed is Khadījah's visit to her cousin, Warqah b. Nawfal, who draws a parallel between Muḥammad's visions and those previously granted to Moses.[89] Selected for illustration is the Prophet's encounter with Jibrāʾīl on Mt. Ḥirah, the occasion of the revelation of the first verse in Sūrah 96:

> Proclaim! In the name of thy Lord and Cherisher who Created man out of a [mere] clot of congealed blood; Proclaim! And thy Lord is most bountiful, He who taught [the use of] the Pen.[90]

For this dramatic moment the painter has provided a simple but effective visual rendition.[91] The Prophet and Jibrāʾīl are placed within a rocky landscape shaped to complement their figures, forming a cave-like recess around Muḥammad. Rashīd al-Dīn gives only a brief description of the circumstances surrounding this moment of inspiration, focusing instead on Warqah b. Nawfal's testimony about Muḥammad's links with earlier prophets. This composition, however, evokes a more direct and emotional aspect of the revelations. The manner in which Jibrāʾīl's figure fills the picture plane and blocks the Prophet's field of vision recalls the visions referred to in Sūrah 53 and in various traditions. These sources describe a mysterious presence that hovers between heaven and earth, filling the horizon.[92] The painter's depiction of this event suggests that he was aware of these traditions, even though Rashīd al-Dīn did not include them in his text.

Even more complex are the religious associations and symbols connected with the Prophet's "Night Journey." Traditions circulating in the Islamic community connected that incident with the first verse of Sūrah 17:

> Glory to [God] who did take His Servant For a Journey by night from the Sacred Mosque to the Farthest Mosque, whose precincts We did bless—in order that We might show him some of Our signs.[93]

An extensive literary tradition grew up, describing or commenting on this event. Rashīd al-Dīn's text summarizes opinions taken from various sources, but his account also has some unusual features. He gives a longer description of the earlier stages of the Prophet's journey than was customary, and it is this initial phase that is illustrated in the Edinburgh manuscript. Before the journey begins, the Prophet is introduced to his mount, Burāq, and asked to choose between bowls of wine, water, and milk. The latter incident is often connected with Jerusalem rather than Mecca. More unusual, however, is Rashīd al-Dīn's description of the journey between Mecca and Jerusalem. On the way Jibrā'īl instructs Muḥammad to pay his respects to Medina (the city to which he will emigrate), Ṭūr Sīnā' (the place where God spoke to Mūsā [Moses]), and the valley where ʿĪsā (Jesus) was born.[94]

Religious traditions concerning the "Night Journey" had become very elaborate as early as the third/ninth or fourth/tenth century, but its earliest-known illustration is in the Edinburgh manuscript. From the placement of this painting it is clear that the Prophet's choice of milk is its basic subject. Here, however, only one bowl is represented, so the painting apparently shows the result of his decision rather than the moment of the choice itself.[95]

This illustration has particular importance since it contains the earliest-known depiction of Burāq. As shown here, however, Burāq has several unique features. In late fourteenth- and fifteenth-century depictions, Burāq is typically presented as an equine creature having a pink body dappled with white and a crowned head with feminine features.[96] Without precedent, however, is the addition of arms in which this Burāq holds a book and the bust of a human figure armed with sword and shield attached to its tail.

Parallels in both Christian and Islamic illustrations can be found for several of Burāq's features. The equine body of Burāq is reminiscent of the centaur as depicted in Byzantine and Islamic manuscripts. Some centaurs are even dappled in a similar fashion.[97] Normally the centaur has a male torso, although a feminine variant of an equine creature existed in the medieval Christian repertoire of fabulous beasts.[98] The depiction of Burāq with a crowned head is paralleled in renditions of sirens and sphinxes in Byzantine and Armenian manuscripts.[99] The manner in which this Burāq holds a book evokes both the centaur tradition and the human-headed cherubim often used in conjunction with evangelists in Gospel manuscripts.[100] Whatever its pictorial source, this inclusion of a book recalls textual traditions of the "Night Journey." Sources mention a meeting of Muḥammad with several earlier prophets. Each describes his accomplishments. Dā'ūd, ʿĪsā, and Muḥammad each mention scriptures revealed to them. For Muḥammad's book the Koranic term *furqān* is used.[101]

Another curious feature of this illustration is the door-like structure on the right from which an angel emerges. Some accounts of the Prophet's journey specify that he mounted to Heaven on a ladder previously used by angels who descended to the world and by the souls of the dead who ascended to Heaven. It is possible that the illustration of Rashīd al-Dīn's text has depicted this ladder.[102]

The unusual features of this illustration may be due both to the painter's knowledge of various depictions of mythological creatures and to Rashīd al-Dīn's personal interest in this theme. Endowment records from the Rabʿ-i Rashīdī indicate that the anniversary of the "Night Journey" was celebrated there, and Rashīd al-Dīn composed a treatise on this event's meaning.[103]

In comparison with both the Balʿamī and Bīrūnī manuscripts, those of Rashīd al-Dīn's text do

not stress the Prophet's links to either his family or other Muslims. Exceptionally, the Edinburgh manuscript depicts his visit to the encampment of Umm Maʿbad with Abū Bakr during their flight from Mecca to Medina.[104] The text presents a synopsis of incidents connected with the Prophet's departure from Mecca. Particular stress is given to his hiding in a cave near Mecca with Abū Bakr. This portion of the text could derive from either Ibn Isḥāq or Ṭabarī.[105] Illustrated, however, is a later incident when the Prophet miraculously causes the sheep of Umm Maʿbad to produce milk. The text of this story probably derives from Ibn Saʿd's narrative.[106]

Despite the fact that the painting is appropriate to the story of Umm Maʿbad, it is placed in a section of the text describing the Prophet's sojourn in the cave. During that period, Abū Bakr's shepherd came each day to milk his flock near the cave, thus providing the fugitives with milk. It is uncertain whether the painting was incorrectly placed in the text or whether the painter confused the two incidents. Symbolic value was attached to the Prophet's choice of Abū Bakr as his companion in flight. This was interpreted by later theologians as a demonstration of his desire for Abū Bakr to succeed him. Their sojourn in the cave was sometimes commemorated as a Sunni counterpart to the Shiite observances of ʿAlī's designation at Ghadīr Khumm.[107] No specific theological interpretation appears to have been connected with the story of Umm Maʿbad; its inclusion does, however, draw attention to both the Prophet's miraculous powers and his friendship with Abū Bakr. Rashīd al-Dīn composed a short treatise on the miracles of the Prophet, but it is uncertain whether this particular one was mentioned.[108]

CONCLUSION

When these cycles of illustrations depicting the life of Muḥammad are considered in relation to each other, clear differences of approach emerge. The paintings appear to have been used to buttress various religious and political preferences and thus to mirror controversies of their own time. The range of topics treated suggests that these were not the first manuscripts to use paintings to bolster a particular view, but so far no earlier examples are known. Diverse styles used in the manuscripts link them to various centers of production.

The Balʿamī manuscript, now in Washington, focuses attention on the battles of early Islam and the Prophet's crucial role in them. In several scenes ʿAlī b. Abī Ṭālib appears as his assistant. Later events from Islamic history illustrated here suggest that the manuscript was prepared in a Sunni environment. Even the illustrations of the manuscript's earlier sections showing events from Iranian and biblical history may reflect the interests of the Sunni community. Abū al-Rashīd al-Qazwīnī, a twelfth-century Shiite author, accuses Sunni popular singers of using stories from the Iranian past along with those praising Abū Bakr and ʿUmar "as a confutation (radd) of the bravery and virtue of the Prince of the Believers (ʿAlī)."[109] The style of its paintings links the manuscript with the city of Shiraz, but a detailed consideration of the whole manuscript would be needed before a more specific attribution could be made.[110]

Whereas the Balʿamī manuscript presents a Sunni version of Islamic history, the Bīrūnī illustrations indicate the themes favored by the Shiite community. A literary tradition extolling the prowess of ʿAlī and stressing his importance for early Islam had existed for some time, but the Bīrūnī manuscript appears to be its first pictorial manifestation.[111] The specific themes illustrated in that manuscript also appear to parallel themes stressed in polemical literature produced by Shiite theologians active in Mongol court circles, such as Naṣīr al-Dīn Ṭūsī and Ibn Muṭahhar al-Hillī.[112] In style, the Bīrūnī illustrations resemble those in a Manāfiʿ al-Ḥayawān manuscript

probably produced at Maragha, so that the former paintings may also have been executed in that center.[113]

With respect to illustrations from the *Jāmiʿ al-Tawārīkh*, several conclusions can be drawn. One is that the manuscript in Edinburgh and the one formerly in London display features lacking in the Istanbul copy. In the latter manuscript there is an emphasis on action and little attempt to develop the symbolic dimensions of the paintings. In the other manuscripts, however, several illustrations appear designed to bolster the claims of Islam to religious superiority over both Christianity and Judaism. In some cases the message is conveyed by using elements derived from Christian pictorial traditions. This intellectual dimension of the illustrations may be connected with Rashīd al-Dīn's own views. He composed a number of theological treatises, and one of his aims was to demonstrate how Muḥammad was superior to earlier prophets and how Islam had triumphed over both Judaism and Christianity.[114] It is generally assumed that the Edinburgh and former London manuscripts were produced at Rabʿ-i Rashīdī, near Tabriz, where the painter would have had access to varied pictorial sources. The simpler Istanbul copy may well have been illustrated in another center where the pictorial resources were more limited and the guiding hand of Rashīd al-Dīn less immediate.

Despite the many questions remaining about the circumstances under which these manuscripts were produced, it is evident that by the late thirteenth century, paintings of Islamic history could reflect religious controversies of the contemporary world. These manuscripts may be one vestige of efforts made by various segments of the Islamic religious community to gain Mongol support for their own particular view of Islam.

NOTES

1. Abū Ḥanīfah al-Dīnawarī, *al-Akhbār al-Ṭiwāl,* Cairo, 1960, 18–19.

2. Maçoudi, *Les prairies d'or,* ed. and trans. Barbier de Meynard and Pavet de Courteille, Paris, 1914, I, 315–17.

3. Muḥammad b. Khavendshah Mirkhond, *The Rauzat-us-Safa,* trans. E. Rehatsek, ed. F. Arbuthnot, London, 1893, part II, 1, 84. Mīrkhwānd, *Taʾrīkh Rawḍat al-Ṣafāʾ,* Tehran, 1339s./1960–61, II, 58–59.

4. R. Meyer Riefstahl, *The Parish-Watson Collection of Mohammedan Potteries,* New York, 1922, no. 31, fig. 55.

5. Freer Gallery of Art 29.26r; M. S. Simpson, *The Illustration of an Epic,* New York, 1978, pl. 115 (hereafter, Simpson).

6. Firdawsī, *Shāh-nāme,* ed. E. Bertels, Moscow, 1966, I, 18–19. The Freer copy omits verses mentioning Abū Bakr, ʿUmar, ʿUthmān, and ʿAlī considered by Bertels to be later additions; Firdawsī, *Shāh-nāme,* lines 92–95.

7. Ṭabarī, *Annales,* ed. De Goeje, Leiden, 1964, I:3, 2131–33 (hereafter, Ṭabarī, *Annales*); Belʿamī, *Chronique de . . . Ṭabarī,* trans. Zotenberg, Paris, 1958, III, 358–59 (hereafter, Belʿamī); Muḥammad ibn Saʿd, *al-Ṭabaqāt al-Kubrā,* Beirut, A.H. 1376, III, 188–91 (hereafter, Ibn Saʿd, *al-Ṭabaqāt al-Kubrā*).

8. Belʿamī, III, 27; Ibn Saʿd, *al-Ṭabaqāt al-Kubrā,* I, 485–86; Ibn Isḥāq, *The Life of Muḥammad,* trans. A. Guillaume, London 1955, 371 (hereafter, Ibn Isḥāq); "Dhūʾl-Fakār," *EI²,* s.v.

9. Ibn Isḥāq, 156–67; Ibn Saʿd, *al-Ṭabaqāt al-Kubrā,* III, 267–69.

10. J. Wellhausen, *The Arab Kingdom and Its Fall,* trans. M. Weir, Calcutta, 1927, 34.

11. "al-Kurʾān," *EI²,* s.v.; Belʿamī, III, 616–18.

12. A. S. Melikian-Chirvani, "Le roman de Varge et Golšāh," *Arts Asiatiques,* XXII, 1970, 211–12, fig. 64.

13. Simpson, pl. 109; "al-ʿAshara al-mubashshara," *EI²,* s.v.; D. Sourdel, "A propos des 'Dix Élus,'" *Revue des Études Islamiques,* XXXI, 1963, 111–14 (hereafter, Sourdel, "A propos des 'Dix Élus'"); al-Masʿūdī, *Kitāb al-Tanbīh,* Beirut, 1965, 231; Jalāl al-Dīn al-Suyūṭī, *Taʾrīkh al-Khulafāʾ,* Cairo, 1976, 85, 366 (hereafter, al-Suyūṭī, *Taʾrīkh al-Khulafāʾ*); al-Suyūṭī, *History of the Ca-*

liphs, trans. Jarrett, Amsterdam, 1970, 51, 234 (hereafter, al-Suyūtī, *History of the Caliphs*).

14. The Bal°amī manuscript was acquired by the Freer Gallery in three portions: 30:21, 47:19, 57:16; fourteenth-century copies of Rashīd al-Dīn's text are: Edinburgh University Library, Arab 20, for which see D. T. Rice, *The Illustrations to the "World History" of Rashīd al-Dīn*, ed. B. Gray, Edinburgh, 1976 (hereafter, Rice); a copy formerly in the Royal Asiatic Society, London, A. 27, for which see B. Gray *The "World History" of Rashīd al-Dīn: A study of the Royal Asiatic Society Manuscript*, London, 1979 (hereafter, Gray); and Topkapı Sarayı Library, Hazine 1653, for which see S. G. Inal, "The Fourteenth-Century Miniatures of the Jāmi° al-Tavārīkh in the Topkapı Museum in Istanbul, Hazine Library no. 1653," Ph.D. diss., University of Michigan, 1965 (hereafter, Inal).

15. Edinburgh University Library, Arab 161: P. Soucek, "An Illustrated Manuscript of al-Bīrūnī's Chronology of Ancient Nations," *The Scholar and the Saint,* ed. P. J. Chelkowski, New York, 1975, 103–68 (hereafter, Soucek, "An Illustrated Manuscript"); not included in this study are fragments from a *Mi°rāj-nāmah* now preserved in Topkapı Sarayı Library, for which see R. Ettinghausen, "Persian Ascension Miniatures of the Fourteenth Century," *Oriente e Occidente nel Medioevo,* Accademia Nazionale dei Lincei, XII Convengo, 1957, 360–83.

16. Freer Gallery of Art, 57.16: "Angels assist the Muslims in the Battle of Badr," fol. 182a; "The Aftermath of Badr: Muḥammad addresses his dead enemies and Abū Jahl is Executed," fol. 184a; "The Battle of Uḥud: Muḥammad Wounds Ubayy b. Khalaf," fol. 192b; Freer Gallery of Art, 47.19: "The Battle of the Ditch: Duel of °Alī and °Amr," fol. 18a; "The Battle of Ḥunayn: Muḥammad guarded by °Alī," fol. 36b.

17. Ṭabarī, *Annales,* I:4, 1793, line 14; Ibn Kathīr, *Shamā'il al-Rusūl,* ed. M. °Abd al-Waḥīd, Cairo, 1386–1969, 24; Bel°amī, III, 202–3. In this manuscript, ink appears to have been used for the color black, giving areas in that color of surface quality different from other sections of the paintings. Despite its unusual density, this pigment is probably original.

18. Bel°amī, II, 502–12.

19. Ibid., 503. The painting is located after a sentence describing how °Alī and Ḥamzah joined forces to kill °Utbah.

20. Ibid., 504.

21. *The Holy Qur'an,* trans. A. Yūsuf °Alī, Washington, D.C., 1946, 417, Sūrah 8:9 (hereafter, *The Holy Qur'an,* trans. A. Y. °Alī); Ṭabarī, *Jāmi° al-Bayān,* Cairo, 1373/1954, IX, 190–92 (hereafter, Ṭabarī, *Jāmi° al-Bayān*).

22. Bel°amī, II, 511–12.

23. Ṭabarī, *Annales,* I:3, 1187, 1231:9–15, Bel°amī, II, 401–2, 458–64, 492–501; Ibn Isḥāq, 135, 145, 177–78, 191–92, 221–22.

24. Bel°amī, II, 498–501, al-Wāqidī, *Kitāb al-Maghāzī,* ed. Marsden Jones, Oxford, 1966, 61, 63–67 (hereafter, al-Wāqidī); Ibn Isḥāq, 298–99.

25. Freer Gallery of Art, 57.16, fol. 184a; the passage over the painting is equivalent to Bel°amī, II, 511:27–512:8.

26. Bel°amī, II, 512.

27. Ṭabarī, *Annales,* I:3, 1383–1415; Bel°amī, III, 28–31; Ibn Isḥāq, 370–83; al-Wāqidī, I, 286–88.

28. Freer Gallery of Art, 57.16, fol. 192b; Bel°amī, III, 31–32.

29. Freer Gallery of Art, 47.19, fol. 18a; Bel°amī, III, 143–49; Ibn Isḥāq, 569–70; al-Wāqidī, III, 897–99.

30. Bel°amī, III, 147.

31. Freer Gallery of Art, 47.19, fol. 18a.

32. Bel°amī, III, 59–62; Ibn Isḥāq, 450–52; al-Wāqidī, II, 443–45.

33. Ibid., 63–65.

34. Freer Gallery of Art, 30.21, fol. 84a; Bel°amī, III, 555; Freer Gallery of Art, 47.19, fol. 97a; Bel°amī, III, 680–81; H. Laoust, *Les schismes dans l'Islam,* Paris, 1965, 6–12; G. Levi Della Vida, "°Uthmān," *EI¹,* IV, 1077–88; F. Buhl, "Ṣiffīn," *EI¹,* IV, 406–8.

35. Freer Gallery of Art, 47.19, fol. 158a; Bel°amī, IV, 336.

36. Freer Gallery of Art, 57.16, fol. 157b; Bel°amī, II, 356.

37. "Ḳuraysh," *EI²,* s.v.

38. I would like to thank the conservators of the Freer Gallery, Mrs. Martha Smith and Mr. Thomas Chase, for assisting me in an examination of this page.

39. For the traits customarily used to portray Abū Bakr and °Alī, see notes 7–8 above.

40. Ṭabarī, *Annales,* I:3, 112:16–1123; Ibn Sa°d, *al-Ṭabaqāt al-Kubrā,* Beirut, 1380/1960, I, 55–59.

41. Mu°āwiyah was esteemed as a calligrapher. N. Abbott, *Studies in Arabic Literary Papyri. III. Language and Literature,* Chicago, 1972, 3. HIs tomb was the site of a cult (C. Pellat, "Le culte de Mu°āwiya au IIIème siècle de l'Hégire," *Studia Islamica,* VI, 1956, 53–66). °Abd al-Malik ibn Marwān was noted for his reform of administration and credited with introducing vowels into the Koran ("°Abd al-Malik b. Marwān," *EI²,* s.v.). Mus°ab b. al-Zubayr participated in the compilation of the Uthmanic recension of the Koran and was renowned for his piety ("Mus°ab b. al-Zubayr," *EI¹,* s.v.). His tomb was revered by the Sunni community of Baghdad (J. al-Maqdisī, *Ibn °Agīl,* Damascus, 1963, 315–16). °Abd Allāh b. al-Zubayr, a political opponent of Umayyad Rule, was later remembered for his religious devotion (Abū Nu°aym Aḥmad, *Ḥilyat al-Awliyā' wa-Ṭabaqāt al-Aṣfiyā',* Beirut, 1967, I, 329; al-Suyūtī, *Ta'rīkh al-Khulafā',* 335, 337–38; al-Suyūtī, *History of the Caliphs,* 215–17). °Abd al-°Azīz b. Marwān was remembered as a just governor

of Egypt and as father of the pious caliph ᶜUmar b. ᶜAbd al-ᶜAzīz (K. V. Zettersteen, "ᶜAbd al-ᶜAzīz b. Marwān," *EI²*, s.v.).

42. Belᶜamī, II, 241–43.

43. Freer Gallery of Art, 57.16, fol. 138a.

44. H. Buchthal, "Early Islamic Miniatures from Baghdad," *Journal of the Walters Art Gallery*, V, 1942, 23–25, figs. 15, 25.

45. Freer Gallery of Art, 57.16, fol. 170b; Belᶜamī, II, 434–35.

46. Edinburgh University Library, Arab 161, see note 15 above.

47. Abū Rayḥān al-Bīrūnī, *Āthār al-Bāqiyah ᶜan al-Qurūn al-Khāliyah*, ed. C. E. Sachau, Leipzig, 1878, 329–35 (hereafter, Bīrūnī, *Āthār al-Bāqiyah*; Bīrūnī, *Chronology of Ancient Nations*, trans. C. E. Sachau, London, 1879, 325–30, 332–33.

48. Bīrūnī, *Āthār al-Bāqiyah*, 329–30; Bīrūnī, *Chronology*, 326.

49. Bīrūnī, *Āthār al-Bāqiyah*, 333–34; Bīrūnī, *Chronology*, 332–33.

50. H. Busse, *Chalif und Grosskönig: Die Buyiden im Iraq, 945–1055*, Beirut, 1969, 422–26 (hereafter, Busse).

51. L. Massignon, *La Mubāhala de Médine et l'hyperdulie de Fatima*, Paris, 1955, 19–21; R. Strothmann, "Die Mubahala in tradition und Liturgie," *Der Islam*, XXXIII, 1957, 28–29.

52. H. Laoust, "Le rôle de ᶜAlī dans le Sīra chiite," *Revue des Études Islamiques*, XXX, 1962, 23–26 (hereafter, Laoust, "Le rôle de ᶜAlī").

53. D. T. Rice, 98 and note 79 below.

54. On the Prophet's cloak, see "Burda," *EI²*, s.v.; on his hair, see note 17 above.

55. Edinburgh MS, Arab 131, fols. 6b, 10b, 92a; Soucek, "An Illustrated Manuscript," figs. 1, 2, 7.

56. Rice, nos. 28–37; Gray, 17–21.

57. Inal, 41–69, pls. I–IIIa.

58. This preliminary examination of Rashīd al-Dīn's text was made using microfilms of the Edinburgh, Istanbul, and former Royal Asiatic Society manuscripts, which were often difficult to read. A more extensive examination of these copies might reveal the source of Rashīd al-Dīn's text.

59. Edinburgh University Library, Arab 20, fol. 41a; Rice, 94–95; Ibn Isḥāq, 62.

60. Ṭabarī, *Annales*, I:1, 276, 279; I:3, 1074.

61. Edinburgh University Library, Arab 20, fol. 45a; Rice, 100–101; Ṭabarī, *Annales*, I:3, 1136–39; Ibn Isḥāq, 84–86.

62. Edinburgh University Library, Arab 20, fol. 42a; Rice, 96–97; Ṭabarī, *Annales*, I:2, 899, 969–69, 973; Ibn saᶜd, *al-Ṭabaqāt al-Kubrā*, I, 100–102; Ibn Isḥāq, 68–69;

Rashīd al-Dīn, *Waqf-nāma-yi Rabᶜ-i Rashīdī*, ed. M. Minovi, I. Afshar, Tehran, 1350s., 200 (hereafter, Rashīd al-Dīn, *Waqf-nāma-yi Rabᶜi Rashīdī*).

63. Rice, 97; Soucek, "An Illustrated Manuscript," 111–14, 145–48.

64. Edinburgh University Library, Arab 20, fol. 43b; Ibn Isḥāq, 79–81; Ṭabarī, *Annales*, I:3, 1123:5–1125:2.

65. Rice, 98–99, no. 30.

66. A.-T. Khoury, *Polemique byzantine contre l'Islam*, Leiden, 1972, 29–37.

67. S. Der Nersessian, *Armenian Manuscripts in the Walters Art Gallery*, Baltimore, 1973, 37 (hereafter, Der Nersessian).

68. Gray, pls. 1, 3, 24–25; Inal, pls. IB, IIIA.

69. Raschid-Eldin, *Histoire des Mongols de la Perse*, ed. and trans. E. Quatremère, Amsterdam, 1968, v–vii, cxxiii–cxxiv (hereafter, Raschid-Eldin, *Histoire des Mongols*).

70. Ṭabarī, *Annales*, I:3, 1448–53; al-Wāqidī, I, 380–83.

71. Formerly R.A.S., A. 27, fol. 2v, 3r; Hazine 1653, fol. 170v; al-Wāqidī, I, 380–83.

72. Sūrah 59:2, *The Holy Qur'an*, trans. A. Y. ᶜAlī, 1521.

73. Sūrah 59:5.

74. Gray, pl. 1; see also note 65 above.

75. Formerly R.A.S., A.27, fol. 7b–8a; Hazine 1653, fol. 167a; Ṭabarī, *Annales*, I:3, 1360–62.

76. Sūrah 8: 58/60.

77. Inal, pl. IB.

78. Gray, pl. 3.

79. Ṭabarī, *Jāmiᶜ al-Bayān*, Cairo, 1383/1954, VII, 184–85, 187–88; F. Jadanne, 'La place des Anges dans la théologie musulmane," *Studia Islamica*, XLI, 1975, 45, 53–54

80. Ibn Saᶜd, *al-Ṭabaqāt al-Kubrā*, III, 9–11; al-Wāqidī, I, 290; Ibn Isḥāq, 756.

81. See note 17 above, and Rice, 98, 100, 102, 112.

82. Rice, 96, 98; Gray, pl. I.

83. Gray, pl. 2; Formerly R.A.S., MS 27, fol. 7r; al-Wāqidī, I, 68–69, esp. 68:15–18.

84. Hazine 1653, fol. 165v; Inal, pl. IA.

85. Inal, pl. IIB; Hazine 1653, fol. 168a; al-Wāqidī, I, 225–29.

86. Hazine 1653, fol. 169a; al-Wāqidī, I, 228:12.

87. Rice, 96–97, 102–3, 110–11.

88. Edinburgh University Library, Arab 20, fol. 45b; for similar passages, see Ṭabarī, *Annales*, I:3, 1143:15–18, 1147, 1153:13–15, 1154:3–4, 1155:14–15, 1156:3–5; Ibn Saᶜd, *al-Ṭabaqāt al-Kubrā*, I, 194.

89. Edinburgh University Library, Arab 20, fol. 45b; for similar texts, see Ṭabarī, *Annales*, 1:3, 1147:15–1148:2, 1148:19–1150:2, 1151:10–1152:2; Ibn Saᶜd, *al-Ṭabaqāt al-Kubrā*, I, 195.

90. Sūrah 96:1–4, *The Holy Qur'an*, trans. A. Y. ᶜAlī, 1761. Rashīd al-Dīn follows this revelation with the Prophet's visit to Khadījah in which he asks her to cover him, an incident traditionally connected with the revelation of Sūrah 74, not Sūrah 96. Concerning Sūrah 96, see Ibn Saᶜd, *al-Ṭabaqāt al-Kubrā*, I, 196; Ṭabarī, *Annales*, 1:3, 1147:12–15, 1148:13–17, 1150:3–7, 1155:15–16.

91. Rice, 102.

92. Sūrah 53:5–9; Ibn Saᶜd, *al-Ṭabaqāt al-Kubrā*, I, 194–95.

93. *The Holy Qur'an*, trans. A. Y. ᶜAlī, 693.

94. Edinburgh University Library, Arab 20, fol. 54b–55a; compare Ṭabarī, *Jāmiᶜ al-Bayān*, XV, 5–6, 15; Ibn Isḥāq, 184–85.

95. Edinburgh University Library, Arab 20, fol. 55a; Rice, 110–11.

96. T. W. Arnold, *Painting in Islam*, New York, 1965, 117–122; M.-R. Séguy, *The Miraculous Journey of Mahomet*, London, 1977, pls. 2–32; R. Paret, "al-Burāḳ," *EI²*, I, 1310–11.

97. E. Wellesz, "An Early al-Ṣūfī Manuscript in the Bodleian Library in Oxford," *Ars Orientalis*, III, 1959, 10–16, figs. 2, 14, 65–66. J. Strzygowski, *Der Bilderkreis des Griechischen Physiologus*, Leipzig, 1899, 12, 102, pl. II; V. Lazarev, *Storia della pittura bizantina*, Turin, 1967, 191, fig. 240 (hereafter, Lazarev).

98. H. Buchthal, *Miniature Painting in the Latin Kingdom of Jerusalem*, Oxford, 1957, 74–75, pl. 113b.

99. Der Nersessian, 37, fig. 89; Lazarev, fig. 240.

100. R. Nelson, *The Iconography of Preface and Miniature in the Byzantine Gospel Book*, New York, 1980, fig. 18.

101. Ṭabarī, *Jāmiᶜ al-Bayān*, XV, 8–10; Koran, Sūrah 25:1.

102. Ṭabarī, *Jāmiᶜ al-Bayān*, XV, 12, XXII, 59, XXVII, 215–16, XXIX, 70–71; Koran, Sūrah 34:2, 57:4–6, 70:3–5.

103. Rashīd al-Dīn, *Waqf-nāma-yi Rabᶜ-i Rashīdī*, 200; Raschid-Eldin, *Histoire des Mongols*, cxv.

104. Edinburgh University Library, Arab 20, fol. 55a; Rice, 110–11.

105. Ibn Isḥāq, 223–224; Ṭabarī, *Annales*, 1:3, 1235–37:10.

106. Ibn Saᶜd, *al-Ṭabaqāt al-Kubrā*, I, 230–31.

107. Busse, 423–26; Sourdel, "A propos des 'Dix Élus,'" 113.

108. Raschid-Eldin, *Histoire des Mongols*, cxix.

109. A. Bausani, "Religion in the Saljuq Period," *The Cambridge History of Iran*, V, *The Saljuq and Mongol Periods*, ed. J. A. Boyle, 293–94.

110. B. Gray, "Fourteenth-century Illustrations of the Kalilah and Dimnah," *Ars Islamica*, VIII, 1940, 136–38.

111. Laoust, "Le rôle de ᶜAlī," 7–26.

112. M. Mazzaoui, *The Origins of the Safawids: Shiᶜism, Ṣūfism and the Ghulāt*, Wiesbaden, 1972, 24–27; H. Laoust, "Les fondements de l-imamat dans le Minhāj d'al-Hillī," *Revue des Études Islamiques*, XLVI, 1978, 3–55.

113. B. Gray, *Persian Painting*, Geneva, 1961, 22–23, 26–27.

114. Raschid-Eldin, *Histoire des Mongols*, cxxiv.

FIG. 1. The Prophet Enthroned, Flanked by the Four Caliphs. Washington, D.C., Freer Gallery of Art, 29.26r. Courtesy Freer Gallery of Art, Smithsonian Institution

حلیمه اورا سوی عبد المطلب آورد تا وبندش عبدالمطلب دایه را بسیار چیز داد و فرزندش را بسیار چیز داد ماد در
یغامبر گفت این بر من کلان کشتی بر مزدست باز دارد حلیمه گفت تا هفت سال باز و بدارم انکاه بنوباز دهتنی
یک مادرم جنین است و حلیمه یغامبر با باز برد یک سال دیگر چون یغامبر نه ساله کشت هر دو نک بدشت بیرون شدکن
وان عبدالله هم شیر با وک بودکی بر روزی یغامبر بدشت بیرون رفت و آن هم شیر با وک بوده تراز او فرودامذند
ویغامبر را بر نوز دند این برک از بس ایشان بترسید و ایشان راخواهش کرد وکفت این کودکی یتیم است و شمار الزکشتنی
وک چیز نباید اورا عذر کنید ایشان را وک سخن نکفت وبغامبر راحدوا بایند و بستان و شکست نکفایند بد در بیته تاز هار
ان برحلیمه چون آن بدید بترسید وکریان از که فرودآمد و سوی مادر شد و این خبر بکفت حلیمه و سوی هر دو

FIG. 2. Angels Cleanse the Prophet's Heart. Washington, D.C., Freer Gallery of Art, 57.16, fol. 138a. Courtesy Freer Gallery of Art, Smithsonian Institution

کریان بدویدند و سر کوه بر شدند یغامبر را دیدند در نشسته و دو وک زرد شده اورا کفتند که سبز تر اجه شد
یغامبر کفت سه تن بیامدند و با ایشان طشتی زرین بود و آفتابه زرین و شکم من از سینه تا ناف بار بکفایند و هر چه بشکم من
بد چیز بیرون کشیدند و بدان طشت اند ریشتند و سجا که خویش باز نهادند و مرا کفتند باک آمدی بدرنزجهان
کنون باک ترشدی بس یکی از ایشان یک دست بشکم من اند کرد و دل را بد رآورد و دو خونی سیاه از انجا بیرون کرد
بنداخت و کفتند این بهره شیطانست و این اندر همه آدمی هست لیکن از تو بیرون کردیم بس دل را بازبان جای که برد

FIG. 3. The Prophet's Genealogy Considered. Washington, D.C., Freer Gallery of Art, 57.16, fol. 157a. Courtesy Freer Gallery of Art, Smithsonian Institution

سلمه جون نزدیک مکه رسیدہ که اندر جبر بو دی و اوطایف شد و او راند بد همه مکیان جمع امدند و گفتند یک که
شهر بیرون شد او را شهر اندر در کانکنم بر جهل از همه قبایل قریش یعت بسل بدین سخن و پیغامبر صلوات اللہ علیہ
بطن النحل نزدیک یلی از مکه سوک باد یہ آمد و انجا ہیے بود و آن شب انجا نماز کرد و قرآن ہیے خواند و نماز ہے کرد و بر
دیگر روز شهر اند رشد و در سی ہفت تن از بریان یامدند و بشر پیغامبر بیستا ذند و او از قرآن خواندن پیغامبر ون شیند ند
حوث ایشان جون پیغامبر سلم نماز بداذ خویش را بر و عرضه کردند و بیموذند پیغامبر ایشانرا بیدید و دین ہر ایشان عرض
کرد و ایشان بد بر رفتد پیغامبر صلوات اللہ علیہ بذ بروز که بقوم خویش شرید و ایشانرا بدین خواند ایشان بر فتا
و قوم خویش را بدین مسلمانی خواند ند ایشان اجابت کردند جنانک خدای تعالی فرموده و اذ صرف نا الیک نفرا من الجن
بستمعون القرآن و نام آن ہفت تن یک از بریان خسابو ذد و دیگر ماس د یکر ثاذ جہارم ناصر و پنجم قاسم و ششم اش و ہفتم الحمر

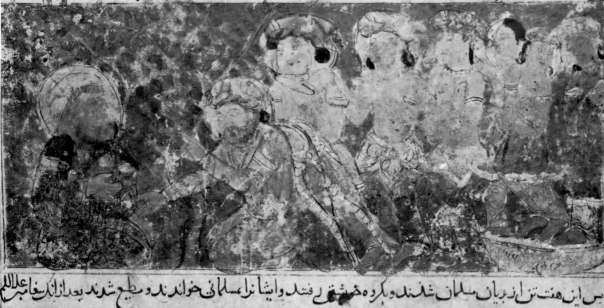

بی این ہفت تن از بریان مسلمان شدند و بکرد و خویش رفتد و ایشانرا مسلمانی خواند ند و مطیع شدند یعد از انکا پیغامبر علیہ اللہ

FIG. 4. The Conversion of Seven Peris. Washington, D.C., Freer Gallery of Art, 57.16, fol. 170b. Courtesy Freer Gallery of Art, Smithsonian Institution

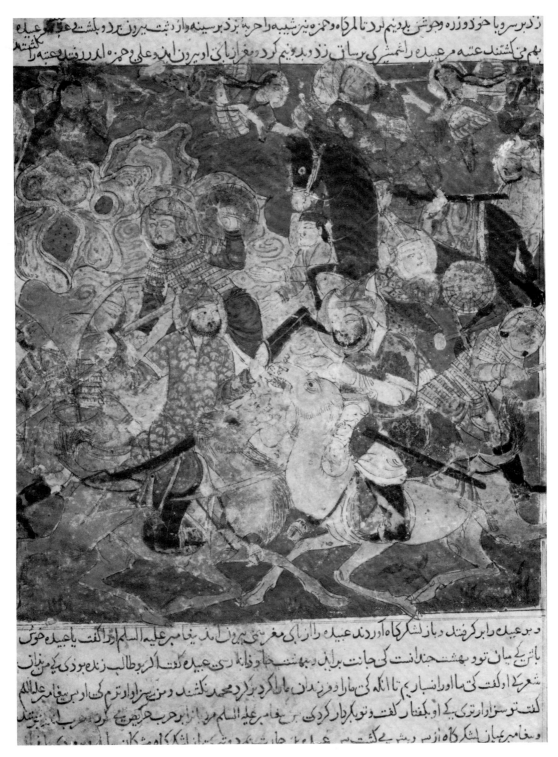

FIG. 5. Angels Assist Muslims in the Battle of Badr. Washington, D.C., Freer Gallery of Art, 57.16, fol. 182a. Courtesy Freer Gallery of Art, Smithsonian Institution

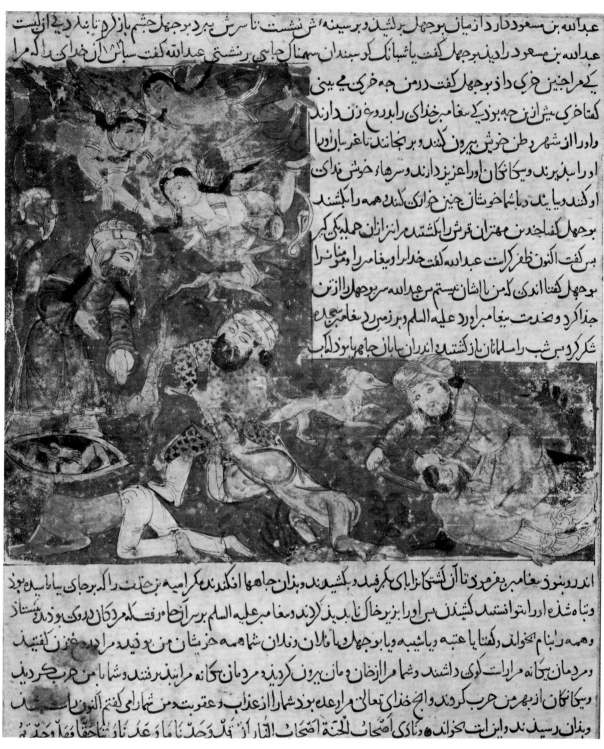

عبدالله بن مسعود وار دمیان بوجهل برکشید و برسینه ... نشست تا سرش ... برد بوجهل چشم باز کرد دید ... زلست
عبدالله بن مسعود را بدید بوجهل بدو گفت یا ... یک کر بندان سمنال جایی برنشستی عبدالله گفت سبائی از خدای را کر مرا
یکی ... چین خری داد بوجهل گفت درمن چه خری بینی ...کتاه ... میر ازبن چه برزید یک ... پیغامبر خدای رابودو نه زن دارند
واور از شهر وطن خویش بیرون کنند و برنجانند ناغریباز اورا ... اورا بدن برند و یکانگان اورا عزیز دارند و سرها خویش فدای اورا
کنند و باشند تا باشخرستان چین خری کنک همه را بکشند بوجهل گفت جدمین مهتران قریش را بکشد مرا ... ازان حمله بکن کبیر
پس کفت الون ظفر کراست عبدالله کفت خدارا ویغامبر مرا و مؤمنان را بوجهل گفتا اندکن که من ... اینان نیستم سر عبدالله سرببوجهل را ... زن
جدا کرد و خدمت پیغامبر اورد علیه السلم و بر زمین و پیغامبر ... شکر کرد بس شب را مسلمانان بازکشتند و اندران سامان جاهی بابر داب

اند و پیغامبر پیغمبر ... تا از ... لشکرها ای کفر فسد و بکشتند و بدان جاهها انکندند و بدان بر حبت را ... بوجهای بابا اسید بود
و تباه شد اورا نتوانستند کشیدن مر اورا زیر خاک بابدید کردند و پیغامبر علیه السلم بر سر که هر که مردگان دروک بود بیستاد
و همه را ببنام بخواند رکفتا یا عتبه و یا بوجهل و یا فلان و فلان شما همه خرشان من بودید مرا بیرون کردن کفتید
ومردمان بیگانه مرا راست گوی داشتند و شما مرا از وطن مان کردید مردمان که مرا بیرون کردند و شما مرا من حرب کردید
و یکانگان ازبهر من حرب کردند واج خدای تعالی مرا عده بود شما از خداب و عقوبت من شما رای گفتم الون ...
بدان رسیدند و این ... بخواند و دای ... اصحاب الجنه و دای اصحاب النار از ... وحد ... ماء و عد ناراً ... احقا ماء وحد

Fig. 6. The Aftermath of Badr: Muḥammad Addresses His Dead Enemies and Abū Jahl is Executed. Washington,
D.C., Freer Gallery of Art, 57.16, fol. 184a. Courtesy Freer Gallery of Art, Smithsonian Institution

مسلمانان را یله برمیده در دیسمان کشید و بر کردن بست و زنان دقیق از زند و هند و قصریه لرد از شاه کردی سب
براست لشکری که رشت اند و میان لشکنان پیغامبر را بیے جست و این مکه او دیغامبر الفتی بکلی جازه را
بیے پردوم نا تر ابلیم و بکشتم و پیغامبر کفتی من ترا کشتم انشا الله ودر ز بدود این مکه بود و براذرش امیه یامد کشته
شد و دوز احد این یامد دیغامبر را بیافت اندران وقت یے سعد نیرے انداخت سعد خراست که تیری انداز د
داور بکشد پیغامبر کفت میانداز تا فراز آید این فراز آمد و بنیزه بری پیغامبر راست کرد و کفت یا محمد که رما ندترا ازمن
په کفت خدای در هاند مرا ازتو وترا از دست من نرهاند پیغامبر را بازی خاست و حا وث برصبه بیترا واستاده
بود با حربه پیغامبر آن حربه را ازحارث بستد و این سلاح تمام داشت بنودش مکر کردن و براشت
نشته بود پیغامبر آن حربه را ابر کردنش زد و سرحربه کردنش ببخراشید و لختی برا سبخرشد از دردان
دبا زکشف و حزدشان لشکر که شد و این بیے کردی ا قوم محمد مرا بدست خویش بکشت ابشان کفت بابک مراد

FIG. 7. The Battle of Uḥud: Muḥammad Wounds Ubayy b. Khalaf. Washington, D.C., Freer Gallery of Art, 57.16, fol. 192b. Courtesy Freer Gallery of Art, Smithsonian Institution

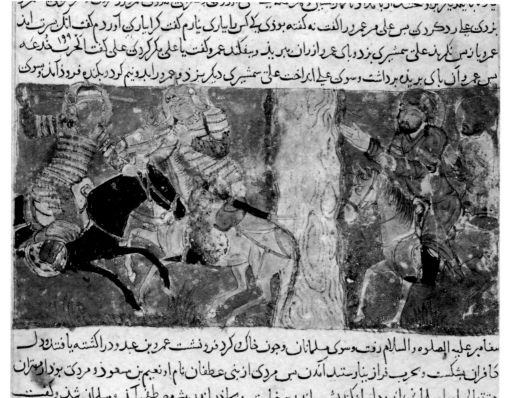

بزدك غا ردكردك بر على مر عمر رالفت نه كفته بود كيك كرايارى يا وكفت كرايارى آورد كفت انكرتا ابد
عمروباى نكر بذ على عمير رى بزد كيك در ازان بين بذ عمروكفت يا على بركردنى كفت على كفت الحرب خدعه
بس عمر باك برين د برداشت وسوكى على ابد اخت على وعمر را بلدونم كرد ربكلن فرودآمد بدوك

FIG. 8. The Battle of
the Ditch: Duel of ʿAlī
and ʿAmr. Washington,
D.C., Freer Gallery of
Art, 47.19, fol. 18a.
Courtesy Freer Gallery
of Art, Smithsonian
Institution

نغامبر على الصلوه والسلام رفت وسوى سلمان رفت وجون خاك كرد فرونشت عمر بن عبد ودد راكشته يافتند دل
كافران بشكست وحرب بشت فراز بنارستدآند بن مردى از ابى عطفان نام او نعيم بن مسعود مردك بود رادم مهران
حق تعالى اورا اسلام بن اندر دل افكلد شب اندر برخاست وبجاذر اندريش مصطفى آمد وسلمان شد وكفت

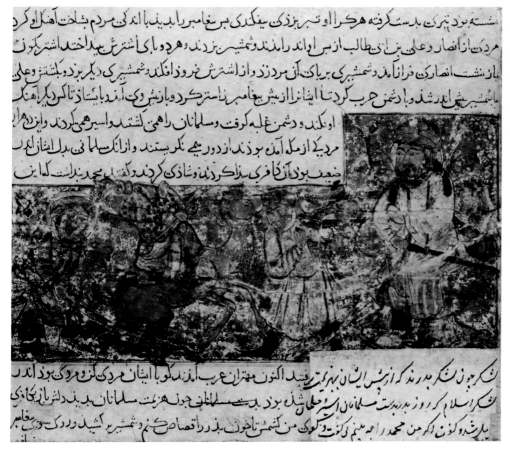

نشسته بود نيزت بدست كرفته هركرا و تير بزدك بيفكدى بر نغامبر با اند كى مردم نشاشلت اهلاكرد
مردكى از انصار وعلى بن ن طالب از بر اواند را بلند وثمشير بزدند وهرد باى اشرث بيداختد اشتركون
بان نشست انصارك فراز آمد دثمشربى برباك آن مردزد واز اشترش فرود وافكلد وثمشير كى ديكر برزد وبكشت وعلى
بامشيرى شى اندر شد وبا دثمن حرب كرد تا ايشان از نيزا بغام بر راسنر كرد وبا زنير وك اند بايشا تاكرد ديكراهنك
اوبلكد و دثمن غلبه كرفت وسلمانان راهمى كشتند واسير همى كردند وايزد هزار
مردكى از ملك آمد بوزند ازدورببى نكر بستند وانانك سلما فى بدل ايشان ليد
ضعيف بود ازآن كافرى سزاكردند وشاذى كردند بس محمد بن ديدارست ابن

FIG. 9. The Battle of
Ḥunayn: Muḥammad
Guarded by ʿAlī.
Washington, D.C.,
Freer Gallery of Art,
47.19, fol. 36b.
Courtesy Freer Gallery
of Art, Smithsonian
Institution

نشكر عون زنكر بدرند كه ازهمس ايشان بهزيمت رفشيد الكون مهتران عرب آمد بزدكوبا ايشان مردكى بزد اند
عشكر اسلام كه روز بدربدست مسلمانان اسير على بذ بدست مسلمانان جون هزت سلمانان بد بذ نشر بازى كاذى
بلرشد بكون اكرمن محمد را مهيم كنت وكوك من كشنم تاخون بذ را قصاص كنم وثمشير كشيد ودرك وعامر

Representations of the *Khāṣṣakīyah* and the Origins of Mamluk Emblems

Estelle Whelan

ONE of the themes that occupied Richard Ettinghausen throughout his career as writer and teacher was the various means by which sovereignty is represented in Islamic art.[1] It therefore seems appropriate in this memorial essay to turn to yet another aspect of this vast subject: the representation of a particular kind of servant as sovereign attribute and the adaptation of related iconography to the social requirements of the Baḥrī Mamluk period (648–791/1250–1389). The focus here will be on the young military slaves, *mamlūks*, who were chosen to serve in the immediate princely entourage.

Quite a lot is known about the organization of the Mamluk armies, thanks especially to extensive studies by Ayalon and, more recently, by Humphreys.[2] The backbone of these armies was the body of royal *mamlūks*—those slaves who were the personal property of the sultan himself, destined for his own regiments and directly dependent upon his power for their own advancement. These slaves were usually Turks purchased as children in the Caucasus, brought to Cairo, and installed in barracks, where they were instructed in the Islamic religion and trained in all aspects of combat. When they completed their training, they were given their freedom and presented with the equipment necessary to begin their military careers. Especially during the Baḥrī Mamluk period, such troops could generally be expected to be loyal to "their" sultan, the

I wish to express my sincere thanks to Layla Diba and Dr. Priscilla Soucek, who, in my absence, undertook the onerous task of obtaining the illustrations presented here.

source of potential rewards and promotions. Those with talent and application would normally rise to positions of substantial command in the army.[3]

Within the body of royal *mamlūks*, the *khāṣṣakīyah* was a small élite;[4] its members were raised not in the barracks but at the sultan's own court, often with his own children. From an early age they enjoyed continuous intimacy with the sultan himself, and it is not surprising that between these favored *mamlūks* and their sovereign there frequently developed bonds of genuine affection and trust, reinforcing considerations of self-interest.[5] At an appropriate age, the youths were appointed to posts in the sultan's immediate entourage: cupbearer, keeper of the polo sticks, sword bearer, keeper of the wardrobe, and the like.[6] Probably these posts involved primarily ceremonial handling of the sultan's attributes on various formal occasions, for it is unlikely that young boys were actually charged with day-to-day supervision of the manual labor involved in caring for the wardrobe or military equipment, for example.[7]

Members of this select group could expect to be appointed amirs immediately upon receiving their freedom, and many of the men who attained great power and wealth in the Mamluk military administration had begun in the *khāṣṣakīyah*. It was largely because of their special relations with the sultan that he preferred to entrust them with the governorship of important provinces, for example. Membership in the *khāṣṣakīyah* was thus almost the necessary first step on the road to high position, at least during much of the Baḥrī Mamluk period.

Although this usage of the term *al-khāṣṣakīyah* is not attested before the Mamluk period,[8] the institution itself appears to have reached nearly full development somewhat earlier. *Mamlūks* had, of course, formed important components of the armies of Muslim princes from early Abbasid times.[9] It is not clear, however, just when membership in a highly structured separate corps of intimates with ceremonial responsibilities first became established as an important route to the most powerful positions within the princely state. Descriptions of Abbasid and Fatimid court ceremonial, though quite detailed in many respects, include no mention of *mamlūks* having functioned in the way described.[10]

The first step may have been taken by the Samanids in northeastern Iran (204–395/819–1005). At least the great Saljuqid vizier Niẓām al-Mulk, who grew up at the Samanid court, reported a fairly rigorous training in which the young military slave (usually called *ghulām* in the eastern Islamic world) began as a kind of footman (*dār rikāb*), passing through several phases of duty until, in his sixth year of service, he became a cupbearer (*sāqī*); in his seventh year he served as a robe bearer (*jamadār*), and after that he assumed responsibility for training younger *ghulāms*.[11] Bosworth, however, considers this description an idealization of the reality and argues that the Samanids were not capable of such a highly structured training scheme.[12] Whether or not he is correct, the ceremonial functions named by Niẓām al-Mulk appear to have been simply levels in the standard career progression for all *ghulāms* and not posts of preferment.

Information from the succeeding Ghaznavid court is slightly more revealing. Bosworth, relying largely on al-Bayhaqī's *Taʾrīkh-i Masʿūdī*, has summarized what there is. There was a substantial contingent of "palace *ghulāms*," which seems comparable—in numbers, functions, and relation to its patron—to the large body of royal *mamlūks* of thirteenth- and fourteenth-century Egypt. Furthermore, favored members of this body could serve in ceremonial posts like *silāḥdār, chatr-dār, ʿalam-dār, sāqī,* and *dawādār*.[13] But it is not clear from the information available that these appointments were reserved for members of an exclusive corps that was segregated from the larger body of "palace *ghulāms*" or even that they were reserved for youths. Indeed, it seems that the Ghaznavid sultans did not automatically free their slaves, and therefore there was probably no orderly "turnover" of favorites as they reached maturity.

A version of such a body was, however, established by the Khwārazmshāh Muḥammad ibn

Takash (596–617/1200–1220), who appears to have been particularly concerned with courtly ostentation and ceremonial.[14] Members of his personal entourage were identified by black emblems on their banners: an inkwell for the *dawādār*,[15] a bow for the *silaḥdār* [sic], a basin (*al-masīnah*) for the *ṭashtdār*,[16] a square of cloth (*buqjah*)[17] for the *jamdār*, a horseshoe for the *amīr akhūr*, and a "golden dome" for members of the *jāwīsh* corps.[18] A number of Muḥammad's *mamlūk*s subsequently rose to the status of amir,[19] specifically his *ṭashtdār*, his *rukubdār*, his *silaḥdār*, and his *jandār*. His son and successor, Jalāl al-Dīn (617–628/1220–1231), however, is said to have dispensed with such ceremonial ostentation.

For the Turkish courts of Iran and the Fertile Crescent during the twelfth and early thirteenth centuries, little detailed information is available; nevertheless, occasional comments in the chronicles, as well as epithets of some amirs referring to ceremonial posts, suggest that princely entourages there included similar élite bodies of *mamlūk*s, though perhaps not as precisely organized as that of Muḥammad.[20] Fortunately, however, this scattered information is reinforced and supplemented by several pictorial representations that survive from northern Mesopotamia. The clearest example is provided by a miniature painting from a copy of the *Kitāb al-Diryāq* probably illustrated in Mosul in the first quarter of the thirteenth century and now in the National-bibliothek, Vienna (fig. 1).[21] The picture space is divided into three registers, the wider central one of which is of interest here.

The scene consists of a Turkish prince seated on a low platform with wine beaker and napkin in his hands. Before him a servant roasts *shīsh kabāb* over a brazier; a plate of rice and some vases of flowers stand in the background. Ten other figures surround the prince. Three of them carry swords in an uncomfortable and obviously ceremonial stance that probably could not be long sustained. At the top left one of them carries an arrow or, more probably, a short hunting spear, his companion a hunting falcon on his gauntleted wrist. Two figures at bottom right hold polo sticks, and above them another two carry a beaker of wine and a live goose respectively. All these figures are unbearded, signifying that they are still boys, and it seems quite clear from their costumes that they are members of the prince's intimate entourage of *mamlūk*s. Only the bearded figure at the lower left remains unaccounted for. He carries nothing in his hand and is clearly a mature man; he may be a kind of supervisor or commanding officer of the *mamlūk*s, but, as he is without a head covering, more likely he is another kind of servant.[22]

Each of the nine youths in this miniature carries an attribute connected with a ceremonial post, but the emphasis is not on the individuals who fill such posts. The attributes refer instead to the prince: They are *his* polo sticks, *his* swords, *his* falcon, *his* wine, and so on. The function of the youths is simply to carry them. In that sense, the entire group of ceremonial *mamlūk*s—the *khāṣṣakīyah* in fact, if not yet in name—is in itself still another attribute of the prince.

It is unlikely that the scene depicted represents an actual moment in courtly life. Not only is it impossible that sovereign dignity could long survive the presence of a live goose, but also the falcon and the polo sticks seem particularly inappropriate to the relatively relaxed atmosphere of a meal taken in private. The attributes seem intended simply to underscore the princely status of the main figure.

This impression is confirmed by a second, closely related miniature painting, one of several frontispieces to volumes in a set of the *Kitāb al-Aghānī* probably copied for Badr al-Dīn Luʾluʾ while he was still *atābik* of Mosul (607–631/1210–1234).[23] The frontispiece to volume IV (part of Adab 579 in the National Library, Cairo) has unfortunately been heavily overpainted, so that it no longer accurately reflects thirteenth-century Mesopotamian style, but, thanks to an infrared photograph published by Farès, it is possible to discuss the iconography with some sense of security.[24]

The composition of this frontispiece is more hieratically organized than that of the Vienna miniature, but the similarities are nonetheless striking. A Turkish prince is seated on a throne with beaker and napkin in his hands, this time with a group of female musicians before him. He is flanked by eight beardless youths, each carrying an attribute. Clockwise from his left shoulder these attributes include a beaker and napkin, an unidentifiable object, a bottle, a staff or lance, a napkin, a folded napkin (?), a sword, and a baton. In addition, a pair of winged "geniuses" hovers in the space above, grasping the ends of the billowing scarf that forms a canopy over the prince's head. This feature is evidence that no specific moment in court ceremonial was being commemorated. Rather, a series of symbolic elements was arranged in order to highlight the princely power of the main figure.

That the *khāṣṣakīyah* and canopy were so strongly identified with sovereignty that they might serve to define the princely setting is suggested by a carved stone niche from the Gu' Kummet at Sinjār, now in the Iraq Museum, Baghdad (fig. 2).[25] Eight individual beardless figures in military dress are carved in relief at regular intervals on the arched panels that frame the niche (figs. 3–8). Clockwise from bottom left they carry an arrow or short spear, a polo stick, an object that is unidentifiable because of damage to the stone, a bow and arrow, a bow suspended from some kind of strap, a beaker and napkin, a baton,[26] and a sword. As the figures clearly form part of an iconographic complex similar to that already discussed, it seems likely that the central figure in the composition was intended to be the prince, this time the living prince, seated in the niche. That this monument is thus a throne niche is supported by several details, most important of which is the small cupola, or baldachin, carved in relief directly above the center of the opening, on what might be called the axis of sovereignty (figs. 2, 6).[27] The baldachin seems iconographically equivalent to the scarf canopy in the miniature from the *Kitāb al-Aghānī*.

The Sinjār niche is difficult to date precisely but most probably falls before 637/1240, when the city was captured by Badr al-Dīn Lu'lu', for the carving seems to belong to an earlier phase of the style typified by Badr al-Dīn's own monuments at Mosul, dating from the 1240s.[28] The niche thus probably was carved during the twenty years of Ayyubid rule at Sinjār, which began in 617/1220; as the Ayyubid prince al-Malik al-Ashraf maintained a residence there until 626/1229, it may fall into the third decade of the thirteenth century.

A fourth monument suggests that already in the mid-twelfth century the *khāṣṣakīyah* was sufficiently closely identified with princely power to stand alone as an indication of princely status. A stone bridge built by the Artuqid Qarā Arslān (543–562/1148–1167) at Ḥiṣn Kayfā still retains on its piers five of what were almost certainly originally eight relief sculptures of standing or striding figures in Turkish military dress (fig. 9).[29] Because of the small size of these reliefs, their worn condition, and their distance from the riverbanks, it has not been possible to obtain clear photographs of all of them. Nevertheless, one figure can be seen to be carrying a short spear or baton on one shoulder (fig. 10).[30] Other figures seem to be carrying a bird and a sword respectively (figs. 11, 12). The attributes carried by the remaining two figures cannot yet be identified. What is discernible, however, is enough to confirm that these figures belong to a group of the same kind as those depicted in the two miniatures and on the Sinjār niche. On the bridge, however, the ruler himself was not represented, probably because such direct representation was considered inappropriate for a public place.[31] Instead, a recognizable sovereign attribute, the *khāṣṣakīyah,* was substituted.

Two of the four monuments discussed are clearly attributable, either through inscriptions or text sources, to courtly patrons; the Sinjār niche can be defined as a princely monument by its function. Only the Vienna *Kitāb al-Diryāq* bears no hint of its patron. All four are products of northern Mesopotamia in the period between the mid-twelfth century and about 1230. They

suggest that the actual composition of the *khāṣṣakīyah* varied, presumably according to the preferences of each prince. It is not necessary therefore to take Abū al-Fidā"s description of Muḥammad ibn Takash's group as an immutable standard for all regions and all courts. Although the nature of such groups was generally similar, at any given court the post of *bāzdār,* for example, might be present or absent; or there might be more than one *silāḥdār,* and the associated attribute might be either a bow or a sword. The fundamental fact of importance is that the corps of ceremonial *mamlūk*s was a recognizable feature of the princely entourage, sufficient to ensure its inclusion in the array of sovereign imagery that was so highly developed in northern Mesopotamia at that period.

In the third decade of the thirteenth century representations of the *khāṣṣakīyah* began to appear on silver-inlaid brass vessels. The earliest known instance is an ewer dated 620/1223 and signed by Aḥmad al-Dhakī al-Mawṣilī; it is now in the Cleveland Museum of Art.[32] Unfortunately, it has lost most of its silver inlays. The drawing in Figure 13 provides the clearest obtainable version of the very worn engravings on the neck, the area of most interest here. Visible in the center (at the front, or spout, side of the vessel) is an enthroned prince raising a beaker to his lips; two winged "geniuses" unfurl a canopy above his head. Two registers of human figures face the throne on each side. The lower register consists of seated and kneeling musicians and entertainers. Above them is a total of eleven figures who seem, despite their poor state of preservation, to belong to the *khāṣṣakīyah;* recognizable among them are men carrying a mace, perhaps a polo stick, a bottle, and a beaker respectively. The hieratic composition, with the prince in the center directly beneath a canopy and flanked by *khawāṣṣ* with entertainers in front, bears a clear relation to that of the slightly earlier Cairo frontispiece from the *Kitāb al-Aghānī* already discussed.

Somewhat better preserved are the representations on a second ewer, made three years later by ʿUmar ibn Ḥājjī Jaldak, a *ghulām,* or apprentice, of Aḥmad.[33] Although the inlays are mostly missing from this vessel also, the surface is less worn, and it has been possible to reproduce the relevant band of decoration, which in this instance encircles the shoulder. This band is divided into two compartments by the handle and the spout, and each compartment is subdivided by an octagonal medallion engraved in the center of each side. Immediately to the right of the spout, a prince sprawls on his throne, one leg dangling, the other folded under, a falcon (?) on his wrist. Facing him are two registers of figures similar to those on the Cleveland ewer, the lower one composed of entertainers, the upper one of four *khawāṣṣ* (fig. 14). The first two, with arms intertwined, carry swords resting on their shoulders, the third a mace; the attribute of the fourth is no longer discernible. The part of the compartment to the right of the central medallion (not illustrated) also contains two registers of figures, this time with agricultural laborers above the entertainers, and at the far right a scene of preparation for a meal. On the other side of the ewer both halves of the compartment contain parts of a single composition. Immediately to the left of the central octagon a crowned ruler is enthroned, in a posture similar to that of the first prince, with a napkin visible in his lap (fig. 15). Facing him from the left the upper register contains five *khawāṣṣ*: a sword bearer, a figure whose attribute cannot be discerned, two mace bearers, and a bow carrier. On the other side of the octagon (fig. 16), the upper register contains a figure apparently carrying both a bottle and a mace, one with a bow, two without discernible attributes, one carrying a beaker, and a final figure so worn that little can be seen. The kinship of these representations with those on the Cleveland ewer is clear, but the off-center compositions and asymmetrical postures are closer to those of the miniature from the Vienna *Kitāb al-Diryāq* than to those of the frontispiece from the *Kitāb al-Aghānī* discussed here.

That the use of *khāṣṣakīyah* imagery continued through the thirteenth century is attested by a series of further silver-inlaid brasses, including the famous "Homberg" ewer, now in the Keir

Collection, London, which was made in 640/1242 by the same Aḥmad who had made the Cleveland ewer.[34] Unfortunately, the inlays on this piece have been replaced, and it is impossible now to reconstruct the attributes of the *khawāṣṣ* depicted on the shoulder with any certainty. Only slightly later, in 646/1248, Dā'ūd ibn Salāmah made a candlestick that is now in the Musée des Arts Décoratifs, Paris. On the shaft of the socket is what appears to be a *khāṣṣakīyah* representation but without the ruler (figs. 17–19).[35] Fifteen male figures in Turkish dress encircle the shaft; among them two bear beakers and napkins, two rest maces against their shoulders, one carries a sword in the same position, and one grasps a long spear and shield. Some others carry attributes that cannot be identified; still others seem not to carry attributes at all. This candlestick has also been entirely re-inlaid, so that such details as the bearded faces cannot be taken as reflecting those of the original inlays.[36]

On all these metal pieces the *khāṣṣakīyah* representations appear as subsidiary parts of the decoration. But in the later thirteenth century ʿAlī ibn Ḥamūd, who is known to have been active between 657/1259 and 673/1274, made an inlaid basin, now in the Gulistan Museum, Tehran, on which the *khāṣṣakīyah* is included in the main band of decorations.[37] This band, which encircles the exterior wall of the basin, is divided by medallions into four zones. In the center of one of these zones is an enthroned prince with a goblet and a single winged "genius" hovering above; in front of the prince are a kneeling figure and two sword bearers, behind him a *sāqī*, a seated musician, and an agricultural worker. The remaining three zones are filled with a procession of servants, mostly game carriers, with *khawāṣṣ* spaced among them at intervals.[38] The combination of different kinds of servants is already known from the Cleveland and Metropolitan ewers, but here the spatial organization is somewhat different.

Finally, around the beginning of the fourteenth century Muḥammad ibn al-Zayn made a small bowl, now in the Louvre, on which the *khāṣṣakīyah* imagery has become more formalized and somewhat reduced. The main decorative band is divided into zones by three medallions. One of these zones contains a seated prince with bow and arrow flanked by four seated *khawāṣṣ* bearing, from left to right, an ax, a penbox, a sword, and a bowl (or basin?).[39] These attributes are, respectively, those of the *ṭabardār* (or *jumaqdār*), the *dawādār,* the *silāḥdār,* and perhaps the *ṭashtdār.*[40]

The parallels between the *khāṣṣakīyah* representations on inlaid metalwork and on the first four Mesopotamian monuments discussed are clear. Indeed, each of the craftsmen mentioned, except Muḥammad ibn al-Zayn, used the *nisbah* "al-Mawṣilī" on one or more of his works. It cannot, however, be concluded that these men worked only, or even primarily, in Mosul. Rice has presented detailed iconographic and stylistic arguments for attributing inlaid objects with Christian imagery to Syria and has thus claimed that origin for the "Homberg" ewer and the candlestick of Dā'ūd ibn Salāmah.[41] Aḥmad, who made both the Cleveland and "Homberg" ewers, also made a basin for al-Malik al-ʿĀdil Abū Bakr II, Ayyubid sultan in Cairo in 636–638/1238–40; Rice has attributed this basin to either Syria or Egypt.[42] It is almost certain that in the third quarter of the thirteenth century ʿAlī ibn Ḥamūd was working outside Mosul, which was destroyed by the Mongols in 660/1261. Finally, Muḥammad ibn al-Zayn worked somewhere in Mamluk domains, though he was clearly familiar with Mesopotamian iconographic traditions.[43] It thus appears that, during the thirteenth century, the Mesopotamian iconography of the *khāṣṣakīyah* spread beyond Mesopotamian borders and continued to develop in Syria and probably also in Egypt, with the gradual absorption of pictorial details and stylistic features characteristic of those regions.

More striking, however, is the fact that no surviving metal object bearing a representation of the *khāṣṣakīyah* was made for a princely patron. Nor, with the probable exception of the aforemen-

tioned throne niche, does any object in any medium made for an Ayyubid prince bear such imagery.[44] In fact, the Sinjār niche is probably the latest princely monument known to bear *khāṣṣakīyah* imagery. It thus seems clear that by the second quarter of the thirteenth century such representations were losing their direct princely connotations and coming to have broader appeal as part of a varied array of decorative programs considered appropriate for luxury objects.[45] This shift can be assigned to the reign of al-Sulṭān al-Malik al-Kāmil Muḥammad (615–635/1218–38), whose capital was Cairo.

The explanation for this change does not have to be sought very far. For, as has been amply documented, the central military role of the *mamlūks* was largely suspended during the period of Ayyubid rule.[46] The Ayyubid princes of Syria and Egypt turned instead to their numerous family connections, to Kurdish tribal brethren, and to hereditary Turkish amirs for their commanders and closest advisers. Although *mamlūks* continued to be purchased and to serve, especially in the armies of lesser princes and amirs, they had relatively little access to the primary centers of power during the early thirteenth century. It is not surprising, then, that *khāṣṣakīyah* representations found no place in Ayyubid princely art. Only when al-Malik al-Ṣāliḥ Ayyūb came to power did the *mamlūks* once again come into their own. Al-Ṣāliḥ distrusted other members of his family and many of their supporters; to balance their strength he founded two military units composed entirely of *mamlūks*: the Baḥrīyah (so named because its barracks were located on the island of Rawḍah in the Nile) and the smaller Jamdārīyah, which apparently functioned as a bodyguard.[47]

With this renewed proximity to power, it was to be expected that the *khāṣṣakīyah* would again become prominent, and indeed it seems to have done so. In an oft-quoted passage, Ibn Taghrībirdī reported that al-Ṣāliḥ's *jāshnikīr*, Aybak al-Turkmānī, when he was promoted to amir, was granted the *khawānjā* (table) as the emblem (*rank*) of his *former* service.[48] This usage seems comparable to that at the court of Muḥammad ibn Takash, though now it is certain for the first time that the emblems were used after the period of service to which they referred.

Does this episode represent a more general practice at al-Ṣāliḥ's court? To answer this question, it is necessary, first, to identify members of his *khāṣṣakīyah* and then to examine their surviving monuments and objects for appropriate emblems. It appears that, of about one thousand *mamlūks* of al-Ṣāliḥ, the names of perhaps fifty or sixty are known from texts.[49] Only a very few of these individuals can, however, be associated with the *khāṣṣakīyah*. Aybak has already been mentioned. A second is ᶜAlā' al-Dīn Aydakīn al-Bunduqdār,[50] who had, as his title suggests, served al-Ṣāliḥ as bow carrier until he was promoted to amir, probably in about 643/1245. He had a long and active career, also serving under Sulṭāns Aybak and Baybars I, but it was under the latter that he achieved real prominence; Baybars had been Aydakīn's own *mamlūk* before being expropriated by al-Ṣāliḥ in 644/1246–47, and, when he himself became sultan, he continued to treat his former master with every mark of affection and respect. It is all the more significant, then, that, despite all the posts and honors that Aydakīn had enjoyed in his long career, when in 683/1284 he built at Cairo the *khānqāh* in which he was subsequently buried, he chose to adorn it with carved representations of two addorsed bows, referring to his service, forty years before, in al-Ṣāliḥ's *khāṣṣakīyah*. The same emblem is repeated five times on a glass lamp from the same building, now in The Metropolitan Museum of Art, New York (fig. 20).[51]

A third *khāṣṣ*, Nāṣir al-Dīn Ughulmush al-Silāḥdār al-Ṣāliḥī, is more obscure. Little is known of his career, nor can any monument or object be ascribed to him.[52] Another *silāḥdār*, Shams al-Dīn Āqsunqur al-Fāriqānī (d. 677/1278), is better known, but he too has left no material trace.[53]

Complicating the problem of identifying al-Ṣāliḥ's *khawāṣṣ* is the difficulty of distinguishing between the ceremonial post of *jamdār* and simple membership in the Jamdārīyah, a bodyguard of approximately two hundred *mamlūks*, probably comparable in function, if not in size, to the

jāwīshīyah of Muḥammad ibn Takash.[54] Rukn al-Dīn Baybars al-Jāliq, for example, was a leading amir of the Jamdārīyah in the days of al-Ṣāliḥ.[55] His only surviving monument is his mausoleum in Jerusalem. In the inscription there the title *al-jamdār* does not appear; only the *nisbah* "al-Ṣāliḥī" is present.[56] Flanking the first line are two circular medallions framing vegetal motifs that Mayer has described as eleven-petaled *fleurs-de-lis,* Balog as palmettos or date palms. Clearly these designs are not related to service either in the *khāṣṣakīyah* or in the Jamdārīyah. It is doubtful that they should be treated as emblems at all.[57]

Nor is much light shed by the only object surviving probably from the earliest phase of the Mamluk period on which the title *al-jamdār* and the appropriate emblem (the *buqjah*) are combined. It is a basin of ʿIzz al-Dīn Aydamur al-Jamdār al-Qaymarī, now in the Museum of Islamic Art, Cairo; on the exterior three *buqjah*s alternate with three lions, each framed in a circular medallion.[58] The *nisbah* "al-Qaymarī" refers to a Kurdish military unit, al-Qaymarīyah, that was among the supporters of al-Ṣāliḥ and subsequently became the mainstay of his cousin al-Malik al-Nāṣir Yūsuf, the last Ayyubid ruler of Damascus (648–658/1250–60).[59] Nothing in the inscription suggests that Aydamur had been a *mamlūk* of al-Ṣāliḥ; indeed, there is no indication of what master he had served as *jamdār*.[60] The only useful conclusion that can at present be drawn from the decoration of this basin, then, is that the *buqjah* did continue to represent the *jamdār* in the Ayyubid and early Mamluk periods, as it had done under Muḥammad ibn Takash.[61]

To return to *mamlūk*s known to have served al-Ṣāliḥ, the most prominent were, of course, the three who themselves eventually became sultans. The first of them was the aforementioned Aybak al-Turkmānī; the *khānjā* was his emblem while he was amir. After al-Ṣāliḥ's death, Aybak married his widow and became the first Mamluk sultan. Other than coins, only two objects of his have survived, both from the period of his sultanate. One is a fragment of linen stamped with his sultanic title, the other a magic bowl copied from a much earlier Abbasid example.[62] Neither of these objects bears a *khānjā,* which suggests that Aybak no longer used his amirial emblem once he had ascended the throne, at which time sovereign devices became available to him.[63]

This suggestion is borne out by examination of the much richer remains of Baybars I al-Bunduqdārī, the fourth Mamluk sultan,[64] who is credited with having laid the foundations of the Mamluk state. The sources on his early career are somewhat contradictory, but certain reliable facts do emerge. After beginning as the *mamlūk* of an obscure amir, he passed into the service of Aydakīn al-Bunduqdār; when al-Ṣāliḥ arrested the latter and confiscated his property in 644/1246, he took Baybars into his own service. The young slave was at that point already twenty years old and was immediately appointed to command a unit of troops.[65] It thus seems certain that he never served in al-Ṣāliḥ's *khāṣṣakīyah.* This impression is confirmed by the fact that he did not include in his titulary any honorific more specific than "al-Ṣāliḥī al-Najmī" in referring to his service to the Ayyubid prince.

It has frequently been observed that Baybars used the lion as his "emblem." Indeed, feline creatures in various forms do appear on many of his architectural reliefs and almost all his coins.[66] Such imagery seems to reflect an essentially Mesopotamian tradition of sovereign representations, carried on outside the boundaries of that region and in somewhat reduced form. The practice of carving appropriate reliefs to accompany monumental inscriptions was deeply rooted in northern Mesopotamia, going back as far as the early tenth century and becoming particularly highly developed after the late eleventh century; this continuous tradition seems not to have had any counterpart elsewhere in the Islamic world. Among the many animals, monsters, and human figures in the Mesopotamian repertoire, the lion was perhaps the most common.[67] It also appeared, though far less often, on figured copper coins struck in the same region. None of the Mesopotamian motifs can be considered a heraldic emblem, however, though certain princes did

show marked preference for certain images. The bicephalic bird is a particularly good example. The Zankid princes of Sinjār introduced it as a sovereign image on their coins, but it was the Artuqid Nāṣir al-Dīn Muḥammad of Kayfā who used it most frequently, both on various coin issues and in architectural reliefs on the defensive towers of Āmid, so that it is particularly identified with him.[68] Viewed against this historical background, the preference of Baybars for felines becomes clearly understandable. Even their placement—on metal doors, flanking inscriptions, on bridges and portals, and on coinage—reflects Mesopotamian practice. They are firmly within the tradition of sovereign imagery, but they should be viewed as part of an iconographic strand separate from that of the *khāṣṣakīyah*.[69]

The common practice of including the imagery of the Mamluk sultans in discussions of "heraldry" seems mistaken, for two reasons. On one hand, it tends to obscure important and observable continuities in sovereign iconography from period to period; on the other hand, by swelling the so-called "armorial roll," it also tends to obscure recognition of what was a genuine innovation of the early Mamluk period: the adoption by amirs of emblems of their former service in the *khāṣṣakīyah*. It thus seems preferable, at least for the early Baḥrī period, to treat sovereign devices and emblems of service as two distinct categories. Of these two, probably only the latter should be considered part of "heraldry."

The third sultan who had served in al-Ṣāliḥ's Baḥrīyah was Qalā'ūn al-Alfī, who came to the throne in 678/1280.[70] He had also begun as *mamlūk* of an amir, ʿAlā' al-Dīn Āqsunqur, or Qarāsunqur, al-Sāqī al-ʿĀdilī.[71] In 647/1249–50 he and his cohorts became the property of al-Ṣāliḥ,[72] and Qalā'ūn was placed in the Baḥrīyah. Again there is no hint either in the chronicles or in surviving inscriptions that Qalā'ūn had served in the *khāṣṣakīyah*. As sultan, he ordered the *nisbah* "al-Ṣāliḥī" inscribed at the top of all official documents, and he customarily included it in his inscriptions as well.[73] His surviving monuments, like those of Baybars, must be considered separately as part of the sovereign category.

Only a few other Ṣāliḥī amirs need be mentioned here. Badr al-Dīn Baysarī al-Shamsī has left a brass incense burner, now in the British Museum (78 12–30 682), on which are several representations of a bicephalic bird. There is no evidence that Baysarī had been a member of the *khāṣṣakīyah*, and it seems now generally accepted that the bicephalic bird in this instance should not be considered an emblem.[74]

The rosette, too, should be eliminated from discussions of "heraldry" in this early period. Jamāl al-Dīn Mūsā ibn Yaghmūr al-Yārūqī has left a copper vase, now in the Museum of Islamic Art, Cairo,[75] that is inlaid on the exterior and upper rim with nine unframed eight-petaled rosettes in silver. He was a prominent amir at the end of the Ayyubid period, a Turkman officer who served as governor of Cairo under al-Ṣāliḥ but had never been a *mamlūk*; he thus would not have been entitled to an emblem of service. Furthermore, the rosettes on his vase belong to a large category of inlaid designs on metalwork that were used only for decoration.[76]

The same observation seems applicable to six-petaled rosettes, which, though less common, also formed part of the decorative repertoire of late Ayyubid and early Mamluk art.[77] Two such rosettes appear on the tomb of Shams al-Dīn ʿAqqūsh al-Burlī (d. 668/1269) at Kafr Sīb in Palestine; ʿAqqūsh had been a member of the ʿAzīzīyah regiment, founded by the Ayyubid al-Nāṣir Yūsuf's father.[78] He had apparently not, however, been a *khāṣṣ*, and the rosettes are almost certainly decorative, rather than emblematic.[79]

Finally, Meinecke has drawn attention to an Azdamur al-Ṣāliḥī, who is reported to have built a mausoleum in Cairo for Shaykh Yūsuf al-ʿAjamī al-ʿAdawī; in this mausoleum another *shaykh*, Muḥibb al-Dīn Abū al-Faraj (d. 672/1272–73), was also interred.[80] At the apex of a stucco window frame on the interior *qiblah* wall of the main room is carved a nonrepresentational design

of a type to which Mayer has given the number 26 (fig. 21).[81] Meinecke ventured the guess that, in view of the early date of Muḥibb al-Dīn's death, Azdamur had been a *mamlūk* of al-Malik al-Ṣāliḥ Najm al-Dīn Ayyūb.[82]

Only two other inscribed objects displaying design No. 26 in a simple circular frame are known. The motif occurs six times on a glass lamp of Ulmās, who had begun as *jāshnikīr* for al-Sulṭān al-Malik al-Nāṣir Muḥammad; the lamp is datable to about 730/1330.[83] It also occurs on the mausoleum of Ibrāhīm ibn Adham, built at Jabalah in 743/1343 by Aybak al-Dawādār, a servant of Ṭūghān al-Ṣāliḥī, governor of Ṭarāblus. In view of these fourteenth-century parallels, it seems more reasonable to suppose that Azdamur, like Ṭūghān, had been a *mamlūk* of al-Malik al-Ṣāliḥ ʿImād al-Dīn Ismāʿīl, who reigned from 743 to 746 (1342–45).[84]

This strange and inexplicable design is only one of a fairly large group of abstract devices that seem to have been used as emblems but that cannot yet be individually interpreted. Mayer suggested that some of them are *tamghahs*,[85] tribal marks of the kind used to brand animals and other personal property in Turkman areas. They would thus have been adopted by *mamlūk*s as emblems referring to their former tribal connections in the Caucasus.

There are several major objections to this interpretation, however. The only so-called *tamghah* known to have been used in the thirteenth century was the one designated No. 24 by Mayer (fig. 22).[86] It occurs on two different monuments at Gaza. On the earlier one, the *masjid* of Shaykh Ilyās ibn Sābiq ibn Khiḍr, dated 671/1272, two unframed examples flank the lintel inscription.[87] It seems clear, however, from the names, from the use of the title *al-shaykh,* and from the tracing of Ilyās' lineage through three generations that he was not a *mamlūk* and probably not even a Turk.

The second instance occurred nearly a quarter-century later, in 694/1295, on a marble column in a cemetery in the same city.[88] Two framed examples precede the inscription, which is in the name of al-Ḥājj Nūr al-Dīn ʿAlī ibn Shihāb al-Dīn Bishārah ibn Khurramshāh (?) ibn (?)ṣir al-Salūrī al-Turkmānī. Although Nūr al-Dīn was ultimately of Turkman descent, the absence of military titles and the fact that he could trace his lineage through four generations in the Islamic world make it clear that he, too, had not been a *mamlūk*.

Neither of the men mentioned seems to have been of immediate tribal origin, and it is thus unlikely that design No. 24 was either a *tamghah* or its Badawī counterpart, a *wasm*. The curious fact that both monuments are located in Gaza suggests some local association for this design, but it is not possible to draw definitive conclusions from only two examples.

The conclusion that design No. 24 was not a *tamghah* is supported by a survey of similar devices used in the fourteenth century; most of them, too, belonged to men who had not been *mamlūk*s and in some instances were not Turks.[89] Many could trace their ancestry back several generations in the Islamic world. It is thus very nearly certain that these abstract designs are not to be considered *tamghah*s. Their individual significance and overall relation to the amirial emblems of the former *mamlūk*s remain open questions, which unfortunately cannot be dealt with here.

It has been possible, then, to identify only four individuals who served in al-Ṣāliḥ's *khāṣṣakīyah*.[90] Of the other Baḥrī *mamlūk*s who have left inscribed objects or buildings, none seems to have used an "emblem" precisely defined. The designs accompanying their inscriptions fall into the category of sovereign devices or can be demonstrated to be simply decorative motifs, sometimes framed, sometimes not. The evidence for the origin of Mamluk emblems in the service of the Ayyubids is thus rather sparse, but viewed in its context it is nonetheless significant. It has been suggested that in the period before the long sultanate of al-Nāṣir Muḥammad (693–741/1294–1340, with interruptions) the *khāṣṣakīyah* probably consisted of no more than two dozen members;[91] if al-Ṣāliḥ's own corps was as large as that (and it seems likely to have been smaller), then one-sixth of its members have been identified. Two of them have left no material trace, but the other two did use their

emblems as *khawāṣṣ* during their subsequent amirial careers. This sample is bolstered by the instance of al-Qaymarī, though his former master is not known.

Further light can be shed on this question by an examination of the pattern among the *khawāṣṣ* of the immediately succeeding rulers, the first Mamluk sultans, in order to see whether or not the practice of adopting amirial emblems based on previous service was carried on by them.

None of Aybak's *khawāṣṣ* has left any material remains, nor have those of his two successors, whose combined reigns totaled only about three years. Baybars I is the first for whose *mamlūks* there is some evidence, but unfortunately it is equivocal.[92]

A candlestick in the Museum of Islamic Art, Cairo (7229), is inscribed to Sayf al-Dīn Bahādur Ustādār al-ʿĀliyah al-Malikī al-Ẓāhirī. Its decoration includes two instances of a sword, the emblem of the *silāḥdār*, each inscribed in the center field of a tripartite disk. Mayer identified the amir in question as the Bahādur al-Ẓāhirī who became *ḥājib al-ḥujjāb* in 694/1294 and died as governor of Ṭarāblus in 710/1310.[93] Wiet and Meinecke, on the contrary, consider the owner of the candlestick to have been Bahādur al-Manjakī, who served al-Ẓāhir Barqūq (784–801/1382–99) as *ustādār*.[94] Their argument that the form of the "shield," presumably its tripartite division, precludes any but a fourteenth-century date does not alone, however, obviate Mayer's identification. The undated candlestick might still belong to the period between 698/1299, when a tripartite disk is first known to have been used with an emblem,[95] and 710/1310, when the earlier Bahādur al-Ẓāhirī died. Nevertheless, it does appear from the sources that this man had not served as *ustādār*.

An enameled glass "lamp" inscribed to Shams al-Dīn Altunbughā Raʾs Nawbat al-Jamdārīyah al-Ẓāhirī, an amir known from the literature, was purchased by the Museum of Islamic Art, Cairo, in the 1950s.[96] Four large *buqjahs* in dark olive green (or black?) are framed in circles in lighter green painted over orange; superimposed on each *buqjah* is a lion *rampant* in similar light green painted over orange. There are, however, several reasons to doubt that this object was made in the Mamluk period,[97] and the unique "emblem" cannot therefore legitimately be included in discussions of Mamluk "heraldry."

Finally, Qulunjaq al-Ẓāhirī al-Saʿīdī has left a bronze plate with twenty-four pointed "shields" inlaid in silver.[98] There is no evidence that Qulunjaq served either Baybars or his son as *khāṣṣ*; furthermore, evidence that the pointed shield by itself was an emblem at this early date is lacking, as Mayer and Meinecke have both acknowledged.[99] So many repetitions of an emblem on a single object are uncommon, but decorative motifs like rosettes and whorls were customarily repeated many times.

It is from among the *khawāṣṣ* of Qalāʾūn that the first evidence of widespread use of amirial emblems referring to former servitude survives. The former *silāḥdār* ʿAqqūsh al-Afram (d. 716 or 720/1316–17 or 1320–21) is reported to have had as his emblem a white disk bisected by a green band with a red sword laid across all three fields.[100] From another *silāḥdār*, Asandamur (d. 710–711/1310–11), there is an undated brass bowl, formerly in the Harari collection, on which a sword enclosed in a circle appears three times. A similar sword framed in a pointed shield is carved on the lid of his wife's cenotaph, now in the National Museum, Damascus.[101]

Qarāsunqur al-Jūkandār (d. 728/1328) had a particularly precarious career. On his *madrasah* in Cairo and a public fountain that he sponsored at Aleppo there are several instances of a pair of carved polo sticks.[102] In 711/1311–12 Qarāsunqur fell afoul of al-Nāṣir Muḥammad and fled to Mongol Iran, where he remained for the rest of his life. It is indicative of the prestige by then attached to Mamluk amirial emblems that he had his polo sticks carved even on his mausoleum at Maraghah (728/1328), though such emblems seem to have played little part in the art of Iran.[103]

Rukn al-Dīn Mankuwīrish al-Jamdār al-Manṣūrī (d. 688/1289) was governor of ʿAjlūn in 686/

1287, when he restored the mosque there. On a reused inscription slab from that mosque there are three occurrences of the *buqjah* in a circular frame.[104] Aybak al-Mawṣilī had carved on his mausoleum at Ṭarāblus, where he died in 698/1298–99, three reliefs with the *khānja* of the *jāshnikīr* on the middle of three fields framed in a circle.[105] Although neither his inscriptions nor the few short references to his life in the chronicles mention his having filled the post of *jāshnikīr,* the association seems too well established for doubt.

Kitbughā, who had been a *sāqī,* has left a brass candlestick, the base of which is preserved in the Walters Art Gallery, Baltimore.[106] On it is repeated several times a round frame containing a goblet inlaid in copper on a silver ground beneath a horizontal copper bar. In 694/1295 Kitbughā usurped the throne from Qalā'ūn's younger son al-Malik al-Nāṣir Muḥammad and adopted the sultanic devices. This point is confirmed by a passage from al-Dhahabī, who reported that, while Kitbughā had been an amir, his emblem (*rank*) had been a goblet beneath a bar but that, when he ruled, it was yellow banners,[107] the traditional device of the sultan. Nevertheless, on a few of his copper coins Kitbughā included the goblet that had been his emblem as an amir; he was the first sultan to do so.[108]

Kitbughā's successor, the former *silāḥdār* Lājīn, also issued at Damascus some copper coins carrying what appears to be an emblem, a plain disk divided into three fields.[109] This so-called "fesse" has been widely accepted as the emblem of the *barīdī,* or long-distance mail carrier, ever since Mayer first made the identification.[110] The evidence supporting it is, however, tenuous at best.

To begin with, Sauvaget, in his study of the Mamluk postal service, seems to have been mistaken in his conclusion that the *barīdī*s were drawn from the *khāṣṣakīyah.*[111] Al-Ẓāhirī listed thirty-nine of the forty posts that constituted the corps during the reign of al-Nāṣir Muḥammad.[112] They were all clearly ceremonial; it is unlikely that the fortieth post was that of the *barīdī,* for there must have been many more than one, and, in addition, al-Qalqashandī has made clear that the work was demanding, not at all ceremonial.[113] Nor does Sauvaget's observation that sometimes *khawāṣṣ* were entrusted with special or secret errands for the sultan prove that they were part of the *barīd.* Indeed, as the mail service must have required that a certain number of riders be on call at each administrative center, it is unlikely that they were even royal *mamlūk*s, who generally remained in the capital. These riders must therefore have ranked well below the *khāṣṣakīyah.*

It thus seems questionable whether former *barīdī*s were entitled to emblems at all, at least through the first decade of the fourteenth century. There are two well-known passages in which al-Qalqashandī describes the metal plaque, inscribed on both faces, that each dispatch rider wore over his chest suspended on two bands inside his clothes; it was counterbalanced in the back by a silk tassel that was meant to be visible outside his clothing.[114] It is this plaque that is thought to be represented in "heraldry" by the uninscribed tripartite disk. Such a disk occurs twice flanking the niche of an undated fountain in Damascus; the interior of the niche contains an inscription in the name of ᶜAlā' al-Dīn [ᶜAlī] al-Barīdī.[115] The inscription offers no evidence that ᶜAlā' al-Dīn had been a *khāṣṣ,* or even a *mamlūk,* and he is not mentioned in the sources. A similar tripartite disk is carved above the entrance to a building at Quṭayfah, which Sauvaget has convincingly identified as a postal relay station. Although the carving on the portal was never finished and the inscription could not be read, Sauvaget considered the disk to be the emblem of the postal service, rather than of an individual.[116] This conclusion is contradicted, however, by the absence of the disk from other such stations, even those that are quite well preserved.

Ibn Taghrībirdī reports that Sayf al-Dīn Salār had a black and white emblem.[117] On the shrine of Shaykh ᶜAlī Bakkā' at Hebron (702/1302), two tripartite disks interrupt the inscription, which

is in Salār's name; the center field of each is inlaid with a darker stone.[118] The only evidence that permits identification of Salār as a *barīdī*, however, is the following statement, to be found in al-Maqrīzī's account of Lājīn's seizure of the sultanate from Kitbughā while both were in Palestine:

> Furthermore, the *barīd* was sent from Ghazzah, and the Amīr Sayf al-Dīn Salār conveyed the *barīd* to Qalʿat al-Jabal [the citadel at Cairo], in order that those of the amirs who were there might swear the oath of allegiance [to Lājīn].[119]

The import of this sentence is not that Salār was a *barīdī;* on the contrary, he was an amir, entrusted with the sensitive mission of conveying the news of Lājīn's coup to the capital and obtaining the necessary guarantees of a favorable reception for the new sultan's return. Indeed, it is unlikely that Lājīn, who was still encamped in Palestine, had yet been able to take control of the official *barīd* and its dispatch riders. A well-known amir like Salār, who would be instantly recognized in Cairo, would thus have been the obvious choice for such a mission.

Lājīn himself is supposed, also on the basis of al-Maqrīzī's report, to have been a *barīdī*. The passage occurs in an account of Qalā'ūn's first acts as sultan after he seized the throne on 21 Rajab 678/27 November 1279:

> And the *barīd* arrived in Damascus—and it was in the charge of Lājīn al-Ṣaghīr and the Amīr Rukn al-Dīn Baybars al-Jāliq—on the 28th of [Rajab] after two days and seven hours from the departure from Qalʿat al-Jabal, and the likes of this were unheard of. Then the troops of Damascus swore the oath of allegiance. . . .[120]

Again, as in the later instance of Salār's mission to Cairo, it seems that Qalā'ūn had sent one of the most venerable Ṣāliḥī amirs in the realm[121] and his own trusted *mamlūk* Lājīn to secure the loyalty of the troops at Damascus. There is no suggestion that Lājīn was a professional *barīdī;* in fact, he is known to have been a *silāḥdār,* and it is unlikely that as amir he would deliberately have chosen the emblem of a post lower than his post in the *khāṣṣakīyah.* Unfortunately, no emblem at all appears on the sole monument surviving from his amirial days, the Khān ʿAyāsh east of Damascus near ʿAdhrā, so that the inclusion of the tripartite disk on coins issued after he became sultan remains something of a mystery.[122]

From the brief survey presented here, however, it appears that the only evidence linking such a disk with a *barīdī* is the fountain at Damascus. But it is counterbalanced by the use of the same device on a plate inscribed to Baktamur al-Ḥusāmī (d. 724/1324),[123] who had served al-Sulṭān al-Nāṣir Muḥammad as *jumaqdār;* like Lājīn before him, then, he had been a *khāṣṣ* but apparently not a *barīdī.* Three other Nāṣirī amirs—Baktamur's son Ibrāhīm, Arghūn (or Arghūn Shāh), and Kujkun—used the same device, but again none of them is known to have been connected with the *barīd.*[124]

Although there can be little doubt that the tripartite disk was used as an emblem in the Baḥrī Mamluk period, its precise referent remains unclear. Lājīn appears to have been the first to adopt it, for a few of his copper coins. It can tentatively be concluded, then, that, in doing so, he was following a precedent established by Kitbughā: using an amirial emblem on coinage issued after succession to the sultanate.

The third Manṣūrī *khāṣṣ* to become sultan was Baybars II, who had served Qalā'ūn as *jāshnikīr* and who used the *khānjā* as emblem while he was an amir.[125] In 708/1309 he seized the throne—and the accompanying prerogatives—but, unlike his two *mamlūk* predecessors, he did not include his amirial emblem on his rare copper coins.[126] There is, however, a sword, formerly in the

collection of Count Giovanni Gozzadini in Bologna, the blade of which is inscribed "al-Sayfī al-Manṣūrī al-Malik al-Muẓaffar Jāshnikīr Baybars."[127] This inscription provides a unique instance from the Baḥrī Mamluk period of a sultan's having combined his sovereign title with that of his previous position in the *khāṣṣakīyah*.

To sum up, then, during the first half-century of Mamluk rule, amirs who had served in the *khāṣṣakīyah* increasingly came to adopt emblems of their former posts as identifying marks on personal property of various kinds, whether architectural or portable. This innovation appears, from sparse textual and material remains, to have been made by former *khawāṣṣ* of al-Ṣāliḥ, the last effective Ayyubid sultan in Cairo.

Several basic questions are raised by this conclusion. First, the relation of these emblems to Mesopotamian courtly iconography has been emphasized here. This relation must be viewed as an integral part of the pattern of events in the Near East from the time of the Turkish invasions. In the twelfth century the three most powerful figures in the Islamic heartlands were successively Zankī ibn Āqsunqur, ruler of Mosul; his son Nūr al-Dīn Maḥmūd; and Ṣalāḥ al-Dīn Yūsuf ibn Ayyūb, who was raised in the inner circles of Nūr al-Dīn's court. All of these figures were Mesopotamian by birth or adoption, and, as they came to operate in a larger political arena, it is not surprising that they carried Mesopotamian ideas of dynastic prerogatives and representation with them. A primary example is the introduction into Syria by Nūr al-Dīn of the mausoleum complex, the *muqarnas* semidome, and so on.[128]

This general trend of ideas flowed even more strongly in the thirteenth century. The example of inlaid metalwork has already been touched on. A school of craftsmen centered in Mosul began to work for Ayyubid patrons, and the style and iconography of such works reflect the mutual assimilation of Mesopotamian and Syrian traditions. Finally, as the Mamluk period progressed, some Mosul workers and their successors also worked in Egypt.

A similar pattern can be discerned in manuscript painting. The illustrated manuscripts of the Mamluks through the early fourteenth century show clear continuity, in the texts chosen, in the episodes illustrated, in pictorial compositions, and in iconography, with those produced in Mesopotamia and Syria in the first half of the thirteenth century.[129]

The mausoleum complex was not introduced to Cairo until after the death of al-Ṣāliḥ, at which point (647–648/1249–50) his widow placed his tomb at his already-existing *madrasah*. The Syrian practice of lining *miḥrāb*s with panels of colored marble was also introduced in this mausoleum.[130] The mausoleum of the Abbasid caliphs (c. 640/1242) and the buildings of Baybars I were other key monuments in the introduction of Mesopotamian-Syrian ideas of architectural decoration into Cairo—from stained-glass windows in arabesque designs to extensive use of *ablaq* masonry and the *muqarnas* portal.[131] All these features then took root and underwent a long development in Egypt under the Mamluks.

There was, of course, no slavish dependence on Mesopotamian and Syrian artistic forms under the Mamluks. Rather, from the mid-twelfth through the end of the thirteenth century, there was a kind of cultural flow, reflecting the flow of political power. The Zankids carried ideas and forms from Mesopotamia to Syria, where they were adapted and assimilated to local traditions; at the end of the Ayyubid period these amalgams then penetrated into Egypt, where again they were adapted and assimilated to local traditions. Perhaps this process was also accentuated by the tide of refugees moving westward from Mesopotamia after the Mongol conquests.

At any rate, the aspect of this pattern that is perhaps most germane to the present inquiry is that of courtly ceremonial. For example, Sayf al-Dīn Ghāzī I of Mosul (541–544/1146–49) had introduced the practice of having a banner (*sanjaq*) carried before him, and it was still followed under the Mamluks.[132] In fact, al-Qalqashandī reports explicitly that the Zankids had originated many

of the ceremonial arrangements that had then been introduced into Egypt by Ṣalāḥ al-Dīn and perpetuated by the Mamluks. He goes on to describe in detail the particular usages of the Mamluk sultans, along with their origins and subsequent elaborations.[133] Long-standing Egyptian customs were also incorporated, particularly the annual festivities connected with the cresting of the Nile.[134]

Viewed against this backdrop, the continuation by Baybars I of the Mesopotamian custom of placing sovereign imagery on coins and architectural reliefs seems almost inevitable. The adoption of amirial emblems, however, though related to earlier Mesopotamian representations of the *khāṣṣakīyah*, demands further explanation. A major shift occurred at the end of the Ayyubid period. Whereas previously groups of anonymous servants had been depicted carrying objects identifiable as attributes of the prince, under al-Ṣāliḥ and his successors the individual objects became attributes of the former servants themselves, who took them as emblems for public display in order to underscore their special relations with the prince. That *khāṣṣakīyah* imagery had lost its exclusively princely connotations and had become simply one of several common decorative programs perhaps contributed to a favorable atmosphere in which individual amirs could thus assert themselves, but it is insufficient to explain why they did so.

Probably the answer is to be sought in the peculiar problem of establishing sovereign legitimacy in the Mamluk state. A perpetual tension existed between the principle of succession through the dynastic line and the principle of succession through the *mamlūk* "line" (see Chart II). Birth, of course, was the basis for the claim to dynastic succession, a claim that the early Mamluk rulers sometimes attempted to reinforce by associating their sons in the sultanate during their own lifetimes.[135] For the *mamlūk* who became sultan, however, almost the only available justification for permanent seizure of power was the claim, both for himself and for the cohorts who elected him or ratified his elevation, to a special relationship with al-Ṣāliḥ, the last effective Ayyubid sultan in Egypt.[136] This conclusion is underscored by the insistence, especially of Qalā'ūn, on this relationship, even thirty years after al-Ṣāliḥ's death.

By the last decade of the thirteenth century, however, there were few Ṣāliḥī amirs left, and there thus came to be greater emphasis on the *mamlūk* "descent" from Qalā'ūn, the last of the Ṣāliḥī sultans. Naturally, this claim could be more effectively pressed by his former *khawāṣṣ*, those amirs who had been personally singled out by the sultan for advancement and favor. The point is dramatically illustrated by the behavior of the three Manṣūrī amirs who managed to serve briefly as sultan in alternation with Qalā'ūn's own son al-Malik al-Nāṣir Muḥammad. One of them, Kitbughā, even went so far as to put the emblem of his service as Qalā'ūn's *sāqī* on some of his coins; probably Lājīn's tripartite disk should be viewed in the same light, though the point cannot be settled definitively until the precise referent of this emblem is clarified. Finally, the significance of the inscription on Baybars II's sword is that the designations "al-Manṣūrī" and *jāshnikīr* are combined with his title as sultan, "al-Malik al-Muẓaffar."

Allan and Meinecke consider the use of emblems on coins either experimental or transitional.[137] It seems instead to have been merely abortive, for, beginning with the third reign of al-Nāṣir Muḥammad, who had not been a *mamlūk* and whose claim to legitimacy as sultan depended upon his filial relation to Qalā'ūn, no former *mamlūk* became sultan until al-Ẓāhir Barqūq seized the throne in 784/1382. The principle of dynastic succession prevailed during that period, and there was thus no occasion for the use of amirial emblems on coins.

From the end of the Ayyubid period, then, having been a *khāṣṣ* of the sultan was a source of personal pride, but, as time passed, the peculiar pressures inherent in the Mamluk system tended to enhance the prestige of such an association. It was explicit in the boast of Qawṣūn, who had served al-Nāṣir Muḥammad as *sāqī*:

> I was bought by the Sulṭān, and I was among his *khawāṣṣ,* and he made me an amīr and advanced me and married me to his daughter. And, as for the others, they were transferred from the merchants to the barracks to the stables. . . . [138]

The attributes of service in the *khāṣṣakīyah* thus became treasured emblems for public advertisement of one's exalted status. The importance of such reminders is clear from the incident, already mentioned, in which Qarāsunqur had polo sticks carved on his mausoleum in distant Iran nearly twenty years after having fled the Mamluk domains.

It was during the long third reign of al-Nāṣir that the *khāṣṣakīyah* seems finally to have become the recognized organ of upward social mobility that Ayalon has described. At the same time the associated system of amirial emblems appears to have become more precisely codified, though it did not remain static.[139] The origins of the system have been emphasized here, but it did continue to evolve to fit changing circumstances and requirements until the end of the Mamluk period in 922/1517. The subsequent phases of that evolution must, however, be left for further study.

For the present, it can be concluded that the system of amirial emblems was a product of both deeply rooted traditions and changing requirements within the Islamic world. It apparently owed nothing to Europe; indeed, it is difficult to imagine in what way it would have differed had European heraldry never developed at all. It thus seems wise to abandon the vocabulary of European heraldry in discussing Mamluk emblems, for it carries with it connotations and generates unconscious expectations that tend to distort understanding of the subject.

Chart I

Office		*Emblem* ★
ʿalām-dār	standard-bearer	
amīr akhūr	stable master, marshal	horseshoe
bashmaqdār	shoe bearer	
bāzdār	falconer	falcon
bunduqdār	bowman	bow
chatr-dār	parasol carrier	
dawādār	secretary, scribe	inkwell, penbox
jamdār, jamadār	wardrobe master	lozenge
jandār	sword bearer, executioner	
jāshnikīr	taster	table
jāwīsh	mace bearer, guard	golden dome or parasol
jūkandār	polo master	polo sticks
jumaqdār, ṭabardār	ax bearer	
rukubdār, dār rikāb	stirrup holder, footman	
sāqī	cupbearer	goblet
silāḥdār, silaḥdār	arms bearer	sword, bow
ṭashtdār	bearer of the washbasin	copper basin

★As established by texts or unequivocal association with inscriptions.

Chart II

Baḥrīyah

1. Aybak	4. Baybars I	7. Qalā'ūn
648–655	658–676	678–689
1250–57	1260–77	1280–90
K	†	†

2. ʿAlī.........3. Qutuz 5. Muḥammad 6. Salāmish
655–657 657–658 Barakah Khān 678
1257–59 1259–60 676–678 1280
D K 1277–80 D
 D

8. Khalīl 9. Muḥammad
689–693 693–694
1290–94 1294–95
K D

10. Kitbughā 11. Lājīn
694–696 696–698
1295–97 1297–99
D K

12. —
698–708
1299–1309
A

13. Baybars II
708–709
1309
K

14. —
709–741
1309–40
†

A = Abdicated D = Deposed K = Killed † = Died
solid lines = Filial relationships broken lines = Mamlūk relationship dotted lines = Atābik relationship

NOTES

1. Among his more important contributions on this theme are "Notes on the Lusterware of Spain," *Ars Orientalis*, I, 1954, 133–56; "The Emperor's Choice," *De Artibus Opuscula XL: Essays in Honor of Erwin Panofsky*, ed. M. Meiss, I, New York, 1961, 98–120; "Hilāl" (in Islamic Art), *EI²*, s.v.; "The Throne and Banquet Hall of Khirbat al-Mafjar," *From Byzantium to Sasanian Iran and the Islamic World*, Leiden, 1972, 12–65.

2. See especially D. Ayalon, *L'esclavage du mamelouk*, Jerusalem, 1951 (hereafter, Ayalon, *L'esclavage*); Ayalon, "Studies on the Structure of the Mamluk Army—I–III," *BSOAS*, XV, 1953, 203–28, 448–76, XVI, 1954, 57–90 (hereafter, Ayalon, "Studies"); S. Humphreys, "The Emergence of the Mamluk Army," *Studia Islamica*, XLVI, 1977, 67–99, 147–82 (hereafter, Humphreys, "Emergence").

3. Ayalon, "Studies—I," 204–6; Ayalon, *L'esclavage*, 26.

4. The size of the *khāṣṣakīyah* seems to have varied with time. In the reign of al-Sulṭān al-Nāṣir Muḥammad (693–741/1294–1340, with interruptions), it had forty members; al-Ẓāhirī, *Kitāb Zubdah Kashf al-Mamālīk*, ed. P. Ravaisse, Paris, 1894, 115–16. The author of the *Dīwān al-Inshā'* reported that it had "formerly" consisted of only twenty-four members; M. Quatremère, trans., *Histoire des sultans mamlouks de l'Égypte écrite en arabe par Taki-eddin-Ahmed-Makrizi*, 2 vols., Paris, 1837–42, Ib, 159, continuation of n. 3 (hereafter, Quatremère). In the earlier Mamluk period it was probably much smaller.

5. That there was also a sexual element in such bonds is generally recognized. Although little has been written on this point in relation to the Mamluk empire, C. E. Bosworth has discussed it in relation to earlier periods in *The Ghaznavids*, 2d ed., Beirut, 1973, 103 (hereafter, Bosworth, *Ghaznavids*); "Ghulām," *EI²*, s.v.

6. Ayalon, *L'esclavage*, 22–24; Ayalon, "Studies—I," 213–16. For a list of such posts, see Chart I.

7. Indeed, it is clear from al-Qalqashandī's account that the departments of the sultan's household were managed by responsible adult administrators, with staffs of *ghulām*s, or household slaves, to do the actual work; al-Qalqashandī, *Ṣubḥ al-Aʿshā fī Ṣināʿat al-Inshā'* (15 vols., Cairo, 1963–72), IV, 9–13 (hereafter, al-Qalqashandī).

8. For a discussion of this point, see Ayalon, "Studies—I," 214, n. 6.

9. *Mamlūk*s were used in Islamic armies even under the Umayyads; Ayalon, "Aspects of the Mamlūk Phenomenon," *Der Islam*, LIII, 1976, 205.

10. See, for example, D. Sourdel, "Questions de cérémonial ʿabbaside," *Revue des Études Islamiques*, XXVIII, 1960, 121–48; M. Canard, "Le cérémonial fatimite et le cérémonial byzantin: Essai de comparaison," *Byzantion*, XXI, 1951, 355–420.

11. Niẓām al-Mulk, *Siyar al-Mulūk* (*Siyāsatnāma*), ed. H. Darke, Tehran, 1962, 133–34; Darke, trans., *The Book of Government or Rules for Kings*, London, 1960, 105–7. Niẓām al-Mulk also prescribed that the intimates of the prince should be men of high social standing and accomplishment, whereas military prowess seems to have been a lesser requirement; Niẓām al-Mulk, 113–15, 151–55; see also Darke, 92–94, 121–24. These strictures would naturally exclude youthful slaves.

12. Bosworth, *Ghaznavids*, 102.

13. Ibid., 102–6, 138.

14. The material in this and the next paragraph was reported in Abū al-Fidā', *Kitāb al-Mukhtaṣar fī Akhbār al-Bashar*, VI, Beirut, 1976, 49 (hereafter, Abū al-Fidā'). See also "Khʷārazm-Shāh," *EI²*, s.v.

15. See "Dawādār," *EI²*, s.v.

16. L. A. Mayer, *Saracenic Heraldry: A Survey*, Oxford, 1933, 4 (hereafter, Mayer, *Heraldry*), translated *masīnah* as "ewer." According to F. Steingass, *A Comprehensive Persian-English Dictionary*, London, 1977, however, *masīn* and *masīnah* in Persian mean simply "made of copper"; R. Dozy, in *Supplément aux dictionnaires arabes*, II, Leiden, 1881, 593, gave the Arabic meaning of *masīnah* as "copper basin." The correctness of the latter definition is underscored by al-Qalqashandī's detailed discussion of the derivation and correct spelling of the word *ṭasht*; al-Qalqashandī, IV, 10. In Mamluk Cairo it referred to a basin for washing hands and for washing clothes. The emblem of Muḥammad's *ṭashtdār* was thus probably in a form similar to that of a copper basin.

17. Both the edition of Abū al-Fidā' cited here and I. I. Reiske, ed. and trans., *Abulfedae Annales Moslemici Arabice et Latine*, IV, Copenhagen, 1792, 380, give this word as *nafjah*, but that is clearly incorrect. The Arabic equivalent of *buqjah* is *mandīl*, referring to a large square of cloth with manifold uses, including as a wrapping for clothing. As such, it was an appropriate choice for the emblem of the *jamdār*. See F. Rosenthal, "A Note on the Mandīl," *Four Essays on Art and Literature in Islam*, Leiden, 1971, 69–99.

18. The term used is *qubbah dhahab*. Perhaps it would be better to translate *qubbah* in this context as "parasol"; see discussion by Quatremère, Ia, 134–35, n., no. 5.

19. Abū al-Fidā', VI, 49, reports that they attained *mulūkīyah*, a word that normally means "kingship" or "sovereignty" in Arabic. In twelfth-century Persia, however, *malik* had become a standard title for an amir; Humphreys, personal communication. See also A. K. S. Lambton, "The Administration of Sanjar's Empire as Illustrated in the ʿAtabat al-Kataba," *BSOAS*, XX, 1957, 372. Abū al-Fidā' seems to have been familiar with this Persian usage.

20. That use of such banners with emblems was also established at other courts by the end of the twelfth

century is suggested by a miniature from *Carme,* written and illustrated by Pietro da Eboli in A.D. 1196 and now in the Municipal Library at Berne; G. B. Siragusa, *Liber honorem Augusti di Pietro da Eboli secondo il Codice 120 della Biblioteca Civica di Berna,* II, Rome, 1905, pl. xxv. The miniature, which appears on folio 119, shows the Holy Roman Empress Constance being carried off in a boat to captivity at Messina; planted in the boat are two banners, one of which carries a lozenge, possibly a *buqjah.* As the Empress' abductor, Tancred of Lecce, had fought in the eastern Mediterranean briefly, it is possible that he followed Eastern practice and employed *mamlūks* in his army. This notion receives some confirmation from the presence of a turbaned figure in the boat. The author is grateful to Dr. Helmut Nickel for having called this miniature to her attention.

21. For a detailed study of this manuscript (A.F. 10), see K. Holter, "Die Galen-Handschrift und die Makamen des Ḥarīrī der Wiener Nationalbibliothek," *Jahrbuch der Kunsthistorischen Sammlungen in Wien,* N.F. XI, 1937, 1–15.

22. The *mamlūk* at the upper left, however, also wears no head covering.

23. Two of the volumes are dated 614/1217 and 616/1219, respectively. D. S. Rice, "The Aghānī Miniatures and Religious Painting in Islam," *The Burlington Magazine,* xcv, 1953, 132–33 (hereafter, Rice, "Aghānī"), accepted the attribution to Badr al-Dīn on the basis of the scribe's *nisbah* (al-Badrī) and the inscriptions on the sleeve bands of the princely figures in two Istanbul frontispieces, which, unlike the three in Cairo, have not been overpainted or tampered with; S. Stern, in "A New Volume of the Illustrated Aghānī Manuscript," *Ars Orientalis,* II, 1957, 501–3, concurred. The sleeve bands in the Istanbul and Copenhagen frontispieces are inscribed "Badr al-Dīn Lu'lu' ibn ʿAbd Allāh" (sometimes incomplete), the correct form of his name in the period before 631/1234, when he assumed sovereignty in his own right. As the *naskhī* script is identical on all three miniatures, it must predate 1861, by which time the Copenhagen volume was already in the Royal Library there.

The details of Badr al-Dīn Lu'lu''s career first became generally known with the publication by M. van Berchem of "Monuments et inscriptions de l'atabek Lu'lu' de Mossoul," *Orientalische Studien Theodor Nöldeke,* ed. C. Bezold, I, Gieszen, 1906, 197–210. It therefore seems unlikely that the inscriptions are modern additions. Farès claimed, however, on the basis of the calligraphy that the inscriptions had all been added in the later thirteenth or fourteenth century; "L'art sacré chez un primitif musulman," *Bulletin de l'Institut d'Égypte,* XXXVI, 1953–54, 646–54 (hereafter, Farès, "L'art sacré"). Nevertheless, the calligraphy is quite similar to that of the text itself; see, for example, Stern, pl. I, and Farès, "Une miniature religieuse de l'école arabe de Bagdad: Son climat, sa structure et ses motifs, sa relation avec l'iconographie chrétienne de l'Orient," *Mémoires de l'Institut d'Égypte,* LI, 1948, pls. I–III.

24. Farès, "L'art sacré," pl. VI.

25. The initial publication, giving the circumstances of the niche's discovery, was G. Reitlinger, "Medieval Antiquities West of Mosul," *Iraq,* v, 1938, 151–53; Reitlinger mentioned Creswell's idea that the niche is a throne niche, though he himself rejected it. A more detailed version of the argument in the following two paragraphs was presented by E. Whelan, "The Sinjār 'Miḥrāb': A New Interpretation," paper delivered at the Third Conference of Islamic Art Historians of North America, Ann Arbor, 9 November 1978; see also Whelan, "The Public Figure: Political Iconography in Medieval Mesopotamia," Ph.D. diss., Institute of Fine Arts, New York University, 1979, 902–13 (hereafter, Whelan, "Public Figure"), where the niche and the bridge at Ḥiṣn Kayfā are discussed together. In its present state the Sinjār niche is somewhat altered from its original appearance.

26. The baton may have been an attribute carried by the *jāwīsh* in Mesopotamia. That it had princely connotations is suggested by another frontispiece from the *Kitāb al-Aghānī,* this one in Istanbul (Millet Kütüphanesi, Feyzullah Effendi 1565). In this miniature, the mounted prince holds a baton in his right hand, suggesting that it may have been carried in processions; see Rice, "Aghānī," figs. 15, 19.

27. There are two slightly less ornate baldachins carved in relief at the sides of the monument; in its original form they served to delimit the composition.

28. See especially a *miḥrāb* (badly reconstructed) found in the Nūrī mosque and doorway A to the shrine of ʿAwn al-Dīn; F. Sarre and E. Herzfeld, *Archäologische Reise im Euphrat- und Tigris-Gebiet,* III, Berlin, 1911, pls. V left and VIII right, respectively. In each, the opening is framed by keyhole-shaped arches linked by simple loops in an arrangement similar to that on the Sinjār niche; the Mosul arches are, however, more elongated, the small baldachins with *muqarnas* more elaborate and more conventionalized, and the symmetrical arabesques more rigid and less three-dimensional. These two very similar monuments are undated, but another inscription in the shrine of ʿAwn al-Dīn dates Badr al-Dīn's restorations there to 646/1248–49; Sarre and Herzfeld, I, Berlin, 1912, 22.

29. This monument was long considered to be datable to 510/1116–17, on the basis of a marginal note by one of the commentators on Ibn Ḥawqal, *Kitāb al-Masālik wa al-Mamālik,* Leiden, 1873, 152, continuation of n. *b;* see A. Gabriel, *Voyages archéologiques dans la Turquie orientale,* I, Paris, 1940, 77–78. The contemporary Artuqid chronicler Ibn al-Azraq, however, reports that Qarā Arslān built this bridge after Timurtāsh of Mardin had built his own bridge east of Mayyāfarqīn in 541–542/1146–47; see British Library Or. 5803, fol. 180r.

30. A clear photograph of this relief has been published by F. Ilter, "Anadolu'nun Erken Devir Türk Köprüleri ile Iran Köprü Mimarliği Ilişkileri," *Atatürk*

Universitesi Edebiyat Fakültesi Araştırma Dergisi, special number, 1978, fig. 14.

31. This question has been discussed at length in Whelan, "Public Figure," Appendix II, passim.

32. For a detailed study and illustrations of this object, see Rice, "Inlaid Brasses from the Workshop of Aḥmad al-Dhakī al-Mawṣilī," *Ars Orientalis,* II, 1957, 287–301 (hereafter, Rice, "Brasses").

33. This ewer is 91.1.586 in the collection of The Metropolitan Museum of Art, New York. The author is grateful to Carolyn Kane and George Berard of the Islamic Department for permitting study and reproduction of the ewer.

34. Rice, "Brasses," 311–16 and pl. 3; see also G. Fehérvári, *Islamic Metalwork of the Eighth to the Fifteenth Century in the Keir Collection,* London, 1976, 105, no. 131, and color pl. I.

35. The candlestick is no. 4414 in the collection; for photographs of the whole, see L. T. Schneider, "The Freer Canteen," *Ars Orientalis,* IX, 1973, pl. 8, fig. 23; U. Scerrato, *Metalli islamici,* Milan, 1966, 101.

36. For discussion of the re-inlaying on these two pieces, see Rice, "Brasses," 312–13.

37. For other views of ʿAlī ibn Ḥamūd's basin, see G. Wiet, "Un nouvel artiste de Mossoul," *Syria,* XII, 1931, pl. XXVIII; G. D. Guest and R. Ettinghausen, "The Iconography of a Kāshān Luster Plate," *Ars Orientalis,* IV, 1961, pl. 7, fig. 23.

38. The zone to the right of that in which the prince is enthroned has, unfortunately, not been published; very likely it contains a greater concentration of *khawāṣṣ* than do the other zones.

39. E. Atıl, *Renaissance of Islam: Art of the Mamluks,* Washington, D.C., 1981, 74, no. 20 (hereafter, Atıl).

40. For somewhat different assignments for these figures, see *Arts de l'Islam des origines à 1700 dans les collections publiques françaises,* Paris, 1971, 109, no. 163.

41. Rice, "Brasses," 316, 320–25.

42. Ibid., 301–11, pl. 6d.

43. Some Mosul metalworkers are known to have worked in Egypt after 668/1270; Rice, "Brasses," 326.

44. It has been demonstrated elsewhere that, in their various provinces, the Ayyubids tended to emulate regional traditions in coinage, architectural reliefs, and paleography; this tendency was particularly marked in northern Mesopotamia. See Whelan, "Public Figure," 690–748, 973–1003.

45. For a parallel, though somewhat earlier, instance of the same phenomenon, see R. Ettinghausen, "The Bobrinsky 'Kettle': Patron and Style of an Islamic Bronze," *Gazette des Beaux-Arts,* XXIV, 1943, 193–208.

46. The discussion in this paragraph is based on Ayalon, "Le régiment Bahriyah dans l'armée mamelouke," *Revue des Études Islamiques,* 1951, 133–41 (here-

after, Ayalon, "Régiment"); Humphreys, *From Saladin to the Mongols,* Albany, 1977, chaps. II, VIII (hereafter, Humphreys, *Saladin*); Humphreys, "Emergence," 94–97.

47. Ayalon, "Régiment," 134, has estimated the Baḥrīyah at 800 to 1,000 men; Humphreys, "Emergence," 97, set the Jamdārīyah at 200. Although Humphreys only hinted at the possibility, there seems to be some evidence that the Jamdārīyah was a corps within the Baḥrīyah. For example, Fāris al-Dīn Aqṭāy al-Jamdār (d. 651/1254) was commander of both; see references in G. Wiet, "Les biographies du Manhal Safi," *Mémoires de l'Institut d'Égypte,* XIX, 1932, no. 499 (hereafter, Wiet, "Biographies"). According to al-Maqrīzī, *al-Mawāʿiz wa-al-Iʿtibār fī Dhikr al-Khiṭaṭ wa-al-Āthār,* II, Būlāq, 1853, 299–300 (hereafter, al-Maqrīzī, *Khiṭaṭ*), Baybars al-Bunduqdārī began in al-Ṣāliḥ's service as a unit commander in the Jamdārīyah, but all other reports on his career make it clear that he was also a member of the Baḥrīyah; see bibliographies given in Mayer, *Heraldry,* 106, n. 3, and Wiet, "Biographies," no. 708. Finally, Baybars al-Jāliq had been a member of the Jamdārīyah but was also the last of the Baḥrīyah to die; see al-Mufaḍḍal, "Histoire des sultans mamlouks," ed. and trans. E. Blochet, *Patrologia Orientalis,* XX, 1929, 139 (hereafter, al-Mufaḍḍal); Wiet, "Biographies," no. 710; Mayer, *Heraldry,* 110, n. 1.

48. Ibn Taghrībirdī, *al-Nujūm al-Ẓāhirah fī Mulūk Miṣr wa-al-Qāhirah,* VII, reprint ed., Cairo, 1964, 4 (hereafter, Ibn Taghrībirdī, *Nujūm*).

49. The precise number is difficult to determine because of vague identifications and variant readings. Particularly fruitful are al-Maqrīzī, *Khiṭaṭ,* al-Maqrīzī, *Kitāb al-Sulūk li-Maʿrifah Duwal al-Mulūk,* 12 vols., Cairo, 1934–73 (hereafter, al-Maqrīzī, *Sulūk*); Ibn Iyās, *Taʾrīkh Miṣr,* Būlāq, 1894 (hereafter, Ibn Iyās). Unfortunately, however, major sources like Ibn Taghrībirdī's *Manhal al-Ṣāfī* are not yet completely available in published editions; summary references in secondary sources have therefore been relied on when necessary.

50. Frequently and erroneously called "al-Bunduqdārī," especially by al-Maqrīzī.

51. See references in Mayer, *Heraldry,* 83–84, as well as al-Maqrīzī, *Khiṭaṭ,* II, 208, 300, 374, 420–21; al-Mufaḍḍal, XII, 419–21; Ibn Iyās, I, 98.

52. In 660/1262 Sulṭān Baybars I sent him with 300 men to the aid of the Saljuqids of Rūm, who were fighting the Mongols; he also awarded him Āmid and its dependencies as fief. See Quatremère, Ia, 176; al-Maqrīzī, *Sulūk,* Ia, 470 and n. 7, gives the name alternatively as Aʿlamush or Aʿlamus.

53. Al-Maqrīzī, *Sulūk,* Ia, 533; Quatremère, Ib, 14; Wiet, "Biographies," no. 494, and references given there.

54. See note 14 above; "Djamdār," *EI²,* s.v.

55. Al-Mufaḍḍal, XX, 139. For full bibliography on

his life, see references given in Wiet, "Biographies," no. 710, and Mayer, *Heraldry*, 110, n. 1.

56. As with many of the individuals discussed here, there is some confusion in the chronicles over the details of this Baybars' life. Van Berchem, *CIA*, part 2, *Syrie du Sud*, I. *Jérusalem "Ville,"* Cairo, 1922, 224 (hereafter, *CIA, Syrie du Sud*), says that he was made an amir by Sulṭān Baybars I. All the sources that van Berchem cited on this point have been checked, with the exception of the inaccessible manuscripts of *al-Manhal al-Ṣāfī*, but none supports the statement. Furthermore, as al-Jāliq died in 707/1307 at about the age of 80 years (al-Maqrīzī, *Sulūk*, IIa, 40–41; Quatremère, IIb, 281; Ibn Taghrībirdī, *Nujūm*, VIII, 227–28; al-Mufaḍḍal, XX, 139–40, where it is reported that he was 120 years old, clearly an error), he must have been born about 627; he would thus have been about 21 years old when al-Ṣāliḥ died in 648 and a decade older when Baybars I took the throne in 658. It is unlikely that he would have had to wait until he was in his thirties to be promoted. This conclusion is supported by the statement in al-Mufaḍḍal that he was already an amir during the lifetime of al-Ṣāliḥ.

57. *CIA, Syrie du Sud*, I, pl. LV; the drawing in P. Balog, "New Considerations on Mamlūk Heraldry," *The American Numismatic Society Museum Notes*, XXII, 1977, 205, no. 84 (hereafter, Balog, "New Considerations"), showing twelve branches is incorrect. Mayer did not include these motifs in his discussion of the *fleur-de-lis* as emblem. Mayer, *Heraldry*, 22–24, 110.

58. No. 15088. Mayer, *Heraldry*, 84–85, pl. XXX, no. 1.

59. Humphreys, *Saladin*, 305–6, 341.

60. Mayer, *Heraldry*, 84, nn. 2–3, has linked him with Aydamur al-Ẓāhirī (d. 700/1301), one of several men bearing the name ᶜIzz al-Dīn Aydamur in the early Mamluk period. It is likely that he made this association because of the lions, thought to be the emblem of al-Ẓāhir Baybars and, by extension, of some of his *mamlūk*s, but, as will be shown later, the motif was never exclusively connected with Baybars. If Aydamur was a Kurd, he is unlikely to have been a *mamlūk;* if, however, he was a Turk, as his name suggests, then his use of the nisbah "al-Qaymarī" is a mystery. Perhaps he had originally belonged to a Qaymarī amir.

61. Another problem is presented by an incense burner (or hand warmer) in the Museo Nazionale, Florence (Carrand 370), on which the *buqjah* is depicted below a heraldic bird with wings displayed; see Mayer, *Heraldry*, pl. XVII. It is inscribed to Sayf al-Dīn Bahādur al-Ḥamawī Ra's Nawbat al-Jamdārīyah al-Malikī al-Nāṣirī. Once again, Mayer, *Heraldry*, 95–96, encountered difficulties in identifying this amir, for, according to K. V. Zettersteen, *Beiträge zur Geschichte der Mamlükensultane in den Jahren 690–741 der Hiǧra nach arabischen Handschriften*, Leiden, 1919, 28, the most likely candidate had been killed in 693/1294, just before Sulṭān al-Nāṣir Muḥammad succeeded to the throne for the first time. M. Meinecke, "Zur mamlukischen Heraldik," *Mitteilungen des Deutschen Archäologischen Instituts, Abteilung Kairo*, XXVIII, 1972, 225, n. 90 (hereafter, Meinecke, "Heraldik"), has pointed out, however, that Bahādur al-Ḥamawī was still alive and serving as *ra's nawbah* in 694; see al-Dawādārī, *Kanz al-Durar wa-Jāmiᶜ al-Ghurar*, VIII, Cairo, 1971, 357. The emblem is strikingly similar to that of Ṭuquztamur al-Ḥamawī, except that, on the eleven surviving objects associated with the latter, the *buqjah* has been placed by the goblet of the *sāqī;* Mayer, *Heraldry*, 235–39. Ṭuquztamur, originally a *mamlūk* of Abū al-Fidā' at Hama, had been presented as a gift to Sulṭān al-Nāṣir; see references in Wiet, "Biographies," no. 1250, and Mayer, *Heraldry*, 235, no. 1. These two amirs, the only two who can be identified with emblems of service placed below heraldic birds, were both known by the nisbah "al-Ḥamawī." The enumerated correspondences suggest possible Hama connections for these unusual emblems, a question that calls for further investigation at a later time.

62. See H. M. El-Hawary, "Un tissu abbaside de Perse," *Bulletin de l'Institut d'Égypte*, XVI, 1954, 67, n. 1, and pl. III; and Wiet, *Catalogue général du Musée Arabe du Caire: Objets en cuivre*, Cairo, 1932, no. 4431, 121 and pl. LX (hereafter, Wiet, *Objets en cuivre*). Aybak's coins simply continued Ayyubid types; Balog, *The Coinage of the Mamlūk Sultans of Egypt and Syria*, New York, 1964, 75–77 (hereafter, Balog, *Coinage*).

63. This observation has already been made by Meinecke, 223.

64. After Aybak's death in 655/1257, his minor son ᶜAlī succeeded him, with Aybak's own former *mamlūk* Qutuz as regent; in the face of the Mongol threat, Qutuz usurped the throne after two years. He was murdered by Baybars al-Bunduqdārī and some Baḥrī associates very shortly after the victory of ᶜAyn Jālūt in 658/1260. Baybars then assumed the sultanate and reigned until 676/1277. Neither ᶜAlī nor Qutuz has left any material trace other than coins, which are without emblems; Balog, *Coinage*, 78–84. For Baybars' career, see references in Wiet, "Biographies," no. 708; Mayer, *Heraldry*, 106–10; Meinecke, "Heraldik," 217–19. See also *RCEA*, nos. 4476–78, 4485, 4501, 4552, 4554, 4556–57, 4562–65, 4586, 4588–89, 4593, 4600, 4608, 4611–12, 4623–26, 4638, 4660–62, 4673, 4686, 4690, 4692, 4714, 4723–24, 4726, 4728, 4730, 4732–40, 4745–46, 4750–51.

65. According to al-Maqrīzī, *Khiṭaṭ*, II, 299–300, it was a section of the Jamdārīyah; according to other sources, it was a section of the Baḥrīyah. It is probable that there is no contradiction here; see note 47 above. It is also likely that Baybars was freed by al-Ṣāliḥ at the time of this appointment.

66. For the coins, see Balog, *Coinage*, 85–106. Baybars' son and successor, Muḥammad Barakah Khān (676–678/1277–80), who had, of course, not been a *mamlūk*, also struck coins with lions; another son, Salāmish, who succeeded Barakah Khān in the sultanate (678/1280), did not; Balog, *Coinage*, 107–11. In addition,

Dr. Helmut Nickel has called attention to a suggestive but still unstudied late fourteenth-century Italian miniature painting from the so-called Cocharelli manuscript in the British Library (Add. 27695), purporting to depict the Mamluk siege of Ṭarāblus in 688/1289. The Mamluk troops are identifiable by the "lion of Baybars" repeated on saddle blankets and banners. This siege was, however, conducted by Qalā'ūn, with whom the lion has not generally been associated. Without a thorough study of this mysterious miniature painted a century after the event, little can be said about the sources of its imagery.

67. For a detailed study of this repertoire, see Whelan, "Public Figure," Appendix II.

68. This motif, its origins, and its sovereign connotations in Mesopotamia are discussed in Whelan, "Public Figure," 596–635.

69. A statement by Ibn Iyās, I, 110, confirms this view. He declared that the *rank* of Baybars was a lion (*sabᶜ*), signaling his audacity and the strength of his courage. This kind of association is precisely what sovereign imagery was designed to convey. Whereas the sovereign device thus represented a princely quality, the emblem marked a more concrete social status. It should also be noted, however, that the lion was never an exclusively sovereign image. Like the bicephalic bird, *khāṣṣakīyah* representations, and other motifs, it too had passed into the repertoire of decorative designs. See, for example, the basin of ᶜIzz al-Dīn Aydamur, on which the emblem of the amir alternates with lions (note 60 above), and the so-called Baptistère de Saint-Louis, on the exterior of which French *fleurs-de-lis* have been inlaid over four round medallions originally containing two lions and two abstract motifs that may have been intended as emblems; Rice, *Le baptistère de Saint Louis*, Paris, 1951, 27 (hereafter, Rice, *Baptistère*). Also there are a number of surviving ceramic sherds and a few glass vessels with such lions, not attributable through inscriptions to any sultan; see, for example, Mayer, *Heraldry*, pl. I, nos. 1–3, 5–7; and Atıl, 128, no. 46. Contrary to Meinecke, "Heraldik," 224, there seems no justification for assuming that any of these objects belonged to amirs of Baybars I.

70. Qalā'ūn had been the regent for Salāmish and then, under still another threat of Mongol invasion, had usurped the throne for himself on grounds that a boy could not adequately defend the realm. For Qalā'ūn's life, see references given in Wiet, "Biographies," no. 1878.

71. This amir is called ᶜAlā' al-Dīn Qarāsunqur al-Sāqī al-ᶜĀdilī in Abū al-Fidā', VI, 80, where it is reported that he died in 645/1247–48. According to al-Maqrīzī, *Sulūk*, IC, 1939, 663, his name was ᶜAlā' al-Dīn Āqsunqur al-Sāqī al-ᶜĀdilī, and his *mamlūks* did not pass into the control of al-Ṣāliḥ until 647/1249–50. See also Wiet, "Biographies," no. 1878, where Qalā'ūn is given the *nisbah* "al-Āqsunqurī."

72. They may have spent the intervening period in the service of al-Malik al-Kāmil II at Mayyāfarqīn (642–658/1244–60), for in the summary of Qalā'ūn's career in Wiet, "Biographies," he is referred to as al-Āqsunqurī al-Kāmilī al-Najmī al-Ṣāliḥī al-Turkī al-Alfī.

73. Al-Maqrīzī, *Sulūk*, IC, 663; Quatremère, IIa, 2; *RCEA*, nos. 4787–88, 4796, 4809–10, 4820, 4844–50, 4852–53, 4855, 4587–58, 4876–77, 4884, 4886, 4895, 4918, 4925, 4927, 4931, 4946. Only five inscriptions from Qalā'ūn's own lifetime, none of them in Cairo, omit the *nisbah* "al-Ṣāliḥī": *RCEA*, nos. 4815, 4823–24 (all in Baalbek), 4859 (in Aleppo), and 4879 (in Jerusalem). Qalā'ūn's son al-Malik al-Nāṣir Muḥammad continued to include this *nisbah* in his own inscriptions referring to his father; for examples from the early years of his sultanate, see *RCEA*, nos. 5059, 5100, 5135, 5146–47, 5160–61, 5234, 5264, 5269.

74. Mayer, *Heraldry*, 112, did consider it so, and his opinion has been repeated by Meinecke, "Heraldik," 219–20. For the contrary view, see Rice, "Two Unusual Mamlūk Metal Works," *BSOAS*, XX, 1957, 498, n. 2 (hereafter, Rice, "Two Unusual Mamluk Metal Works"); Atıl, 59. For details on Baysarī's career, see references in Mayer, *Heraldry*, 112, n. 1; Wiet, "Biographies," no. 732. The bicephalic bird has already been touched on here. It had a long history in the Near East. At the end of antiquity and in the early Islamic period, it served primarily as a decorative motif for textiles and jewelry. After a brief *floruit* as a sovereign image in northern Mesopotamia at the end of the twelfth and the beginning of the thirteenth centuries, it became part of a more general repertoire. It was particularly popular in Syria and Anatolia. See note 68 above.

75. No. 15096; Mayer, *Heraldry*, 171 and pl. XXXIV, no. 2.

76. Eight-petaled rosettes of clearly decorative import are inlaid in silver on several metal objects from the late Ayyubid and early Mamluk periods, for example, an incense burner of al-Malik al-ᶜĀdil II (Fehérvári, "Ein ayyubidisches Räuchergefäss mit dem Namen des Sultan al-Malik al-ᶜĀdil II," *Kunst des Orients*, V, 1968, 37–54); a basin made for the same ruler by Aḥmad al-Dhakī (Rice, "Brasses," pl. 6d); the Gulistan basin made by ᶜAlī ibn Ḥamūd (note 37 above); and an undated ewer in the Pinacoteca, Naples (112112; Rice, "Two Unusual Mamlūk Metal Works," 497–98 and pl. XIV).

77. Mayer, *Heraldry*, 24, considered the six-petaled rosette characteristic of the Ayyubids and Mamluks, though it seems to have been less common than the eight-petaled variety. Both types occur in the decoration at Qalᶜat al-Muḍīq in Syria (604/1207–08) and at the mausoleum of al-Malik al-Ṣāliḥ in Cairo, built by his widow in 648/1250. See van Berchem and E. Fatio, *Voyage en Syrie*, Cairo, 1913, 189–90 and pl. 27, no. 2; Balog, "Considerations," 199–200; *MAE*, II, pl. 39a, c. For an example of six-petaled rosettes on a later thirteenth-century inlaid incense burner in the Museum of Islamic Art, Cairo (15107), see Atıl, 60, no. 12.

78. Wiet, "Biographies," no. 506; Mayer, *Heraldry*, 73.

79. Shibl al-Dawlah Kāfūr al-Rūmī al-Khāzindār al-

Malikī al-Ṣāliḥī has also left a glass mosque lamp, now in the Victoria and Albert Museum, London (6820–1860), on which a framed six-petaled rosette occurs six times; Mayer, *Heraldry*, 135–36. Mayer had difficulty associating this Kāfūr with any of those listed in *al-Manhal al-Ṣafī* but finally settled on Kāfūr al-Ṣafawī, a *mamlūk* of al-Ṣāliḥ Ayyūb. Meinecke, "Heraldik," 230, n. 126, however, has presented textual and other evidence for identifying Kāfūr al-Rūmī as an amir of the fifteenth century. The rosettes on the lamp are thus not of concern here.

80. Meinecke, "Heraldik," 227; *MAE*, II, 180.

81. Mayer, *Heraldry*, 8; Meinecke, "Heraldik," pl. LIVg.

82. He reasoned partly from what he considered the "early Mamluk" style of the stucco decorations. He seems to have agreed with Creswell that they are contemporary with those of Baybars I. Because the inscriptions in this part of the building are supposedly not enclosed in round-ended panels, Creswell dated it earlier than the *khānqāh* of Aydakīn al-Bunduqdār (d. 683/1285), where such panels do occur; *MAE*, II, 180. The rounded ends of such panels are, however, clearly visible in *MAE*, II, pl. 56b, and in Meinecke, "Heraldik," pl. LIVg. Furthermore, a comparison of the stuccos from Baybars I's mosque (665–667/1266–69) with those of Azdamur (*MAE*, II, pls. 52c, 53a–d and pls. 56a–b, respectively) reveals no close stylistic parallels. Indeed, the latter show decided affinities with some of the stucco decorations at the fourteenth-century Alhambra in Granada; see the Mirador de la Daraxa and the Salón de Comáres, E. García Gómez and J. Bermúdez Pareja, *The Alhambra: The Royal Palace,* Granada, 1966, pls. 18, 12.

83. Mayer, *Heraldry,* 241; Meinecke, "Heraldik," 227, n. 107.

84. J. Sauvaget, "Cinq blasons màmelouks inédits," *Journal Asiatique,* CCXXVII, 1935, 301–2; *RCEA,* no. 5964. Ṭūghān cannot have been a *mamlūk* of al-Ṣāliḥ Ayyūb.

85. Mayer, *Heraldry,* 18–19.

86. Ibid., 8.

87. Ibid., 124.

88. Ibid., 53–54.

89. See, for examples, entries in Mayer, *Heraldry,* for ᶜAlī ibn Hilāl al-Dawlah, Khalīl, Muḥammad ibn Aḥmad, Salmā wife of ᶜAlī, and Sunqur al-Saᶜdī; undated examples include ᶜAbd al-Qādir, Ibrāhīm ibn ᶜAqīl, Muḥammad al-ᶜAlawī, Ṣalāḥ al-Dīn ibn Samrī, and Shihāb al-Dīn ibn Farajī.

90. The Aydakīn al-Ṣāliḥī al-Bashmaqdār mentioned in al-Maqrīzī, *Sulūk,* 1b, 1936, 402, is surely an error for Aydakīn al-Bunduqdār.

91. See note 4 above.

92. According to P. M. Holt, "The Sultanate of al-Manṣūr Lāchīn (696–8/1296–9)," *BSOAS,* XXXVI, 1973, 522 (hereafter, Holt), only Baybars I, Qalāʾūn, and al-Nāṣir Muḥammad reigned long enough to leave behind them significant groups of great amirs who had been their *mamlūks*.

93. Wiet, "Biographies," no. 703; Mayer, *Heraldry,* 97.

94. Wiet, *Objects en cuivre,* 129–30 and pl. XXVIII, no. 7229; Meinecke, "Heraldik," 245–46, n. 218. See also Wiet, "Biographies," no. 701.

95. The tripartite disk with emblem on the center field occurs on the mausoleum of Aybak al-Mawṣilī al-Manṣūrī at Ṭarāblus, built in 698/1298; the emblem in this instance is a *khānjā*. See note 105 below.

96. 18038. For discussion and illustrations, see M. Mostafa, "Neuerwerbungen des Museums für Islamische Kunst in Kairo," *Aus der Welt der islamischen Kunst: Festschrift für Ernst Kühnel zum 75. Geburtstag am 26.10.1957,* Berlin, 1959, 91–92, figs. 3–7.

97. Some of the elements that cause doubt are the shape, peculiar in so large an object; the density and relative freedom from bubbles of the thick, almost opaque green glass; the very unusual colors; oddities in the drawing of the lion, including the specific angle of its rampant position; and, above all, the clumsy *naskhī* script, with such anomalous features as bent ascenders and uneven variations in thickness of single strokes. As a matter of interest, it should be noted that a loop of string and fragments of straw are embedded in the interior wall of the glass body.

98. The object is in the Musée Jacquemart-André, Paris, but apparently no photograph has been published; Mayer, *Heraldry,* 190–91.

99. Mayer, *Heraldry,* 19; Meinecke, "Heraldik," 226, n. 96. It is possible that a few later instances of the pointed shield framed in a circle did have some still unexplained emblematic status; see Mayer, *Heraldry,* 50–51; and Balog, "New Considerations," 192–93.

100. Wiet, "Biographies," no. 505; Mayer, *Heraldry,* 262. See also Quatremère, IIa, 15, n. 2.

101. Mayer, *Heraldry,* 79–80 and pls. xxxvi, no. 3, xxxvii.

102. Wiet, "Biographies," no. 1875; Mayer, *Heraldry,* 183–84 and pl. XXVII. In one instance at the *madrasah,* the polo sticks are framed in a pointed shield; all the other instances are in circular frames. The Aleppo examples include the polo balls.

103. A. Godard, "Notes complémentaires sur les tombeaux de Marāgha," *Āthār-é-Īrān,* I, 1936, 143–49.

104. Wiet, "Biographies," no. 2546; Mayer, *Heraldry,* 155–56 and pl. XXIX.

105. Wiet, "Biographies," no. 570; Mayer, *Heraldry,* 82–83. This emblem is the earliest extant instance in which the badge of office appears on a disk divided into three fields.

106. 54.459, Aṭīl, 64–67; the socket is in the Museum

of Islamic Art, Cairo (4463). The inscriptions make clear that the candlestick was made for Kitbughā while he was an amir in the service of Qalā'ūn's immediate successor, al-Malik al-Ashraf Khalīl (689–693/1290–94). For Kitbughā's life, see Wiet, "Biographies," no. 1892; Mayer, *Heraldry*, 143–44; and S. M. Elham, *Kitbuġā und Lāġīn: Studien zur Mamluken-Geschichte nach Baibars al-Manṣūrī und an-Nuwairī*, Freiburg, 1977 (hereafter, Elham).

107. This information from al-Dhahabī is reported in Mayer, *Heraldry*, 144.

108. Balog, *Coinage*, 128 and pl. VI, no. 161a–b. As the emblem occurs on an undated copper coin type from an unknown mint, it is difficult to assess its significance.

109. Balog, *Coinage*, 131 and pl. VII, no. 166.

110. Mayer, *Heraldry*, 17; Sauvaget, *La poste aux chevaux dans l'empire des mamelouks*, Paris, 1941, 46–49 (hereafter, Sauvaget, *La poste*).

111. Sauvaget, *La poste*, 18–20.

112. See note 4 above.

113. Al-Qalqashandī, I, 114, XIV, 317; see also Sauvaget, *La poste*, 46, n. 196.

114. Al-Qalqashandī, I, 114, XIV, 317.

115. Mayer, *Heraldry*, 52 and pl. XLIV, no. 3.

116. Sauvaget, *La poste*, 59–61, esp. nn. 252–53.

117. Ibn Taghrībirdī, *Nujūm'*, IX, 9.

118. Mayer, *Heraldry*, 196–97; Mayer, "Le blason de l'Amīr Salār," *The Journal of the Palestine Oriental Society*, V, 1925, 59. Rice's attribution of the famous "Baptistère" to this amir seems unconvincing, however, for, if there is an emblem on this object at all, it is surely the strange key-shaped device that occurs twice under the later French royal inlays on the exterior of the vessel; see Rice, *Baptistère*, 13–17, 27.

119. Al-Maqrīzī, *Sulūk*, IC, 822.

120. Ibid., IC, 664. For Lājīn's career, see Wiet, "Biographies," no. 1935; Mayer, *Heraldry*, 148–49; Holt; Elham.

121. See notes 55 and 56 above.

122. Sauvaget, "Caravansérails syriens du Moyen-Âge, I. Caravansérails mamelouks," *Ars Islamica*, VII, 1940, 1–3; *RCEA*, no. 4946.

123. Mayer, *Heraldry*, 98–99; *RCEA*, no. 5494. The plate, which has apparently not been published, was formerly in the Mailly collection, Paris; its present whereabouts are unknown to this author.

124. See Mayer, *Heraldry*, 123, 76–77, and 145–46, respectively. Mayer considered that there were two Arghūns with nearly identical inscriptions, probably because one lamp, formerly in the collection of G. Roth-schild, Paris, bears the tripartite shield (Mayer, *Heraldry*, pl. XLVI), another the *buqjah*. The latter lamp was said to have been in the Goupil collection in Paris and to have

been destroyed after it had been copied by Philippe-Joseph Brocard in the late nineteenth century. Brocard's copy is now in the Musée des Arts Décoratifs, Paris; a similar copy was formerly in the Morot collection in Paris. See H. Lavoix, "La collection Albert Goupil," *Gazette des Beaux-Arts*, 2e pér., XXXII, 1885, facing 286; and Wiet, "Les lampes d'Arghūn," *Syria*, XIV, 1933, 204. Three other lamps with *buqjahs* and inscriptions to Arghūn are known; at present it is not clear how many, if any, are genuine. See P. Ravaisse, *Une lampe sépulcrale en verre émaillé au nom d'Arghūn en-Nāṣirī*, Paris, 1931; Wiet, "Lampes"; Mayer, Review of Paul Ravaisse, *Une lampe sépulcrale . . .*, *The Journal of the Palestine Oriental Society*, XII, 1933, 115–17. Meinecke, "Heraldik," 238 and pl. LVd, has called attention to the existence of a plain triparitite disk on the portal of the *madrasah* of Sulṭān Ḥasan at Cairo. It is known, however, that the carving of the decoration at this portal was not finished, and it is difficult to share in Meinecke's certainty that the disk was not intended to receive an inscription.

125. Two disks framed by circles interrupt one line of an inscription of Baybars dated 706/1306, now in the Museum of Islamic Art, Cairo (4151); see Wiet, *Catalogue général du Musée de l'Art Islamique du Caire: Inscriptions historiques sur pierre*, Cairo, 1971, 64–65 and pl. XIX left. Wiet expressed doubts that they can be interpreted as emblems, but, as Meinecke, "Die Bedeutung der mamlukischen Heraldik für die Kunstgeschichte," *ZDMG*, Supplement II (1974), 223 (hereafter, Meinecke, "Bedeutung"), has pointed out, there are sufficient close analogies among other "heraldic" objects to render the identification convincing. For Baybars' life, see Wiet, "Biographies," no. 709; *RCEA*, nos. 5240, 5246–50.

126. Balog, *Coinage*, 135–36 and pl. VII. Meinecke, "Bedeutung," 223, has identified the concentric circles on the copper coin type no. 175 as another instance of the *khānjā*, but it seems more likely that they are merely frames for the inscriptions, especially as they are beaded.

127. M. Lanci, *Trattato delle simboliche rappresentanze arabiche e della varia generazione de' musulmani caratteri sopra differenti materie operati*, II, Paris, 1846, 50, III, Paris, 1845, pl. XXVIB–C.

128. See Herzfeld, "Damascus: Studies in Architecture—I," *Ars Islamica*, IX, 1942, 7, 11–14; *Les monuments ayyoubides de Damas*, I, Paris, 1938, 15–25.

129. See, for example, Ettinghausen, *Arab Painting*, Geneva, 1962, 143–56; Holter.

130. *MAE*, II, 100–103.

131. *MAE*, 91–92, 134, 146–47, 149, 157, 171–72. Interlaced spandrel designs were also introduced at Baybars's mosque; *MAE*, 156–57, 170–71, and pl. 50a.

132. Ibn al-Athīr, *al-Kāmil fī al-Ta'rīkh*, XI, Beirut, 1966, 138.

133. Al-Qalqashandī, IV, 5–9.

134. Ibid., 47–48.

135. For Baybars and Muḥammad Barakah Khān, see al-Maqrīzī, *Sulūk,* 1b, 573; for Qalā'ūn and, first, al-Malik al-Ṣālih, and, second, Khalīl, see al-Maqrīzī, *Sulūk,* 1c, 682 and 746, respectively.

136. Al-Ṣāliḥ was actually succeeded by his son, al-Malik al-Muʿaẓẓam Tūrān Shāh (647–648/1249–50), with Aybak as *atābik,* but the boy was soon killed and the throne usurped by al-Ṣāliḥ's widow and Aybak.

137. J. W. Allan, "Mamluk Sultanic Heraldry and the Numismatic Evidence: A Reinterpretation," *Journal of the Royal Asiatic Society,* 1970, 108; and Meinecke, "Bedeutung," 225, n. 53.

138. The boast is to be found in Ibn Ḥajar al-ʿAsqalānī, *al-Durar al-Kāminah,* III, Hyderabad, 1931–32, 257; see also Ayalon, *L'esclavage,* 22.

139. Because al-Nāṣir ruled for so long a time, several generations of *mamlūk*s must have passed through his *khāṣṣakīyah;* a large proportion of the "heraldic" buildings and objects recorded in Mayer, *Heraldry,* are associated with Nāṣirī amirs.

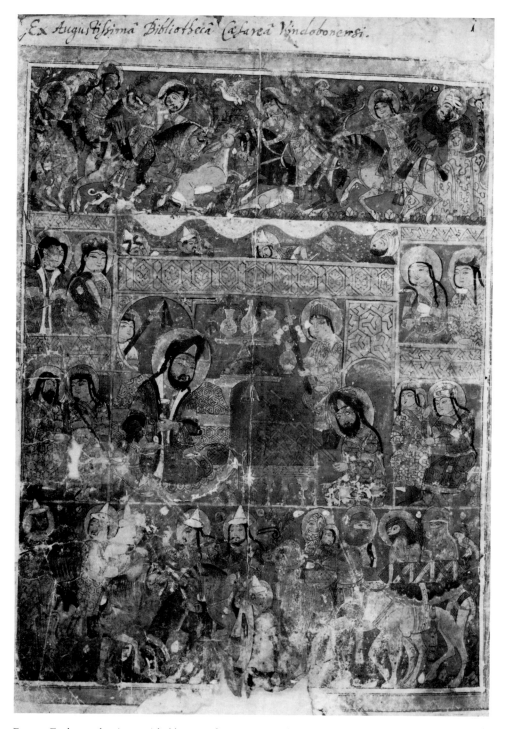

FIG. 1. Enthroned prince with *khawāṣṣ*, from a copy of *Kitāb al-Diryāq*, second quarter of the thirteenth century. Vienna, Courtesy Nationalbibliothek, Cod. A.F. 10, fol. 1

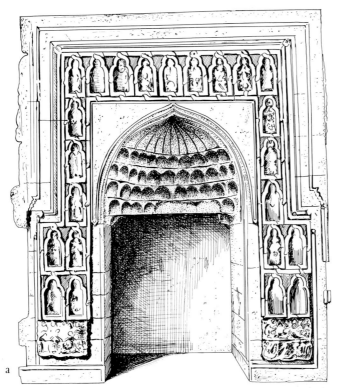

FIG. 2a, b. Stone niche, from Gu'
Kummet, Sinjār, c. 626/1229. (Figure
2a, Baghdad, Iraq Museum, drawing:
Thomas Amorosi)

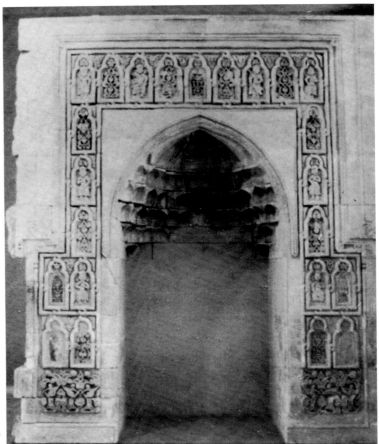

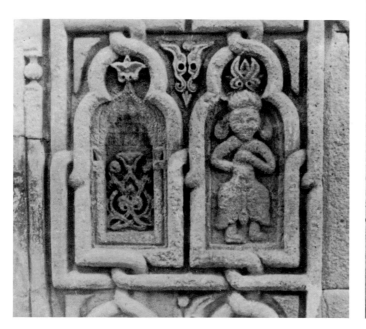

FIG. 3. Detail, left side of niche shown in Figure 2

FIG. 4. Detail, upper left side of niche shown in Figure 2

FIG. 5. Detail, top left corner of niche shown in Figure 2

FIG. 6. Detail, top right corner of niche shown in Figure 2

FIG. 8. Detail, right side of niche shown in Figure 2

FIG. 7. Detail, upper right side of niche shown in
Figure 2

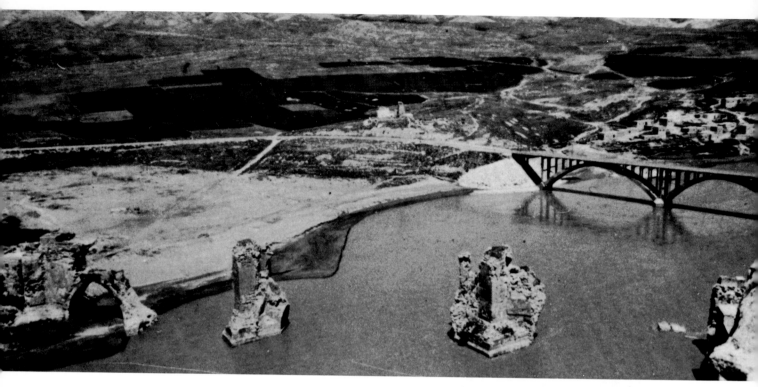

Fig. 9. Bridge, Ḥiṣn Kayfā (Hasankeyf), c. 550/1155

Fig. 10. Relief, from bridge shown in Figure 9

Fig. 11. Relief, from bridge shown in Figure 9

Fig. 12. Relief, from bridge shown in Figure 9

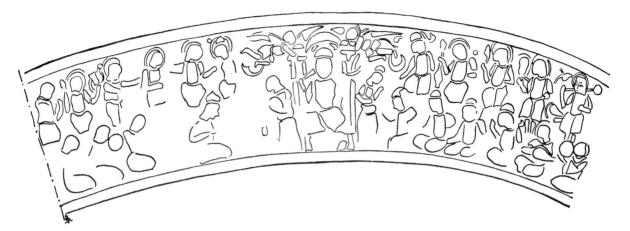

FIG. 13. Aḥmad al-Dhakī al-Mawṣilī, brass ewer, neck frieze, 620/1233. Cleveland Museum of Art (drawing after D. S. Rice, "Inlaid Brasses from the Workshop of Aḥmad al-Dhakī al-Mawṣilī," *Ars Orientalis,* II, 1957, fig. 3)

FIG. 14. ᶜUmar ibn Ḥājjī Jaldak, brass ewer, shoulder frieze (detail), 623/1226. New York, Metropolitan Museum of Art, 91.1.586. Courtesy The Metropolitan Museum of Art

FIG. 15. Second detail of shoulder frieze of ewer in Figure 14. Courtesy The Metropolitan Museum of Art

FIG. 16. Third detail of shoulder frieze of ewer in Figure 14. Courtesy The Metropolitan Museum of Art

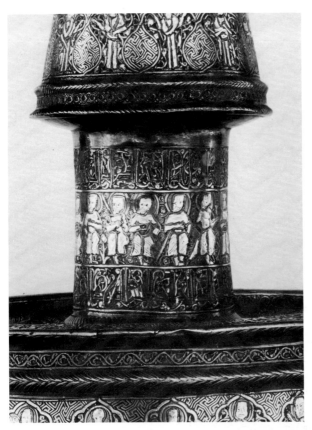

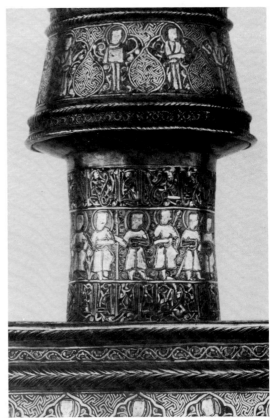

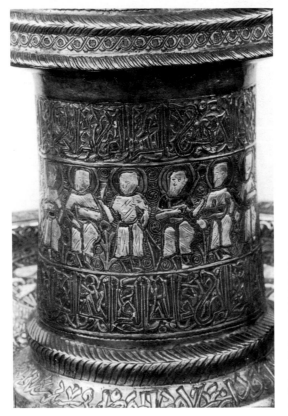

Top left: FIG. 17. Dā'ūd ibn Salāmah, brass candlestick, socket shaft (detail), 646/1248. Paris, Musée des Arts Décoratifs. Courtesy Musée des Arts Décoratifs

Top right: FIG. 18. Second detail of candlestick socket shaft in Figure 17. Courtesy Musée des Arts Décoratifs

Bottom: FIG. 19. Third detail of candlestick socket shaft in Figure 17. Courtesy Musée des Arts Décoratifs

Fig. 21. Emblem 26 (drawing: Thomas Amorosi, after L. A. Mayer, *Saracenic Heraldry: A Survey,* Oxford [Clarendon Press], 1933, 8)

Fig. 22. Emblem 24 (drawing: Thomas Amorosi, after L. A. Mayer, *Saracenic Heraldry: A Survey,* Oxford [Clarendon Press], 1933, 8)

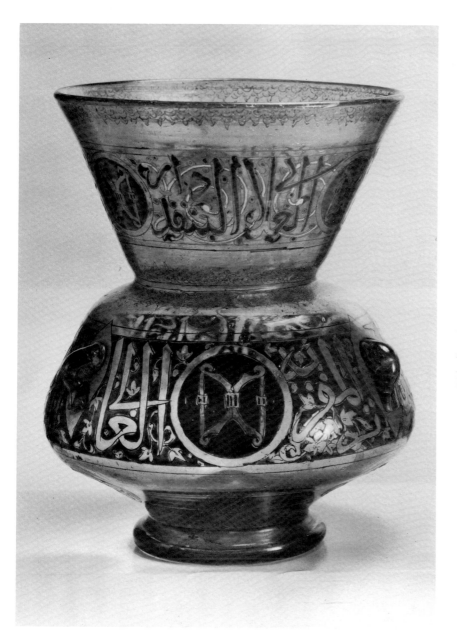

Fig. 20. Enameled glass lamp of Aydakīn al-Bunduqdār, c. 683/1284. New York, Metropolitan Museum of Art, 17.190.985. Courtesy The Metropolitan Museum of Art

The Scholar, the Drinker, and the Ceramic Pot-Painter

Marina D. Whitman

IN 1935, Richard Ettinghausen wrote an article entitled "Important Pieces of Persian Pottery in London Collections,"[1] and shed a broad beam of light onto the until-then-unclear field of Persian ceramic chronology. His discussion of specific pieces drew attention to one of the few surviving dated ceramic objects from the first half of the sixteenth century, a wine jar painted with the numerals 930 (A.D. 1523) (fig. 1). With reference to iconographical questions, Ettinghausen proposed that the painter of the 1523 wine bottle probably chose his theme—a single bird perched nearly in the center of a flowering bush—to appeal to Persian taste;[2] Persian poems frequently unite a rose with a nightingale as a symbol of mystical union. To the Persian viewer, the image might summon up lines from Saʿdī:

> If there were no rose the nightingale would not be
> singing in the grove . . .[3]

Ettinghausen, however, recognized that what he called "the artistic and technical conception" of the wine flask was derived from Chinese wares, and he suggested that the bush had been drawn to resemble a peony.[4] When a Chinese porcelain painter rendered such a theme, he probably used either a *prunus* or a peach tree to signify the herald of spring (fig. 2).[5] Thus, whereas the Near Easterner was prone to read the message as a wedding of spiritual attractions, the Far Easterner saw the visual symbol as a signal of cheerful times and as an embodiment of happiness. The Persian painter, apparently unself-conscious about borrowing this theme, was not at all anxious to disguise its sources, and seems to have been unconcerned with any symbolism

the bird or branch may have had in its place of origin. The Persian artist, by generalizing the formal definition of the *prunus,* enabled the blossom to be read more easily as a rose, possibly triggering a certain empathy in the Persian viewer. Yet the image remained sufficiently distinct and foreign to be seen as inspired by Chinese themes.

Ettinghausen realized that images with positive associations—even though they might derive from various sources—enhanced an object's value when the Persian viewer recognized his own tradition in a foreign yet artistically esteemed context.

In a 1972 publication, *From Byzantium to Sasanian Iran and the Islamic World,* Ettinghausen established three separate levels of artistic absorption that result from the confrontation and interaction of two distinct but complex civilizations.[6] He identified these three modes of artistic transmission as transfer, adoption, and integration, and demonstrated them in case histories. This system of classification is helpful in establishing a hypothetical chronology for a small group of Persian blue-and-white ceramics that all exhibit the bird-and-foilage motif.

A Persian dish in Figure 3 exemplifies the initial stage of this process—the transfer state—which is achieved when shapes or concepts are taken over with minimal change, development, or investigation of their possible meaning. When the dish is compared to a Chinese porcelain flask (fig. 2), the two birds and a *prunus* branch seem (with some leeway for awkwardness) remarkably pure and unadulterated. The bamboo and *prunus* blossoms are there on a second Persian dish (fig. 4), but they are moved to the edge of the medallion, and one wonders what supports the two birds. A certain amount of formal disintegration seems to have occurred and the original source has become slightly obscured. Such an adoption may be the result of a copy of a copy and probably should be placed later in time than the original.

A third Persian dish (fig. 5) based on a slightly later Chinese model (fig. 6) again portrays flora of an ambiguous botanical species. This in turn summons up a question similar to that of whether the bush on the 1523 flask should be read as a peony or a rose. Because these two vessels indicate that some adaptive mechanism, conscious or unconscious, was at work, they may be placed in the category of artistic adoption. This suggests that they were created later then those Persian dishes where the botanical rendering is fairly accurate.[7]

Ettinghausen labeled the third stage of artistic assimilation, integration; it represents a synthesis in which the source and the creativity of the copyist fuse. In Figure 7, for example, the composition is so homogenized that it would be difficult to identify the original source for the two birds in a landscape. The creatures might be posed in courtship, but if the bird with fluttering wings is in fact pecking at the stationary one, the combination recalls the image of a hawk striking a duck (in which the predator normally seizes its prey by the beak). The Chinese often included one or a pair of birds—although not in the act of combat, a visual symbol that in Islamic usage was frequently intended to suggest the quest for power.[8] These birds are set into a mixture of Chinese and Persian landscape elements in which the Chinese cloud knot merges with a flowering arabesque, and the curving *prunus* tree, sinuously Persianized, is at ease with the Far Eastern cavetto scroll. The object is a good example of integration, where a foreign artistic idiom is harmonized with a local one. For that reason it most likely is somewhat later in date than vessels upon which foreign designs are merely copied.

My introductory remarks focus on the theme of birds and branches rather than on the figural images indicated in my title because the model for my arguments was established by reading publications in which Ettinghausen refers to ceramic objects with botanical themes. Some of his thoughts guided and conditioned my thinking about the iconographical confusions that arise from an exchange of goods without an exchange of ideas. When considering an artistic blending of two radically different cultures, the portrayal of human behavior presents knottier problems

with less chance of mutual intelligibility than is true with flora and fauna, but the basic mechanism of transmission and mutation remains the same. Having applied Ettinghausen's methodology to a simple sequence, I will now show how a composition using a human figure can be transmitted.

To understand the relationships between Chinese (fig. 8) and Persian (fig. 9) ceramics where a seated figure is portrayed, I believe it is best to start with the Chinese model. Customarily these vessels depict a Confucian scholar who has retreated from the world. In brief, such a person belonged to a well-educated class. By passing examinations he became a civil servant and, by extension, a member of the intelligentsia. In order for these scholars to function as bureaucrats they needed to cooperate with China's rulers. When such scholars found that traditional cultural values were no longer honored, the Confucian tradition dictated that they either actively protest or demonstrate their disapproval of a monarch and his court by withdrawing from the public sphere and retiring to the country.

A Chinese humorist of the tenth century describes Confucian scholars in retreat as:

> Subjects . . . deprived of their professional opportunities [who] sank to an unprecedented low in social status and self-respect. . . . These school officials look noble but are actually debased. Their salaries are not even sufficient to save them from cold and hunger. The worst among them have sunken faces, needle sharp adam's apples and firewood-like bones.[9]

This may be a bit of an overstatement, but if the Chinese viewed scholars in retreat as eccentrics, Persians must have found them even more puzzling.

The Persian dish shows a straightforward use of the theme—an example of the transfer mode (fig. 9). Its similarities to a Chinese model appear obvious; a Ming artist might identify the person at its center as a scholar-in-the-mountains. The Persian artist boldly used a quotation and makes obvious reference to an earlier work. Some features, the landscape backdrop in particular, were already known to the Persian artistic tradition. The bent, gnarled pine tree behind the figure had become a stock image in Persian painting. For the Chinese, this evergreen, which stays alive and intact through the long, cold winter, is analogous to the scholar who maintains his integrity through trying circumstances. In Persian examples, the pine tree and scholar often appear together, but it is questionable whether the deeper meaning of this combination was understood by the Persian artist or viewer. Even Chinese ceramic depictions of this theme lack the solemn grandeur of Chinese landscape paintings. Here only a loose cascade of dangling lines behind the seated scholar recall a precipitous mountain setting. A low bentwood table with a vase resting upon it is placed beside the scholar. Although in later versions all landscape elements are deleted, here he sits outdoors on a rudimentary hill defined by layers of curving rocks, with his hands and legs hidden beneath a generous garment.

Did the Persian painter copying this theme understand its meaning? The Near Eastern depiction of a scholar usually shows him with a book, paper, or pen, and frequently also with a group of companions or listeners, rather than in isolation. For example, the author portrayed in a thirteenth-century painting from Baghdad appears deeply immersed in thought, but he has an audience and the gesture of his hand implies that his ideas are to be shared with others (fig. 10). In a marginal drawing of the early fifteenth century, the gnarled old tree serves as a backdrop for groups of scholars seated in discussion (fig. 11). Even in a seventeenth-century painting, roughly contemporary with the sage on the dish, a *mullā* is paired with a disciple (fig. 12) and a book lies before him on the ground.

The Persian dish (fig. 9) demonstrates that Chinese porcelain vessels with similar depictions were known in Iran, but the Persian pot-painter may not have realized that the image portrayed a scholar. The composition includes no listener, no writer taking notes, and no books to suggest texts being studied. For the Persian viewer, then, the scene might have been subject to various interpretations.

Less ambiguous for a Persian viewer were situations where Chinese scholars were shown in conversation or in meetings with the emperor. A Persian dish now in London appears to show such an encounter (fig. 13). Its asymmetrically placed figures, moving or turning toward the seated figure, are somewhat reminiscent of those depicted on a Chinese vessel (fig. 14) in placement.

A second scene of scholar and associate (fig. 15) indicative of the adoption mode of artistic transmission, portrays the characters in a more specific situation. The gentlemen standing at the far left might be a counselor tutoring the kneeling listener. This allusion to study and scholarship might be based on a specific Chinese source, but the painter's inclusion of two demure Buddhist guardian lions (the dogs of Fu) playing with a ball raises questions about his use of a single source.[10] Possbily the Persian painter had seen a depiction of an Emperor with a *ch'i-lin* in the foreground (fig. 16). To a Chinese, the presence of this creature before the emperor would be viewed as heralding an age of enlightened government and civic prosperity. The Persian painter may have substituted a lion for a *ch'i-lin*.

Another Persian vessel depicts a scholar and his companion (fig. 17). In them, the older man carries a cane or staff, so that he looks more like a shepherd than a scholar; this figure was not widely used by the Persian artists,[11] who seem to have preferred the combination of a seated figure and a servant (fig. 18). Precedents for scenes of Chinese scholars served by small, obeisant boys are common. The boys may carry bowls of fruit, beverage bottles, a live goose, musical instruments, or other paraphernalia useful to their master (fig. 19). On Chinese porcelains the servant figure often has a jutting profile and large facial features (fig. 20). The combination of sage and servant developed new variants in a Persian context. In this process the ascetic flavor of the Chinese theme is transformed and a more festive atmosphere created.

Thus, from the image of servant and scholar comes a new group: a musician receiving a vase of flowers (?) from a bearer (fig. 21). The person serving the musician is relatively larger than servants in the Chinese examples. The servant has been portrayed more as an equal, possibly as a cupbearer (*sāqī*), trained not only to serve but also to please. In some cases the relationship of master and servant evolved into that of lover and beloved.[12] Here, however, the musician's attendant carries a curious object. It consists of a partially filled bottle topped by a petaled ornament carried on a large dish. This combination may derive from a Chinese source where a servant carried a tall bottle containing sticks with projecting arrow-like side fins (fig. 22). Scholars played a game (*To-Hu*) in which these sticks were tossed, in hopes of placing them in the vessel's mouth. A Persian painter's unfamiliarity with this game may have led him to create the curious vessel seen in Figure 22.

Musicians are commonly portrayed in Safavid painting on paper (fig. 23) as well as on ceramics (fig. 24). In China scholars were frequently trained to play instruments, so possibly images of scholarly Chinese lute players exist, but the only example known to me shows a Taoist immortal holding what is probably a flute (fig. 26).[13] The seated musician on the Persian vessel now in Leningrad (fig. 24) may, however, be derived from a different image where a scholar is shown holding a large fan with a lute-shaped silhouette (fig. 25). It is difficult to determine whether the Persian image was inspired by a Chinese musician, a scholar holding a fan, or the Persian musician theme.

The Persian vessel depicting a seated man clutching a bottle may also have derived from this same repertoire (fig. 27). By placing this bibulous reprobate in a Chinese framework, the Near

Eastern painter has transformed the foreign image of a scholar-recluse into a familiar figure—the drinker. Persian poets have left us verses that correspond to a similar image type. The most general association would simply speak of the easygoing life of conviviality. Manūchihrī Dāmghānī (d. 1041), a Ghaznavid court poet, speaks of the enjoyment of wine and music:

> In a gathering of noble men, there are three things, and no more, and those three things are the *rubāb* [rebeck], *kabāb,* and wine (*sharāb*).[14]

In the life of the courtier, wine functions as a social lubricator. Manūchihrī exhorts a companion to serve wine.

> O idol of Hisar! You have nothing else to do—why don't you have a party, why don't you serve wine? . . . If you are my lover, O handsome Turk, you must court me more than this.[15]

Ḥāfiz (1321–91) elaborates on the theme of the wine drinker as a symbol for the lover.

> With locks disheveled, flushed in a seat of drunkenness, His shirt torn open, a song on his lips and winecup in hand—With eyes looking for trouble, lips softly complaining—So at midnight last night he came and sat at my pillow. He bent his head down to my ear, and in a voice full of sadness He said: "Oh my old lover, are you asleep?" What lover, being given such wine at midnight, Would prove love's heretic, not worshiping wine? Don't scold us, you puritan, for drinking down to the dregs: This fate was dealt us in God's prime Covenant. Whatever He poured into our tankard we'll swallow: If it's liquor of Paradise, or the wine that poisons. A laughing wine cup, a tangle of knotted hair—And let good resolutions, like those of Ḥāfiz, be shattered![16]

The anonymous pot-painters could have pictured wine drinking without any underlying thoughts or references to the mysteries and emotions of life. Yet the allegorical implications of wine in Ṣūfī doctrine offer another possible interpretation of the drinker—a person seeking spiritual knowledge by means of intoxication.

At this point it seems appropriate to refer to the inscription painted on the border of the convex sides of the 1523 wine flask (fig. 1). The verses do not refer to the depicted scene of a bird with flowers, rather the words describe the wine flask's function and give some hint of the painter's attitude. I quote Ettinghausen's translation of these verses:

> Oh, my Lord, may my soul not reach a union with you, and may no word nor sign of my existence come to you, at the end of the time may I not for a moment be with you, in short, may the world not be with you! In this old tavern a drunkard said: May the end of all drunkards be auspicious![17]

The sixteenth-century ceramic calligrapher did not choose to sanctify the consumption of alcoholic beverages, but he indirectly expressed an awareness of religious strictures. He reassured the drinkers who might use his vessel that their end could, nevertheless, be auspicious. By means of these verses, the painter gave tacit support to bacchanalian activities.

Further Iranian variants of the theme of scholar-drinker are derived from Chinese export porcelains of the late sixteenth and seventeenth centuries (fig. 28). The artist focuses his energy on the pose and appearance of the drinker. The left hand is given a bottle to hold, one leg is drawn up

and folded under, whereas the second is extended. The gesture of the right arm also becomes formal. From the shoulder to the elbow, the right arm is placed diagonally, angled downward away from the body. Covered with a loose sleeve, it suggests a Chinese costume. The lower part of the arm is left bare and is bent at the elbow, crossing the chest, and then bent again at the wrist, so that the unencumbered hand points in the direction of the bottle. The meaning of this gesture is uncertain.

On earlier Persian dishes representing the same theme the arms of the central figures were hidden under their garments, or their hands rested on a chair or rocks, or played a lute. Here the man's gesture resembles that of a lute player, but the instrument is not present. Was this figure's posture derived from that of a lute player or did it arise from a series of formal experiments intended to determine the most aesthetically balanced and graceful posture?

A similar hand posture is assumed by a Taoist sage who holds a double-gourd flask (fig. 29). In the Chinese pictorial tradition wine bottles were held by servants or placed on tables; they were not held by Confucian gentlemen. Taoist sages, however, frequently held a container perhaps filled with an elixir. A Taoist figure may have inspired a unique Persian example (fig. 30) which depicts a partially clad figure with bare chest and short skirt. In the Chinese tradition, Taoists may wear loosely draped garments that partially expose a bare torso. In the Iranian tradition it was customary for all figures to be fully clad, even when inebriated. The portrayal of the scantily clad drinker on the Perisan bowl therefore suggests that a Taoist element may have entered into the conception of the scholar-drinker.

The metamorphosis from Chinese scholar to Persian drinker was a gradual one. Iconographic evolution is complicated and probably the result of a series of coincidences. The initial stimulus to change was probably the need to make the figure of the scholar recluse meaningful to Persian viewers.[18] Without the figure's assumption of a new significance, the theme probably would have been discarded. That transformation occurred by changing the scholar's attributes rather than his surroundings or garment, both of which contributed an exotic aura to the image. The ambiguity of the figure was eliminated by adding a servant, a lute, or a bottle.[19] Finally, the servant (sāqī) disappears and the drinker is placed at the center of the composition. He is crowned by a wavy cloud, or surrounded by circles that are decorative extensions of rock formations (fig. 31). Sometimes the figure is isolated and crowned by a halo, serving not as a metaphysical symbol but as an artistic device to accentuate the solitary drinker. The figure is flanked by abbreviated landscape symbols, a soft rolling hill and a flower. This simplified version of the scholar in a landscape appears to have had the widest circulation. In Figure 32, for example, this hackneyed but instantly recognizable character inhabits the side of a wine bottle, leading an independent existence removed from its former context. Here the image has reached the final stage of integration.

The complete and final interpretation of this figure is elusive, but clearly the Persian drinker is descended from a Chinese scholar.

NOTES

1. R. Ettinghausen, "Important Pieces of Persian Pottery in London Collections," *Ars Islamica*, II, pt. 1, 1935, 45–64.

2. Ettinghausen, "Important Pieces," 53.

3. Seyyed Ḥossein Naṣr, "Rūmī and the Ṣūfī Tradition," *The Scholar and the Saint: Studies in Commemoration*

of Abū'l Rayḥān al-Bīrūnī and Jalāl al-Dīn al-Rūmī, ed. Peter Chelkowski, New York, 1975, 180.

4. Ettinghausen, "Important Pieces," 54.

5. The rose appears as a flowering spray on some examples of Chinese porcelains (see J. A. Pope, *Chinese Porcelains from the Ardebil Shrine,* Washington, D.C., 1956, 91), but very infrequently, and then not in connection with a bird. When the Chinese ceramic painter illustrated the nightingale, *Liothrix lutens* (a somewhat different species from the Persian *bulbul* [*Luscinia golzii*]), he perched the bird on the branch of a tree, not on a peony scroll or on a rose-blossom spray.

6. R. Ettinghausen, "From Byzantium to Sasanian Iran and the Islamic World, Three Modes of Aristic Influences," *The L. A. Mayer Memorial Studies in Islamic Art and Archaeology,* III, Leiden, 1972, 2–3.

7. The stiffer, less naturalistic style of the Persian dish illustrated in Figure 5 seems to be derived from a Chinese work of the Hsüan-te period (A.D. 1426–36) rather than a model of the Yung-lo period (A.D. 1403–24) (fig. 2). The model used by the painter of the 1523 flask is more problematic. The pudgy buds and pointed arching leaves that emanate from the tendrils are rendered in a highly generalized manner. The anatomy of the bird in the center of the dish has also been minimally differentiated, in comparison with the earlier dishes. The bird's head directed obliquely upward might indicate its search for a missing partner placed in the branches above (in the other compositions, either Chinese or Persian). By the second quarter of the fifteenth century, the Chinese themselves often reused well-established formulas and consciously attempted to follow an earlier style. Although connoisseurs usually can distinguish between a Yung-lo and Hsüan-te piece, these differences may not have been conveyed by the Persian copyist. The original Chinese model or a Persian copy of a Yung-lo or Hsuan-te model might have served as inspiration for this piece, but the lack of specific definition and precise imitation given to the flora and fauna lends credence to the latter possibility. The shape of the A.D. 1523 footed flask, with its banded edge that meets the two sides at sharply pronounced angles, was an imitation of a Near Eastern metalwork shape. The Chinese did not incorporate this shape into their repertoire until the second quarter of the fifteenth century. During the first quarter of the fifteenth century, the moon flask (fig. 2), with more unified and curving surfaces that tended toward a spherical shape (based upon Islamic glass models) was preferred. Although the Persian ceramists could have looked directly to their own metalwork for typological molds, if they were following a Chinese model, it was Hsüan-te.

8. E. Baer, "An Islamic Inkwell in the Metropolitan Museum of Art," *Islamic Art in the Metropolitan Museum of Art,* ed. R. Ettinghausen, New York, 1972, 207.

9. Wai-Kam Ho, "Chinese Under the Mongols," *Chinese Art Under the Mongols: The Yuan Dynasty (1279–1368),* Cleveland, 1968, 77.

10. The painting in the roundel is a composite of diverse elements not traditionally linked in Chinese lore. A money symbol (one of the eight treasures), delineated by a circle enclosing a square, is loosely alluded to and substituted for the more common brocaded ball with flaming streamers.

11. The Safavid ceramic industry, judging from what has survived above ground, must have been prodigious. Assessment of what themes were preferred and tended to be propagated over a long period of time can be precarious, considering that only a fraction of the production is known. The V & A dish in Figure 15 is unique; figures holding sticks are more numerous but still do not appear with great frequency, and that theme seems to have had a short life expectancy in the repertoire of a ceramic atelier.

12. E. Yarshater, "The Theme of Wine Drinking and the Concept of the Beloved in Early Persian Poetry," *Studia Islamica,* XIII, 1960, 43–53.

13. I am grateful to Alfreda Murck of The Metropolitan Museum of Art, who freely discussed possible interpretations of objects held by the figures.

14. J. W. Clinton, *The Divan of Manūchihrī Dāmghānī: A Critical Study,* Minneapolis, 1972, 67. This reference was kindly provided by Dr. Irene Bierman of the University of California, Los Angeles, who also suggested that a Ṣūfī explanation of the presence of the wine bottle should not be overlooked.

15. Clinton, 83.

16. *Hafiz of Shiraz, 30 poems,* trans. P. Avery and J. Heath-Stubles, London, 1952, 30. I am grateful to Professor E. Yarshater, who advised me to look to the words of Ḥāfiẓ for literary images to pair with painted configurations.

17. Ettinghausen, "Important Pieces," 53.

18. Hermits and recluses, such as Majnūn in the desert, were part of the corpus of seventeenth-century illustrated narratives (cf. B. Gray, *Persian Painting,* Geneva, 1961, 120 and 140), but this theme does not seem to have been pursued by the ceramic painters.

19. Lisa Golombek proposed the idea that the subject of a Safavid painting with a single figure was often communicated by an inanimate object held close to the person's body, "Toward a Classification of Islamic Painting," *Islamic Art in the Metropolitan Museum of Art,* 29 (see note 8 above for the complete citation).

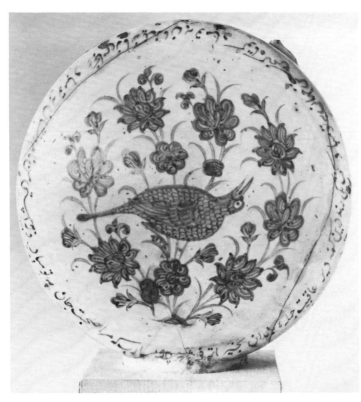

FIG. 1. Flask, Iran, dated 930/1523–24. London, By courtesy of the Victoria and Albert Museum, Crown Copyright (Salting Bequest, no. 658, 1973–1910)

FIG.2. Flask, China, early fifteenth century. London, By courtesy of the Percival David Foundation of Chinese Art (A 612)

FIG. 3. Dish (detail), Iran, late fifteenth or early sixteenth century. Courtesy of the State Hermitage, Leningrad (drawing: Thomas Amorosi)

FIG. 4. Dish (detail), Iran, early sixteenth century. Courtesy of the State Hermitage, Leningrad (drawing: Thomas Amorosi)

FIG. 5. Dish (detail), Iran, sixteenth century. New York, H. Anavian (drawing: Thomas Amorosi)

FIG. 6. Dish (detail), China, Hsüan-te period, 1426–36. Tokyo, Kochukyo Co. Ltd. (drawing: Thomas Amorosi, after *Oriental Art,* Summer 1965, 78)

FIG. 7. Dish, Iran, sixteenth century. London, By courtesy of the Victoria and Albert Museum, Crown Copyright (C30–1960)

FIG. 8. Dish, China, Wan-li period, 1573–1619. Leeuwarden, Princessehof Museum (no. 874). Courtesy and copyright of the Princessehof Museum

FIG. 9. Dish, Iran, seventeenth century. London, By courtesy of the Victoria and Albert Museum, Crown Copyright (1088–1876)

FIG. 10. *Author, scribe, and attendants,* from *The Epistles of the Sincere Brethren,* Iraq, dated 686/1287. Istanbul, Library of the Suleymaniye Mosque, Esad Efendi 3638, fol. 3v

Left: FIG. 11. *Gathering of Scholars, Dīwān of Aḥmad Jalayir,* Iran, c. 1400. Washington, D.C., Freer Gallery of Art. Courtesy Freer Gallery of Art, Smithsonian Institution

Below: FIG. 12. *Princely youth and dervish,* Iran, seventeenth century. New York, Metropolitan Museum of Art, Purchase, Rogers Fund 1911 (11.84.13). Courtesy The Metropolitan Museum of Art

FIG. 13. Dish, Iran, seventeenth century. London, By courtesy of the Victoria and Albert Museum, Crown Copyright (1000–1883) (drawing: Lenora Paglia)

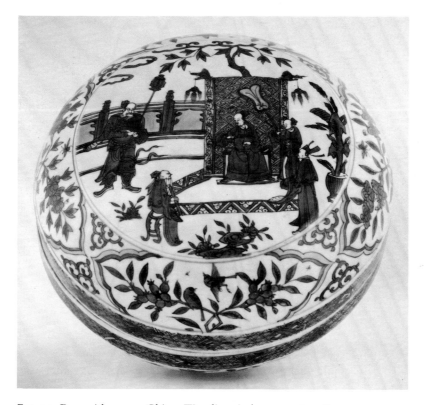

FIG. 14. Box with cover, China, Wan-li period, 1573–1619. Boston, Museum of Fine Arts, John Gardner Coolidge Collection, 46.489. Courtesy Museum of Fine Arts, Boston

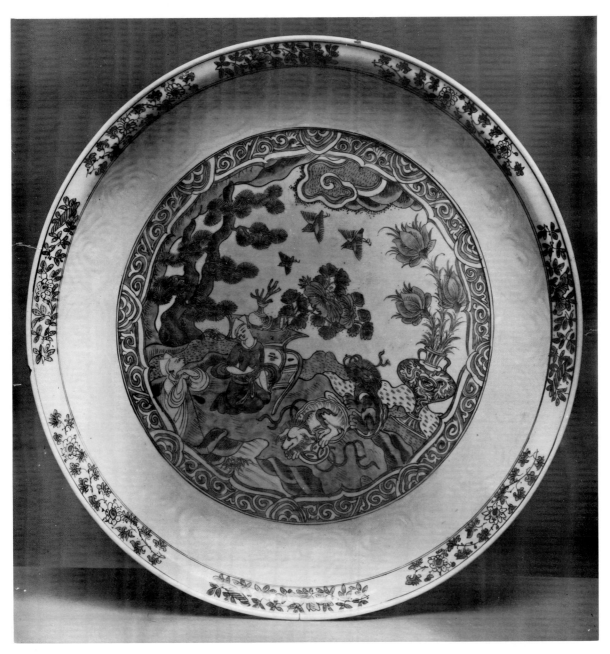

FIG. 15. Dish, Iran, seventeenth century. London, By courtesy of the Victoria and Albert Museum, Crown Copyright (451–1878)

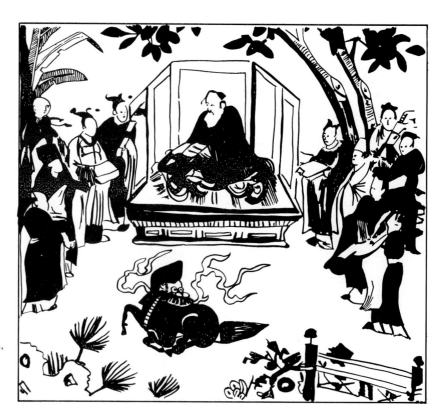

FIG. 16. Porcelain plaque, China, sixteenth century (second half). Hong Kong, Sotheby Parke Bernet Ltd., 24 May 1978, Sale (drawing: Thomas Amorosi)

FIG. 17. *Qalyān*, Iran, seventeenth century. Cambridge (England), Fitzwilliam Museum (reproduced by Permission of the Syndics of the Fitzwilliam Museum) (C 49–1911)

FIG. 18. Dish (detail, inner roundel), Iran, seventeenth century. London, By courtesy of the Victoria and Albert Museum, Crown Copyright (1452–1878)

FIG. 19. Bowl, China, Wan-li, 1573–1619. Hong Kong, Sotheby Parke Bernet Ltd., 28 November 1978, Sale (drawing: Thomas Amorosi)

FIG. 22. Tankard, China, seventeenth century. Leeuwarden, Princessehof Museum (no. 347). Courtesy and copyright of the Princessehof Museum

Top left: FIG. 20. *Mei-P̌ing,* China, fifteenth century, Hong Kong, Sotheby Parke Bernet Ltd., 28 November 1978, Sale (drawing: Thomas Amorosi)

Bottom left: FIG. 21. Dish (detail, inner roundel), Iran, seventeenth century. London, By courtesy of the Victoria and Albert Museum, Crown Copyright (1003–1876) (drawing: Thomas Amorosi)

FIG. 23. Painting, Iran, sixteenth century. London, The British Museum, Department of Oriental Antiquities, 1974 6–17 015 (23). Courtesy The Trustees of The British Museum

FIG. 24. Dish, Iran, seventeenth century. Courtesy of the State Hermitage, Leningrad

FIG. 25. Bowl, China, late sixteenth-early seventeenth century. Stockholm, Coutesy Östasiatiska Museet (The Museum of Far Eastern Antiquities)

FIG. 26. Wine vase, China, sixteenth century. Paris, Tournet Collection (drawing: Thomas Amorosi, after J. van Goidsenhoven, *La Céramique Chinoise . . .*)

FIG. 27. Dish (detail, inner roundel), Iran, seventeenth century. London, By courtesy of the Victoria and Albert Museum, Crown Copyright (451–1878) (drawing: Thomas Amorosi)

FIG. 28. Dish (detail, inner roundel), Iran, seventeenth century. London, By courtesy of the Victoria and Albert Museum, Crown Copyright (442–1878) (drawing: Thomas Amorosi)

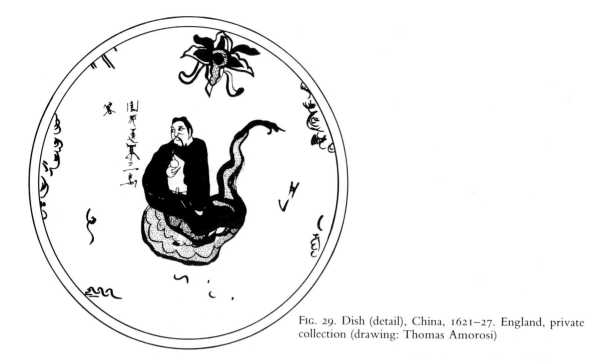

FIG. 29. Dish (detail), China, 1621–27. England, private collection (drawing: Thomas Amorosi)

FIG. 30. Dish, Iran, seventeenth century. Hanley, Stoke-on-Trent (England), City Museum and Art Gallery (photo: courtesy A. R. Mountford)

FIG. 31. Ceramic bowl, Iran, seventeenth century. New York, Metropolitan Museum of Art, Purchase, Bequest of Nellie Kuh, by exchange, Louis V. Bell Fund, and funds from various donors, 1967 (67.108). Courtesy The Metropolitan Museum of Art

FIG. 32. Bottle, Iran, late seventeenth century. London, The British Museum, 78–12–30 616 (Henderson Bequest). Courtesy The Trustees of the British Museum (drawing: Thomas Amorosi)